MANDELA, TAMBO
AND THE AFRICAN
NATIONAL CONGRESS

MANDELA, TAMBO, AND THE AFRICAN NATIONAL CONGRESS

The Struggle Against Apartheid, 1948 – 1990

A DOCUMENTARY SURVEY

EDITED BY

SHERIDAN JOHNS

R. HUNT DAVIS, JR.

New York Oxford
OXFORD UNIVERSITY PRESS
1991

Oxford University Press

Oxford New York Toronto
Delhi Bombay Calcutta Madras Karachi
Petaling Jaya Singapore Hong Kong Tokyo
Nairobi Dar es Salaam Cape Town
Melbourne Auckland

and associated companies in
Berlin Ibadan

Copyright © 1991 by Oxford University Press, Inc.

Published by Oxford University Press, Inc.
200 Madison Avenue, New York, NY 10016

Oxford is a registered trademark of Oxford University Press

Library of Congress Cataloging-in-Publication Data
Mandela, Tambo, and the African National Congress : the struggle
against apartheid, 1948–1990 : a documentary survey / edited by
Sheridan Johns, R. Hunt Davis, Jr.
p. cm. Includes bibliographical references.
ISBN 0-19-505783-X
ISBN 0-19-505784-8 (pbk.)
1. Apartheid—South Africa—History—Sources.
2. South Africa—Politics and government—20th century—Sources.
3. Blacks—South Africa—Politics and government—Sources.
4. African National Congress—History—Sources.
5. Mandela, Nelson, 1918- .
6. Tambo, Oliver, 1917- .
I. Johns, Sheridan, 1935- . II. Davis, R. Hunt, 1939.
DT1757.M36 1991 968—dc20
90-40526

Published in South Africa by
Oxford University Press Southern Africa
Harrington House, Barrack Street, Cape Town, 8001
ISBN 0-19-570641-2 (pbk.)

2 4 6 8 9 7 5 3 1

Printed in the United States of America
on acid-free paper

To all
who have dedicated their lives
to achieving democracy in South Africa

Preface

This book seeks to provide for its readers an understanding of the evolution of the struggle against apartheid, the aspirations and demands of the ANC and its leaders, the central issues in the discourse of African politics, and the role of Nelson Mandela and Oliver Tambo in South African politics from the time of World War II.

In the 1980s Nelson Mandela, the world's most famous political prisoner until his release on February 11, 1990, emerged as the central symbol of the intensified antiapartheid struggle in South Africa—despite his inability to speak directly to the public. It fell to Oliver Tambo, Mandela's longtime associate, who has been free to speak throughout his lengthy exile, to counterpoint Mandela's enforced silence in prison (until his release on February 11, 1990) with frequent articulation of the viewpoints of the African National Congress (ANC). The ANC, the political organization of which both men have been prominent leaders since the 1940s, has sustained its position as the preeminent political body challenging the white monopoly of political and economic power.

The militancy of the 1980s had its roots in a struggle of more than four decades, with Mandela, Tambo, and the ANC at its heart. At the center of South African politics since 1948 has been the clash between the blacks' insistence on full participation in society and the whites' determination to retain power exclusively in their own hands. The intensity of the conflict has generated vigorous debates among Africans (and other South Africans) over the nature of an apartheid-free South Africa. Particularly salient issues have included defining democracy in the South African setting; arguing over whether full citizenship is to be limited to Africans only or open to all South Africans; questioning the fashion in which socialism might redress the inequalities engendered by more than a century of capitalist development; disputing whether the African struggle is primarily racial and national or essentially class based; determining the proper role of external support in a contest for power that remains essentially internal; developing tactics appropriate to the escalat-

ing violence and repression of the government; and assessing when and if negotiation can produce an acceptable resolution of the conflict.

Mandela, Tambo, and the ANC have repeatedly addressed these issues before diverse audiences, both inside and outside South Africa and both before and since Mandela's imprisonment. They also set out these views in the documents that comprise the major part of this volume. Although we had decided on most of these documents by 1988, we also have included some from 1989, to reflect the continuity of the activity of the ANC and its leaders as well as their responses to developments focusing on the willingness of F. W. de Klerk, the new head of the National party government, to seek a dialogue with representatives of South Africa's black majority. The release of Nelson Mandela from prison, coupled with the unbanning of the ANC and other African political organizations, has initiated a new phase in the struggle against apartheid, thus providing a natural concluding point for this study.

This book is not intended to be a complete and authoritative documentary collection of either ANC documents or the writings of Mandela and Tambo. Indeed, from among the vast corpus of ANC materials, this volume includes only those documents that have constituted touchstones for both challenging white supremacy and creating a nonracial South Africa. Likewise, the Tambo documents represent only a portion of the many statements he has made since circumstances beginning in the mid-1960s dictated that he become the prime spokesperson for the ANC in exile. In contrast, the Mandela documents presented in this book include most of those available, largely dating from before his sentence in 1964 of life imprisonment and the enforced silence that followed until he emerged from prison in 1990 to again become the foremost spokesperson of the African cause. Augmenting the few Mandela statements smuggled out of prison are recollections of fellow prisoners and reports of some of the few outsiders permitted to visit him before 1989; these recollections and reports illuminate his continued leadership in prison and his views on the direction the ANC should take. In many instances, only the pertinent sections of these documents have been reproduced, but the list of sources at the end of the book indicates where the complete document can be found.

The documents are grouped into four sections, and within each section they are presented chronologically in the following order: writings and statements of Mandela, writings and statements of Tambo, documents of the ANC, recollections of fellow prisoners, and accounts of prison visitors. The first section covers the period between 1948 and 1960, in which the ANC mounted an increasingly militant, but still open and legal, challenge to apartheid. The second section deals with the period between 1960 and 1964, in which the ANC was banned, with its most prominent leaders either in prison or in exile. The ANC thus was compelled to reorient radically its methods of operation—from above ground to underground and exile and from nonviolence to selective violence. The third section focuses on the way in which Mandela since 1964 adapted his struggle to the conditions of prison. The last section considers the same post-1964 period but concentrates on the activities of the exiled ANC and the post-1976 period in the country during which the underground ANC

reestablished an extensive presence amidst an unprecedented mobilization of antiapartheid resistance. Overcoming imprisonment and exile, both Mandela and Tambo took the spotlight in the 1980s as political figures central to any resolution of the South African crisis. In 1990, though, it has been Nelson Mandela who has occupied center stage since a stroke sidelined Oliver Tambo in August 1989.

Preceding the documents of each section is an introductory essay that analyzes the pertinent developments of that period in order to place the documents in their proper context. A general introduction and a conclusion assessing continuity and change within the ANC provide a further overview of the period between 1948 and 1990. A chronology, a brief guide to further reading, and a list of sources also are included.

The editors of any volume dealing with South Africa must consider what terms to use to describe the different peoples of the country. We decided to use conventional terms in the text, for example, *African* for members of groups speaking the Bantu languages, *white* for European settlers or their descendents, *Colored* for those persons legally classified by the government as being of mixed descent, and *Indian* for descendents of South Asians who arrived in the nineteenth or early twentieth century. The term *black* is used to refer collectively to the African, Colored, and Indian components of the population. Terms in the documents are as they appeared in the originals and accordingly may vary from those in the text; they have been copy edited to have capitalization conform to current American usage.

The preparation of this volume was possible only with generous assistance from many individuals. We are particularly indebted to Mary Benson, Gail Gerhart, and Thomas Karis for their invaluable assistance in suggesting sources and locating documents. Marie Louise Tecklenburg in St. Albans and Hunt and Helen Davis in Jekyll Island provided congenial retreats for the initial culling and editing of documents. Doug Imig and Mary Frances Davis provided crucial advice and technical support for successive drafts of the manuscript. Throughout, Valerie Aubry and Niko Pfund gave the steady editorial guidance without which this volume would not have appeared. Donna Grosso and Margaret Yamashita rendered essential assistance in the final preparation of the text for the printer. Tim Sanbrook located and provided the photographs from the library of the International Defence and Aid Fund for Southern Africa. Our wives, Christa Johns and Jeanne Davis, have exhibited a forbearance that is rooted in shared hopes for rapid democratic change in South Africa.

All royalties from this book will be split equally between the International Defence and Aid Fund for Southern Africa and the Southern African Medical Aid Project.

Responsibility for the contents of this volume, of course, is exclusively ours.

Durham, N.C. S.J.
Gainesville, Fla. R.H.D.
June 1990

Contents

III A LEADER AMONG PRISONERS, 1964–1990

MANDELA, TAMBO,
AND THE AFRICAN
NATIONAL CONGRESS

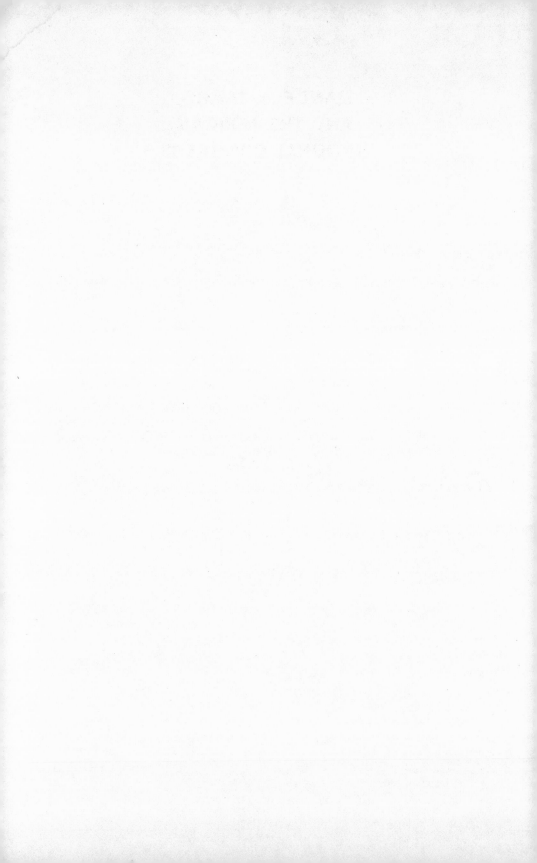

Introduction

The African National Congress (ANC) in 1990 is a stronger organization than ever before in its seventy-eight-year history. After thirty years as a banned and thus illegal organization under South African law, the ANC once again, as a result of the recision of its ban in February 1990, operates openly and freely in South Africa. Even before its reestablished legality, it had carried out extensive activities within South Africa that gave testimony to its viability and organizational effectiveness. As a legal organization it is steadily gaining even further support among Africans, increasingly meeting the already strong approval of other black South Africans, and progressively making inroads into white political circles. At the international level, the ANC is clearly viewed as the leader of the opposition to apartheid and the organization that will be the key negotiating partner with the government for ending apartheid. Indeed, the ANC enjoys the status of being the most likely successor to the Afrikaner National party in forming the next government of South Africa. How has it achieved this feat—despite the long period of its ban, the lengthy imprisonment (1962–1990) of its most prominent leader, Nelson Mandela, and the three decades of exile of its president-general, Oliver Tambo?

The Two Leaders

At the time of his imprisonment in 1962, Nelson Mandela was the preeminent figure in African politics. A man then in his mid-forties, he had established his position of political leadership through both his professional accomplishments and his political work. As one of a handful of practicing African attorneys, he combined his defense of black political activists with an activism of his own, serving as president of the ANC Youth League, later of the Transvaal branch of the ANC, and then playing a key role as a behind-the scenes organizer. This phase of his political work culminated in his leadership of the 1961 stay-at-home campaign and his subsequent underground activities in organizing the military wing of the ANC, Umkhonto we Sizwe.[1] Apprehended in 1962, Mandela further enhanced his stature through forceful and widely publicized court testimony in separate trials in 1962 and 1964.

3

Although Mandela's sentence of life imprisonment removed him from the public eye for many years, he continued to exhibit his unique qualities of leadership among his fellow political prisoners on Robben Island. Reports of Mandela's conduct began to filter out of prison, adding to his reputation in South Africa and thus complementing the efforts of Oliver Tambo and others in the exiled ANC leadership to keep his case (and that of all political prisoners) before the international public. In the wake of the Soweto uprising in 1976 and the subsequent revival of the underground ANC in South Africa, Nelson Mandela came to symbolize the spirit of African resistance, bridging the gap between his own generation and the youth of the 1970s. As a new wave of militant black opposition surged, a broad spectrum of South Africans rallied around the slogan of "Free Mandela," demonstrating their conviction that the long-imprisoned ANC figure had to be centrally involved in shaping their country's future. Amidst the deepening crisis of the mid-1980s, the United States, Great Britain, and other Western powers often viewed as supporters of the South African state joined in demanding Mandela's release. In turn, Mandela, though still imprisoned, was able to capitalize on the new political environment and his own prominence to become a decisive and public voice in South African politics. This process included his much-publicized tea with former President P. W. Botha in July 1989, his orchestration of the government's release of Walter Sisulu, Ahmed Kathrada, Elias Motsoaledi, and five other long-term political prisoners in October 1989, and his December 1989 meeting with President F. W. de Klerk in the latter's office. The entire process culminated with the government's decision to release Mandela unconditionally and Mandela's widely televised emergence from prison on February 11, 1990.

Unconfined by prison walls but constrained by the exigencies of exile, Oliver Tambo also managed to surmount the seeming defeat of the 1960s and to emerge as the acknowledged spokesperson of the renascent ANC. A year older than Mandela, the two men have had a long association that began during their student days at Fort Hare University College in the early 1940s. Their relationship continued with their mutual participation in founding the ANC Youth League and their increasingly visible leadership roles in the ANC in the 1950s (for instance, Tambo was its secretary-general from 1954 to 1958). They also shared a joint legal practice in Johannesburg during the 1950s. Their careers diverged in 1960, however, when the ANC sent Tambo abroad to head its external mission. He has lived in exile ever since and has played a key role in rebuilding the ANC from the low ebb of its organizational fortunes in the early 1960s. Named as its acting president-general in 1967 after the death of Chief Albert Luthuli and as its president-general in 1977, Tambo became the central figure in the externally based ANC. Under his leadership the ANC developed as a strong organization in exile and reestablished a functioning presence inside South Africa. Tambo also proved effective in representing the African cause in the international arena. He clearly has been able to retain the support and respect of the various generations and viewpoints in the ANC. And as the struggle for control of South Africa mounted in the 1980s, Tambo was the individual who articulated most fully and widely the ANC vision of the country's future. Unfortunately, a serious illness (most likely a stroke) in August 1989

forced him to relinquish active leadership of the ANC. Although Tambo continues as president-general, it has been Mandela, as deputy president-general, who has been the foremost spokesperson for the ANC during the first half of 1990.

The African National Congress

The African National Congress is the oldest political organization not only in South Africa but on the continent as well. Founded in 1912, its fortunes have waxed and waned to varying degrees over the nearly eight decades of its existence. Other organizations, ranging from the Industrial and Commercial Workers' Union (ICU) in the 1920s to the All-African Convention in the 1930s to the Pan Africanist Congress in the late 1950s and 1960s to the Black Conscious Movement, Inkatha, and various other organizations of the 1970s and 1980s, have periodically challenged its paramount position in African political circles. Whatever its fortunes of the moment, however, the ANC has consistently and persistently given voice to African aspirations for a fairer and more just South Africa.

The founders of the ANC were primarily professional men, with the first executive committee consisting of three attorneys, four ministers of religion (among them its founding president, John L. Dube, who received his secondary education and ministerial training in the United States), three businessmen (two of whom had also been teachers), and a newspaper editor. Their approach to politics was one that dictated staying within constitutional limits and employing methods such as petitions and delegations to present the African case to the appropriate government circles. They did take up issues of major concern to all Africans, such as the 1913 Natives Land Act, but the membership was limited mainly to the nascent African middle class. Thus, in the 1920s the ICU, with its focus on bread-and-butter economic issues as well as political matters, challenged the ANC for the position of the leading African political organization. In the end, however, the ICU broke apart into competing factions and lost its credibility among those it aspired to lead, while the ANC carried on.

Although the ANC survived the challenge from the ICU, it did so not because of its own organizational strength but because of the ICU's weakness. In fact, when the South African Parliament debated and then passed in 1936 the so-called Hertzog bills (named after the South African prime minister from 1924 to 1939, General J. B. M. Hertzog) which further curtailed the already-limited African voting rights, the ANC was incapable of mounting an effective opposition to the proposed legislation. Leadership instead came from Professor D. D.T. Jabavu, who was not a member of the ANC, and Dr. A. B. Xuma, later president of the ANC but not a member at that time. These two men were involved with the series of so-called Non-European Conferences, which brought together Africans, Coloreds, and Indians to voice political opposition to government policies. Out of this background emerged the All-African Convention (AAC), with Jabavu as president. Although the AAC included members of the ANC on its executive board, in effect African political leadership had passed out of ANC hands. In the late 1930s, however, the AAC

stagnated, in part due to internal organizational problems, and the ANC began to witness a resurgence of its fortunes. By the 1940s the ANC was again the principal organization speaking out on the myriad of issues that confronted Africans in a country where white supremacy was ever intensifying.

The revival of ANC fortunes in the 1940s took place amidst the far-reaching economic and social changes associated with World War II. Heading the reinvigorated organization from 1940 until 1949 was its new president-general, the American-trained physician A. B. Xuma, who infused the ANC with a renewed energy and sense of commitment. Another element contributing to this reemergence was the ANC's recruitment of a new generation of activists. The major vehicle for this initiative was the African National Congress Youth League (ANCYL), organized under the senior body's auspices in 1944. From its ranks emerged not only Nelson Mandela and Oliver Tambo but also other subsequently prominent ANC leaders such as Robert Resha and Walter Sisulu. All of these developments found expression in a new intellectual vitality reflected in major statements of purpose and aims such as *Africans' Claims in South Africa* (1943) and *The Programme of Action* (1949). The latter document was particularly noteworthy, reflecting the movement of the ANC away from the cautious approach of Dr. Xuma toward mass action and civil disobedience. Thus, at the end of the decade when the National party initiated its program of apartheid legislation for the purpose of entrenching yet further the position of existing white privilege at the even greater expense of the overwhelming majority of the population, the ANC was prepared to organize and lead the opposition.

The 1950s constituted for the ANC a period of militant but nonviolent struggle undertaken openly against apartheid and the repressiveness it represented. In addition, it transformed itself from an essentially African middle-class organization to one that could rightly claim to speak on behalf of the masses. This was a decade of major antiapartheid activities: large-scale demonstrations such as the Defiance Campaign of 1952; a growing level of cooperation among African, Colored, Indian, and radical white organizations in developing an antiapartheid front; the successful convocation of the multiracial Congress of the People in 1955 which adopted the Freedom Charter (which has remained the basic ANC statement on the type of society it is seeking); a division within African nationalist ranks with the hiving off from the ANC in 1959 of the Pan Africanist Congress (which insisted on African self-reliance and opposed multiracial tactics); and a mounting challenge to apartheid, which in turn led to increasing government efforts to repress the opposition, including the arrest and trial of 156 leaders of the ANC and allied organizations on charges of treason.

The new decade of the 1960s opened on a note of cautious optimism among an ANC leadership that was making headway in its antiapartheid campaign, but dramatic political changes soon produced a much different mood. On March 21, 1960, the Pan Africanist Congress (PAC) launched a campaign to protest the passes that Africans were obligated to carry at all times and that they consequently regarded as a symbol of their oppression. The campaign led to the tragedy of Sharpeville, in which police fired on an unarmed African crowd, killing sixty-nine people. Shock waves ran throughout South Africa, but after a brief hesitation the government banned the ANC and the rival PAC and declared

a state of emergency. Suddenly an illegal organization, the ANC sought to establish an underground resistance movement that included setting up a military wing, Umkhonto we Sizwe (Spear of the Nation), to undertake a campaign of sabotage. It also sought to develop an organization in exile out of its external mission in order to present the African case more effectively in the international arena and to organize support for Umkhonto we Sizwe. But the government's determination to preserve white political control at all costs proved too strong, and by 1964 it had effectively silenced the antiapartheid movement within the country. The forces of repression remained fully in control throughout the rest of the decade and well into the 1970s. Outside the country, however, the ANC gradually built a viable organization in exile. The PAC, on the other hand, failed to make this transition, though it did not fade away altogether.

The South African government's seemingly secure lock on the country came to a sudden and dramatic end on June 16, 1976, when police fired into a crowd of African student demonstrators in the sprawling urban township of Soweto outside Johannesburg, killing a thirteen-year-old boy. Demonstrations erupted and spread throughout the cities and towns of South Africa in the ensuing days, weeks, and months, in which many hundreds died. The government moved forcefully to contain the uprising. Unlike the early 1960s, however, it proved incapable of fully reimposing its will on the populace. The ANC acted to take advantage of the situation by both building up its base of support within the country and receiving the large numbers of young people who fled South Africa.

The ANC has continued to face rivals vying for the position of the principal African political organization. For a while, the Black Consciousness movement and affiliated organizations such as the South African Students' Organization (SASO), the Black People's Convention (BCP)—both subsequently banned— and the Azanian People's Organization (AZAPO) received considerable attention and claimed a large following. Ethnically based organizations, particularly the Inkatha movement among the Zulu, also challenged the leadership of the ANC.

Yet the ANC became by the mid-1980s the preeminent African political organization, overshadowing all of its rivals. Internationally it acquired both a presence and a credibility that none of its rivals could match. Within the country it enjoyed a barely concealed underground presence for most of the decade. Furthermore, the above-ground United Democratic Front (UDF), a multiracial umbrella alliance formed in 1983 and now numbering some seven hundred organizations, has progressively identified with the ANC, formally adopting the Freedom Charter in 1987. Subsequently, ANC flags have been featured prominently at the large-scale rallies of the UDF. The December 1989 Conference for a Democratic Future (the largest such convocation of antiapartheid forces since the Congress of the People met in 1955 and produced the Freedom Charter) was clearly under the control of a leadership aligned with the ANC.

Freed of all legal restrictions on its activities in early February 1990, the ANC in the first half of 1990 moved to consolidate its position in South Africa. The leadership of the UDF, for instance, stated that virtually all of its membership were supporters of the ANC, and a majority of the homeland leaders also threw in their lot with the ANC. The most important homeland leader, Gatsha

Buthelezi, however, actively opposed ANC claims to be the paramount organization in the struggle for freedom and justice. As a result, in the early months of 1990 the province of Natal witnessed bloody fighting between supporters of the ANC and adherents of Buthelezi's Inkatha that left many hundreds dead and thousands homeless. The PAC, also unbanned, refused to join in a common effort with the ANC to bring an end to apartheid and instead cautioned Africans against a possible ANC "sell-out." Yet, despite such opposition, the ANC was in a sufficiently strong position to compel the government to negotiate solely with its representatives in early May about full-scale negotiations on the country's future. Only a few months earlier de Klerk had been insisting that the ANC would be only one of several parties with which the government would eventually negotiate.

Principal Themes

During the more than forty years of its fight against apartheid, the ANC has focused on a range of issues concerning the methods of its struggle and its vision of postapartheid South Africa, as indicated in the documents in this volume. First comes its commitment to democratic ideals. Beginning with its inception in 1912 the ANC has sought African participation in the country's representative institutions and an end to segregation and discrimination. In the 1940s the ANC became even more insistent on a full and unqualified franchise and the elimination of legal and economic barriers to African advancement. With the advent of apartheid in 1948, the ANC not only continued its insistence on political and civil rights but also began to argue more forcefully for an economic democracy. The broad outlines of its model for social democracy in South Africa were fully articulated in the 1955 Freedom Charter (Document 14), which to this day remains at the center of ANC thinking.

The Freedom Charter also sets forth ANC thinking on a second major issue: whether South Africa is for Africans alone or for all who live in it. Considerable tension had developed within the ranks of the ANC during the 1940s, between those who advocated a more inclusive, nonracial nationalism and those who argued for an exclusively African nationalism. Common engagement in the antiapartheid struggle with allies from all racial groups culminated in the Freedom Charter, in which the ANC resolved that the liberation of South Africa was the task of all genuine democrats, irrespective of race, and that South Africa's future belonged to all who made the country their home. The ANC has steadfastly maintained this commitment in the face of both the Africanist challenge of the PAC and the later Black Consciousness challenge. In 1969, the ANC further elaborated its principle of nonracialism by opening its membership to non-Africans and then, in 1985, by doing the same with its national executive committee.

The Freedom Charter also set forth the ANC's position on the nature of the future South African economy. It explicitly endorsed the goal of a mixed economy in which state power would be used to remedy the great inequalities of wealth and vastly unequal access to opportunities along racial lines. Major industries, including the mining sector, would be nationalized, but the remain-

der of the economy would remain primarily in private hands. A major land reform was envisaged, as were a range of affirmative action programs to ensure opportunities for those who had been disadvantaged by previous state policies. Despite attacks in the 1980s from a new breed of Marxists (but not the South African Communist party), the ANC has adhered to its vision of a social democratic South Africa.

Intertwined with issues concerning the appropriate form of socialism (and capitalism) for South Africa has been the debate over the role of nationalism and class conflict in the antiapartheid struggle. The ANC has always accorded primacy to the mobilization of Africans as an oppressed nation. In 1969, therefore, the ANC unequivocally reaffirmed its stance at the same time that it recognized that special attention must be given to the organization of workers as an integral component of the struggle for liberation.

For much of its history, the question of external support was not particularly important to the ANC. Although in the early years of its existence it had continued the pre-Union practice of seeking backing from Britain, it was not until the Nationalist government forced it underground and into exile in 1960 that it had to shift to concentrating on securing foreign support in order to survive. In the intervening three decades it forged links with key independent African countries (especially the Frontline states), with other nonaligned states outside the continent (particularly some in the Commonwealth), with the Soviet Union and some of the Eastern-bloc countries, with smaller Western European states, and with antiapartheid groups in Britain, the United States, and other major Western countries.

A different set of issues, those involving tactics, also become salient in the wake of the ban of the ANC and the subsequent necessity of adapting to the draconian government repression of the 1960s. Throughout its first decades the ANC utilized a range of tactics, including petitions to the government, deputations to cabinet members, and peaceful demonstrations protesting the African disadvantage and exclusion from the bodies of government. Following the 1948 Nationalist electoral victory, the ANC shifted to more militant tactics, placing a much greater emphasis on civil disobedience and mass mobilization, yet carefully adhering to a policy of nonviolence. Banned and blocked from open and peaceful protest, leaders of the ANC concluded in 1961 that they had no choice but to adopt violence in response to the government's escalating use of force and violence. Creating Umkhonto we Sizwe as its military wing, the ANC organized a campaign of selective sabotage and planned for eventual guerrilla warfare. As it stepped up its military activity in the country after the Soweto uprising, new questions arose concerning the extent to which the attacks should move beyond strictly military and economic targets even if civilians were imperiled. Since 1961 the ANC has continued to insist that military activity minimize the loss of human life. The organization has also stressed that its military wing is subordinate to and a complement of political activity, which remains primary in its efforts to topple apartheid.

Once again at the center stage of African politics, as a result of the events of the 1980s, the ANC faces questions concerning the desirability and utility of negotiation to secure its objectives. During the militant civil disobedience

campaigns of the 1950s, it fruitlessly sought direct negotiations with the government. And throughout most of the 1980s the government continued its refusal to engage in direct negotiations with the banned ANC. Yet expanded Umkhonto we Sizwe attacks in South Africa, widening support for both the underground and the exiled ANC amidst deepening black resistance, and international pressure against apartheid served to create a setting in which both the government and its opponents, both inside and outside Parliament, began seeking opportunities for a dialogue. The decision of F. W. de Klerk, almost immediately after his September 1989 election to the state presidency, to release Walter Sisulu and seven other long-term political prisoners indicated that the government was perhaps at last moving toward genuine negotiations.

As the 1990s got underway, the ANC, with its enhanced support and prospects for success far greater than ever before in its history, grappled with the dilemma of how and when negotiations might be used to advance its goals without compromising its ability to realize a nonracial democratic and economically just society in South Africa. Nelson Mandela's address at Cape Town City Hall on the day of his release, televised and broadcast around the world, provided guidance about the direction in which the ANC intended to move. Making clear that he was speaking on behalf of the ANC and not just himself, Mandela addressed each of the principal themes that have been at the heart of the struggle since 1948. First, he reiterated the ANC commitment to democratic ideals: "Universal suffrage on a common voters roll in a united democratic and nonracial South Africa is the only way to peace and racial harmony." He also elaborated on the theme that South Africa belongs to all who live in it by paying special tribute to the Black Sash and the National Union of South African Students: "We note with pride that you have acted as the conscience of white South Africa [by holding] the flag of liberty high." Taking up the theme of the need for a mixed economy, he declared that there was a need for "a fundamental restructuring of [both] our political and economic systems to insure that the inequalities of apartheid are addressed and our society thoroughly democratized." Commenting on the importance of external support, he noted: "We thank the world community for their great contribution to the antiapartheid struggle. Without your support our struggle would not have reached this advanced stage." He also reasserted the need for armed struggle: "The factors which necessitated the armed struggle still exist today. We have no option but to continue . . . [until a climate conducive to a negotiated settlement is created]." Finally, he took up the issue of negotiations. Noting that they "cannot take place . . . above the heads or behind the backs of our people," he also stated that they could not occur until the government met certain fundamental demands, including "the immediate ending of the state of emergency and the freeing of all . . . political prisoners" (see Document 44).

The Documents

The documents in this volume are sorted into five categories. The first category is documents originating with Nelson Mandela. Consisting of speeches, trial testimony, statements, and articles, the Mandela documents can be found in the

sets of documents for all four parts of the volume but primarily in Section I (A New Generation Challenges Apartheid, 1948–1960) and Section II (Proscription and Enforced Reorientation, 1960–1964). Those documents associated with Oliver Tambo come mainly from his speeches, statements, and articles. Although there is one Tambo document each in Sections I and II, most of the documents in Section IV (Mandela, Tambo, and Post-Rivonia Politics, 1964–1990) originate with Tambo. The third category is the major ANC statements of both policy and principle, which can also be found in Sections I, II and IV.

The two more specialized categories of documents, both of which provide testimony about Mandela's years as a political prisoner, are located exclusively in Section III (A Leader Among Prisoners, 1964–1990). The first of these categories is the recollections of fellow prisoners, and the second is the accounts of individuals who visited Mandela in prison.

The documents originate from diverse sources, the most important of which are the publications, statements, and press releases of the ANC. The official organ of the ANC, *Sechaba*, is a particularly important source of documents for the latter part of the period covered in this volume. Left-wing publications in South Africa, such as *Liberation* and *New Age*, are the principal sources of articles by Mandela from the 1950s. A third source of documents is trial testimony. On three separate occasions between 1960 and 1964 while standing trial, Nelson Mandela delivered particularly noteworthy statements to the court. Public speeches by Mandela and Tambo before various audiences, ranging from a 1951 presidential address to the ANCYL (Mandela) to a 1987 speech delivered at Georgetown University (Tambo), constitute a fourth source of documents. Yet another source consists of published interviews with Oliver Tambo, fellow prisoners of Mandela, and individuals who visited Mandela in prison. A sixth source is both published and unpublished accounts by fellow prisoners and by those who met with Mandela during his long prison term. Scholarly publications containing articles by Mandela and Tambo are the final source of documents for this volume.

Many of these documents, especially those in Sections I and II, are from the Carter–Karis Collection, *South African Political Materials*, which is available on microfilm from the Cooperative Africana Microform Project (CAMP) of the Center for Research Libraries. Susan G. Wynne compiled a catalogue of the collection (see the Guide to Further Reading for the full citation of this and the other volumes mentioned in this paragraph). Most of these documents have been published previously in the Carter–Karis volumes of collected documents and in Mandela's collected writings. Likewise, several of the Tambo documents appear in the collection of his writings. The remaining documents are by and large from less easily accessible published sources, such as newspapers, or have not been published previously.

Nelson Mandela, Oliver Tambo, and the ANC had in mind different audiences according to the time, place, and circumstances in which they wrote or spoke. In the majority of the documents (aside from those in Section III), the authors were addressing their audience directly. In some instances, however, particularly those involving Mandela in prison, there were intermediaries between the author and the audience.

Over time many of the documents have acquired new audiences. The Freedom Charter (Document 14) is a case in point. The original intended audience was almost totally South African, but for many years this document was used to interpret the ANC's aims and objectives to a continually expanding international audience as well as to an enlarged domestic audience. Indeed, the appearance of the Freedom Charter and the other documents in our book will create yet new audiences for them. In keeping with our book's framework, which presents these documents in their original historical context, the discussion of audiences at this point will be about those to which the documents were first targeted.

One of the principal audiences is certainly the ANC's rank-and-file and leadership. Statements of policy ranging from the 1949 "Programme of Action" (Document 13) to the 1985 Political Report and Communiqué of the Second National Conference of the African National Congress (Document 59), along with certain speeches and statements of Mandela and Tambo to ANC gatherings (e.g., Documents 1, 42, and 46), clearly have the ANC membership in mind as the primary audience. Seldom if ever, however, is the ANC membership the sole intended audience of even these documents. The authors almost invariably were seeking wider audiences.

Basically, the audiences fall into two categories, domestic and international. Within South Africa there also are different audiences—Africans, other blacks, antiapartheid groups, white liberals and radicals, and whites in general. Internationally, too, there are various audiences—other African countries, the Third World, the Eastern bloc, and the governments and citizens of the West. Over the four decades of the fight against apartheid the ANC leaders altered their understanding of the nature and potential size of their audiences. In the 1940s, the ANC spoke mainly for and to Africans in South Africa; by the 1950s, as it sought to create a broad antiapartheid front, the ANC leadership increasingly tried to influence all groups and individuals who were working for a democratic South Africa. For instance, the readership for Mandela's articles in *Liberation* was primarily left-wing whites and some black intellectuals.

With the banning of the ANC in 1960, Mandela and the other leaders shifted to a two-pronged attack on the apartheid edifice. The first (and familiar) prong sought to create a broad antiapartheid coalition, including middle-of-the-road whites (see Document 18), to bring sufficient pressure to bear on the government to force it to reverse course. In a sense, this effort came to fruition only with the formation of the UDF in the mid-1980s, the campaigns of the Mass Democratic Movement at the end of that decade, and the rallying to the ANC standard that took place following Mandela's release. The other prong was to use selective violence to convince the government to change its course and to demonstrate to Africans and others opposed to apartheid that the ANC was intensifying its challenge (see especially Document 25). During this period the ANC was also for the first time consciously enlisting international backing, whether it was speaking directly to a foreign audience (Document 21) or delivering a dramatic speech at home that would generate sympathy and support abroad (Document 23).

sets of documents for all four parts of the volume but primarily in Section I (A New Generation Challenges Apartheid, 1948–1960) and Section II (Proscription and Enforced Reorientation, 1960–1964). Those documents associated with Oliver Tambo come mainly from his speeches, statements, and articles. Although there is one Tambo document each in Sections I and II, most of the documents in Section IV (Mandela, Tambo, and Post-Rivonia Politics, 1964–1990) originate with Tambo. The third category is the major ANC statements of both policy and principle, which can also be found in Sections I, II and IV.

The two more specialized categories of documents, both of which provide testimony about Mandela's years as a political prisoner, are located exclusively in Section III (A Leader Among Prisoners, 1964–1990). The first of these categories is the recollections of fellow prisoners, and the second is the accounts of individuals who visited Mandela in prison.

The documents originate from diverse sources, the most important of which are the publications, statements, and press releases of the ANC. The official organ of the ANC, *Sechaba*, is a particularly important source of documents for the latter part of the period covered in this volume. Left-wing publications in South Africa, such as *Liberation* and *New Age*, are the principal sources of articles by Mandela from the 1950s. A third source of documents is trial testimony. On three separate occasions between 1960 and 1964 while standing trial, Nelson Mandela delivered particularly noteworthy statements to the court. Public speeches by Mandela and Tambo before various audiences, ranging from a 1951 presidential address to the ANCYL (Mandela) to a 1987 speech delivered at Georgetown University (Tambo), constitute a fourth source of documents. Yet another source consists of published interviews with Oliver Tambo, fellow prisoners of Mandela, and individuals who visited Mandela in prison. A sixth source is both published and unpublished accounts by fellow prisoners and by those who met with Mandela during his long prison term. Scholarly publications containing articles by Mandela and Tambo are the final source of documents for this volume.

Many of these documents, especially those in Sections I and II, are from the Carter–Karis Collection, *South African Political Materials*, which is available on microfilm from the Cooperative Africana Microform Project (CAMP) of the Center for Research Libraries. Susan G. Wynne compiled a catalogue of the collection (see the Guide to Further Reading for the full citation of this and the other volumes mentioned in this paragraph). Most of these documents have been published previously in the Carter–Karis volumes of collected documents and in Mandela's collected writings. Likewise, several of the Tambo documents appear in the collection of his writings. The remaining documents are by and large from less easily accessible published sources, such as newspapers, or have not been published previously.

Nelson Mandela, Oliver Tambo, and the ANC had in mind different audiences according to the time, place, and circumstances in which they wrote or spoke. In the majority of the documents (aside from those in Section III), the authors were addressing their audience directly. In some instances, however, particularly those involving Mandela in prison, there were intermediaries between the author and the audience.

Over time many of the documents have acquired new audiences. The Freedom Charter (Document 14) is a case in point. The original intended audience was almost totally South African, but for many years this document was used to interpret the ANC's aims and objectives to a continually expanding international audience as well as to an enlarged domestic audience. Indeed, the appearance of the Freedom Charter and the other documents in our book will create yet new audiences for them. In keeping with our book's framework, which presents these documents in their original historical context, the discussion of audiences at this point will be about those to which the documents were first targeted.

One of the principal audiences is certainly the ANC's rank-and-file and leadership. Statements of policy ranging from the 1949 "Programme of Action" (Document 13) to the 1985 Political Report and Communiqué of the Second National Conference of the African National Congress (Document 59), along with certain speeches and statements of Mandela and Tambo to ANC gatherings (e.g., Documents 1, 42, and 46), clearly have the ANC membership in mind as the primary audience. Seldom if ever, however, is the ANC membership the sole intended audience of even these documents. The authors almost invariably were seeking wider audiences.

Basically, the audiences fall into two categories, domestic and international. Within South Africa there also are different audiences—Africans, other blacks, antiapartheid groups, white liberals and radicals, and whites in general. Internationally, too, there are various audiences—other African countries, the Third World, the Eastern bloc, and the governments and citizens of the West. Over the four decades of the fight against apartheid the ANC leaders altered their understanding of the nature and potential size of their audiences. In the 1940s, the ANC spoke mainly for and to Africans in South Africa; by the 1950s, as it sought to create a broad antiapartheid front, the ANC leadership increasingly tried to influence all groups and individuals who were working for a democratic South Africa. For instance, the readership for Mandela's articles in *Liberation* was primarily left-wing whites and some black intellectuals.

With the banning of the ANC in 1960, Mandela and the other leaders shifted to a two-pronged attack on the apartheid edifice. The first (and familiar) prong sought to create a broad antiapartheid coalition, including middle-of-the-road whites (see Document 18), to bring sufficient pressure to bear on the government to force it to reverse course. In a sense, this effort came to fruition only with the formation of the UDF in the mid-1980s, the campaigns of the Mass Democratic Movement at the end of that decade, and the rallying to the ANC standard that took place following Mandela's release. The other prong was to use selective violence to convince the government to change its course and to demonstrate to Africans and others opposed to apartheid that the ANC was intensifying its challenge (see especially Document 25). During this period the ANC was also for the first time consciously enlisting international backing, whether it was speaking directly to a foreign audience (Document 21) or delivering a dramatic speech at home that would generate sympathy and support abroad (Document 23).

After the early 1960s, a radical shift occurred in the audience the ANC was addressing. Divided between internal and external wings, with the internal leaders imprisoned or driven underground, the ANC found that the government's suppression gravely hampered its efforts to address its traditional audience—the African population of South Africa—or any other domestic South African audience. Although the ANC leaders continued to address and exhort the members, particularly those in exile (see Document 58), the major audience became the international community. The immediate heart of the struggle no longer lay in South Africa but, rather, was on the diplomatic front and centered on efforts to challenge the legitimacy of the South African government (see Documents 45 and 46).

The aftermath of the 1976 Soweto uprising led to another shift in the mix of audiences the ANC was addressing. Despite the government's continued efforts to keep the ANC's voice from being heard, it was again increasingly audible within South Africa. Yet the international audience also remained crucial. Furthermore, there was a growing diversification of the audiences both inside and outside South Africa. Africans remained the central component of its audience, but the ANC was finally able to achieve the breakthrough it had earlier sought with the Freedom Charter and the 1961 campaign against the declaration of the republic to reach a larger audience among whites. In the process, it moved as an organization that sought alliances across racial lines to become a nonracial organization itself (see Document 59). Before the end of the decade of the 1980s, it clearly aspired to represent, and thus speak to, all South Africans, excluding perhaps the most conservative whites (see Document 62). The international audience that was receptive to the ANC message also diversified to the point that it included the major Western governments, a development that Albertina Sisulu's June 1989 White House meeting with U.S. President George Bush dramatically underscored. At last free and no longer muffled, Mandela's voice from February 11 joined that of Tambo and others in the ANC in carefully crafting messages to the international audience that would at the same time reinforce their domestic standing.

Over the forty years of struggle against apartheid, the ANC's audience, and hence the nature of the documents it produced, underwent substantial transformation. As this book shows, however, the central purpose remained unaltered, to articulate the aspirations of Africans for full participation in a more equitable and democratic order in South Africa.

Notes

1. *Umkhonto* (meaning "spear") is sometimes spelled as *umkonto* in the documents and by some authors. We have adopted the spelling *umkhonto* in the text, based on both C. M. Doke and B. W. Vilakazi, *Zulu–English Dictionary* (Johannesburg: Witwatersrand University Press, 1964), p. 403; and J. McLaren, *A New Concise Xhosa–English Dictionary* (Cape Town: Longmans, 1963), p. 74; and have left the spelling in the documents as in the original.

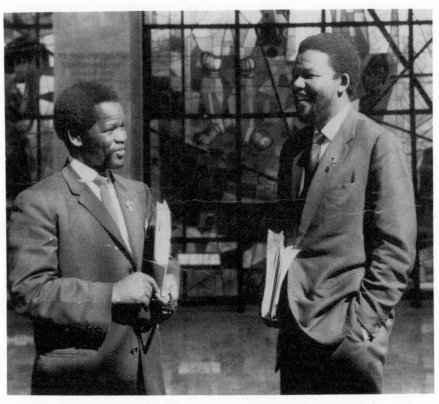

Oliver Tambo and Nelson Mandela in South Africa in the 1950s.
(International Defence & Aid Fund for Southern Africa)

A NEW GENERATION CHALLENGES APARTHEID, 1948–1960

The year 1948 is the most critical year in South Africa's political history since the formation in 1910 of the Union of South Africa. The key political event of 1948 was the electoral victory of the National party (NP), which elevated Dr. D. F. Malan to the prime ministership and led to a cabinet composed exclusively of Afrikaans-speaking ministers. Scholarly attention has generally focused on the construction of the apartheid edifice—the thoroughly rationalized and systematically implemented system of white supremacy that was far more extensive and oppressive than the segregation that had preceded it—as the major political development of the dozen or so years that followed the 1948 election and that ended with the shooting death of sixty-nine Africans at the hands of the police at Sharpeville in 1960. The emphasis on the political history of the period thus has been on the growing lock of the NP on the white electorate, the various pieces of apartheid legislation that the NP-dominated Parliament enacted, the African efforts to halt the growth of white supremacy and substitute in its place a vision of a more equitable society, and the government's efforts to quell the rising tide of black dissent.

The year 1948 also is noteworthy for those who study the black role in South African political history from an African-based perspective rather than primarily as a response to white political initiative, but it does not represent as sharp and as distinctive a dividing point. In the first instance, major changes of direction and emphasis had begun to take place in black politics earlier in the decade. African political leaders were more than ever before questioning and rejecting the paternalistic ideology of white trusteeship, with its notion of a possible assimilation of Africans into "white" civilization in the distant future. Thus they were already challenging the legitimacy of white supremacy before the electoral triumph of the NP and its apartheid ideology. Nonetheless, the NP did pose a new challenge to Africans. Through its rigid apartheid legislation it eliminated all possible points of political accommodation between African aspirations and continued white control. The 1948 election had constituted something of a referendum among white voters on the future of black–white relations. The NP, with its slogans of the *swart gevaar* (black peril) and

the *oorstrooming* (swamping) of the cities, won a plurality of parliamentary seats and, in alliance with the much smaller Afrikaner party, was able to form a government. The white electorate had thus endorsed a much harsher government policy toward Africans in the face of what they perceived as a growing black threat to their existence.

The NP seized the political initiative in 1948 and retained it into the early 1950s, pushing through its agenda of apartheid legislation without seeming to pay any heed, let alone making any compromises, to the political forces ranged against it. Political opposition did exist, however, and virtually each new piece of government legislation increased the level and intensity of struggle against the apartheid order. The government responded at first with increased police efforts to control the black opposition, expanding the police power of the state through measures such as the Suppression of Communism Act (1950) and the Public Safety Act (1953) and then using this legislation to curb African political organizations and activities through arrests, bannings, trials, and imprisonment.

African political strength was such, however, that reliance on police powers alone appeared insufficient to check it. The government thus sought other ways to respond to African political initiative. The Promotion of Bantu Self-Government Act (1959) was well suited to this purpose, for it served to deflect African politics away from the political center and to concentrate them instead on the peripheral 13 percent of the country that remained in African hands. These areas, successively termed *reserves, bantustans, homelands*, and *national states*, lacked exploitable resources and were vastly overcrowded. Their inhabitants were almost totally dependent economically on the remitted earnings of migrant workers employed on white-owned farms and in white-owned industries. The government thus held out to Africans the promise of full political control of what were supposedly their "own" areas but what in reality were huge rural slums incapable of existing independently from greater South Africa. In return for such a hollow gain, Africans were to relinquish all political claims to the country as a whole. Limited though the bantustan scheme was, however, it did introduce a policy of cooptation to complement the previous policy of reliance solely on police repression to stem the unremitting African opposition to apartheid. The majority of Africans opposed the bantustans, but there were those who for their own personal gain stood ready to be coopted and thus serve the ends of government policy.

In early 1960 South Africa found itself in the midst of an extensive political upheaval that has become known as the Sharpeville crisis. The political initiative passed into African hands, if only for a moment. Actions on the part of Africans caused the government to suspend the pass laws and brought the economy to a halt. Unprecedented international attention focused on South Africa. Also clear to Africans were the fear and uncertainty that gripped the white population. The acting prime minister, Paul Sauer, even went so far as to declare that "the old book of South African history was closed at Sharpeville." But the government soon regained its confidence and moved swiftly to reassert its authority. Africans, nonetheless, had been able to catch a glimpse of their potential power.

To understand how African political strength developed from being on the defensive in 1948 to the point of momentarily seizing the political initiative in 1960, one must go back to developments in the ANC and especially the founding of the ANCYL.

The Revival of the African National Congress

Founded in 1912 by politically conscious Africans from all four provinces of the newly formed Union of South Africa to represent African opinion and interests, by the early 1930s the African National Congress had fallen on hard times. Indeed, for several years the ANC failed to hold its annual conferences and seemed in danger of dissolving altogether. By the late 1930s the organization had revived somewhat, but it still catered almost exclusively to the small African middle class and continued to pursue a moderate and deferential political course. But dramatic changes took place in the ANC during the 1940s, so that a much stronger, more militant organization came into existence and became better prepared to take up the challenge that the apartheid elections of 1948 were to pose. Simply put, the ANC of 1938 would have been totally unfit for the task of taking on the victorious National party, but the ANC of 1948 could do so.

Three developments undergirded the transformation of the ANC in the 1940s. The first of these consisted of the far-reaching economic and social changes that were associated with World War II and that created the conditions for a mass-based African political movement. The second was a new and more energetic president, the American-educated physician Alfred Bitini Xuma, who headed the ANC from 1940 until 1949. The third development was the emergence of a new generation of political thinkers and activists who were prepared to abandon the more polite and more conservative political discourse of their elders in favor of militant action. These new members formed the ANCYL to give organizational expression to their political activism.

World War II marked a watershed in the social and economic history of South Africa, second only to that wrought by the discovery of diamonds in 1867 and of gold in 1886. The principal impact of the war was to accelerate the growth of manufacturing in South Africa which before that time had been limited. This expanding industry in turn led to a growing demand for labor which, with so many whites in military service, was met to a large degree by blacks. This, in turn, meant a growing urbanization of the African population. At the time of the 1936 census, for instance, approximately 1.15 million of the country's nearly 6.6 million Africans lived in towns (compared with slightly more than 1.3 million of the 2 million whites). Over the next fifteen years, the African urban population more than doubled, to over 2.3 million. The black population of Johannesburg climbed in ten years by two-thirds, rising from about 229,000 in 1936 to nearly 385,000 in 1946. Nor did the phenomenon of increased African urbanization taper off. In the Transvaal industrial town of Benoni, for instance, the black population doubled from 12,000 in 1938

to 24,000 in 1945 and reached 34,000 in 1949, 40,000 in 1950, and 77,000 in 1957.

Accompanying the increased flow of Africans from the countryside to the towns was another demographic change. In the past, the great majority of African urban immigrants had been adult males. But the massive wartime movement of entire families meant that for the first time women and children began to constitute significant portions of the African urban population. Underlying this new pattern of urban migration were both push and pull factors. The African rural areas had long been in decline because of decreasing soil productivity, the heavy outflow of able-bodied labor, lack of capital, and a growing overpopulation, among other factors. Their deterioration accelerated during the war years, forcing even greater numbers of their inhabitants to look elsewhere for the means to make ends meet. The expanding urban economy beckoned to the impoverished rural dwellers, pulling them into the cities where they more often than not settled permanently. Conditions were extremely harsh in the cities. Wages were often insufficient to meet family subsistence needs, and as many as one in four urban Africans lived in squatter camps consisting of dwellings made of hessian sacking, wood, corrugated iron, and cardboard.

The rapid growth of a permanent urban African population did much to change the political landscape of South Africa. Indeed, as we already noted, one of the elements in the NP electoral victory was white concern with the so-called swamping of the cities (which by law and in policy were supposedly the preserve of whites). The urbanizing African working class was militant by its very nature, and its struggles both were more visible and posed a greater challenge to white power than did the hidden struggles of their rural brethren and forebears. Large-scale squatter movements involving many thousands of homeless people took shape during the mid-1940s. Africans in large numbers engaged in a series of bus boycotts to protest increased fares. Labor unions began to organize African workers on a significant scale, and a wave of strikes erupted during the war despite wartime regulations prohibiting them. In 1946 some seventy thousand gold miners went on strike. For the first time, then, the conditions existed for a mass-based African political organization.

The revival and restructuring of the ANC during the 1940s were very much an outgrowth of the wider social and economic changes taking place in South Africa. Although the organization had begun to climb back from the political nadir of the 1930s, its principal renewal dates from the December 1940 election of Dr. A. B Xuma as president-general. Xuma's major contribution was that of a skilled organizer, as he both brought the provincial branches of the Congress and their often fractious factions under tighter discipline and asserted the authority of the national leadership. He also reorganized the ANC's financial affairs, placing them on a sound footing and providing audited accounts at the time of the annual conferences. This step also made it possible to set in motion measures that would ultimately lead to full-time paid organizers. Finally, Dr. Xuma drew on his experiences with the Non-European Conferences of the late 1920s and early 1930s to build closer ties between the ANC and other domi-

nated communities in South Africa. Particularly important in this regard was the so-called Doctors' Pact in 1947, which was a "Joint Declaration of Cooperation" signed by Xuma and by Drs. Y. M. Dadoo and G. M. Naicker on behalf of the Transvaal Indian Congress and the Natal Indian Congress.

A further hallmark of the revival during the Xuma years was a renewed intellectual vigor. The focal document of this development was the *Africans' Claims in South Africa*, published in 1943. It constituted the most important ANC document in nearly a quarter-century and was to remain an authoritative statement of the ANC's aims.[1] Acting in full cognizance of the Allies' characterization of the war as a crusade for democracy, *Africans' Claims* asserted that the Atlantic Charter, proclaimed by U.S. President Franklin D. Roosevelt and British Prime Minister Winston Churchill at their meeting of August 14, 1941, applied to Africa in general and South Africa in particular. *Africans' Claims* also contained a bill of rights, which addressed the issues of full citizenship rights and demands, land, industry and labor, commerce, education, public health and medical services, and discriminatory legislation in a manner that presaged the militant and forceful African political rhetoric of the 1950s.

Yet another and equally critical feature of the Xuma era was the recruitment of a new generation of Africans into the ranks of the ANC. The new generation was better educated, reflecting the fact that more Africans than ever before, though still very few in terms of the total population, had access to higher education. By 1941 the new University College at Fort Hare, which had earlier been a secondary school, was awarding thirty bachelor's degrees annually. Both Mandela and Tambo were among the students of that period. Africans could also earn a B.A. degree through correspondence from the University of South Africa as well as attend the so-called white English-speaking universities. Further, in contrast with the founders of the ANC, the generation of the 1940s had no illusions about the efficacy of polite representations as a means of acquiring equal rights in a common society. The country's political history and the legislative record of entrenching white supremacy under every successive government since 1912 had clearly disabused them of any such hopes and aspirations. Finally, whereas most of the earlier ANC leaders tended to hold themselves aloof from the masses on the basis of class and cultural distinctions, the new generation realized that it would have to enlist the support of the masses if it were to overcome white supremacy. During the 1940s and 1950s, as the hitherto-separate working-class and middle-class cultural streams became increasingly juxtaposed and began to blend together to form a single vibrant and dynamic African urban culture, the ANC sought membership and support from all groups in the African population.

The African National Congress Youth League

Impatient with African political progress to date, members of the new generation took up Dr. Xuma's call to youth in his 1943 presidential address to become more involved in ANC affairs, and in April 1944 they formed the

ANCYL. It was from the ranks of this body that the African political leadership of the 1950s and 1960s, and even the 1970s and 1980s, emerged. The members were mainly young professionals who had been caught up in the intellectual ferment that characterized the wartime years. One of the two prime movers behind the Youth League was A. P. Mda (b. 1916), a teacher and later an attorney, who was the author of the manifesto on "Basic Policy of Congress Youth League" (see Document 12). The other was Anton Lembede (b. 1914), a rural teacher who qualified as an attorney and who stood out as the central personality and key thinker in a group of outstanding future leaders. Lembede was the Youth League's first president, an office he held until his untimely death at a young age in 1947. Nelson Mandela (b. 1918), then a law student at the University of the Witwatersrand, was a member from the start, as was Oliver Tambo (b. 1917), a teacher at the time in Johannesburg, who went on to hold several elective offices in the organization. Jordan K. Ngubane (b. 1917), who became a distinguished journalist and, in the mid-1950s, a leader of the Liberal party, was among the early activists in the ANCYL, as was William Nkomo (b. 1915), a medical student at the time who broke with the ANC in the early 1950s but who before his death in 1972 helped found the Black People's Convention. J. Congress M. Mbata (b. 1919), a teacher and later headmaster who was secretary of the Transvaal African Teachers' Association, also played a key role. Two other early members, who in the 1950s parted political ways, were Walter Sisulu (b. 1912) and Robert Sobukwe (b. 1924). Sisulu was a key figure behind the adoption of the ANC's Programme of Action (see Document 13) and served as secretary-general of the ANC from 1949 to 1954. He was sentenced to life imprisonment at the same time as Mandela was, but his wife, Albertina, and his son, Zwelakhe, have continued to play a prominent role in the antiapartheid movement. While still a student, Sobukwe founded the Fort Hare branch of the ANCYL. Ultimately he led the walkout from the ANC in 1958 that resulted in the founding of the PAC in 1959, and he became its first president.

Discussion and debate within the ANCYL over the next several years about the methods of struggle and the growing pressures for action led to the publication in 1948 of the "Basic Policy of Congress Youth League" (see Document 12). This crucial document set forth several themes that were to resonate in African political thought in the years ahead: Africans are a people who "suffer national oppression" rather than being oppressed as a class; they were responsible for achieving their own freedom through building a mass liberation movement; and the goal of the liberation struggle, which would of necessity be "long, bitter and unrelenting," was a democratic society in political and economic terms in which the "four chief nationalities" (African, European, Indian, and Colored) would live free from racial oppression and persecution. Finally, it should be noted that the "Basic Policy" did not adopt the tone of racial exclusiveness that pervaded much of the Youth League's discussions and thinking, particularly that of Lembede. Africans were to be accorded primary status in the struggle for liberation, but the goal was a free society for all South

Africans. The ANCYL membership contended that the time was ripe for mass action, and they succeeded in committing their parent organization to embark on such a course.

The NP electoral victory accentuated the questions about tactics. The ANCYL executive committee, which included both Mandela and Tambo, drafted a "Programme of Action" (see Document 13), which the ANC adopted at its annual conference in December 1949. It claimed for Africans the right of self-determination and called for the use of boycotts, strikes, civil disobedience, and other such weapons to "bring about the accomplishment and realization of our aspirations." For years, the ANC's approach had been, in the words of its 1919 constitution, "to record all grievances and wants of native people and to seek by constitutional means the redress thereof." The sharp contrast in the tone of the "Programme of Action" clearly indicated the new political mood and circumstances of the African population as they faced the new Afrikaner NP government, determined as it was to realize its vision of apartheid.

Point, Counterpoint: The ANC Responds to Apartheid

The new Malan government moved promptly to implement its electoral slogan of apartheid through the enactment of a major legislative agenda. This was the period of classical, or *baasskap* (bossdom), apartheid, when the government behaved as if South Africa was truly a "white man's country" and all other segments of the population should have absolutely no voice in the affairs of government.

In order to understand the context in which African politics operated during the 1950s, we shall examine in some detail the body of apartheid legislation. First, such an examination will provide a clear picture of the NP agenda for the country and vision of the society it was seeking to establish. Second, it will reveal the economic interests at stake and how the prevailing government opinion was that the white minority should take complete precedence, whatever the cost to the majority. Third, we shall see that the government's legislative agenda during the 1950s served largely to determine the parameters of the political struggles in the country. Fourth, it will become clear that the very harshness of the apartheid legislation, combined with the ongoing economic and social transformation, served to promote a stronger and more militant African response. Mandela, Tambo, and other African political leaders were able to strike a more responsive chord in the general African populace than hitherto had been the case. Finally, our examination should show that because the NP government was seeking to ensure white supremacy also over the Coloreds and Indians and was attempting to suppress political dissent, the apartheid legislation provided a greater common political ground among Africans, Coloreds, and Indians, and it helped promote ties between the ANC and the political left, especially the Communist party. On the other hand,

dissension emerged within the ANC ranks over the advisability of alliances with non-Africans, a dissension that ultimately led to the formation of the Pan Africanist Congress.

⟨The NP government designed its apartheid legislation program to achieve four goals: racial purity, physical separation of the races, more effective political domination, and stronger control over the black population. Many of the acts served more than one purpose. Also, this new battery of legislation did not introduce white supremacy to South Africa but, rather, built on deeply rooted patterns of legislative segregation that had long been in existence.

The first legislative item on the apartheid agenda pertained to racial purity. This was the Prohibition of Mixed Marriages Act (1949), which made interracial marriages illegal. In 1950, Parliament enacted the Population Registration Act in order to classify all South Africans in one of four so-called racial groups (European, African, Colored, or Asian) and the Immorality Act, which prohibited all sex between whites and members of any other racial group.

Physical separation, of course, rested in part on the notion of racial exclusiveness. It also had major economic dimensions, for this category of legislation worked to entrench even further the already well-established white privilege. Having determined who belonged to what "racial" group, the government then enacted the Group Areas Act (1950), which gave it the power to designate an area as the exclusive preserve of a given group. This act, which is still in force, has continued to provide the government with the legal means to relocate large numbers of people for purposes of government policy. Two pieces of legislation affected Africans' rights to live in the cities. The Native Laws Amendment Act (1952) further restricted the right of Africans to live in urban areas, and the Natives Resettlement (Western Areas) Act (1954) provided the basis for prohibiting Africans from living in the central cities and for placing them in remote and isolated townships (the sprawling conglomeration of townships outside Johannesburg that constitutes Soweto had its origin in this act). Yet another piece of legislation in this category, the Prevention of Illegal Squatting Act (1951), dealt a further blow to Africans who were trying to maintain an independent agricultural existence outside the reserves, by giving the government the power to uproot so-called unauthorized African settlements on white-designated land.

The cumulative effect of the legislation mandating physical separation has been disastrous for Africans. The most glaring example of the hardships that Africans have had to endure is the policy of forced removals. Although it is difficult to determine the exact total, the Surplus People Project estimated that between 1960 and 1983, more than three and a half million Africans were evicted from white farms, forced to relinquish land that they owned that was in predominantly white-owned rural areas (the so-called black spots), relocated in urban areas, or otherwise forced to abandon their homes to serve the purposes of apartheid policy. In addition to causing enormous social dislocation, forced removals have intensified African poverty through the loss of capital assets (land, housing, etc.), the rise in unemployment through loss of access to jobs, and the denial of schools, clinics, and other social services. More stringently

than ever before, the South African government limited the right of Africans to maintain a permanent residence, to own property, or to earn an independent livelihood outside the 13 percent of the country legislatively mandated (by the 1913 Natives Land Act and the 1936 Native Trust and Land Act) as the African reserves.

Along with the legislation altering the demographic geography of South Africa, the government also enacted measures that enforced segregation in public facilities. At first the government relied on administrative edicts to extend the segregation that already existed. A court decision stating that separate amenities had to be equal, however, led to the passage of the Reservation of Separate Amenities Act (1953), which legislated that segregated facilities could be inherently unequal. The State Aided Institutions Act (1957) gave the government the authority to enforce segregation in libraries, theaters, and other public cultural facilities. Often termed *petty apartheid*, these measures have in more recent years been selectively ignored as the government has attempted to put a more human face on its policies.

In the political sphere the government sought to tighten even further the electoral monopoly of white South Africans. The Suppression of Communism Act (1950), for example, not only outlawed the Communist party but also defined communism in such broad terms that almost any form of political protest could be labeled communist and thus prohibited. Ironically, one effect of this act was to heighten the prestige of the Communist party and its members in antiapartheid circles and to create an environment in the ANC favorable to a united multiracial opposition to the state and cooperation with the left. The Bantu Authorities Act (1951) abolished the advisory Natives' Representatives Council, already nearly defunct, and in its place set up local authorities in the reserves, which were dominated by government-appointed chiefs. In the vision of the apartheid planners, these were to be the only sanctioned outlets for African political participation.

A third key measure in the government's efforts to ensure a white electoral monopoly was the South Africa Act Amendment Act (1956) which removed Colored voters from the common voting roll and placed them on a separate voting roll to elect members of Parliament and provincial councils (who had to be white to sit in these bodies) to represent Colored interests. This arrangement was similar to the special representatives that Parliament had established for Africans under the "Hertzog bills" in 1936. African and Colored voting rights, limited to adult males who met certain educational and income or property qualifications, extended back to the Cape Colony's constitution of 1853 and were retained (for the Cape Province only) under the provisions of the 1910 Act of Union.[2] The communal representation in Parliament that began for Africans in 1936 and Coloreds some twenty years later came to an end when the government abolished all parliamentary representatives for both groups (Africans in 1959 and Coloreds in 1969).

The fourth category of baasskap apartheid legislation consisted of measures of control—over movement, over participation in economic activity, over educational opportunities, and over the expression of political opposition. In

order to enforce limitations on Africans' rights to live, work, or even move about areas of the country outside the reserves, the government expanded the existing pass system. This it accomplished with the Abolition of Passes and Consolidation of Documents Act (1952) which required all Africans above age sixteen, including women who had previously been exempt from the pass laws, to carry on their person at all times a reference book containing extensive personal data. Of course, acts designed for other functions, as well as the Abolition of Passes and Consolidation of Documents Act, also had major control functions.

➤ Other legislation was designed to enhance the whites' economic control over Africans. This included the Native Labor (Settlement of Disputes) Act (1953), which made permanent the wartime prohibition of strikes by Africans that had been renewed regularly in the intervening years. Under the Industrial Conciliation Act (1924), African males were excluded from the legal definition of "employee" and thus from the right to engage in collective bargaining. A 1954 amendment extended the exclusion to African women, thus denying to all African workers the government-sanctioned collective bargaining machinery. The negative economic impact of apartheid on African labor was severe. For example, in the gold-mining industry (which set the standard for wage labor earnings), the earnings gap between white and black labor steadily widened in the 1950s and 1960s. In 1946 the average annual income of a white miner was 1,106 rands and of a black miner 87 rands (an earnings gap ratio of 12.7:1). By 1969 white miners averaged 4,006 rands per year, whereas black miners received only 199 rands (a ratio of 20.1:1). Over the same period, the index of real earnings (with 1938 as the base year) for white miners rose steadily from 99 to 172, while that of black miners first dropped from 92 to 89 before rising to 99.[3] Clearly, white mine workers, who constituted about one-eighth of the total mine labor force, advanced their own economic interests at the expense of their black fellow workers, shackled as they were by harsh labor legislation. Furthermore, aided by apartheid labor laws, white mine owners were able to keep black labor costs down and thus meet the demands of their white workers while also increasing their earnings.

The Bantu Education Act (1953), with its creation of an entirely separate school system and curriculum for Africans, brought the education of Africans fully under the control of the state and sought to control them through their schooling. To a significant degree, the motivation behind Bantu Education was economic, for at its heart it was designed to safeguard whites from black competition. The Extension of University Education Act (1959) applied the logic of the 1953 act to higher education.

Finally, there were those measures designed to extend the police powers of the state to suppress the growing black opposition to apartheid, especially as it had manifested itself in the Defiance Campaign of 1952. Two critical such measures, both enacted in 1953, were the Criminal Law Amendment Act, which imposed heavy sentences for disrupting public order (e.g., for organizing and engaging in antiapartheid demonstrations), and the Public Safety Act, which provided the government with the authority to declare a state of emer-

gency in specific locales or throughout the country. By passing such legislation, the government was clearly responding to the rising tide of African protest against apartheid.

The NP government faced organized and militant African political opposition to the enactment of its legislative program. With the adoption of the Programme of Action the ANC had already signaled its intent to challenge white supremacy. Nonetheless, the steady barrage of apartheid legislation created a sense of immediacy and crisis in African political circles and forced the pace of political protest faster than might otherwise have been the case. In June 1952 the ANC, with support from the Indian Congress, individual Coloreds, and a handful of whites, launched the Defiance Campaign, in which thousands of trained volunteers courted arrest by staging sit-ins in facilities reserved for members of other races, in order to draw attention to segregation and to induce changes in government policies.

Nelson Mandela was one of the key leaders in the 1950s in setting forth an African political agenda that challenged government hegemony. Much of his work, however, had to be behind the scenes, because in September 1953 the government imposed a ban on him that forced him to resign from the ANC (though he continued his membership in secret) and prohibited him from attending meetings for five years (the authorities subsequently extended his bans until March 1961).

Having emerged as one of the most prominent members of the Youth League, Mandela was elected its president in late 1950. In his presidential address to the December 1951 Conference of the ANCYL (see Document 1) Mandela at length defined the nature of the struggle as well as the need of Africans to develop a coherent strategy. The struggle in South Africa, he stated, was part of a general global contest in which "the oppressed all over the world . . . are irrevocably opposed to imperialism in any form." Furthermore, expounding a theme that was to recur regularly in the ANC literature in the years ahead, Mandela contended that "the ruling circles in America" were undergirding the efforts of the European colonial powers and "their servitors in South Africa" to maintain their rule in Africa. This was, after all, the era of the cold war in which the United States was giving its full backing to the Western European powers not only in Europe but also in their colonial empires. In addition, South African troops were part of the UN forces in Korea, and the British had a major naval base in South Africa. In short, this was an era in which colonialism remained politically acceptable in the West and in which the South African political system raised few questions. Mandela undertook a fuller exposition of this theme in a 1958 article entitled "A New Menace in Africa" (see Document 8). Finally, in an era when memories of Nazi Germany were still fresh, Mandela charged the National party and the "financial lords" with moving the country in "the direction of an openly Fascist state." The forces of oppression were indeed powerful, he asserted, and "the struggle will be a bitter one," but in the end the people would prevail because their spirit could not be crushed.

If the people were to challenge effectively their national oppression, then it would have to be under the banner of African nationalism. For Mandela, this

meant "the African nationalism propounded by the Congress and the Youth League." The issues to which he was alluding had to do with divisions inside African political ranks over the central question of how Africans were to be best mobilized. Was it to be on the basis of class origin, as the Communist party argued, or on the basis of common oppression and injustices, as the Indian Congress and white liberals argued, or exclusively on the basis of African nationalism, as Mda and some other Youth Leaguers (and Mandela previously) argued. Eventually the schism became too deep to bridge, and those calling for an "Africans only" policy broke with the ANC in 1958 and formed the PAC in 1959. In 1951, however, Mandela could assert that the internal debates about the May 1, 1950, stay-at-home protest in the Transvaal, the National Day of Protest and Mourning on June 26, 1950, and the May 7, 1951, protest march by Coloreds in Port Elizabeth were simply over tactics and not about the basic strategies of the struggle.

The ANCYL and its parent body, the ANC, Mandela stated, had to grapple with several pressing issues. First, the government was using the Suppression of Communism Act to ban African leaders (Mandela was arrested under the provisions of the act in August 1952), thus posing the potential problem of how their organization was to carry on with its leaders restricted. Another issue also concerned organization—the need to develop a solid cadre of members to carry their message of "a free, independent, united, democratic, and prosperous South Africa" to the masses. A third issue had to do with "the participation of other national groups in our struggles." In Mandela's view, the successful resolution of these issues and the general need for a disciplined approach to the struggle was essential in order for the ANC to embark on its proposed Defiance Campaign in 1952. Mandela served as the volunteer in chief for the campaign.

During the last half of 1952, more than eight thousand volunteers went to jail for disobeying minor apartheid regulations such as using whites-only facilities in post offices, railway stations, and so forth in what constituted the Defiance Campaign. The purpose of the campaign was to convince the government to abandon apartheid and to eliminate discrimination. Instead, as Mandela noted in his September 21, 1953, presidential address to the Transvaal branch of the ANC (see Document 3), the government launched "a reactionary offensive" of arrests, new repressive legislation (e.g., the Public Safety Act), and bannings. Not only had the "reactionary offensive" created turmoil in South Africa, but it also had "scared away foreign capital from South Africa" (according to government statistics, the net inflow of foreign capital dropped from 187 million rands in 1951 to 144 million in 1952 to 113 million in 1953). The speech was read in Mandela's name, as he was prohibited under the terms of his ban from attending the conference.

Although the Defiance Campaign had not achieved its stated goals, Mandela's address nonetheless conveyed a sense of accomplishment. In his view the ANC had now launched the fight against apartheid in a massive way, and the campaign had forced the government into the unaccustomed position of react-

ing to the African political initiative. A strategy was clearly emerging, one of action by "a real militant mass organization" (the ANC) in alliance with non-African organizations (at this point limited primarily to the Indian Congress).

The major issues were also becoming clearer, according to Mandela. One was the increasing poverty of the people, heightened by the deleterious economic impact of the mounting apartheid legislation. Another was the intent of the government through Bantu Education to teach Africans that they were inferior to whites. The United States and its allies seemed committed to maintain their position in the world and thus to suppressing through force and violence the legitimate aspirations of the colonial peoples, whether it be in Kenya or Korea. Repression in South Africa served as yet another example of such efforts. Throughout Mandela's speech there is a clear recognition of the powerful forces arrayed against the Africans. Quoting Nehru, he proclaimed that "there is no easy walk to freedom anywhere, and many of us will have to pass through the valley of the shadow (of death) again and again before we reach the mountain tops of our desires."[4] Yet, Africans would "reach the moutain tops" and thus emerge victorious in the end.

Many within the ANC ranks had come to believe that the liberation of Africans from their national oppression as a people constituted the central feature of the antiapartheid struggle at the same time that it also demanded a common front of all democratic forces arrayed against the fascist apartheid regime. Asians and Coloreds were natural allies, as they too suffered oppression as dark-skinned people. The real question had to do with the position of whites. "We are convinced," wrote Mandela in a 1953 article in the left-wing monthly *Liberation*, "that there are thousands of honest democrats among the white population who . . . stand . . . for the complete renunciation of 'white supremacy'" (see Document 2). Mandela's argument had its roots in a deep-seated belief in nonracialism as well as in a pragmatism that saw the potential power of white allies working within the system for change. In addressing these whites, Mandela stated that there could be "no middle course" to the struggle. It was a false notion to believe, as the Liberal party did, that the struggle against apartheid had to be limited to constitutional and legal means, for the very constitutional and legal structure of South Africa was intended to maintain white supremacy. Democratic-minded whites would thus have to decide whether to throw in their lot completely with the extraparliamentary antiapartheid movement or to abstain and remain on the sidelines.

ANC efforts to develop a broad multiracial antiapartheid alliance culminated in the Congress of the People which met at Kliptown outside Johannesburg on June 25–26, 1955. Some three thousand delegates, representing the ANC, the South African Indian Congress (SAIC), the South African Colored People's Organization (SACPO), the (white) Congress of Democrats (COD), and the multiracial South African Congress of Trade Unions (SACTU), convened in an open-air meeting as a self-declared national convention to endorse the Freedom Charter (see Document 14). Even though Mandela was certainly overoptimistic, in the light of subsequent events, in asserting that the move-

ment that led to the charter "shall vanquish all opposition and win the South Africa of our dreams during our lifetime" (see Document 5), he was correct in asserting its significance.

The Freedom Charter, with its unambiguous and forthright statement that "South Africa belongs to all who live in it, black and white," has remained for more than thirty years the single most important statement of the ANC's aims and purposes. The charter sets forth the vision of a South Africa with the full range of civil rights and liberties associated with Western liberal democracies, but it also was beyond standard Western constitutionalism to address the fundamental social and economic inequalities of South African life. In its pledge to restore the national wealth of the country to the people (including the redistribution of white-owned land and the nationalization of "the mineral wealth beneath the soil, the banks, and monopoly industry"); to provide fair and equitable working conditions for all workers, including equal pay to men and women for equal work; to commit the government to energetic educa- tion and cultural policies; and to call for wide-ranging social welfare measures, the charter recognizes that the deep-rooted and fundamental social and eco- nomic disparities in South Africa are the product of many decades of white supremacy and capitalist development. Thus the provision of full-scale politi- cal rights and liberties would not in and of itself resolve the country's enor- mous social and economic problems.

Mandela regularly expressed his concern about African economic and social disabilities in his public statements (see Documents 1 and 23), for he realized that these could easily be overlooked if the struggle concentrated exclusively on political rights. In the mid-1950s he directly addressed these matters in a series of articles for *Liberation.* In "People Are Destroyed" (see Document 4), Mandela wrote about how "the actual workings of the hideous and pernicious doctrines of racial inequality" led to "the breaking up of African homes and families and the forcible separation of children from mothers, the harsh treatment meted out to African prisoners, and the forcible detention of Africans in farm colonies for spurious statutory offenses." "Land Hunger" (see Document 6) presents his analysis of how discriminatory land policies resulted in the impoverishment of the rural masses, compelling them to seek low-wage labor in the white-owned mines and on the large white-owned farms. In this article, Mandela also noted how the Bantu Authorities Act set up instruments of government that were "designed to keep down the people" rather than to provide a means for genuine local self-government. A third article, "Bantu Education Goes to University" (see Document 7), points out how apartheid education was "designed to relegate the Africans to a position of perpetual servitude in a baasskap society" and how the government also intended to carry this principle into higher education. These are clearly the machinations of a fascist state, Mandela reminded his readers (mostly white, in this instance). By making this point, he was turning the issue of Bantu educa- tion into yet another reason for endorsing a broad united front as the best means for fighting apartheid.

Mandela also used his series of articles in *Liberation* to return to a theme he

had raised in his 1951 and 1953 presidential addresses (see Documents 1 and 3)—the threat of American imperialism. In an article entitled "A New Menace in Africa" (Document 8), he deals at length with the reasons that Africans in South Africa, in common with the other peoples of Africa and Asia, should oppose U.S. expansion. Imperialism, Mandela noted, constitutes "the exploitation of the mineral and agricultural wealth" of Africa and Asia "by foreign powers without . . . consent and without compensation," to the severe detriment of the indigenous populations. For centuries the Western European nations had been the principal imperial powers, but the two world wars had destroyed their abilities to continue their empires.[5] The wars had also made them dependent on the United States, which "had emerged from them as the richest and most powerful state in the West." Mandela believed that the United States was intent on expanding its economic and military hegemony while at the same time denying that it was engaging in imperialism. Yet "the American brand of imperialism is imperialism all the same," and it thus remained as deleterious to the interests of Africans and Asians as were the earlier European versions. The future of Africa, Mandela concluded, must be "in the hands of the common people."

Dissension in African Nationalist Ranks

The strategy of a broad united front became the point of contention that split the African nationalist ranks. The problems of dissension to which Mandela had alluded in his 1951 address to the ANCYL (see Document 1) flared up when some in African nationalist circles viewed with concern the prominent Indian role in the Defiance Campaign. Gradually a group formed under the leadership of A. P. Mda to argue the case that South Africa belonged to the Africans. In 1954 they founded a journal, *The Africanist*, to propound their position. "From our inception," stated an editorial in the first anniversary issue of the journal, "we saw the burning need of ridding the ANC of foreign domination. . . . We sternly refused to be reduced to the level of doormats and instruments of selfish white capitalist liberals and the Indian merchant class." "NO WHITE MAN HAS EVER IMPRESSED US," added the editorial, for even liberals are hypocrites who "cannot accept clear-cut African nationalism." *The Africanist* editor further claimed that he spoke for the group that represented the true spirit of the Programme of Action (see Document 13) and thus best embodied true African nationalism.[6]

The leadership of the ANC did not shrink from its commitment to the Congress Alliance in the face of the Africanist attacks. It instead responded with a spirited defense and counterattack. Oliver Tambo, for example, set forth the ANC's positions in a 1958 article entitled "ANC Stands by the Alliance with Congress of Democrats" (see Document 11). He chastised the Africanists for their go-it-alone attitude and for their blanket opposition to whites. All democratic forces suffered oppression at the hands of the apartheid regime, not just Africans, Tambo asserted. It was therefore necessary to build as strong and

as wide a base of support as possible to combat apartheid. The Congress Alliance had emerged from the clear recognition of this need. Only those Africans who believed in the notion of African inferiority, rather than those who had confidence in themselves, would suggest that the alliance meant that the ANC was under the control of non-Africans. Further, to dispel any belief to the contrary, Tambo pointed out that the ANC had boldly and forcefully carried out the 1949 Programme of Action's call for mass action despite relentless government hostility and attacks.[7]

The tension between the Africanists and the ANC leadership steadily mounted, leading to an open break in November 1958 at the Transvaal provincial ANC conference. For a while violence seemed a possible outcome of the conflict between the two factions, but in the end the Africanists conceded defeat in the ANC. They withdrew and reiterated their intention to recapture the spirit of African nationalism as originally intended by the founders of the ANC and as it had existed until the time of the Freedom Charter. In April 1959, they launched their own organization, the PAC, to challenge both the ANC and the NP government. In less than a year the rivalry between the two organizations intensified and helped lead to the cataclysmic set of events that began at Sharpeville and altered the face of South African politics.

The Initiative Begins to Shift

Through its legislative agenda, the NP government sought to impose its own vision of society on South Africa. When Africans and others stepped up protests against their subordinate status, a status that baasskap apartheid viewed as perpetual, the state at first responded with repressive tactics. Using its newly enlarged police powers, the government arrested and jailed demonstrators and banned leaders. In December 1956, the government took yet another drastic step to quell dissent when it arrested 156 members of the opposition (104 Africans, 23 whites, 21 Indians, and 8 Coloreds) on charges of treason for having engaged in an allegedly communist-inspired conspiracy to overthrow the government by force. Included among those arrested were Mandela, Tambo, ANC president Luthuli, and most of the others in the ANC leadership. The trial of those charged (though the numbers were gradually reduced to thirty, including Mandela) lasted for almost five years.

With all of the power and authority at its disposal, the government nevertheless was proving incapable of cowing the antiapartheid forces. South Africa was also coming under increasing international attack for its apartheid policies. For example, antiapartheid resolutions and votes after 1952 onward came up annually in the sessions of the UN General Assembly, and books calling attention to the inequities and injustice of South African racial policy, such as Father Trevor Huddleston's *Naught for Your Comfort*,[8] gained wide readerships. Facing this growing hostility to its policies at home and abroad, South Africa thus set out to refurbish its image and to speak in terms of a policy of

separate development. By touting the "positive side" of apartheid, the government hoped to coopt some of the African leadership and to convince its foreign critics of its good intentions toward its African population.

The key to the new policy was an expanded role for the bantustans, as the reserves were now known. The original apartheid conception of these areas was that they would be permitted to develop local self-government but to advance no further. The Promotion of Bantu Self-Government Act, which Prime Minister H. F. Verwoerd introduced to Parliament in 1959, considerably altered the initial baasskap vision of the bantustans by introducing provisions that would allow them to mature politically to the point that they might eventually become independent sovereign states. Although apartheid theorists and propagandists painted a rosy scenario for the future of the bantustans (including potential United Nations membership), the reality pointed in the opposite direction. Desperately poor and lacking economic infrastructure, industry, and urban centers, these areas were backward by any standard of measurement and are doomed to remain so. As one study noted, "In 1981 an estimated 80 percent of South Africa's poor lived in the homelands." Food production per capita in these almost-exclusively rural areas has fallen dramatically decade by decade. "One estimate suggests that in 1946–48 annual per capita output of maize and sorghum averaged 113 kilograms; in 1955–57, 81 kilograms; in 1971–74, 50 kilograms." Another study noted that in 1975, 40 percent of the bantustan households had incomes of less that 500 rands, 84 percent were under 1,500 rands, and 98 percent had less than 3,000 rands (89 percent of white households had an annual income of more than 3,000 rands, and 50 percent had more than 8,000 rands).[9]

According to the government, Africans would have the opportunity to develop fully their own potential in the bantustans. In return, they would forfeit all their rights as citizens of South Africa. This was the heart of separate development. Along with the continued use of repressive tactics, it was to be the cornerstone of internal policy toward Africans for the next decade and a half. By convincing Africans that they were citizens of individual bantustans rather than of a unitary South African state, the government hoped that it could successfully defuse internal protest and deflect African aspirations from the core to the peripheral areas. Simultaneously, it hoped to persuade the international community that South Africa had also embraced the process of decolonization leading to national independence. Accordingly, it would both disarm its external critics and restore South Africa to a position of international acceptability.

The ANC was quick to challenge the new scheme for the bantustans and the future it implied for South Africa. Terming the whole proposal "nothing but a crude, empty fraud, [intended] to bluff the people at home and abroad, and to serve as a pretext for heaping yet more hardships and injustices upon the African people," Mandela stated that "the talk about self-government for the reserves" constituted a political swindle and an economic absurdity (see Document 9). Mandela pointed out specific African nationalist objections to the

bill: the vast hardships it would cause, the attempt to force Africans to settle for 13 percent (and the poorest 13 percent at that) of South Africa as their share of the country, and the effort to destroy the African political voice through retribalization. Beyond these issues, however, were two even more fundamental grievances. First, African opinion had not been canvassed in any form, let alone been given the opportunity to express itself freely. "Let the people speak for themselves!" Mandela stated. "Let us have a free vote and a free election of delegates to a national convention, irrespective of color or nationality." Second, Mandela predicted that behind the rhetoric lay "a grim programme of mass evictions, political persecution, and police terror." Government actions in subsequent years proved this prediction to be all too true.

The End of an Era

As the 1960s dawned, Mandela could look back on the previous decade with a sense of progress. Whereas in his 1951 presidential address to the ANCYL (see Document 1) he had spoken about the need to mount the struggle, in his testimony in 1960 during his treason trial (see Document 10), Mandela could state "that already since we applied these new methods of political action, this policy of exerting pressure, we have attained—we have achieved, we have won ground." To be certain, the apartheid edifice remained solid, but African nationalism had found allies among whites who believed that those Africans who met educational or similar qualifications should have the right to vote. Similar gains in the 1960s, Mandela believed, might actually lead to extending the franchise to Africans. In 1953, Mandela had reminded his fellow Africans that there would be "no easy walk to freedom" (see Document 3). From this perspective there was some cause for cautious optimism about the course of this walk.

Events were quickly to overtake this optimism and divert the course of the antiapartheid struggle in a much different direction from that of the 1950s. In an effort to win popular support and to best the rival ANC, the PAC launched a campaign against the pass laws on March 21, 1960, ten days before the planned start of an ANC antipass campaign. In Sharpeville, located some thirty-five miles south of Johannesburg, police shot into an unarmed and nonthreatening crowd, variously estimated at between 3,000 and 10,000 African protestors, killing 69 and wounding 186. Given the level of violence that became almost the norm in South Africa in the 1980s, it is somewhat difficult to understand how shocking and unnerving an event the Sharpeville massacre seemed in 1960. Black demonstrations spread to major urban areas, and government leaders reacted uncertainly. For a few days there seemed to be the possibility that the government might relent and begin to move toward a more democratic society. But instead, on March 30 it declared a state of emergency, and the police moved rapidly to crush all signs of revolt. Parliament hurriedly passed the Unlawful Organizations Act, empowering the government to proscribe the ANC, PAC, and other similar organizations, which it promptly did.

An era thus came to an abrupt end. For more than a decade, Mandela, Tambo, and other ANC leaders had led their organization in an open, militant, and nonviolent campaign against apartheid. The Freedom Charter expressed the goals of that campaign, and many were sure that they ultimately would prevail. "In spite of the hostility which we still encounter from the majority of the whites, already our policy was succeeding," Mandela stated in 1960 (see Document 10). The government had previously tried to repress the opposition, even going as far as to charge it with treason. The state of emergency and the outlawing of African political organizations, however, marked a new harshness not previously seen in South Africa. It also caught the antiapartheid opposition off guard, without strategies and tactics appropriate to the operation of a proscribed organization. The government had, for the moment at least, recaptured the political initiative.

Notes

1. For the entire text of *African's Claims*, see Thomas Karis, *Hope and Challenge, 1935–1952*, vol. 2 of Thomas Karis and Gwendolen Carter, eds., *From Protest to Challenge* (Stanford, Calif.: Hoover Institution Press, 1973), pp. 209–23.

2. In 1936, there were only 10,268 Africans on the common voting role of the Cape Province (down more than 50 percent from the late 1920s), along with 23,392 Coloreds, 1,401 Asians, and 382,103 whites (more than double the figure for the late 1920s, as white women received the right to vote in 1930, and all qualifications for white males were removed in 1931). In 1958 there were 29,000 registered Colored male voters. See Gwendolen M. Carter, *The Politics of Inequality: South Africa Since 1948* (New York: Praeger, 1959), pp. 120, 453, 493.

3. Francis Wilson, *Labour in the South African Gold Mines, 1911–1969* (Cambridge, England: Cambridge University Press, 1972), p. 46.

4. Jawaharlal Nehru used this phrase in an article entitled "From Lucknow to Tripoli," in his *The Unity of India: Collected Writings, 1937–1940* (New York: John Day, 1942), pp. 131–2. For references to this source, see Ruth First, ed., *No Easy Walk to Freedom* (London: Heinemann, 1965), p. 31; and Nelson Mandela, *The Struggle Is My Life* (New York: Pathfinder Press, 1986), p. 115.

5. The sections of the article defining imperialism and dealing with the decline of European imperialism are omitted from the edited version presented as Document 8. For these sections, see Mandela, *The Struggle Is My Life*, pp. 72–74.

6. "The Editor Speaks: We Shall Live," an editorial in *The Africanist*, December 1955, in Thomas Karis and Gail M. Gerhart, *Change and Violence, 1953–1964*, vol. 3 of Karis and Carter, eds., *From Protest to Challenge* (Stanford, Calif.: Hoover Institution Press, 1977), pp. 208–10.

7. The rupture between the ANC leadership and the Africanist faction was one of the fundamental issues in African political circles during the 1950s. "What sort of men made up the initial Africanist inner circle, and what differences set them apart from their protagonists in the leadership of the ANC?" According to Gail Gerhart, "More important than any measurable criterion of class, education, or ethnicity were psychological differences which distinguished the Africanists as a group from the type of men

in control of the ANC." See Gerhart, *Black Power in South Africa: The Evolution of an Ideology* (Berkeley and Los Angeles: University of California Press, 1978), pp. 141–45.

8. Trevor Huddleston, an Anglican priest and a member of the celibate order, the Community of the Resurrection, wrote *Naught for Your Comfort* (Garden City, N.Y.: Doubleday, 1956) to illustrate the deprivation, brutality, and poverty that apartheid has injected into the daily lives of Africans in South Africa. As Alexander Steward, a sharp critic of Huddleston, noted on the first page in the preface to his *You Are Wrong Father Huddleston* (London: The Bodley Head, 1956), "Few books have ever received greater publicity in the British Press."

9. John Iliffe, *The African Poor: A History* (Cambridge, England: Cambridge University Press, 1987), p. 269; Francis Wilson and Mamphela Ramphele, *Uprooting Poverty: The South African Challenge* (New York: Norton, 1989), pp. 19, 25.

MANDELA

1 *Presidential Address*

From Annual Conference of the African National
Congress Youth League, December 1951

It is always a most difficult task to deliver a presidential address to an organisation such as ours. One is expected to give as comprehensive a picture as possible of the political situation, both nationally and internationally. Then included must be the review of the organisational strength and power of the movement and the progress it has made in its efforts to carry the people to victory. Lastly, some indication must be given to the reply the organisation must make to the situation having regard to the preceding analyses. Quite clearly it is not possible to do justice to all these, and yet a presidential address in which anyone of them is missing is not worthy of the name. I have [heard] it said that Dr. Nkrumah addresses conferences for five hours. I do not intend to break his record.

Mankind as whole is today standing on the threshold of great events—events that at times seem to threaten its very existence. On the one hand are those groups, parties, or persons that are prepared to go to war in defence of colonialism, imperialism, and their profits. These groups, at the head of which stands the ruling circles in America, are determined to perpetuate a permanent atmosphere of crisis and fear in the world. Knowing that a frightened world cannot think clearly, these groups attempt to create conditions under which the common men might be inveigled into supporting the building of more and more atomic bombs, bacteriological weapons, and other instruments of mass destruction. These crazy men whose prototype is to be found at the head of the trusts and cartels of America and Western Europe do not realise that they will suffer the destruction that they are contemplating for their innocent fellow beings. But they are desperate and become more so as they realise the determination of the common men to preserve peace. Yes, the common man who for generations has been the tool of insane politicians and governments, who has suffered privations and sorrow in wars that were of profit to tiny privileged groups, is today rising from being the object of history [to] becoming the subject of history. For the ordinary men and women in the world, the oppressed all over the world are becoming the conscious creators of their own history. They are pledged to carve their destiny and not to leave it in the hands of tiny ruling circles—or classes. Whilst the dark and sinister forces in the world are organising a desperate and last-minute fight to defend a decadent and bankrupt civilization, the common people, full of confidence and buoyant hope, struggle for the creation of a new, united, and prosperous human family. That this is so can be gathered from the increasingly militant and heroic struggle that is being waged in all colonial countries against heavy odds. Our

mother body has in clean and unmistakable terms indicated in which camp we are in the general world contest. We are with the oppressed all over the world and are irrevocably opposed to imperialism in any form.

In Africa the colonial powers—Great Britain, Portugal, France, Italy, Spain, and their servitors in South Africa—are attempting with the help of the notorious American ruling class to maintain colonial rule and oppression. Millions of pounds are pouring into the continent in the form of capital for the exploitation of our resources in the sole interests of the imperialist powers. So-called geological and archeological expeditions are roaming the continent ostensibly engaged in gathering material for the advancement of science and the furtherance of humanity but being in reality the advance guard of American penetration. It is important for us and for the African people as a whole to realise that but for the support of American finance it would have been difficult if not impossible for the Western colonial powers to maintain rule in Africa, nor indeed anywhere in the world. In thinking of the direct enemies of the African people, namely, Great Britain, Spain, France, Portugal, Italy and S.A. [South Africa], we must never forget the indirect enemy, the infinitely more dangerous enemy who sustains all those with loans, capital, and arms.

In common with people all over the world, humanity in Africa is fighting these forces. In the Gold Coast a situation exists which is capable of being translated into complete victory for the people. ——— [events] in Nigeria are leading to a similar situation. In French West Africa, the Democratic Rally of African People is leading the people into what is virtually open war against the French imperialists. In Egypt the heroic struggle is being waged which must receive the support of all genuine anti-imperialist forces, albeit with certain reservations. In Uganda the leaders of the Bataka Association who were condemned to fourteen years of imprisonment have had to be released as a result of the attitude of the masses. In Central Africa the people saw through the tricks of the British imperialists who sought to foist a bogus federation scheme on them. What the rulers have reaped instead is a rejection of partnership, trusteeship, and white leadership and a clear demand for self-determination and independence. These are hopeful signs, but precisely because the African liberation movement is gaining strength the rulers will become more brutal and, in their desperation, will practice all manner of deception in order to stay on at any rate to postpone the day of final victory. But history is on the side of the oppressed.

Here in South Africa the situation is an extremely grave and serious one. The plans of the Broederbond to set up an openly police state have so far almost run to schedule. About that there can be no question. This is in the interest of the ruling class in South Africa whether it is nominally in the U.P. [United party] or the Nationalist party.

The United party represents the mining interests and also the rapidly rising industrialist power. The Nationalist party represents farming interests and the growing Afrikaner commercial interest. The farming group as a distinct and separate interest is, of course, dying out if it is not dead already! The financial lords are destroying the farmer group, and instead we have huge semi-indus-

trial estates and plantations through which the big money power seeks to extend its monopoly of economic South Africa to the agricultural sphere. At one time it was thought that the development of a powerful industrialist class would produce a clash involving the primitive feudal–capitalist farming and mining interest on the one hand and the industrialist on the other. It was thought that this clash might result in a realignment of forces that might be advantageous to the oppressed people in the country. But it is becoming clear that there is no possibility of [a] clash between such groups. There is no chance that Sir Ernest Oppenheimer, the leading mining magnate, will clash with Harry Oppenheimer, the leading industrialist. There is also noticeable a growing affinity among the English, Jewish, and Afrikaner financial and industrial interests. It is quite conceivable that all their interests find the fascist policy of Malan suitable, as it will enable them to continue their bankrupt role by crushing the tribal union movement and the national movements of the people. It is true that in the rank-and-file of the white parties are a number who whilst they support the maintenance of colour as an instrument of white political and economic supremacy are scared of a naked Hitlerite regime which might later turn out to be a danger to themselves; hence movements like the now thoroughly discredited Torch Commando. This white South African people who have lost all their moral backbone [sic]. The possibility of a liberal capitalist democracy in S.A. [South Africa is] extremely nil. The ——— propaganda among the whites and their desire to maintain what they imagine to be a profitable situation make it utterly unthinkable that there can be a political alignment that favours a liberal white group. In any case the political immorality, cowardice, and vacillations of the so-called progressives among whites render them utterly useless as a force against fascism.

The situation is developing [in] the direction of an openly fascist state. The Broederbond is the center of the fascist ideology in this country, but like other things it is itself merely an instrument of the ruling circles which are to be found in all white parties. The ——— commandos are the nucleus of a future Gestapo. The acts passed by the government, in particular the Suppression of Communism Amendment Act and the Group Areas Act, provide the ready-made framework for the establishment of the fascist state. True to the pattern depicted for the rest of the imperialist world, South African capitalism has developed [into] monopolism and is now reaching the final stage of monopoly capitalism gone mad, namely, fascism.

But the development of fascism in the country is an indication of the fear they have [of] the people. They realise that their world is a dying world and that the appearance of impregnable strength is a mere facade. The new world is the one in which the oppressed Africans live. They see before their eyes the growth of a mighty people's movement. The struggles of 1950 were an indication that the leaders of the Africans and their allies were fully aware of the weakest link in the chain of white supremacy. The labour power of the African people is a force which when fully tapped is going to sweep the people to power in the land of their birth. True, the struggle will be a bitter one. Leaders will be deported, imprisoned, and even shot. The government will terrorise the people

and their leaders in an effort to halt the forward march; ordinary forms of organisation will be rendered impossible. But the spirit of the people cannot be crushed, and no matter what happens to the present leadership, new leaders will arise like mushrooms till full victory is won.

The people are possessed of tremendous potential powers which can be unleashed at short notice by a determined leadership. But is the African movement as at present organised capable of answering to the challenge of the present conditions?

African Nationalism

On the ideological plain there can be no question of [the] dynamism of African nationalism as an outlook for our people in the present stage of our struggle. At the present historical stage African nationalism is the only outlook or creed for giving the African people the self-confidence and subjective liberation without which a people can never hope to challenge effectively any national oppression.

As the guardian of African nationalism, the Congress Youth League and, to a lesser extent, the senior Congress are undoubtedly the greatest hope that the African people, and indeed all oppressed people, have that they will ever live in a free, independent, united, democratic, and a prosperous South Africa. The Congress and the Youth League are the instruments through which these aims will be achieved.

African nationalism was born in the ANC and grew in confidence through years of struggle. In the Congress Youth League, African nationalism found new form and was made concrete and crystalised. I wish to say emphatically as possible that there is only one *African nationalism* and that is the African nationalism propounded by the Congress and the Youth League. In certain quarters there is a feeling that the language of African nationalism within the movement is not uniform. It is said that there are various brands of African nationalism. I think it is more a question of concept of struggle. I have no doubt that so far as this stage of struggle is concerned, our language is sufficiently uniform. It is, however, when we seek to apply our creed to concrete situations that there are revealed different approaches. This was made clear during the three struggles of the past two years. I refer to campaigns of May 1st, June 26th, and May 7th this year. Owing to differences that developed regarding them, there is a tendency to think that these campaigns revealed differences in our concept of African nationalism. Fundamentally, African nationalism is one, and what these campaigns revealed was our inexperience in actual struggle. There is nothing to be afraid of in the setbacks we have suffered. Many of us grew in those campaigns by [the] very reason of our failure. The Youth League has, in my opinion, become stronger.

We learned in those struggles that the face of a liberatory movement must always be turned against the main enemy—fight fascism. We learned that when the masses of the people were on the march, even if we had genuine principled

objections to the move, we must never be against the mass movement of the people. We learned that always a true fighter must be on the side of the people against the oppressor. We learned during these campaigns that the political dilettante, the [person] who regards politics as the attendance of conferences and the making of beautiful analyses, is over. Today politics has become the affairs of a professional revolutionary. Our policy and attitude towards the national groups was in practice severely tested in the campaigns. In short, these were in a way a test of our concept of actual struggle. Our imperfections were made clear to us, and the duty of the conference will be directed towards correcting these mistakes and practicing honest objective and serious self-criticism to fully prepare ourselves for the struggle we will have to wage early next year. Sons and daughters of Africa, I do not think we differ concerning our ideas of the aims of African nationalism in Africa. In any case the very nature of [the] national movement to which we belong makes it impossible to expect [an] absolutely identical approach. The very nature of the national struggle and the manner of its organisations make it impossible to achieve what is perhaps possible to achieve in a party. African nationalism has to my mind been sufficiently concretized, and its aims are, for the present historical stage, clear. Any attempt to go beyond this might well be unconstructive and will merely [delay] the consideration of what our answer should be to the immediate crises facing our people.

Expressed in what is perhaps an oversimplification, the problem of the Youth League and the Congress today is the maintenance of full dynamic contact with the masses and the fight in the daily issues that face them. We have a powerful ideology capable of capturing the imaginations of the masses. Our duty is now how to carry that ideology fully to the masses. In the past two years we have registered certain big successes in this task in spite of setbacks.

We must here in conference confine our attention to a few vital considerations. Firstly, our National Executive of the Senior Congress has called upon the country to rally to [a] nationwide struggle that will probably begin at this national conference. In accordance with this policy it has called upon other national organisations to fall in line with this programme. In view of our claim to leadership of South Africa, it was perfectly logical that Congress should take initiative in calling all the people of South Africa to join in its struggle. Needless to say, the whole situation demands an answer of struggle. The possibility of our movement being banned makes it doubly necessary that the message of struggle should be carried to the people in the manner contemplated by the senior Congress! It is clear that if a movement is banned and its leaders' activities proscribed, this should happen in the midst and as a result of an actual struggle. Then also we must make clear our attitude to the participation of other national groups in our struggles, always bearing in mind the international situation and the political theses that the mind of the masses must always be directed towards the fight against Malan and must not be diverted from this for any reason.

Then we have to design on concrete steps to be taken to deal with the situation that has arisen as a result of the Suppression of Communism Amend-

ment Act. How are we going to react to the liquidation of Congress leaders as [a] result of this act? And how are the operations going to be carried on in the event of our being banned? This is a serious matter and can hardly be discussed in the conference except in very general terms.

We have to discuss measures [for] the creation of strong nuclei of active workers in the struggle on the proper organisation of the League and the Congress [and] the elimination of unredeemable reactionaries, which work has proceeded quite far in certain areas. We have to consider measures to eliminate the looseness and lack of discipline in the movement and also the cultivation of a serious approach to the struggle. In this context we have to examine various tactics and weapons in our struggle, including boycott, civil disobedience, and strikes.

Sons and daughters of Africa, our tasks are mighty indeed, but I have abundant faith in our ability to reply to the challenge posed by the situation. Under the slogan of FULL DEMOCRATIC RIGHTS IN SOUTH AFRICA NOW, we must march forward into victory.

2 *The Shifting Sands of Illusion*

Excerpted from *Liberation*, June 1953

In South Africa, where the entire population is almost split into two hostile camps in consequence of the policy of racial discrimination, and where recent political events have made the struggle between oppressor and oppressed more acute, there can be no middle course. The fault of the Liberals—and this spells their doom—is to attempt to strike just such a course. They believe in criticising and condemning the government for its reactionary policies, but they are afraid to identify themselves with the people and to assume the task of mobilising that social force capable of lifting the struggle to higher levels.

The Liberals' credo states that to achieve their objects the party will employ "only democratic and constitutional means and will oppose all forms of totalitarianism such as communism and fascism." Talk of democratic and constitutional means can only have a basis in reality for those people who enjoy democratic and constitutional rights.

We must accept the fact that in our country we cannot win one single victory of political freedom without overcoming a desperate resistance on the part of the government, and that victory will not come of itself but only as a result of a bitter struggle by the oppressed people for the overthrow of racial discrimination.

To propose in the South African context that democrats limit themselves to constitutional means of struggle is to ask the people to submit to laws enacted by a minority parliament whose composition is essentially a denial of democ-

racy to the overwhelming majority of the population. It means that we must obey a constitution which debars the majority from participating in the government and other democratic processes of the country by reason only of race, colour, or creed. It implies in practice that we must carry passes and permit the violation of the essential dignity of a human being. It means that we must accept the Suppression of Communism Act which legalises the gagging and persecution of leaders of the people because of their creed. It implies the acceptance of the Rehabilitation Scheme, the Bantu Authorities, the Group Areas, the Public Safety, the Criminal Law Amendment Act, and all the wicked policies of the government.

The real question is: In the general struggle for political rights can the oppressed people count on the liberal party as an ally?

It becomes clear, therefore, that the high-sounding principles enunciated by the Liberal party, though apparently democratic and progressive in form, are essentially reactionary in content. They stand not for the freedom of the people but for the adoption of more subtle systems of oppression and exploitation. Though they talk of liberty and human dignity, they are subordinate henchmen of the ruling circles. They stand for the retention of the cheap labour system and of the subordinate colonial status of the non-European masses together with the Nationalist government whose class interests are identical with theirs. In practice they acquiesce in the slavery of the people, low wages, mass unemployment, the squalid tenements in the locations and shanty-towns.

We of the non-European liberation movement are not racialists. We are convinced that there are thousands of honest democrats among the white population who are prepared to take up a firm and courageous stand for unconditional equality, for the complete renunciation of "white supremacy." To them we extend the hand of sincere friendship and brotherly alliance. But no true alliance can be built on the shifting sands of evasions, illusions, and opportunism. We insist on presenting the conditions which make it reasonable to fight for freedom.

3 *No Easy Walk to Freedom*

Excerpted from the Presidential Address to the
Transvaal Branch of the African National Congress,
September 21, 1953

Today the people speak the language of action: there is a mighty awakening among the men and women of our country and the year 1952 stands out as the year of this upsurge of national consciousness.

In June, 1952, the African National Congress and the South African Indian Congress, bearing in mind their responsibility as the representatives of the

downtrodden and oppressed people of South Africa, took the plunge and launched the Campaign for the Defiance of the Unjust Laws. . . . Factory and office workers, doctors, lawyers, teachers, students and the clergy; Africans, Coloureds, Indians, and Europeans, old and young, all rallied to the national call and defied the pass laws and the curfew and the railway apartheid regulations. At the end of the year, more than 8,000 people of all races had defied. . . . Defiance was a step of great political significance. It released strong social forces which affected thousands of our countrymen. It was an effective way of getting the masses to function politically: a powerful method of voicing our indignation against the reactionary policies of the government. It was one of the best ways of exerting pressure on the government and extremely dangerous to the stability and security of the state. It inspired and aroused our people from a conquered and servile community of yesmen to a militant and uncompromising band of comrades-in-arms. The entire country was transformed into battle zones where the forces of liberation were locked up in immortal conflict against those of reaction and evil. Our flag flew in every battlefield and thousands of our countrymen rallied around it. We held the initiative and the forces of freedom were advancing on all fronts. It was against this background and at the height of this campaign that we held our last annual provincial conference.

Today we meet under totally different conditions. By the end of July last year, the campaign had reached a stage where it had to be suppressed by the government or it would impose its own policies on the country.

The government launched its reactionary offensive and struck at us [with arrests, new repressive legislation, and banning].

The congresses realised that these measures created a new situation which did not prevail when the campaign was launched in June 1952. The tide of defiance was bound to recede, and we were forced to pause and to take stock of the new situation. . . . The old methods of bringing about mass action through public mass meetings, press statements, and leaflets calling upon the people to go to action have become extremely dangerous and difficult to use effectively. The authorities will not easily permit a meeting called under the auspices of the ANC; few newspapers will publish statements openly criticising the policies of the government; and there is hardly a single printing press which will agree to print leaflets calling upon workers to embark on industrial action for fear of prosecution under the Suppression of Communism Act and similar measures. These developments require the evolution of new forms of political struggle which will make it reasonable for us to strive for action on a higher level than the Defiance Campaign. The government, alarmed at the indomitable upsurge of national consciousness, is doing everything in its power to crush our movement by removing the genuine representatives of the people from the organisations. . . . There are thirty-three trade union officials and eighty-nine other people who have been served with notices in terms of the Suppression of Communism Act. This does not include that formidable array of freedom fighters who have been named and blacklisted under the Suppression of Communism Act and those who have been banned under the Riotous Assemblies Act.

Meanwhile, the living conditions of the people, already extremely difficult,

are steadily worsening and becoming unbearable. The purchasing power of the masses is progressively declining and the cost of living is rocketing. . . . They cannot afford sufficient clothing, housing, and medical care. They are denied the right to security in the event of unemployment, sickness, disability, [and] old age, and where these exist, they are of an extremely inferior and useless nature. Because of lack of proper medical amenities our people are ravaged by such dreaded diseases as tuberculosis, venereal disease, leprosy, [and] pelagra, and infantile mortality is very high. The recent state budget made provision for the increase of the cost-of-living allowances for Europeans, and not a word was said about the poorest and most hard-hit section of the population—the African people. The insane policies of the government which have brought about an explosive situation in the country have definitely scared away foreign capital from South Africa, and the financial crisis through which the country is now passing is forcing many industrial and business concerns to close down, to retrench their staffs, and unemployment is growing every day. The farm labourers are in a particularly dire plight.

The government has introduced in Parliament the Native Labour (Settlement of Disputes) Bill and the Bantu Education Bill. Speaking on the labour bill, the minister of labour, Ben Schoeman, openly stated that the aim of this wicked measure is to bleed African trade unions to death. By forbidding strikes and lockouts it deprives Africans of the one weapon the workers have to improve their position. . . . The minister of native affairs, Verwoerd, has also been brutally clear in explaining the objects of the Bantu Education bill. According to him, the aim of this law is to teach our children that Africans are inferior to Europeans. African education would be taken out of the hands of people who taught equality between black and white. When this bill becomes law, it will not be the parents but the Department of Native Affairs which will decide whether an African child should receive higher or other education. It might well be that the children of those who criticise the government and who fight its policies will almost certainly be taught how to drill rocks in the mines and how to plough potatoes on the farms of Bethal. High education might well be the privilege of those children whose families have a tradition of collaboration with the ruling circles.

The attitude of the congress on these bills is very clear and unequivocal. Congress totally rejects both bills without reservation.

The cumulative effect of all these measures is to prop up and perpetuate the artificial and decaying policy of the supremacy of the white men. The attitude of the government to us is: "Let's beat them down with guns and batons and trample them under our feet. We must be ready to drown the whole country in blood if only there is the slightest chance of preserving white supremacy."

But in spite of all the difficulties outlined above, we have won important victories. The general political level of the people has been considerably raised, and they are now more conscious of their strength. Action has become the language of the day. The ties between the working people and the congress have been greatly strengthened. This is a development of the highest importance because in a country such as ours a political organisation that does not receive the support of the workers is in fact paralysed on the very ground on

which it has chosen to wage battle. Leaders of trade union organisations are at the same time important officials of the provincial and local branches of the ANC. In the past we talked of the African, Indian, and Coloured struggles. Though certain individuals raised the question of a united front of all the oppressed groups, the various non-European organisations stood miles apart from one another, and the efforts of those for co-ordination and unity were like a voice crying in the wilderness, and it seemed that the day would never dawn when the oppressed people would stand and fight together shoulder to shoulder against a common enemy. Today we talk of the struggle of the oppressed people which, though it is waged through their respective autonomous organisations, is gravitating towards one central command.

Our immediate task is to consolidate these victories, to preserve our organisations and to muster our forces for the resumption of the offensive. To achieve this important task the National Executive of the ANC in consultation with the National Action Committee of the ANC and the SAIC formulated a plan of action popularly known as the "M" plan and the highest importance is [given] to it by the national executives. Instructions were given to all provinces to implement the "M" plan without delay.

The underlying principle of this plan is the understanding that it is no longer possible to wage our struggle mainly on the old methods of public meetings and printed circulars. The aim is:

1. to consolidate the congress machinery;
2. to enable the transmission of important decisions taken on a national level to every member of the organisation without calling public meetings, issuing press statements, and printing circulars;
3. to build up in the local branches themselves local congresses which will effectively represent the strength and will of the people; [and]
4. to extend and strengthen the ties between congress and the people and to consolidate congress leadership.

I appeal to all members of the Congress to redouble their efforts and play their part truly and well in its implementation. The hard, dirty and strenuous task of recruiting members and strengthening our organisation through a house to house campaign in every locality must be done by you all. . . . You must protect and defend your trade unions. . . . You must make every home, every shack, and every mud structure where our people live, a branch of the trade union movement, and *never surrender*.

You must defend the right of African parents to decide the kind of education that shall be given to their children. Teach the children that Africans are not one iota inferior to Europeans. Establish your own community schools. . . . Never surrender to the inhuman and barbaric theories of Verwoerd.

The decision to defy the unjust laws enabled congress to develop considerably wider contacts between itself and the masses and the urge to join congress grew day by day. But due to the fact that the local branches did not exercise proper control and supervision, the admission of new members was not carried out satisfactorily. No careful examination was made of their past history and political characteristics. As a result of this, there were many shady characters

ranging from political clowns, place-seekers, splitters, saboteurs, agents-provo-cateurs to informers and even policemen, who infiltrated into the ranks of congress. . . . The presence of such elements in congress constitutes a serious threat to the struggle, for the capacity for political action of an organisation which is ravaged by such disruptive and splitting elements is considerably undermined. . . . We must rid ourselves of such elements and give our organi-sation the striking power of a real militant mass organisation.

Kotane, Marks, Bopape, Tloome, and I have been banned from attending gatherings, and we cannot join and counsel with you on the serious problems that are facing our country. We have been banned because we champion the freedom of the oppressed people of our country and because we have consis-tently fought against the policy of racial discrimination in favour of a policy which accords fundamental human rights to all, irrespective of race, colour, sex, or language. We are exiled from our own people for we have uncompro-misingly resisted the efforts of imperialist America and her satellites to drag the world into the rule of violence and brutal force, into the rule of the napalm, hydrogen, and the cobalt bombs where millions of people will be wiped out to satisfy the criminal and greedy appetites of the imperial powers. We have been gagged because we have emphatically and openly condemned the criminal attacks by the imperialists against the people of Malaya, Vietnam, Indonesia, Tunisia, and Tanganyika and called upon our people to identify themselves unreservedly with the cause of world peace and to fight against the war policies of America and her satellites. We are being shadowed, hounded, and trailed because we fearlessly voiced our horror and indignation at the slaughter of the people of Korea and Kenya. The massacre of the Kenya people by Britain has aroused worldwide indignation and protest. Children are being burnt alive, women are raped, tortured, whipped, and boiling water poured on their breasts to force confessions from them that Jomo Kenyatta had administered the Mau Mau oath to them. Men are being castrated and shot dead. In the Kikuyu country there are some villages in which the population has been completely wiped out. We are prisoners in our own country because we dared to raise our voices against these horrible atrocities and because we expressed our solidarity with the cause of the Kenya people.

You can see that "there is no easy walk to freedom anywhere, and many of us will have to pass through the valley of the shadow (of death) again and again before we reach the mountain tops of our desires.

"Dangers and difficulties have not deterred us in the past; they will not frighten us now. But we must be prepared for them like men in business who do not waste energy in vain talk and idle action. The way of preparation (for action) lies in our rooting out all impurity and indiscipline from our organisa-tion and making it the bright and shining instrument that will cleave its way to (Africa's) freedom."*

*The last four sentences are quoted with some minor changes from Jawaharlal Nehru, *The Unity of India: Collected Writings 1937–1940* (New York: John Day, 1942), pages 131–32. The reference to this source is provided by Ruth First, ed., *No Easy Walk to Freedom: Articles, Speeches, and Trial Addresses of Nelson Mandela* (London: Heinemann, 1965), p. 31.

4 *People Are Destroyed*

From *Liberation*, October 1955

Rachel Musi is fifty-three years of age. She and her husband had lived in Krugersdorp for thirty-two years. Throughout this period, he had worked for the Krugersdorp municipality for £7 10s. a month. They had seven children ranging from nineteen to two years of age. One was doing the final year of the junior certificate at the Krugersdorp Bantu High School, and three were in primary schools, also in Krugersdorp. She had several convictions for brewing kaffir beer. Because of these convictions she was arrested as an undesirable person in terms of the provisions of the Native Urban Areas Act and brought before the additional native commissioner of Krugersdorp. After the arrest but before the trial her husband collapsed suddenly and died. Thereafter the commissioner judged her an undesirable person and ordered her deportation to Lichtenburg. Bereaved and brokenhearted, and with the responsibility of maintaining seven children weighing heavily on her shoulders, an aged woman was exiled from her home and forcibly separated from her children to fend for herself among strangers in a strange environment.

In June 1952 I and about fifty other friends were arrested in Johannesburg while taking part in a defiance campaign and removed to Marshall Square. As we were being jostled into the drill yard, one of our prisoners was pushed from behind by a young European constable so violently that he fell down some steps and broke his ankle. I protested, whereupon the young warrior kicked me on the leg in cowboy style. We were indignant and started a demonstration. Senior police officers entered the yard to investigate. We drew their attention to the injured man and demanded medical attention. We were curtly told that we could repeat our request the next day. And so it was that Samuel Makae spent a frightful night in the cells reeling and groaning with pain, maliciously denied medical assistance by those who had deliberately crippled him and whose duty it is to preserve and uphold the law.

In 1941 an African lad appeared before the native commissioner in Johannesburg charged with failing to give a good and satisfactory account of himself in terms of the above act. The previous year he had passed the junior certificate with a few distinctions. He had planned to study matric in the Cape, but because of illness, on the advice of the family doctor he decided to spend the year at home in Alexandra Township. Called upon by the police to produce proof that he had sufficient honest means of earning his livelihood, he explained that he was still a student and was maintained by his parents. He was then arrested and ordered to work at Leeuwkop Farm Colony for six months as an idle and disorderly person. This order was subsequently set aside on review by the supreme court, but only after the young man had languished in jail for seven weeks, with serious repercussions to his poor health.

The breaking up of African homes and families and the forcible separation of children from mothers, the harsh treatment meted out to African prisoners,

and the forcible detention of Africans in farm colonies for spurious statutory offences are a few examples of the actual workings of the hideous and pernicious doctrines of racial inequality. To these can be added scores of thousands of foul misdeeds committed against the people by the government; the denial to the non-European people of the elementary rights of free citizenship; the expropriation of the people from their lands and homes to assuage the insatiable appetites of European land barons and industrialists; the flogging and calculated murder of African labourers by European farmers in the countryside for being "cheeky to the baas", the vicious manner in which African workers are beaten up by the police and flung into jails when they down tools to win their demands; the fostering of contempt and hatred for non-Europeans; the fanning of racial prejudice between whites and nonwhites, between the various nonwhite groups; the splitting of Africans into small hostile tribal units; the instigation of one group or tribe against another; [and] the banning of active workers from the people's organisations and their confinement into certain areas.

All these misdemeanours are weapons resorted to by the mining and farming cliques of this country to protect their interests and to prevent the rise of an all-powerful organised mass struggle. To them, the end justifies the means, and that end is the creation of a vast market of cheap labour for mine magnates and farmers. That is why homes are broken up and people are removed from cities to the countryside to ensure enough labour for the farms. That is why non-European political opponents of the government are treated with such brutality. In such a setup, African youth with distinguished scholastic careers are not a credit to the country but a serious threat to the governing circles, for they may not like to descend to the bowels of the earth and cough their lungs out to enrich the mining magnates, nor will they elect to dig potatoes on farms for wretched rations.

Nevertheless, these methods are failing to achieve their objective. True enough, they have scared and deterred certain groups and individuals and, at times, even upset and temporarily dislocated our plans and schemes. But they have not halted the growing struggle of the people for liberation. Capable fighters and organisers are arising from amongst the people. The people are increasingly becoming alive to the necessity of the solidarity of all democratic forces regardless of race, party affiliation, religious belief, and ideological conviction.

Taking advantage of this situation, the people's organisations have embarked on a broad programme of mutual cooperation and closer relations. The Freedom Charter recently adopted by people of all races and from all walks of life now forms the ground plan for future action.

However, the fascist regime that governs this country is not meeting this situation with arms folded. Cabinet ministers are arming themselves with inquistorial and arbitrary powers to destroy their opponents and hostile organisations. They are building a monoparty state, the essence of which is the identification of the Nationalist party with state power. All opposition to the Nationalists has been deemed opposition to the state. Every facet of the

national life is becoming subordinated to the overriding necessity of the party's retention of power. All constitutional safeguards are being thrown overboard, and individual liberties are being ruthlessly suppressed. Lynchings and pogroms are the logical weapons to be resorted to, should the onward march of the liberation movement continue to manifest itself.

The spectre of Belsen and Buchenwald is haunting South Africa. It can only be repelled by the united strength of the people of South Africa. Every situation must be used to raise the people's level of understanding. If attacks on the people's organisations, if all discriminatory measures, be they the Industrial Conciliation Amendment Act, Bantu Education, or the classification of the Coloured people, are used as a rallying point around which a united front will be built, the spectre of Belsen and Buchenwald will never descend upon us.

5 *Freedom in Our Lifetime*

Excerpted from *Liberation*, June 1956

Few people will deny . . . that the adoption of the charter is an event of major political significance in the life of this country. The intensive and nationwide political campaigning that preceded it, the 2,844 elected delegates of the people that attended, the attention it attracted far and wide, and the favourable comment it continues to receive at home and abroad from people of diverse political opinions and beliefs long after its adoption, are evidence of this fact.

The charter is more than a mere list of demands for democratic reforms. It is a revolutionary document precisely because the changes it envisages cannot be won without breaking up the economic and political setup of present South Africa. To win the demands calls for the organisation, launching, and development of mass struggles on the widest scale. They will be won and consolidated only in the course and as the result of a nationwide campaign of agitation; through stubborn and determined mass struggles to defeat the economic and political policies of the Nationalist government; by repulsing their onslaughts on the living standards and liberties of the people.

The most vital task facing the democratic movement in this country is to unleash such struggles and to develop them on the basis of the concrete and immediate demands of the people from area to area. Only in this way can we build a powerful mass movement which is the only guarantee of ultimate victory in the struggle for democratic reforms. Only in this way will the democratic movement become a vital instrument for the winning of the democratic changes set out in the charter.

Whilst the charter proclaims democratic changes of a far-reaching nature,

it is by no means a blueprint for a socialist state but a programme for the unification of various classes and groupings amongst the people on a democratic basis. . . . Its declaration "The People Shall Govern!" visualises the transfer of power not to any single social class but to all the people of this country be they workers, peasants, professional men, or petty bourgeoisie.

It is true that in demanding the nationalisation of the banks, the gold mines, and the land, the charter strikes a fatal blow at the financial and gold-mining monopolies and farming interests that have for centuries plundered the country and condemned its people to servitude. . . . The breaking up and democratisation of these monopolies will open up fresh fields for the development of a prosperous non-European bourgeois class. For the first time in the history of this country the non-European bourgeoisie will have the opportunity to own in their own name and right mills and factories, and trade and private enterprise will boom and flourish as never before. To destroy these monopolies means the termination of the exploitation of vast sections of the populace by mining kings and land barons and there will be a general rise in the living standards of the people.

The democratic struggle in South Africa is conducted by an alliance of various classes and political groupings amongst the non-European people supported by white democrats. African, Coloured, and Indian workers and peasants, traders and merchants, students and teachers, doctors and lawyers, and various other classes and groupings: All participate in the struggle against racial inequality and for full democratic rights. It was this alliance which launched the National Day of Protest on June 26, 1950. It was this alliance which unleashed and waged the campaign for the defiance of unjust laws on June 26, 1952. It is this same alliance that produced the epoch-making document—the Freedom Charter. In this alliance the democratic movement has the rudiments of a dynamic and militant mass movement and, provided the movement exploits the initial advantages on its side at the present moment, immense opportunities exist for the winning of the demands in the charter within our lifetime.

In the present political situation in South Africa when the Nationalist government has gone all out to smash the people's political organisations and the trade union movement through the Suppression of Communism Act and its antitrade union legislation, it becomes important to call upon and to stimulate every class to wage its own battles. It becomes even more important that all democratic forces be united and the opportunities for such [a] united front are growing every day. . . . In fact, the rise of the Congress movement and the powerful impact it exerts on the political scene in the country is due precisely to the fact that it has consistently followed and acted on the vital policy of democratic unity. It is precisely because of the same reason that the Congress movement is rapidly becoming the real voice of South Africa. If this united front is strengthened and developed, the Freedom Charter will be transformed into a dynamic and living instrument, and we shall vanquish all opposition and win the South Africa of our dreams during our lifetime.

6 *Land Hunger*

From *Liberation*, February 1956

The Transkeian territories cover an area of more than four million morgen of land, exclusive of trading sites and towns, with an African population of over three million. In comparison with the other so-called native reserves, this area is by far the largest single reserve in the Union and also the greatest single reservoir of cheap labour in the country. According to official estimates, more than one-third of the total number of Africans employed on the Witwatersrand gold mines come from the Transkei.

It is thus clear that this area is the greatest single support of the most vicious system of exploitation—the gold mines. The continued growth and development of gold mining in South Africa brought about by the discovery of gold in the Orange Free State calls for more and more of this labour at a time when the Union loses about ten thousand workers a year to the Central African Federation.

This labour problem compels South African mining circles to focus their attention more and more on the reserves in a desperate effort to coerce every adult male African to seek employment on the mines. Recruiting agents are no longer content with discussing matters with chiefs and headmen only, as they have done in days gone by. Kraals, drinking parties, and initiation ceremonies are given particular attention, and kraal heads and tribesmen told that fame and fortune await them if they sign up their mine contracts. Films portraying a rosy picture of conditions on the mines are shown free of charge in the villages and rural locations.

But just in case these somewhat peaceful methods of persuasion fail to induce enough recruits, the authorities have in reserve more draconian forms of coercion. The implementation of the so-called rehabilitation scheme, the enforcement of taxes, and the foisting of tribal rule upon the people are resorted to in order to ensure a regular inflow of labour.

The rehabilitation scheme, which is the trump card of both the mining and the farming industries in this sordid game of coercion, was first outlined by Dr. D. L. Smit, then secretary for native affairs, at a special session of the General Council of the Ciskei held at King William's Town in January 1945. According to the secretary's statement, the scheme had two important features, namely, the limitation of stock to the carrying capacity of the land and the replanning of the reserves to enable the inhabitants to make the best possible use of the land.

The main object of replanning, the statement continued, would be to demarcate residential, arable, and grazing areas in order that each portion of land should be used for the purpose to which it is best suited. Rural villages would be established to provide suitable homes for the families of Africans regularly employed in industrial and other services and, therefore, unable to make efficient use of a normal allotment of land.

In point of fact, the real purpose of the scheme is to increase land hunger for the masses of the peasants in the reserves and to impoverish them. The main object is to create a huge army of migrant labourers, domiciled in rural locations in the reserves far away from the cities. Through the implementation of the scheme it is hoped that in course of time the inhabitants of the reserves will be uprooted and completely severed from their land, cattle, and sheep, to depend for their livelihood entirely on wage earnings.

By enclosing them in compounds at the centres of work and housing them in rural locations when they return home, it is hoped to prevent the emergence of a closely knit, powerful, militant, and articulate African industrial proletariat who might acquire the rudiments of political agitation and struggle. What is wanted by the ruling circles is a docile, spineless, unorganised, and inarticulate army of workers.

Another method used to coerce African labour is the poll tax, also known as the general tax. When Cecil Rhodes introduced it in the old Cape Colony he openly and expressly declared that its main object would be to ensure cheap labour for industry, an object which has not changed since. In 1939, Parliament decided to make all African tax defaulters work for it, and the then minister of finance expressed the view that farms would benefit through this arrangement. The extent of this benefit is clearly revealed by reference to statistics. According to the 1949 official year book for the Union, 21,381 Africans were arrested that year for general tax. Earlier, John Burger had stated in *The Black Man's Burden* that something like sixty thousand arrests were made each year for nonpayment of this tax. Since the Nationalist party came to power these arrests have been intensified. In the reserves, chiefs, headmen, mounted police, and court messengers comb the countryside daily for tax defaulters, and fearing arrest, thousands of Africans are forced to trek to the mines and surrounding farms in search of work. Around the jails in several parts of the country, queues of farmers are to be observed waiting for convicts.

Much has been written already on the aims and objects of the Bantu Authorities Act and on the implications of its acceptance by the Transkeian bunga. Here we need only reiterate that reversion to tribal rule might isolate the democratic leadership from the masses and bring about the destruction of that leadership as well as of the liberation organisations. It will also act as a delaying tactic. In course of time the wrath of the people will be directed, it is hoped, not at the oppressor but at the Bantu authorities, who will be burdened with the dirty work of manipulating the detestable rehabilitation scheme, the collection of taxes, and the other measures which are designed to keep down the people.

It is clear, therefore, that the ruling circles attach the greatest importance to the Transkeian territories. It is equally clear that the acceptance of tribal rule by the bunga will henceforth be used by the government to entice other tribal groups to accept the act. As a matter of fact, this is precisely what the chiefs were told by government spokesmen at the Zululand and Rustenburg indabas. Yet by a strange paradox the Transkei is the least politically organised area in the Union. The Transkeian Organised Bodies Association, once a powerful

organisation, is for all practical purposes virtually defunct. The Cape African Teachers' Association is dominated by a group of intellectual snobs who derive their inspiration from the All-African Convention. They are completely isolated and have no influence whatsoever with the masses of the people.

Recently, when the African National Congress declared for a boycott of Bantu Education and advocated the withdrawal of children from such schools, the AAC fought against the withdrawal and placed itself in the ridiculous position of opposing a boycott it had pretended to preach all along. This somersault completely exposed their opportunism and bankruptcy, and the volume of criticism now being directed against them has temporarily silenced even the verbal theatricals for which they are famous.

Nevertheless, it is perfectly clear that the people of the Transkei are indignant. Isolated and sporadic insurrections have occurred in certain areas directed mainly against the rehabilitation scheme. Chiefs and headmen have been beaten up by their tribesmen, and court actions are being fought. But in the absence of an organised peasant movement coordinating these isolated and sporadic outbursts, the impact of this opposition will not be sharply felt by the authorities.

Once more the problem of organisation in the countryside poses itself as one of major importance for the liberatory movement. Through the coordination of spontaneous and local demonstrations, and their raising to a political level, the beginnings will be found of opposition to the policy of oppressing and keeping backward the people of the Transkei. Then we can look forward to the day when the Transkei will not be a reserve of cheap labour, but a source of strength to build a free South Africa.

7 *Bantu Education Goes to University*

From *Liberation*, June 1957

The Nationalist government has frequently denied that it is a fascist government inspired by the theories of the National Socialist [Nazi] party of Hitlerite Germany. Yet the declarations it makes, the laws its passes, and the entire policy it pursues clearly confirm this point. It is interesting to compare the colonial policy of the Hitlerite government as outlined by the leading German theoreticians on the subject. Dr. Gunther Hecht, who was regarded as an expert on colonial racial problems in the office of the German National Socialist party, published a pamphlet in 1938 entitled *The Colonial Question and Racial Thought* in which he outlined the racial principles which were to govern the future treatment of Africans in German colonies. He declared that the German government would not preach equality between Africans and Europeans. Africans would under no circumstances be allowed to leave Ger-

man colonies for Europe. No African would be allowed to become a German citizen. African schools would not be permitted to preach any "European matter" as that would foster a belief among them that Europe was the peak of cultural development and they would thus lose faith in their own culture and background. Local culture would be fostered. Higher schools and universities would be closed to them. Special theatres, cinemas, and other places of amusement and recreation would be erected for them. Hecht concluded the pamphlet by pointing out that the programme of the German government would stand in sharp contrast to the levelling and antiracial teachings of equality of the Western colonial powers.

In this country the government preaches the policy of baasskap, which is based on the supremacy in all matters of the whites over the nonwhites. They are subjected to extremely stringent regulations both in regard to their movement within the country as well as in regard to overseas travel lest they should come into contact with ideas that are in conflict with the *herrenvolk* policies of the government. Through the Bantu Authorities Act and similar measures, the African people are being broken up into small tribal units, isolated one from the other, in order to prevent the rise and development of national consciousness amongst them and to foster a narrow and insulated tribal outlook.

During the parliamentary debate on the second reading of the Bantu Education Bill in September 1953, the minister of native affairs, Dr. H. F. Verwoerd, who studied in German universities, outlined the educational policy of his government. He declared that racial relations could not improve if the wrong type of education was given to Africans. They could not improve if the result of African education was the creation of a frustrated people who, as a result of the education they received, had expectations in life which circumstances in South Africa did not allow to be fulfilled; when it created people who were trained for professions not open to them; when there were people amongst them who had received a form of cultural training which strengthened their desire for white-collar occupations. Above all, good racial relations could not exist when the education was given under the control of people who believed in racial equality. It was, therefore, necessary that African education should be controlled in such a way that it should be in accord with the policy of the state.

The Bantu Education Bill has now become law and it embodies all the obnoxious doctrines enunciated by the minister in the parliamentary debate referred to above. An inferior type of education, known as Bantu education, and designed to relegate the Africans to a position of perpetual servitude in a baasskap society, is now in force in almost all African primary schools throughout the country and will be introduced in all secondary and high schools as from next year. The Separate Universities Education Bill, now before Parliament, is a step to extend Bantu education to the field of higher education.

In terms of this bill the minister is empowered to establish, maintain, and conduct university colleges for nonwhites. The students to be admitted to the university colleges must be approved by the minister. As from January 1958,

no nonwhite students who were not previously registered shall be admitted to a European university without the consent of the minister. The bill also provides for the transfer and the control and management of the University College of Fort Hare and of the medical school for Africans at Wentworth to the government; all employees in these institutions will become government employees.

The minister can vest the control of Fort Hare in the Native Affairs Department. The government is empowered to change the name of the college. For example, he can call it the Hendrik Frensch Verwoerd University College for Bantu persons. The minister is entitled to dismiss any member of the staff for misconduct, which includes public adverse comment upon the administration and propagating ideas, or taking part in, or identifying himself with, any propaganda or activities calculated to impede, obstruct, or undermine the activities of any government department.

No mixed university in the country will be permitted to enroll new non-European students any more. The mixed English universities of Cape Town, Witwatersrand, and Rhodes will thus be compelled to fall in line with the Afrikaans universities of Pretoria, Potchefstroom, Stellenbosch, and the Orange Free State whose doors are closed to non-Europeans.

The main purpose of the bill is to extend the principle of Bantu education to the field of higher education. Non-Europeans who are trained at mixed universities are considered a menace to the racial policies of the government. The friendship and interracial harmony that is forged through the admixture and association of various racial groups at the mixed universities constitute a direct threat to the policy of apartheid and baasskap, and the bill has been enacted to remove this threat. The type of universities the bill envisages will be nothing more than tribal colleges, controlled by party politicians and based upon the doctrine of the perpetual supremacy of the whites over the blacks. Such colleges would be used by the government to enforce its political ideology at a university level.

They will bear no resemblance whatsoever to modern universities. Not free inquiry but indoctrination is their purpose, and the education they will give will not be directed towards the unleashing of the creative potentialities of the people but towards preparing them for perpetual mental and spiritual servitude to the whites. They will be permitted to teach only that which strictly conforms to the racial policies of the Nationalist government. Degrees and diplomas obtained at these colleges will be held in contempt and ridicule throughout the country and abroad and will probably not be recognised outside South Africa. The decision of the government to introduce university segregation is prompted not merely by the desire to separate non-European from European students. Its implications go much further than this, for the bill is a move to destroy the "open" university tradition which is universally recognised throughout the civilised world and which has up to now been consistently practised by leading universities in the country for years. For centuries, universities have served as centres for the dissemination of learning and knowledge to all students irrespective of their colour or creed. In multiracial societies they serve as centres for the development of the cultural and spiritual aspects of the life of the

people. Once the bill is passed, our universities can no longer serve as centres for the development of the cultural and spiritual aspects of the entire nation.

The bill has aroused extensive and popular indignation and opposition throughout the country as well as abroad. Students and lecturers, liberals and conservatives, progressives, democrats, public men and women of all races and with varying political affiliations have been stirred into action. A former chief justice of the union, Mr. Van der Sandt Centlivres, in a speech delivered at a lunch meeting of the University Club in Cape Town on 11 February this year and reported in the *Rand Daily Mail* of the 12th of the same month, said: "I am not aware of any university of real standing in the outside world which closes its doors to students on the ground of the colour of their skins. The great universities of the world welcome students from other countries whatever the colour of their skins. They realize that the different outlook which these students bring with them advances the field of knowledge in human relations in the international sphere and contributes to their own culture."

The attack on university freedom is a matter of vital importance and constitutes a grave challenge to all South Africans. It is perhaps because they fully appreciate this essential fact that more people are participating in the campaign against the introduction of academic segregation in the universities. Students in different parts of the country are staging mammoth demonstrations and protest meetings. Heads of universities, lecturers, men, and women of all shades of opinion, have in speeches and articles violently denounced the action of the government. All this reveals that there are many men and women in this country who are prepared to rally to the defence of traditional rights whenever they are threatened.

But we cannot for one moment forget that we are up against a fascist government which has built up a massive coercive State apparatus to crush democracy in this country and to silence the voice of all those who cry out against the policy of apartheid and baasskap. All opposition to the Nationalist government is being ruthlessly suppressed through the Suppression of Communism Act and similar measures. The government, in defiance of the people's wishes, is deporting people's leaders from town and country in the most merciless and shameful manner. All rights are being systematically attacked. The right to organise, to assemble, and to agitate has been severely fettered. Trade unions and other organisations are being smashed up. Even the sacred right of freedom of religious worship, which has been observed and respected by governments down the centuries, is now being tampered with. And now the freedom of our universities is being seriously threatened. Racial persecution of the nonwhites is being intensified every day. The rule of force and violence, of terror and coercion, has become the order of the day.

Fascism has become a living reality in our country, and its defeat has become the principal task of the entire people of South Africa. But the fight against the fascist policies of the government cannot be conducted on the basis of isolated struggles. It can only be conducted on the basis of the united fight of the entire people of South Africa against all attacks of the Nationalists on traditional rights whether these attacks are launched through Parliament and

other state organs or whether through extraparliamentary forms. The more powerful the resistance of the people, the less becomes the advance of the Nationalists. Hence the importance of a united front. The people must fight stubbornly and tenaciously and defend every democratic right that is being attacked or tampered with by the Nationalists.

A broad united front of all the genuine opponents of the racial policies of the government must be developed. This is the path the people should follow to check and repel the advance of fascism in this country and to pave the way for a peaceful and democratic South Africa.

8 *A New Menace in Africa*

Excerpted from *Liberation*, March 1958

A New Danger

Whilst the influence of the old European powers has sharply declined and whilst the anti-imperialist forces are winning striking victories all over the world, a new danger has arisen and threatens to destroy the newly won independence of the people of Asia and Africa. It is American imperialism, which must be fought and decisively beaten down if the people of Asia and Africa are to preserve the vital gains they have won in their struggle against subjugation. The First and Second World Wars brought untold economic havoc especially in Europe, where both wars were mainly fought. Millions of people perished whilst their countries were ravaged and ruined by the war. The two conflicts resulted, on the one hand, in the decline of the old imperial powers.

On the other hand, the U.S.A. emerged from them as the richest and most powerful state in the West, firstly, because both wars were fought thousands of miles away from her mainland and she had fewer casualties. Whereas the British Empire lost 1,089,900 men, only 115,660 American soldiers died during the First World War. No damage whatsoever was suffered by her cities and industries. Secondly, she made fabulous profits from her allies out of war contracts. Due to these factors the U.S.A. grew to become the most powerful country in the West.

Paradoxically, the two world wars, which weakened the old powers and which contributed to the growth of the political and economic influence of the U.S.A., also resulted in the growth of the anti-imperialist forces all over the world and in the intensification of the struggle for national independence. The old powers, finding themselves unable to resist the demand by their former colonies for independence and still clinging desperately to their waning empires, were compelled to lean very heavily on American aid. The U.S.A., taking

advantage of the plight of its former allies, adopted the policy of deliberately ousting them from their spheres of influence and grabbing these spheres for herself. An instance that is still fresh in our minds is that of the Middle East, where the U.S.A. assisted in the eviction of Britain from that area in order that she might gain control of the oil industry, which prior to that time was in the control of Britain.

Through the Marshall Plan the U.S.A. succeeded in gaining control of the economies of European countries and reducing them to a position analogous to that of dependencies. By establishing aggressive military blocs in Europe, the Middle East and Asia, the U.S.A. has been able to post her armies in important strategic points and is preparing for armed intervention in the domestic affairs of sovereign nations. The North Atlantic Treaty Organisation in Europe, the Baghdad Pact in the Middle East, and the South East Asian Treaty Organisation are military blocs which constitute a direct threat not only to world peace but also to the independence of the member states.

The policy of placing reliance on American economic and military aid is extremely dangerous to the "assisted" states themselves and has aggravated their positions. Since the Second World War, Britain, France and Holland have closely associated themselves with American plans for world conquest, and yet within that period they have lost empires in Asia, the Middle East, and Africa, and they are fighting rear-guard actions in their remaining colonial possessions. Their salvation and future prosperity lie not in pinning their faith on American aid and aggressive military blocs but in breaking away from her, in repudiating her foreign policy which threatens to drag them into another war, and in proclaiming a policy of peace and friendship with other nations.

U.S. Offensive in Africa

American interest in Africa has in recent years grown rapidly. This continent is rich in raw minerals. It produces almost all the world's diamonds, 78 percent of its palm oil, 68 percent of its cocoa, half of its gold, and 22 percent of its copper. It is rich in manganese, chrome, in uranium, radium, in citrus fruits, coffee, sugar, cotton, and rubber. It is regarded by the U.S.A. as one of the most important fields of investment. According to the "Report of the Special Study Mission to Africa, South and East of the Sahara," by the Honorable Frances P. Bolton which was published in 1956 for the use of the United States Congress Committee on Foreign Affairs, by the end of World War II United States private investments in Africa amounted to scarcely £150 million. At the end of 1954 the total book value of U.S. investments in Africa stood at £664 million.

Since then the American government has mounted a terrific diplomatic and economic offensive in almost every part of Africa. A new organisation for the conduct of African Affairs has come into existence. The Department of State has established a new position of deputy assistant secretary for African Affairs. The Bureau of African Affairs has been split into two new offices, the office of

Northern African Affairs and that of Southern African Affairs. This reorganisation illustrates the increasing economic importance of Africa to the U.S.A. and the recognition by the governing circles of that state of the vital necessity for the creation and strengthening of diplomatic relations with the independent states of Africa. The U.S.A. has sent into this continent numerous "study" and "goodwill" missions, and scores of its leading industrialists and statesmen to survey the natural wealth of the new independent states and to establish diplomatic relations with the present regimes. Vice-President Nixon, Adlai Stevenson, the Democratic party candidate for the American presidency in the last elections, and scores of other leading Americans, have visited various parts of the continent to study political trends and market conditions. Today, American imperialism is a serious danger to the independent states in Africa, and its people must unite before it is too late and fight it out to the bitter end.

Imperialism in Disguise

American imperialism is all the more dangerous because, having witnessed the resurgence of the people of Asia and Africa against imperialism and having seen the decline and fall of once powerful empires, it comes to Africa elaborately disguised. It has discarded most of the conventional weapons of the old type of imperialism. It does not openly advocate armed invasion and conquest. It purports to repudiate force and violence. It masquerades as the leader of the so-called free world in the campaign against communism. It claims that the cornerstone of its foreign policy is to assist other countries in resisting domination by others. It maintains that the huge sums of dollars invested in Africa are not for the exploitation of the people of Africa but for the purpose of developing their countries and in order to raise their living standards.

Now it is true that the new self-governing territories in Africa require capital to develop their countries. They require capital for economic development and technical training programmes, they require it to develop agriculture, fisheries, veterinary services, health, medical services, education, and communications. To this extent, overseas capital invested in Africa could play a useful role in the development of the self-governing territories in the continent. But the idea of making quick and high profits, which underlies all the developmental plans launched in Africa by the U.S.A., completely effaces the value of such plans in so far as the masses of the people are concerned. The big and powerful American trade monopolies that are springing up in various parts of the continent and which are destroying the small trader, the low wages paid the ordinary man, the resulting poverty and misery, his illiteracy and the squalid tenements in which he dwells are the simplest and most eloquent exposition of the falsity of the argument that American investments in Africa will raise the living standards of the people of this continent.

The American brand of imperialism is imperialism all the same in spite of the modern clothing in which it is dressed and in spite of the sweet language

spoken by its advocates and agents. The U.S.A. is mounting an unprecedented diplomatic offensive to win the support of the governments of the self-governing territories in the continent. It has established a network of military bases all over the continent for armed intervention in the domestic affairs of independent states should the people in these states elect to replace American satellite regimes with those who are against American imperialism. American capital has been sunk into Africa not for the purpose of raising the material standards of its people but in order to exploit them as well as the natural wealth of their continent. This is imperialism in the true sense of the word.

The Americans are forever warning the people of this continent against communism which, as they allege, seeks to enslave them and to interfere with their peaceful development. But what facts justify this warning? Unlike the U.S.A., neither the Soviet Union, the Chinese People's Republic nor any other Socialist state has aggressive military blocs in any part of the world. None of the Socialist countries has military bases anywhere in Africa, whereas the U.S.A. has built landing fields, ports, and other types of strategic bases all over North Africa. In particular it has jet fields in Morocco, Libya and Liberia. Unlike the U.S.A., none of the Socialist states has invested capital in any part of Africa for the exploitation of its people. At the United Nations Organisation, the Soviet Union, India, and several other nations have consistently identified themselves unconditionally with the struggle of the oppressed people for freedom, whereas the U.S.A. has very often allied itself with those who stand for the enslavement of others. It was not Soviet but American planes which the French used to bomb the peaceful village of Sakiet in Tunisia. The presence of a delegation from the Chinese People's Republic at the 1955 Afro-Asian conference as well as the presence of a delegation from that country and the Soviet Union at the 1957 Cairo Afro-Asian conference show that the people of Asia and Africa have seen through the slanderous campaign conducted by the U.S.A. against the Socialist countries. They know that their independence is threatened not by any of the countries in the Socialist camp, but by the U.S.A., who has surrounded their continent with military bases. The communist bogey is an American stunt to distract the attention of the people of Africa from the real issue facing them, namely, American imperialism.

The peoples of resurgent Africa are perfectly capable of deciding upon their own future form of government and discovering and themselves dealing with any dangers which may arise. They do not require any schooling from the U.S.A., which—to judge from such events as the Little Rock outrage and the activities of the Un-American Witch-hunting Committee—should learn to put its own house in order before trying to teach everyone else.

The people of Africa are astir. In conjunction with the people of Asia, and with freedom-loving people all over the world, they have declared a full-scale war against all forms of imperialism. The future of this continent lies not in the hands of the discredited regimes that have allied themselves with American imperialism. It is in the hands of the common people of Africa functioning in their mass movements.

9 *Verwoerd's Tribalism*

Excerpted from *Liberation*, May 1959

South Africa belongs to all who live in it, black and white.

Freedom Charter

All the Bantu have their permanent homes in the reserves, and their entry into other areas and into the urban areas is merely of a temporary nature and for economic reasons. In other words, they are admitted as work seekers, not as settlers.

Dr. W. W. M. Eiselen, secretary of the Department of Bantu
Administration and Development, in *Optima*, March 1959

The statements quoted above contain diametrically opposite conceptions of this country, its future, and its destiny. Obviously, they cannot be reconciled. They have nothing in common, except that both of them look forward to a future of affairs rather than that which prevails at present. At present, South Africa does not "belong" except in a moral sense to all.

Eighty-seven percent of the country is legally owned by members (a handful of them at that) of the dominant white minority. And at present by no means "all" Africans have their "permanent homes" in the reserves. Millions of Africans were born and have their permanent homes in the towns and cities and elsewhere outside the reserves, have never seen the reserves, and have no desire to go there.

It is necessary for the people of this country to choose between these two alternative paths.

Let us therefore study the policies submitted by the Nationalist party.

It is typical of the Nationalists' propaganda techniques that they describe their measures in misleading titles, which convey the opposite of what the measures contain. Verwoerd called his law greatly extending and intensifying the pass laws the "Abolition of Passes" Act. Similarly, he has introduced into the current parliamentary session a measure called the "Promotion of Bantu Self-Government Bill." It starts off by decreeing the abolition of the tiny token representation of Africans (by whites) in Parliament and the Cape Provincial Council.

It goes on to provide for the division of the African population into eight "ethnic units" (the so-called Bantustans). They are North and South Sotho, Swazi, Tsonga, Tswana, Venda, Xhosa, and Zulu. These units are to undergo a "gradual development to self-government."

This measure was described by the prime minister, Dr. Verwoerd, as a "supremely positive step" towards placing Africans "on the road to self-government." Mr. De Wet Nel, minister of Bantu Affairs, said the people in the reserves "would gradually be given more powers to rule themselves."

The scheme is elaborated in a White Paper, tabled in the House of Assembly, to "explain" the bill. According to this document, the immediate objects of the bill are

a. The recognition of the so-called Bantu national units and the appointment of commissioners-general whose task will be to give guidance and advice to the units in order to promote their general development, with special reference to the administrative field.
b. The linking of Africans working in urban areas with territorial authorities established under the Bantu Authorities Act, by conferring powers on the Bantu authorities to nominate persons as their representatives in urban areas.
c. The transfer to the Bantu territorial authorities, at the appropriate time, of land in their areas at present held by the Native Trust.
d. The vesting in Bantu territorial authorities of legislative authority and the right to impose taxes, and to undertake works and give guidance to subordinate authorities.
e. The establishment of territorial boards for the purpose of temporary liaison through commissioners-general if during the transition period the administrative structure in any area has not yet reached the stage where a territorial authority has been established.
f. The abolition of representation in the highest European governing bodies.

According to the same White Paper, the bill has the following further objects:

a. The creation of homogeneous administrative areas for Africans by uniting the members of each so-called national group in the national unit, concentrated in one coherent homeland where possible.
b. The education of Africans to a sound understanding of the problems of soil conversion and agriculture so that all rights over and responsibilities in respect of soil in African areas may be assigned to them.
 This includes the gradual replacement of European agricultural officers of all grades by qualified and competent Africans.
c. The systematic promotion of a diverse economy in the African areas, acceptable to Africans and to be developed by them.
d. The education of the African to a sound understanding of the problems and aims of Bantu education so that, by the decentralisation of powers, responsibility for the different grades of education may be vested in them.
e. The training of Africans with a view to effectively extending their own judicial system and their education to a sound understanding of the common law with a view to transferring to them responsibilities for the administration of justice in their areas.
f. The gradual replacement of European administration officers by qualified and competent Africans.
g. The exercise of legislative powers by Africans in respect of their areas, at first on a limited scale, but with every intention of gradually extending this power.

It will be seen that the African people are asked to pay a very high price for this so-called self-government in the reserves. Urban Africans—the workers, businessmen, and professional men and women, who are the pride of our

people in the stubborn and victorious march towards modernisation and progress—are to be treated as outcasts, not even "settlers" like Dr. Verwoerd. Every vestige of rights and opportunities will be ruthlessly destroyed. Everywhere outside the reserves an African will be tolerated only on condition that he is for the convenience of the whites.

There will be forcible uprooting and mass removals of millions of people to "homogeneous administrative areas." The reserves, already intolerably overcrowded, will be crammed with hundreds of thousands more people evicted by the government.

In return for all these hardships, in return for Africans abandoning their birthright as citizens, pioneers, and inhabitants of South Africa, the government promises them "self-government" in the tiny 13 percent that their greed and miserliness "allocates" to us. But what sort of self-government is this that is promised?

There are two essential elements to self-government, as the term is used and understood all over the modern world. They are

1. *Democracy*. The organs of government must be representative; that is to say, they must be freely chosen leaders and representatives of the people, whose mandate must be renewed at periodic democratic elections.
2. *Sovereignty*. The government thus chosen must be free to legislate and act as it deems fit on behalf of the people, not subject to any limitations upon its powers by any alien authority.

Neither of these two essentials is present in the Nationalist plan. The "Bantu national units" will be ruled in effect by the commissioners-general appointed by the government and administered by the Bantu Affairs Department officials under his control. When the government says it plans gradually increasing self-government, it merely means that more powers in future will be exercised by appointed councils of chiefs and headmen. No provision is made for elections. The Nationalists say that chiefs, not elected legislatures, are "the Bantu tradition."

There was a time when, like all peoples on earth, Africans conducted their simple communities through chiefs, advised by tribal councils and mass meetings of the people. In those times the chiefs were indeed representative governors. Nowhere, however, have such institutions survived the complexities of modern industrial civilisation. Moreover, in South Africa we all know full well that no chief can retain his post unless he submits to Verwoerd, and many chiefs who sought the interest of their people before position and self-advancement have, like President Lutuli, been deposed.

Thus, the proposed Bantu authorities will not be, in any sense of the term, representative or democratic.

The point is made with pride by the Bantu Affairs Department itself in an official publication:

"The councillors will perform their task without fear or prejudice, because they are not elected by the majority of votes, and they will be able to lead their people onwards . . . even though . . . it may demand hardships and sacrifices."

A strange paean to autocracy, from a department of a government which claims to be democratic!

In spite of all their precautions to see that their "territorial authorities"—appointed by themselves, subject to dismissal by themselves and under constant control by their commissioners-general and their Bantu Affairs Department—never become authentic voices of the people, the Nationalists are determined to see that even those puppet bodies never enjoy real power of sovereignty.

In his notorious (and thoroughly dishonest) article in *Optima*, Dr. Eiselen draws a far-fetched comparison between the future "Bantustans" and the Union government, on the one hand, and those between Britain and the self-governing dominions of the other. He foresees "a cooperative South African system based on the Commonwealth conception, with the Union government gradually changing its position from guardian and trustee to become instead the senior member of a group of separate communities."

To appreciate the full hypocrisy of this statement, it must be remembered that Dr. Eiselen is an official of a Nationalist party government, a member of a party which has built its fortune for the past half-century on its cry that it stands for full untrammelled sovereignty within the Commonwealth, that claims credit for Hertzog's achievements in winning the Statute of Westminster, which proclaims such sovereignty and which even now wants complete independence and a republic outside the Commonwealth.

It cannot be claimed, therefore, that Eiselen and Verwoerd do not understand the nature of a commonwealth, or sovereignty, or federation.

What are we to think, then, in the same article, when Dr. Eiselen comes into the open, and declares: "The utmost degree of autonomy in administrative matters which the Union Parliament is likely to be prepared to concede to these areas will stop short of actual surrender of sovereignty by the European trustee, and there is therefore no prospect of a federal system with eventual equality among members taking the place of the South African Commonwealth."

There is no sovereignty then. No autonomy. No democracy. No self-government. Nothing but a crude, empty fraud, to bluff the people at home and abroad, and to serve as a pretext for heaping yet more hardships and injustices upon the African people.

Politically, the talk about self-government for the reserves is a swindle. Economically, it is an absurdity.

The few scattered African reserves in various parts of the Union, comprising about 13 percent of the least desirable land area, represent the last shreds of land ownership left to the African people of their original ancestral home. After the encroachments and depredations of generations of European land sharks, achieved by force and by cunning, and culminating in the outrageous Land Act from 1913 onwards, had turned the once free and independent Tswana, Sotho, Xhosa, Zulu, and other peasant farmers in this country into a nation of landless outcasts and roving beggars, humble "work seekers" on the mines and the farms where yesterday they had been masters of the land, the

new white masters of the country "generously presented" them the few remaining miserable areas as reservoirs and breeding grounds for black labour. These are the reserves.

It was never claimed or remotely considered by the previous governments of the Union that these reserves could become economically self-sufficient "national homes" for 9,600,000 African people of this country. The final lunacy was left to Dr. Verwoerd, Dr. Eiselen, and the Nationalist party.

The facts are—as every reader who remembers Govan Mbeki's brilliant series of articles on the Transkei in *Liberation* will be aware—that the reserves are congested distressed areas, completely unable to sustain their present populations. The majority of the adult males are always away from home working in the towns, mines, or European-owned farms. The people are on the verge of starvation.

The White Paper speaks of teaching Africans soil conservation and agriculture and replacing European agricultural officers by Africans. This is merely trifling with the problem. The root problem of the reserves is the intolerable congestion which already exists. No amount of agricultural instruction will ever enable 13 percent of the land to sustain 66 percent of the population.

The government is, of course, fully aware of the fact. They have no intention of creating African areas which are genuinely self-supporting (and which could therefore create a genuine possibility of self-government). If such areas were indeed self-supporting, where would the Chamber of Mines and the Nationalist farmers get their supplies of cheap labour?

In the article to which I have already referred, Dr. Eiselen bluntly admits: "In fact not much more than a quarter of the community (on the reserves) can be farmers, the others seeking their livelihood in industrial, commercial, professional, or administrative employment."

Where are they to find such employment? In the reserves? To anyone who knows these poverty-stricken areas, sadly lacking in modern communications, power-resources, and other needed facilities, the idea of industrial development seems far-fetched indeed. The beggarly £500,000 voted to the so-called Bantu Investment Corporation by Parliament is mere eyewash: It would not suffice to build a single decent road, railway line, or power station.

The government has already established a number of "rural locations"— townships in the reserves. The Eiselen article says a number more are planned: He mentions a total of no less than 96. Since the residents will not farm, how will they manage to keep alive, still less pay rents and taxes and support the traders, professional classes, and civil servants whom the optimistic Eiselen envisages will make a living there?

Fifty-seven towns on the borders of the reserves have been designated as centres where white capitalists can set up industries. Perhaps some will migrate, and thus "sport" their capital resources of cheap labour and land. Certainly, unlike the reserves (which are a monument to the callous indifference of the Union Parliament to the needs of the nonvoting African taxpayers), these towns have power, water, transport, railways, etc. The Nationalist gov-

ernment, while it remains in office, will probably subsidise capitalists who migrate in this way. It is already doing so in various ways, thus creating unemployment in the cities. But it is unlikely that any large-scale voluntary movement will take place away from the big, established industrial centres, with their well-developed facilities, available materials, and markets.

Even if many industries were forced to move to the border areas around the reserves, it would not make one iota of difference to the economic viability of the reserves themselves. The fundamental picture of the Union's economy could remain fundamentally the same as at present: a single integrated system based upon the exploitation of African labour by white capitalists.

Economically, the "Bantustan" concept is just as big a swindle as it is politically.

Thus we find, if we really look into it, that this grandiose "partition" scheme, this "supremely positive step" of Dr. Verwoerd, is like all apartheid schemes—high-sounding double talk to conceal a policy of ruthless oppression of the nonwhites and of buttressing the unwarranted privileges of the white minority, especially the farming, mining, and financial circles.

Even if it were not so, however, even if the scheme envisaged a genuine sharing out of the country on the basis of population figures, and a genuine transfer of power to elected representatives of the people, it would remain fundamentally unjust and dangerously unstable unless it were submitted to, accepted, and endorsed by all parties to the agreement. To think otherwise is to fly in the face of the principle of self-determination, which is upheld by all countries, and confirmed in the United Nations Charter, to which this country is pledged.

Now even Dr. Eiselen recognises this difficulty to some extent. He pays lipservice to the Atlantic Charter and appeals to "Western democracy." He mentions the argument that apartheid would only be acceptable "provided that the parties concerned agreed to this of their own free will," he writes. "The Bantu as a whole do not demand integration, in a single society. This is the idea . . . merely of a small minority."

Even Dr. Eiselen, however, has not the audacity to claim that the African people actually favour apartheid or partition.

Let us state clearly the facts of the matter, with the greatest possible clarity. NO SERIOUS OR RESPONSIBLE LEADER, GATHERING, OR ORGANISATION OF THE AFRICAN PEOPLE HAS EVER ACCEPTED SEGREGATION, SEPARATION, OR THE PARTITION OF THIS COUNTRY IN ANY SHAPE OR FORM.

At Bloemfontein in 1956, under the auspices of the United African clergy, perhaps the most widely attended and representative gathering of African representatives of every shade of political opinion ever held, unanimously and uncompromisingly rejected the Tomlinson Report, on which the Verwoerd plan is based, and voted in favour of a single society.

Even in the rural areas, where dwell the "good" (i.e., simple and ignorant) "Bantu" of the imagination of Dr. Verwoerd and Dr. Eiselen, attempts to

impose apartheid have met, time after time, with furious, often violent resistance. Chief after chief has been deposed or deported for resisting "Bantu authorities" plans. Those who, out of shortsightedness, cowardice, or corruption, have accepted these plans have earned nothing but the contempt of their own people.

It is a pity that on such a serious subject and at such a crucial period, serious misstatements should have been made by some people who purport to speak on behalf of the Africans. For example, Mrs. Margaret Ballinger, the Liberal party M.P., is reported as saying in the Assembly "no confidence" debate:

"The Africans have given their answer to this apartheid proposition but, of course, no one ever listens to them. They have said: 'If you want separation then let us have it. Give us half of South Africa. Give us the eastern half of South Africa. Give us some of the developed resources because we have helped to develop them'" (*SA Outlook*, March 1959).

It is most regrettable that Mrs. Ballinger should have made such a silly and irresponsible statement towards, one fears, the end of a distinguished parliamentary career. For in this instance she has put herself in the company of those who do not listen to the Africans. No Africans of any standing have ever made the proposal put forward by her.

The leading organisation of the African people is the African National Congress. Congress has repeatedly denounced apartheid. It has repeatedly endorsed the Freedom Charter, which claims South Africa "for all its people." It is true that occasionally individual Africans become so depressed and desperate at Nationalist misrule that they have tended to clutch at any straw to say: Give us any little corner where we may be free to run our own affairs. But Congress has always firmly rejected such momentary tendencies and refused to barter our birthright, which is South Africa, for such illusory "Bantustans."

Commenting on a suggestion by Professor du Plessis that a federation of "Bantustans" be established, Mr. Duma Nokwe, secretary-general of the African National Congress, totally rejected such a plan as unacceptable. The correct approach, he said, would be the extension of the franchise rights to Africans. Thereafter a national convention of all the people of South Africa could be summoned, and numerous suggestions of the democratic changes that should be brought about, including the suggestion of Professor du Plessis, could form the subject of the convention.

Here, indeed, Mr. Nokwe has put his finger on the spot. There is no need for Dr. Eiselen, Mrs. Ballinger, or others to argue about "what the Africans think" about the future of this country. Let the people speak for themselves! Let us have a free vote and a free election of delegates to a national convention, irrespective of colour or nationality. Let the Nationalists submit their plan, and the Congress its charter. If Verwoerd and Eiselen think the Africans support their schemes, they need not fear such a procedure. If they are not prepared to submit to public opinion, then let them stop parading and pretending to the outside world that they are democrats, and talking revolting nonsense about "Bantu self-government."

Dr. Verwoerd may deceive the simple-minded Nationalist voters with his talk of Bantustans, but he will not deceive anyone else, neither the African people, nor the great world beyond the borders of this country. We have heard such talk before, and we know what it means. Like everything else that has come from the Nationalist government, it spells nothing but fresh hardships and suffering to the masses of the people.

Behind the fine talk of "self-government" is a sinister design.

The abolition of African representation in Parliament and the Cape Provincial Council shows that the real purpose of the scheme is not to concede autonomy to Africans but to deprive them of all say in the government of the country, in exchange for a system of local government controlled by a minister who is not responsible to them but to a Parliament in which they have no voice. This is no autonomy but autocracy.

Contact between the minister and the Bantu authorities will be maintained by five commissioners-general. These officials will act as the watchdogs of the minister to ensure that the "authorities" strictly toe the line. Their duty will be to ensure that these authorities should become the voice not of the African people but of the Nationalist government.

In terms of the White Paper, steps will be taken to "link" Africans working in urban areas with the territorial authorities established under the Bantu Authorities Act, by conferring powers on these authorities to nominate persons as their representatives in urban areas. This means in effect that efforts will be made to place Africans in the cities under the control of their tribal chiefs—a retrograde step.

Nowhere in the bill or in the various proclamations dealing with the creation of Bantu authorities is there provision for democratic elections by Africans falling within the jurisdiction of the authorities.

In the light of these facts it is sheer nonsense to talk of South Africa as being about to take a "supremely positive step towards placing Africans on the road to self-government" or of having given them more powers to rule themselves. As Dr. Eiselen clearly pointed out in his article in *Optima*, the establishment of Bantustans will not in any way affect white supremacy, since even in such areas whites will stay supreme. The Bantustans are not intended to voice the aspirations of the African people; they are instruments for their subjection. Under the pretext of giving them self-government, the African people are being split up into tribal units in order to retard their growth and development into full nationhood.

The new Bantu bill and the policy behind it will bear heavily on the peasants in the reserves. But it is not they who are the chief target of Verwoerd's new policy.

His new measures are aimed, in the first place, at the millions of Africans in the great cities of this country, the factory workers and intellectuals who have raised the banner of freedom and democracy and human dignity, who have spoken forth boldly the message that is shaking imperialism to its foundations throughout this great continent of Africa.

The Nationalists hate and fear that banner and that message. They will try

to destroy them, by striking with all their might at the standard bearer and vanguard of the people, the working class.

Behind the "self-government" talks lies a grim programme of mass evictions, political persecution, and police terror. It is the last desperate gamble of a hated and doomed fascist autocracy—which, fortunately, is soon due to make its exit from the stage of history.

10 *Courtroom Testimony*

Excerpted from Treason Trial, 1960

PROSECUTION: Do you think that your people's democracy could be achieved by a process of gradual reforms? Suppose, as a result of pressure, the ruling class were to agree next month to a qualified franchise for the Africans, an educational test perhaps—not a stringent one—and next year, as a result of further pressure, a more important concession is made—a further concession is made in 1962, and so on over a period of ten or twenty years—do you think that the people's democracy could be achieved in that fashion?

MANDELA: Well, this is how I approach the question. I must explain at the outset that the Congress, as far as I know, has never sat down to discuss the question. . . . We demand universal adult franchise, and we are prepared to exert economic pressure to attain our demands, and we will launch defiance campaigns, stay-at-homes, either singly or together, until the government should say, "Gentlemen, we cannot have this state of affairs, laws being defied, and this whole situation created by stay-at-homes. Let's talk." In my own view I would say, yes, let us talk, and the government would say, "We think that the Europeans at present are not ready for a type of government where there might be domination by non-Europeans. We think we should give you sixty seats. The African population to elect sixty Africans to represent them in Parliament. We will leave the matter over for five years and we will review it at the end of five years." In my view, that would be a victory, my lords; we would have taken a significant step towards the attainment of universal adult suffrage for Africans, and we would then for the five years say, we will suspend civil disobedience; we won't have any stay-at-homes, and we will then devote the intervening period for the purpose of educating the country, the Europeans, to see that these changes can be brought about and that it would bring about better racial understanding, better racial harmony in the country. I'd say we should accept it, but, of course, I would not abandon the demands for the extension of the universal franchise to all Africans. That's how I see it, my lords. Then at the end of the five-year period we will have discussions, and if the government says, 'We will give you again forty more seats," I might say that that is quite sufficient. Let's accept it, and still demand that the franchise should be ex-

tended, but for the agreed period we should suspend civil disobedience, no stay-at homes. In that way we would eventually be able to get everything that we want; we shall have our people's democracy, my lords. That is the view I hold—whether that is Congress's view, I don't know, but that is my view.

* * *

BENCH: Mandela, assuming you were wrong in your beliefs, do you visualise any future action on behalf of the government, by the government? Because I think the evidence suggests that you could not expect the government to soften in its views. Have you any future plans in that event?

MANDELA: No, my lord. I don't think that the Congress has ever believed that its policy of pressure would ultimately fail. The Congress, of course, does not expect that one single push to coerce the government to change its policy will succeed; the Congress expects that over a period, as a result of a repetition of these pressures, together with world opinion, that the government notwithstanding its attitude of ruling Africans with an iron hand, that notwithstanding that, the methods which we are using will bring about a realisation of our aspirations.

PROSECUTION: Mr. Mandela, whether or not there would be success ultimately, one thing is clear, is it not, and that is that the African National Congress held the view, and propagated the view, that in resisting pressure by the Congress movement, the ruling class, the government, would not hesitate to retaliate— would not hesitate to use violence and armed force against the Congress movement?

MANDELA: Yes, the Congress was of that view, my lords. We did expect force to be used, as far as the government is concerned, but as far as we are concerned we took the precautions to ensure that that violence will not come from our side.

BENCH: What were those precautions?

MANDELA: Well, my lord, for example in 1952 when we launched the Defiance Campaign, and secondly, my lord, you will notice that we frequently use "stay-at-home," not "strike" in the ordinary sense. Now, my lord, in a strike what is usually done is to withdraw workers from a particular industry and then have pickets to prevent the people from working in those industries which are boycotted. But the Congress theory [was] that to have pickets might attract police violence. We deliberately decided to use "stay-at-home" where people are asked to remain in their houses.

BENCH: Well, the question is now whether you can ever achieve [the extension of the franchise to the African people] by the methods you are using?

MANDELA: No, but, my lord, this is what I am coming to, that already since we applied these new methods of political action, this policy of exerting pressure, we have attained—we have achieved, we have won ground. Political parties have now emerged which themselves put forward the demand of extending the franchise to the non-European people.

BENCH: Unqualified franchise? One man, one vote?

MANDELA: No, no, my lord, it is qualified.

BENCH: I would like to discuss this with you.

MANDELA: If your lordship could give me time? Now, it is true that these parties, both the Liberal party as well as the Progressive party, are thinking in terms of some qualified franchise. But, if your lordship bears in mind the fact that when we initiated this policy, there were no political parties—none in the Union—which thought along these lines, then your lordship will realise the revolution that has taken place in European parties in this country today. You are now having an organised body of opinion, quite apart from the Congress of Democrats, who themselves are a force, quite apart from them, you are having an organised body of opinion amongst whites who put forward the view that some limited form of franchise should be extended to Africans.

BENCH: I don't think we are quite on the same—let me put it this way—wavelength. During the indictment period, did or did not—I think you said it was accepted by the Congress alliance that white supremacy would be hostile to this claim, one man, one vote?

MANDELA: Yes, it is hostile, except to qualify, of course, that even during that period parties had already emerged which were putting forward this view, and therefore it was reasonable for us to believe that in spite of the hostility which we still encounter from the majority of the whites, already our policy was succeeding.

* * *

MANDELA: Up to the time that the Youth League was formed and until 1949, the only methods of political action which were adopted by the ANC were purely constitutional: deputations to see the authorities, memoranda, and the mere passing of resolutions. We felt that that policy had been tried and found wanting and we thought that the ANC, its organisers and fieldworkers, should go out into the highways and organise the masses of the African people for mass campaigns. We felt that the time had arrived for the Congress to consider the adoption of more militant forms of political action: stay-at-homes, civil disobedience, protests, demonstrations—also including the methods which had previously been employed by the ANC.

DEFENCE: Were some members of the Youth League actually in favour of expelling Communists from the ANC?

MANDELA: Yes, my lords. As a matter of fact the Youth League moved a resolution at conferences of the ANC calling on the ANC to expel Communists, but these resolutions were defeated by an overwhelming majority.

DEFENCE: On what grounds were these resolutions rejected?

MANDELA: The view of the ANC was that every person above the age of seventeen years, irrespective of the political views he might have, was entitled to become a member of the ANC.

DEFENCE: What was your own view at the time?

MANDELA: At that time I strongly supported the resolution to expel the Communists from the ANC.

(*Mandela then went on to say that later he had worked with Communist members of the ANC.*)

DEFENCE: Whatever may have been their opinions or intentions as far as you were concerned, did it appear to you that they were followers of ANC policy?

MANDELA That is correct.

DEFENCE: Did they appear loyal to it?

MANDELA: That is correct.

DEFENCE: Did you become a Communist?

MANDELA: Well, I don't know if I did become a Communist. If by Communist you mean a member of the Communist party and a person who believes in the theory of Marx, Engels, Lenin, and Stalin, and who adheres strictly to the discipline of the party, I did not become a Communist.

* * *

DEFENCE: Do you think that, apart from the increase in your membership, it [the Defiance Campaign] had any other result?

MANDELA: Yes, most certainly. Firstly, it pricked the conscience of the European public which became aware in a much more clear manner of the sufferings and disabilities of the African people. It led directly to the formation of the Congress of Democrats. It also influenced the formation of the Liberal party. It also led to discussions on the policies of apartheid at the United Nations, and I think to that extent it was an outstanding success.

DEFENCE: Do you think it had any effect at all on the government?

MANDELA: I think it had. After the Defiance Campaign the government began talking about self-government for Africans, Bantustans. I do not believe, of course, that the government was in any way sincere in saying it was part of government policy to extend autonomy to Africans. I think they acted in order to deceive . . . but in spite of that deception one thing comes out very clearly and that is that they acknowledged the power of the Defiance Campaign, they felt that striking power of the ANC had tremendously increased.

* * *

DEFENCE: Do you adhere today to the attitude you then [*in the article "The Shifting Sands of Illusion"*] expressed towards the Liberal party?

MANDELA: I still do, except that the Liberal party has now shifted a great deal from its original position. It is now working more closely with the Congress movement, and to a very large extent it has accepted a great portion of the policy of the Congress movement. I also believe that in regard to the question of the qualified vote there has been some healthy development of outlook which brings it still closer to our policy. To that extent some of the views I expressed in that article have now been qualified.

TAMBO

11 ANC Stands by the Alliance with Congress of Democrats

Excerpted from *New Age*, November 13, 1958

The editor, reporters and "Africanist" correspondents of the *World* have been pouring out cheap abuse about the ANC being controlled by the Congress of Democrats.

Others, employing the columns of *Contact*, the Liberal party organ, and *Indian Opinion* have joined the chorus, though they failed to stop at the level of the *World*.

In isolated cases public speakers have attacked the alliance of the ANC with the Congress of Democrats, not on the ground of control of the one by the other, but because COD is "an extreme leftist organ" and "does not honour Western civilization or Christian values."

1949 Programme

The adoption by the ANC of the 1949 Programme of Action was in large measure an answer to the vicious pace at which the Nationalist government was attacking the democratic rights, particularly of the African people. The 1948 general election ushered in a new political era in which the ANC, if it was to fulfil [its] historic task, was called upon to go into action on a militant programme.

It says much to the credit of the ANC that it has honoured the 1949 decision to embark upon mass action, and in the political conflict that mark the period from early 1950, its leaders have been banned, banished, deported, arrested, and persecuted, it has been declared illegal in certain areas, and in others the right of assembly has been severely curtailed. In spite of all this the ANC has not abandoned the fight, nor have its leaders retreated to take shelter behind ideological platitudes.

The Nationalist attack was not concentrated on the African people. The Suppression of Communism Act affected every democrat and served as a barrage to keep off the forces of democracy whilst antidemocratic legislation was being passed and enforced.

The Defiance Campaign uncovered and produced a large body of people of all races, in all parts of the world, who were sympathetic to the cause of the non-European people and of democracy. There was at the time a plan for cooperation between the main non-European political organizations only. Following the lessons of the Defiance Campaign, the need was felt for an

organization through which the ANC and other non-European bodies could make contact with those whites who were prepared to join the non-European in their fight for freedom and democracy.

In the absence of an organized body of European opinion openly and publicly proclaiming its opposition to the government's racialist policies and supporting the non-European cause, the political conflict was developing a dangerously black-versus-white complexion. Such a situation no doubt suited the present government, but it did not suit the ANC nor the movement for liberation and had to be avoided.

It was to a packed meeting of Europeans in 1952 that leaders of the ANC and the SAIC appealed for an organization that would take its stand alongside the three main non-European organizations in their resistance to Nationalist tyranny, which was preparing to arm itself during the 1953 session of Parliament with the Criminal Law Amendment Act and the Public Safety Act, in addition to the Suppression of Communism Act. In response to the appeal, those Europeans who saw the approaching danger to South Africa and to democracy, admitted the justice of our cause and had the courage to identify themselves with that cause, came forward to found the South African Congress of Democrats (SACOD). Whether they were Communists or anti-Communists was immaterial. In any event, in terms of the Suppression of Communism Act, everybody was a "Communist" who disliked the Nationalist government's policies and said so.

Who Controls Whom?

Let us examine the other objection to the alliance of the Congresses, namely, that the Congress of Democrats controls the ANC. Can it be said that there is anything which, but for its association or alliance with the COD, the ANC would have done or refrained from doing? It surely cannot be suggested that the ANC would not have conducted a militant struggle against oppression. The main feature of the 1949 annual conference of the ANC was its adoption of a programme of action, not a programme of inaction, and in taking this decision, the ANC was not influenced or directed by any other organization, although, as indicated earlier, it was largely influenced by the politics of the Nationalist party government. And what the ANC has done since 1949, both before and after the formation of COD, has been to carry out its decisions to embark on militant action.

It is true that other aspects of the 1949 programme have not been carried out. These are certainly less hazardous than "mass action" and are no doubt more attractive to those who cannot but have regard to considerations of risk and safety. In fact, it is significant that a large percentage of the brave and courageous men who are busy carrying out a programme of action against COD have had little contact with the campaigns conducted by the ANC since 1949, their source of information about such campaigns being what they read in newspapers and books. One cannot help feeling that had they accorded the

1949 programme a status in any degree higher than a suitable topic for discussion at academic meetings of political clubs or literary and debating societies, they would know that in the field of political strife the COD has stood, not with the Nationalists, but with the ANC as a friend and ally, and not a dictator and controller, and that it hardly merits being placed in the position of an enemy of the oppressed people.

It is safe to give the assurance that the present leaders of the ANC will leave it to the Nationalist government and those who sympathize with it, either to attack and victimize any of the Congresses or take steps in form of propaganda or otherwise, to weaken and undermine the liberatory front.

Inferiority Complex

If, as has been alleged *ad nauseam*, the COD has been dominating or controlling the ANC by virtue of the mere fact that it is a "white" organization, then the COD cannot be blamed for their being "superior." In that event the "inferior" ANC, to save itself from this inevitable control or domination, must either run away from the COD and, necessarily, from the antiapartheid struggle in which COD is involved, or alternatively, the ANC must join hands with the Nationalist party and fight the COD. The ANC will do neither.

Those Africans who believe, or have been influenced by the belief, that they are inferior or cannot hold their own against other groups, are advised to keep out of any alliance with such groups and, prevention being better than cure, to refrain from joining the people in their active struggle for basic human rights, for in such a struggle many races are to be found.

The ANC is not led by "inferiors." It does not suffer from any nightmares about being controlled or dominated by any organization; it is not subject to any such control or domination and will not run away from the political struggle or from any group or organization. On the contrary, it will continue to lead the movement for liberation against injustice and tyranny to freedom and democracy.

AFRICAN NATIONAL CONGRESS

12 *Basic Policy of Congress Youth League*

Excerpted from Manifesto of the National Executive
Committee of the African National Congress Youth
League, 1948

The African National Congress Youth League established in April 1944 aims inter alia:

a. at rallying and uniting African youth into one national front on the basis of African Nationalism;
b. at giving force, direction, and vigour to the struggle for African National Freedom, by assisting, supporting, and reinforcing the National movement—ANC;
c. at studying the political, economical, and social problems of Africa and the world; [and]
d. at striving and working for the educational, moral, and cultural advancement of African youth.

In order to rally all youths under its banner, and in order to achieve the unity necessary to win the national freedom of the African people, the Congress Youth League adopts the following basic policy, which is also a basis for its political, economic, educational, cultural, and social programme.

1. African Nationalism

The African people in South Africa are oppressed as a group with a particular colour. They suffer national oppression in common with thousands and millions of oppressed colonial peoples in other parts of the world.

African nationalism is the dynamic national liberatory creed of the oppressed African people. Its fundamental aim[s] [are]

i. the creation of a united nation out of the heterogeneous tribes,
ii. the freeing of Africa from foreign domination and foreign leadership, [and]
iii. the creation of conditions which can enable Africa to make her own contribution to human progress and happiness.

The African has a primary, inherent, and inalienable right to Africa which is his continent and motherland, and the Africans as a whole have a divine destiny which is to make Africa free among the peoples and nations of the earth.

In order to achieve Africa's freedom, the Africans must build a powerful national liberation movement, and in order that the national movement should have inner strength and solidarity, it should adopt the national liberatory creed—African nationalism, and it should be led by the Africans themselves.

2. Goal of Political Action

The Congress Youth League believes that the goal of political organisation and action is the achievement of true democracy

 i. in South Africa and
 ii. in the rest of the African continent.

In such a true democracy all the nationalities and minorities would have their fundamental human rights guaranteed in a democratic constitution. In order to achieve this the Congress Youth League and/or the national movement struggles for

a. the removal of discriminatory laws and colour bars, [and]
b. the admission of the Africans into the full citizenship of the country so that he has direct representation in parliament on a democratic basis.

3. Economic Policy

The Congress Youth League holds that political democracy remains an empty form without substance unless it is properly grounded on a base of economic, and especially industrial, democracy.

The economic policy of the league can therefore be stated under the following headings:

a. *Land*: The league stands for far-reaching agrarian reforms in the following directions:
 i. The redivision of land among farmers and peasants of all nationalities in proportion to their numbers.
 ii. The application of modern scientific methods to, and the planned development of, agriculture.
 iii. The improvement of land, the reclamation of denuded areas, and the conservation of water supplies.
 iv. The mass education of peasants and farmers in the techniques of agricultural production.
b. *Industry*: The Congress Youth League aims at
 i. The full industrialisation of South Africa in order to raise the level of civilisation and the standard of living of the workers;
 ii. the abolition of industrial colour bars and other discriminatory provi-

sions, so that the workers of all nationalities should be able to do skilled work and so that they should get full training and education in the skill and techniques of production; [and]

 iii. establishing in the constitution the full and unhampered right of workers to organise themselves in order to increase their efficiency and protect and safeguard their interests, particularly the workers [who] would reap and enjoy benefits of industrial development and expansion.

c. *Trading and cooperation*: In order to improve the lot of the people generally and to give strength and backbone to the national movement, the league shall

 i. encourage business, trading, and commercial enterprises among Africans, [and]

 ii. encourage, support, and even lead workers, peasants and farmers, intellectuals and others, to engage in cooperative saving, cooperative trading, etc.

d. *General national economy*: Generally the Congress Youth League aims at a national economy which will

 i. embrace all peoples and groups within the state;

 ii. eliminate discrimination and ensure a just and equitable distribution of wealth among the people of all nationalities;

 iii. as nearly as possible give all men and women an equal opportunity to improve their lot;

 iv. in short, give no scope for the domination and exploitation of one group by another.

4. Educational Policy

A. The ultimate goal of African nationalism in so far as education is concerned, is a 100 percent literacy among the people, in order to ensure the realisation of an effective democracy. Some of the means to that end are:

 i. Free compulsory education to all children, with its concomitants of adequate accommodation, adequate training facilities, and adequate remuneration for teachers, [and]

 ii. mass adult education by means of night schools, adult classes, summer and winter courses, and other means.

B. All children should have access to the type of education that they are suited for. They should have access to academic, aesthetic, vocational, and technical training.

C. The aim of such education should be:

 i. to mould the characters of the young

 ii. to give them high sense of moral and ethical values, [and]

 iii. to prepare them for a full and responsible citizenship in a democratic society.

5. Cultural Policy

A. Culture and civilisation have been handed down from nation to nation and from people to people, down to historic ages. One people or nation after another made its own contribution to the sum total of human culture and civilisation. Africa has her own contribution to make. The Congress Youth League stands for a policy of assimilating the best elements in European and other civilisations and cultures, on the firm basis of what is good and durable in the African's own culture and civilisation. In this way Africa will be in a position to make her own special contribution to human progress and happiness.

B. The Congress Youth League supports the cultural struggle of the African people and encourages works by African artists of all categories. The Congress Youth League stands for a coordinate development of African cultural activity.

C. African works of art can and should reflect not only the present phase of the national liberatory struggle but also the world of beauty that lies beyond the conflict and turmoil of struggle.

7. [*sic*] Conclusion

The foregoing policy is largely one of ultimate objectives in general terms, although here and there it throws light on the immediate and/or near-range objectives of the national movement.

Whilst the general policy remains fixed and unalterable, the programme of organisation and action may and shall be modified from time to time to meet new situations and conditions and to cope with the ever-changing circumstances.

By adopting this policy the Congress Youth League is forging a powerful weapon for freedom and progress.

The Position of African Nationalism

In view of misunderstanding and even deliberate distortions of African nationalism, it has become necessary to restate the position of our outlook. [Subsections 1–4 and 6 have been omitted.]

5. Two Streams of African Nationalism

Now it must be noted that there are two streams of African nationalism. One centres round Marcus Garvey's slogan—"Africa for the Africans." It is based on the "Quit Africa" slogan and on the cry "Hurl the white man to the sea." This brand of African nationalism is extreme and ultrarevolutionary.

There is another stream of African nationalism (Africanism) which is moderate and which the Congress Youth League professes. We of the Youth League take account of the concrete situation in South Africa and realise that the different racial groups have come to stay. But we insist that a condition for interracial peace and progress is the abandonment of white domination, and such a change in the basic structure of South African society that those relations which breed exploitation and human misery will disappear. Therefore our goal is the winning of national freedom for African people, and the inauguration of the people's free society where racial oppression and persecution will be outlawed.

7. South Africa: A Country of Nationalities

The above summary on racial groups supports our contention that South Africa is a country of four chief nationalities, three of which (the Europeans, Indians, and Coloureds) are minorities, and three of which (the Africans, Coloureds, and Indians) suffer national oppression. When we talk of and take that as the most urgent, the most immediate task of African nationalism. At all events, it is to be clearly understood that we are not against the Europeans as such—we are not against the European as a human being—but we are totally and irrevocably opposed to white domination and to oppression.

8. Fallacies and Diversions That Must Be Expected

[Subsections a–c have been omitted.]

d. *Venders of Foreign Method*: There are certain groups which seek to impose on our struggle cut-and-dried formulae which, so far from clarifying the issues of our struggle, only serve to obscure the fundamental fact that we are oppressed not as a class, but as a people, as a nation. Such wholesale importation of methods and tactics which might have succeeded in other countries, like Europe, where conditions were different, might harm the cause of our people's freedom, unless we are quick in building a militant mass liberation movement.

e. *Tribalism*: Tribalism itself is the mortal foe of African nationalism, and African nationalists everywhere should declare relentless war on centrifugal tribalism.

Conclusion

The position of African nationalism has been made as clear as possible. It remains for us to stress the fact that our fundamental aim is a strong and self-confident nation. Therefore our programme is, of necessity, a many-sided one corresponding to the varied activities and aspirations of our people, and to the

various avenues along which they are making an advance towards self-expression and self-realisation. Our great task is to assist and to lead our people in their herculean efforts to emancipate themselves and to advance their cause and position economically, culturally, educationally, socially, commercially, physically, and so on. But of course, the most vital aspect of our foreward struggle is the political aspect.

Therefore African nationalists should make a scientific study and approach to the problems of Africa and the world and place themselves in a position to give the African people a clear and fearless political leadership.

13 *Programme of Action*

Excerpted from Statement of Policy, Annual
Conference, December 17, 1949

The fundamental principles of the programme of action of the African National Congress are inspired by the desire to achieve national freedom. By national freedom we mean freedom from white domination and the attainment of political independence. This implies the rejection of the conception of segregation, apartheid, trusteeship, or white leadership which are all in one way or another motivated by the idea of white domination or domination of the white over the blacks. Like all other people the African people claim the right of self-determination.

1. [We claim] the right of direct representation in all the governing bodies of the country.
2. To achieve these objectives the following programme of action is suggested:
 a. The creation of a national fund to finance the struggle for national liberation.
 b. The appointment of a committee to organise an appeal for funds and to devise ways and means therefor.
 c. The regular issue of propaganda material through
 i. the usual press, newsletter, or other means of disseminating our ideas in order to raise the standard of political and national consciousness, [and]
 ii. the establishment of a national press.
3. Appointment of a council of action whose function should be to carry into effect, vigorously and with the utmost determination, the programme of action. It should be competent for the council of action to implement our resolve to work for
 a. The abolition of all differential political institutions the boycotting of which we accept and to undertake a campaign to educate our people on this issue and, in addition, to employ the following weapons: immediate

and active boycott, strike, civil disobedience, noncooperation, and such other means as may bring about the accomplishment and realisation of our aspirations.

 b. Preparations and making of plans for a national stoppage of work for one day as a mark of protest against the reactionary policy of the government.

4. *Economic*

 a. The establishment of commercial, industrial, transport, and other enterprises in both urban and rural areas.

 b. Consolidation of the industrial organisation of the workers for the improvement of their standard of living.

 c. Pursuant to paragraph (a) herein instructions be issued to provincial congresses to study the economic and social conditions in the reserves and other African settlements and to devise ways and means for their development, establishment of industries, and such other enterprises as may give employment to a number of people.

5. *Education*

It be an instruction to the African National Congress to devise ways and means for:

 a. Raising the standard of Africans in the commercial, industrial, and other enterprises and workers in their workers' organisations by means of providing a common educational forum wherein intellectuals, peasants, and workers participate for the common good.

 b. Establishment of national centres of education for the purpose of training and educating African youth and provision of large-scale scholarships tenable in various overseas countries.

6. *Cultural*

 a. To unite the cultural with the educational and national struggle.

 b. The establishment of a national academy of arts and sciences.

7. Congress realises that ultimately the people will be brought together by inspired leadership, under the banner of African nationalism with courage and determination.

14 *Freedom Charter*

From Basic Document, Congress of the People,
June 26, 1955

PREAMBLE

We, the people of South Africa, declare for all our country and the world to know

That South Africa belongs to all who live in it, black and white, and that no

government can justly claim authority unless it is based on the will of the people;

That our people have been robbed of their birthright to land, liberty, and peace by a form of government founded on injustice and inequality;

That our country will never be prosperous or free until all our people live in brotherhood, enjoying equal rights and opportunities;

That only a democratic state, based on the will of the people, can secure to all their birthright without distinction of colour, race, sex, or belief;

And therefore, we, the people of South Africa, black and white, together— equals, countrymen, and brothers—adopt this Freedom Charter. And we pledge ourselves to strive together, sparing nothing of our strength and courage, until the democratic changes here set out have been won.

THE PEOPLE SHALL GOVERN!

Every man and woman shall have the right to vote for and stand as a candidate for all bodies which make laws.

All the people shall be entitled to take part in the administration of the country.

The rights of the people shall be the same regardless of race, colour, or sex.

All bodies of minority rule, advisory boards, councils, and authorities shall be replaced by democratic organs of self-government.

ALL NATIONAL GROUPS SHALL HAVE EQUAL RIGHTS!

There shall be equal status in the bodies of state, in the courts, and in the schools for all national groups and races;

All national groups shall be protected by law against insults to their race and national pride;

All people shall have equal rights to use their own language and to develop their own folk culture and customs;

The preaching and practice of national, race, or colour discrimination and contempt shall be a punishable crime;

All apartheid laws and practices shall be set aside.

THE PEOPLE SHALL SHARE IN THE COUNTRY'S WEALTH!

The national wealth of our country, the heritage of all South Africans, shall be restored to the people;

The mineral wealth beneath the soil, the banks, and monopoly industry shall be transferred to the ownership of the people as a whole;

All other industries and trade shall be controlled to assist the well-being of the people;

All people shall have equal rights to trade where they choose, to manufacture, and to enter all trades, crafts, and professions.

THE LAND SHALL BE SHARED AMONG THOSE WHO WORK IT!

Restriction of landownership on a racial basis shall be ended, and all the land redivided amongst those who work it, to banish famine and land hunger;

The state shall help the peasants with implements, seed, tractors, and dams to save the soil and assist the tillers;

Freedom of movement shall be guaranteed to all who work on the land;

All shall have the right to occupy land wherever they choose;

People shall not be robbed of their cattle, and forced labour and farm prisons shall be abolished.

ALL SHALL BE EQUAL BEFORE THE LAW!

No one shall be imprisoned, deported, or restricted without a fair trial;

No one shall be condemned by the order of any government official;

The courts shall be representative of all the people;

Imprisonment shall be only for serious crimes against the people and shall aim at reeducation, not vengeance;

The police force and army shall be open to all on an equal basis and shall be the helpers and protectors of the people;

All laws which discriminate on grounds of race, colour, or belief shall be repealed.

ALL SHALL ENJOY EQUAL HUMAN RIGHTS!

The law shall guarantee to all their right to speak, to organise, to meet together, to publish, to preach, to worship, and to educate their children;

The privacy of the house from police raids shall be protected by law;

All shall be free to travel without restriction from countryside to town, from province to province, and from South Africa abroad;

Pass laws, permits, and all other laws restricting these freedoms shall be abolished.

THERE SHALL BE WORK AND SECURITY!

All who work shall be free to form trade unions, to elect their officers and to make wage agreements with their employers;

The state shall recognise the right and duty of all to work and to draw full unemployment benefits;

Men and women of all races shall receive equal pay for equal work;

There shall be a forty-hour working week, a national minimum wage, paid annual leave, and sick leave for all workers, and maternity leave on full pay for all working mothers;

Miners, domestic workers, farm workers, and civil servants shall have the same rights as all others who work;

Child labour, compound labour, the tot system, and contract labour shall be abolished.

THE DOORS OF LEARNING AND OF CULTURE SHALL BE OPENED!

The government shall discover, develop, and encourage national talent for the enhancement of our cultural life;

All the cultural treasures of mankind shall be open to all, by free exchange of books, ideas, and contact with other lands;

The aim of education shall be to teach the youth to love their people and their culture, to honour human brotherhood, liberty, and peace;

Education shall be free, compulsory, universal, and equal for all children; Higher education and technical training shall be opened to all by means of state allowances and scholarships awarded on the basis of merit;

Adult illiteracy shall be ended by a mass state education plan;

Teachers shall have all the rights of other citizens;

The colour bar in cultural life, in sport, and in education shall be abolished.

THERE SHALL BE HOUSES, SECURITY AND COMFORT!

All people shall have the right to live where they choose, to be decently housed, and to bring up their families in comfort and security;

Unused housing space to be made available to the people;

Rent and prices shall be lowered, food plentiful, and no one shall go hungry;

A preventive health scheme shall be run by the state;

Free medical care and hospitalisation shall be provided for all, with special care for mothers and young children;

Slums shall be demolished, and new suburbs built where all have transport, roads, lighting, playing fields, crêches, and social centres;

The aged, the orphans, the disabled, and the sick shall be cared for by the state;

Rest, leisure, and recreation shall be the right of all;

Fenced locations and ghettos shall be abolished, and laws which break up families shall be repealed.

THERE SHALL BE PEACE AND FRIENDSHIP!

South Africa shall be a fully independent state, which respects the rights and sovereignty of all nations;

South Africa shall strive to maintain world peace and the settlement of all international disputes by negotiation—not war;

Peace and friendship amongst all our people shall be secured by upholding the equal rights, opportunities, and status of all;

The people of the protectorates—Basutoland. Bechuanaland, and Swaziland—shall be free to decide for themselves their own future;

The right of all the peoples of Africa to independence and self-government shall be recognised and shall be the basis of close cooperation.

Let all who love their people and their country now say, as we say here: "THESE FREEDOMS WE WILL FIGHT FOR, SIDE BY SIDE, THROUGHOUT OUR LIVES, UNTIL WE HAVE WON OUR LIBERTY."

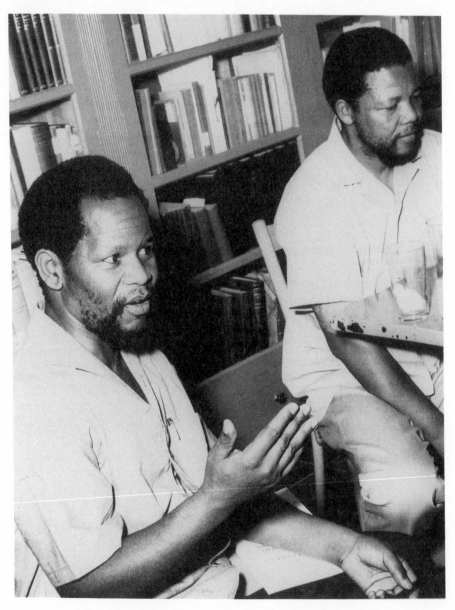

Nelson Mandela with Oliver Tambo in Addis Ababa, 1962.
(International Defence & Aid Fund for Southern Africa)

PART II

PROSCRIPTION AND ENFORCED REORIENTATION, 1960–1964

For Mandela, Tambo, and the ANC, the period from 1960 to 1964 was a brief and tumultuous one. It began with the government's declaration of a state of emergency on March 30 and its banning of the ANC (and the PAC) on April 8 under the auspices of the recently enacted Unlawful Organizations Act. Anti-apartheid forces mounted one last major effort at nonviolent political protest, but the government responded with an even greater show of force than during the emergency. Some leaders, including Mandela, went underground to avoid arrest, while Tambo and a few others left the country to develop in exile an organizational structure for the ANC. The ANC founded a military wing, Umkhonto we Sizwe, to counter the government's use of violence to quell dissent, by mounting a campaign of sabotage against railways, power lines, and other facets of the country's infrastructure. After operating underground in South Africa for more than a year, Mandela was apprehended, tried, and imprisoned. In July 1963, government security forces managed to snare most of the remaining key underground leadership still at large at a farm in Rivonia outside Johannesburg. Mandela was placed on trial along with those arrested at Rivonia. He and seven others—Walter Sisulu, Govan Mbeki, Raymond Mhlaba, Elias Motsoaledi, Andrew Mlangeni, Ahmed Kathrada, and Dennis Goldberg—were convicted and sentenced to life imprisonment. The government was more completely in control than ever before, and the only African political voice remaining in South Africa, on the surface at least, seemed to belong to the bantustan leaders. By 1964 it appeared that the government had thoroughly routed the forces of African nationalism in the country.

A Last Effort at Nonviolent Protest

The state of emergency in 1960 lasted five months. With its termination some semblance of African political activity resumed as leaders detained during the emergency were released. Although the government had hardened its stance, a much broader segment of the white population than previously called for

consultation with Africans. The political climate seemed conducive to one more major political protest against apartheid in order to reverse the country's political course.

African leaders representing the ANC, the PAC, the Liberal party (which had a multiracial membership), and other organizations met in December 1960 to plan a conference that would bring together all African organizations (hence the name, the All-in African Conference). Unfortunately for the cause of African unity, the PAC withdrew its endorsement of the conference because it contended that the ANC was going to use it to call for a national convention rather than for building African unity. Despite the PAC's action, when the conference did meet in Pietermaritzburg on March 25–26, 1961, under ANC leadership, it numbered some 1,400 representatives from what the organizers claimed were 145 organizations.

Mandela emerged as the central figure at the conference, speaking on a public platform for the first time in nearly a decade, because the successive bans imposed on him had lapsed eleven days earlier. His opening speech set the agenda for the conference. The delegates then went on to adopt resolutions calling on the government to convene "a national convention of elected representatives of all adult men and women, on an equal basis, irrespective of race, colour, or creed, with full powers to determine a new democratic constitution for South Africa." Should the government fail to call for such a convention before May 31, the date on which South Africa was to become a republic and thus sever its remaining political ties with Great Britain and the Commonwealth, Africans would engage in mass demonstrations throughout the country to protest government policy and pledge themselves to noncooperation with the new republic (see Document 15). The conference established a National Action Council with Mandela as secretary—the names of other members were kept secret to protect them from arrest—to organize the proposed demonstrations, a role that provided him with considerable publicity as a highly prominent spokesperson. The conference then adjourned. It was to be the last major public African conference for many years. Mandela went into hiding to elude the arrest warrants that had been issued for him for his role in organizing the conference and to direct the planning of the Republic Day protests.

The political strategy that Mandela and the National Action Council moved to implement was designed to mobilize maximum pressure on the government, from two sources. One was the African opposition; the other was the largely English-speaking white opposition to the cherished Afrikaner achievement of a republic. To the African masses, Mandela talked of the unprecedented degree of unity that Africans had achieved so far, of the strength of the weapon that the withdrawal of their labor represented, and of the need for those still holding back to join in and help "deliver the knockout punch" (see Document 16). He also called on the more privileged elements of the Africa population, such as students (see Document 17), to engage fully in the demonstrations for a national convention. To the white political opposition, Mandela called for a commitment to the idea of a national convention in order "to turn the tide against the Nationalist-created crisis." This even in-

cluded an appeal to Sir De Villiers Graff, head of the United party and leader of the opposition in parliament. "A call for a national convention from you now," Mandela wrote, "could well be the turning point in our country's history" (see Document 18).

Although more whites, both individuals and organizations, supported the national convention proposal than had previously supported any other major ANC initiative, the United party did not respond, committed as it was to its own version of white supremacy. Nor did the African masses join in sufficiently large numbers in the actual demonstrations, which took the form of a three-day stay-at-home. Given the exceedingly difficult organizing conditions under which Mandela and other leaders had to operate, however, the fact that there were substantial numbers of protestors was in itself an achievement. Nevertheless, rather than bringing about a national convention, the demonstrations provoked yet another round of swift and severe government repression through mass arrests and additional draconian legislation (see Document 20).

The Adoption of Violence as a Tactic in the Struggle

The government clearly signaled by its repressive measures that it would permit neither mass protest by Africans nor national African political organizations challenging apartheid. It was determined to retain a firm control over the country and to use whatever level of force it deemed necessary to achieve this objective. In the face of such determination, it became increasingly evident to the African nationalist leadership that mass public protest of a nonviolent nature could not produce a change of government policy. Furthermore, the government would meet any mass violent protests with full-scale violence of its own. Given the Africans' unpreparedness for such open violent struggle, disaster would befall those engaging in such tactics. Nonetheless, it now seemed to much of the ANC leadership that they now had to employ violence in some form as a tactic to counter violence on the part of the government. As Tambo noted, the Africans were left "with no alternative but to pursue the goal of freedom and independence by way of taking a 'tooth for a tooth' and meeting violence with violence" (see Document 24).

The decision to use violence as a tactic in the struggle was a difficult one. The ANC had a long history of peaceful and constitutional efforts to protect and promote African rights even in the face of repressive measures and violence on the part of the government, as Tambo (see Document 24) and Mandela (see Document 23) both noted. When the National party government began systematically to intensify state domination of Africans through the implementation of rigid apartheid legislation, the ANC adopted the Programme of Action and carried it out through the Defiance Campaign and other forms of militant protest instead of resorting to violence. The aim had been to apply sufficient pressure on the government to convince it to change its policy rather than to overthrow the government. Finally in 1961 when the ANC ultimately accepted the need for resorting to violence, it viewed its use, as

Tambo observed, as "an extension of, not a substitute for, the forms of political action employed in the past." Mandela was even more to the point: "The violence which we chose to adopt was not terrorism." In other words, the objective remained one of convincing the government and the white electorate to abandon apartheid and establish a democratic society.

If the ANC were to employ any tactics at all, however, it had first to survive. Declared an illegal organization and prohibited from carrying out any open activities in South Africa, the ANC had to develop new means of operation. One was to establish an organization in exile. This it started by sending Oliver Tambo out of the country in March 1960 to represent it elsewhere on the continent and overseas. The other course of action was to go underground. Nelson Mandela had already gone into hiding after the All-in African Conference. On June 26, 1961, the ninth anniversary of the start of the Defiance Campaign, he announced his intention not to surrender himself to the authorities, who had issued another warrant for his arrest, but to remain free to carry out the program of the ANC. "I will not leave South Africa, nor will I surrender," he stated in a press release that received international notice. "Only through hardship, sacrifice, and militant action can freedom be won. The struggle is my life. I will continue fighting for freedom until the end of my days" (see Document 19). Others of the ANC leadership joined him.

The ANC remained a political organization, but to carry out acts of violence it needed a military wing. To meet this need Mandela and others, including members of the Communist party, formed Umkhonto we Sizwe (Spear of the Nation) in November 1961. "The time comes in the life of any nation when there remain only two choices: submit or fight," stated the flyer of December 16, 1961, announcing the existence of the new organization and its first attacks. "That time has now come to South Africa" (see Document 25). Umkhonto, though formed by Africans, included "in its ranks South Africans of all races." The makeup of its membership thus advanced a step further the logic of the Congress Alliance by establishing a single nonracial liberation organization rather than an alliance of separate organizations structured along racial lines. The announcement also stressed that "even at this late hour" the hope of the Umkhonto leadership was to avoid rather than to provoke a civil war, by bringing "the government and its supporters to their senses before it is too late." In his 1964 statement during the Rivonia trial (see Document 23), Mandela elaborated on this point, commenting that there were four possible forms of violence—sabotage, guerrilla warfare, terrorism, and open revolution. Umkhonto chose to start with sabotage in the hope that it would apply pressure for change while at the same time keeping bitterness to a minimum and thus holding out the possibility of accommodation rather than irrevocable confrontation. The first acts of sabotage took place in December 1961 with the bombings of government buildings in several cities. These were the first of more than two hundred attacks that took place over the next year and a half, the majority of which were conducted in such a manner as to avoid bloodshed.

Another strategy the ANC adopted for survival as an organization was securing external allies. The ANC had long regarded its struggle in South

Africa as part of the worldwide effort of colonial peoples to liberate themselves from the yoke of alien rule (see Documents 1, 3, and 8). Throughout the 1950s, however, African nationalists had relied on their own resources while seeking support in South Africa from other groups, such as those that made up the Congress Alliance. In the post-Sharpeville era a new strategy was needed. The utility of internal political support dwindled in the face of even more repressive government policy and growing Nationalist electoral majorities, while the attractiveness of international political support grew, especially as the African states began to join the ranks of independent nations. Furthermore, with the acceptance of violence as a tactic in the struggle, the ANC had to secure military training and supplies for its young militants, resources obviously available only outside the borders of the country. For these reasons Mandela slipped out of South Africa for several months in 1962 to speak at the Addis Ababa Conference of the Pan-African Freedom Movement for East and Central Africa (see Document 21). External pressures and assistance would be of immense help, he told the conference, but "the centre and cornerstone of the struggle . . . lies inside South Africa." The people of South Africa would liberate themselves, but they could use the assistance of friendly forces. After visiting several African states and Great Britain to enlist more support for the ANC, including military training and advanced educational opportunities, Mandela returned to South Africa in late July to resume the struggle from underground. He was arrested less than three weeks later on August 5 and was in prison until February 11, 1990.

Suppressing the African Opposition

Sharpeville and the unrest that immediately followed created a momentary sense of crisis in the white community, including government circles. Indecision soon gave way, however, to decisive government action intended to crush the African opposition and their allies. The state of emergency in 1960 was simply the start. The government continued to expand the police powers of the state to act independently and without judicial review with measures such as the Sabotage Act (1962). This law gave the minister of justice the authority to silence antiapartheid activists and to treat even minor acts of violence as capital crimes. The General Law Amendment Act (1963) allowed police to hold suspects for ninety days without charging them with any crime. The police force strengthened its ability to handle political dissent, which included a resort to arbitrary imprisonment and the use of torture. It also recruited larger numbers of Africans, Asians, and Coloreds in its ranks, employing them as both regular officers and informants. It thus was increasingly effective in rooting out those whom it considered subversive.

The government also aggressively pursued its policy of separate development in the hopes of diminishing the notion of a unified and uncompromising African opposition to its policies. The Transkei Constitution Act (1963), which made the Transkei bantustan located in the eastern Cape Province into a

semiautonomous territory with a limited degree of self-government, was a major step in this direction. Henceforth, the government could promote the image of African "leaders" working within the apartheid political framework. South Africa also recovered somewhat from the international opprobrium it had suffered in 1960. Western powers, including the United States, gave verbal expression to their abhorrence of apartheid, but they did not join in the 1962 United Nations General Assembly vote endorsing economic and diplomatic sanctions. Furthermore, American, British, and other Western business firms and investors poured large sums of overseas capital into the South African economy, reversing the net capital outflow that South Africa had experienced in the early 1960s. Between 1965 and 1970, the net Western investment in South Africa totaled approximately $2 billion, thus further strengthening the apartheid system. The government's harsh crackdown on dissent and its strict control of African labor had created an inviting climate for overseas investors. The 1965–68 average annual rate of return on direct British investments was 12 percent, and that for direct U.S. investments during the same period was nearly 19 percent.[1] In the 1950s, Mandela had spoken out strongly against U.S. and other Western capital investment in apartheid as contributing to the oppression of Africans (see Documents 1 and 8). The new inflow of capital in the mid- and late 1960s served to vindicate his position.

The government destroyed its internal opposition in the early 1960s. During the previous decade it had harassed and pressured the ANC and other antiapartheid organizations, but it had not tried to eliminate the opposition. After Sharpeville, however, it moved to do just that. Mandela's arrest in 1962 was an example of this new government policy. In his defense, which he conducted himself, he clearly recognized what the government wished to accomplish (see Document 22). Charged with leaving the country illegally without a passport and with organizing illegal demonstrations in May 1961, Mandela, who as a practicing attorney had been part of the judicial system, challenged the right of the court to try him. First and foremost, he argued, his was a political trial. He thus questioned the ability of the court to be fair and impartial: "How can I be expected to believe that this same racial discrimination which has been the cause of so much injustice and suffering right through the years should now operate here to give me a fair and open trial?" Mandela's second ground for challenging the court's competence in his case was that he was being tried under laws that he did not consider himself "legally nor morally bound to obey," as they were "made by a Parliament in which I have no representation." Not surprisingly, the court rejected Mandela's argument and on November 7, 1962, convicted him on both charges and sentenced him to five years in prison.

Mandela's arrest, trial, and convictions were but one of many such cases as the government extended its harsh crackdown on its opponents. The climax of this effort came on July 11, 1963, when the security police captured key ANC activists Walter Sisulu and Govan Mbeki along with four others at the farm in Rivonia. The documents seized in the Rivonia raid implicated Mandela along with those captured on July 11 in planning and carrying out acts of sabotage.

As a result Mandela was brought out of jail to stand trial with the others on charges brought against them under security legislation. On June 12, 1964, Mandela, Sisulu, Mbeki, and five others received life sentences. For all intents and purposes, the government had triumphed in its campaign of suppression, for it had effectively silenced the African nationalist leadership.

Persevering in the Struggle:
The Foundation for Mandela's Leadership

The Rivonia trial marked an end to an era of active and growing African nationalist protest. For a time the ANC and its allies had openly challenged the National party regime and had begun to seize the political initiative, but the government had moved quickly to restore its control. The African political voice was now more effectively silenced than at any other time in the century and would remain so through the 1960s.

Rivonia and Mandela's 1962 trial also marked the beginning of an era, that of Nelson Mandela as the symbol of the African struggle for freedom in South Africa. It was not, however, only Mandela's sentence of life imprisonment but also his personal testimony that marked the Rivonia trial as a beginning as well as an end. Mandela's statement of April 20, 1964, to the court was a powerful argument for the justice of the African cause, a compelling personal statement of his own convictions and motivations, and, by implication, a clear call to others to take up the struggle (see Document 23). His trial testimony also received wide publicity, first in news accounts of the trial and then in a collection of his articles, speeches, and trial addresses published in England.[2]

Mandela used the occasion of his last public appearance both to refute government allegations and propaganda and to set forth a clear definition of the struggle from an African perspective. First, and foremost, Africans had defined the struggle and had led it as a result of their own experience and background. They were not the pawns of any other group. Second, the cause of violence was white oppression. After decades of peaceful effort, the ANC had confronted a situation in which there was no other political recourse than to adopt violent means. Mandela went into considerable detail on the history of the struggle to make his point, including a thorough discussion of the origins and purpose of Umkhonto we Sizwe. Third, he rejected the government's claims that he personally or the ANC as an organization was communist. Although the ANC and the Communist party had often cooperated with each other, the basis for their cooperation was their shared common goal of eliminating white supremacy rather than any common ideology or policy. Indeed, the ANC stood for the concept of African nationalism, whereas the Communist party sought a state based on Marxist principles. Finally, Mandela set forth his own personal political beliefs, stating that "I have been influenced in my thinking by both West and East" and that "I must leave myself free to borrow the best from the West and the East." The Magna Carta, the Petition of Rights, and the Bill of Rights had strongly influenced him, but so had Marxist thought.

Perhaps the most important part of Mandela's statement was that dealing with the fundamental issues that had caused him to be on trial for his life. "Our fight is against real, and not imaginary hardships," he told the court. "Basically, we fight against two features which are the hallmarks of African life in South Africa. . . . poverty and the lack of human dignity." In the richest country on the continent, whites enjoyed unparalleled affluence while Africans lived "in poverty and misery," a point that the data Mandela presented clearly underscored.[3] Furthermore, not only were Africans poor and whites rich, but also "the laws which are made by the whites are designed to preserve this situation." The existence of such laws also implied African inferiority and worked to entrench the concept through measures that assailed the Africans' human dignity. These, then, were the issues against which the ANC fought, and to this struggle Mandela had dedicated his life. The ideal he cherished was that "of a democratic and free society" with neither white nor black domination; an ideal for which, if need be, he was "prepared to die."

Nelson Mandela did not receive the death sentence he had expected; instead he stayed in prison serving a life sentence, until he was released on February 11, 1990. His Rivonia statement thus did not become a "last will and testament" but, rather, a document that helps explain both his own leadership in the years that followed and why the government, despite its seemingly overwhelming victory by 1964, was not able to eradicate the spirit of African nationalism. He was not to speak again in public until the day of his release from prison. When he did, he concluded his address as he did in 1964, stating that "I wish to go to my own words during my trial in 1964. They are as true today as they were then" (see Document 44).

Notes

1. For fuller details on the nature, extent, and profitability of Western investment in apartheid, see Ruth First, Jonathan Steele, and Christabel Gurney, *The South African Connection* (New York: Barnes & Noble, 1972).

2. Ruth First, ed., *No Easy Walk to Freedom: Articles, Speeches, and Trial Addresses of Nelson Mandela* (London: Heinemann, 1965).

3. The annual reports of the South African Institute of Race Relations, published under the title of *A Survey of Race Relations in South Africa*, fully substantiate Mandela's statement that "Africans live in misery and poverty." They are replete with statistics that illuminate the intense poverty confronting the great majority of Africans and the contrasting relative affluence of virtually the entire white population. The more than three hundred research papers that were prepared in the early 1980s as part of the Second Carnegie Inquiry into Poverty and Development in South Africa provide further detail on virtually every facet of African poverty.

MANDELA

15 The Struggle for a National Convention

Excerpted from an Article, March 1961

I am attending this conference as delegate from my village. I was elected at a secret meeting held in the bushes far away from our kraals simply because in our village it is now a crime for us to hold meetings. I have listened most carefully to speeches made here, and they have given me strength and courage. I now realise that we are not alone. But I am troubled by my experiences during the last weeks. In the course of our struggle against the system of Bantu Authorities, we heard many fighting speeches delivered by men we trusted most, but when the hour of decision came they did not have the courage of their convictions. They deserted us and we felt lonely and without friends. But I will go away from here refreshed and full of confidence. We must win in the end.

These words were said at the All-in African Conference held at Pietermaritzburg on 25 and 26 March. The man who said them came from a country area where the people are waging a consistent struggle against Bantu Authorities. He wore riding breeches, a khaki shirt, an old jacket and came to conference barefooted. But his words held fire and dignity and his remarks, like those of other speakers, indicated that this conference was no talking shop for persons who merely wanted to let off steam, but a solemn gathering which appreciated the grave decisions it was called upon to take.

The theme of the conference was African unity and the calling, by the government, of a national convention of elected representatives of all adult men and women, on an equal basis, irrespective of race, colour, or creed, with full powers to determine a new democratic constitution for South Africa.

Conference resolved that if the government failed to call this convention by 31 May, countrywide demonstrations would be held on the eve of the republic in protest against this undemocratic act.

The point at issue, and which was emphasised over and over again by delegates, was that a minority government had decided to proclaim a white republic under which the living conditions of the African people would continue to deteriorate.

Conference further resolved that in the event of the government failing to accede to this demand, all Africans would be called upon not to cooperate with the proposed republic. All sections of our populations would be asked to unite with us in opposing the Nationalists.

The resolution went further and called upon democratic people the world over to impose economic and other sanctions against the government. A National Action Council was elected to implement the above decisions.

Three other resolutions were passed in which the arrests of members of the Continuation Committee were strongly condemned and in which conference

called for the lifting of the ban imposed on the African National Congress and the Pan-Africanist Congress. The system of Bantu authorities was attacked as a measure forcibly imposed by the government in spite of the unanimous opposition of the entire African nation.

These resolutions were adopted unanimously by more than fifteen hundred delegates, from town and country, representing nearly one hundred and fifty political, religious, sporting, and cultural organisations.

Delegates fully appreciated that the above decisions were not directed against any other population group in the country. They were aimed at a form of government based on brute force and condemned the world over as inhuman and dangerous. It was precisely because of this fact that conference called on the Coloured and Indian people and all European democrats to join forces with us.

It will indeed be very tragic if, in the momentous days that lie ahead, white South Africa will falter and adopt a course of action which will prevent the successful implementation of the resolutions of conference.

In the past we have been astonished by the reaction of certain political parties and "philanthropic" associations which proclaimed themselves to be antiapartheid but which, nevertheless, consistently opposed positive action taken by the oppressed people to defeat this same policy. Objectively, such an attitude can only serve to defend white domination and to strengthen the Nationalist party. It also serves to weaken the impact of liberal views amongst European democrats and lays them open to the charge of being hypocritical.

All the democratic forces in this country must join in a programme of democratic changes. If they are not prepared to come along with us, they can at least be neutral and leave this government isolated and without friends.

Finally, however successful the conference was from the point of view of attendance and the fiery nature of the speeches made, these militant resolutions will remain useless and ineffective unless we translate them into practice.

If we form local action committees in our respective areas, popularise the decisions through vigorous and systematic house-to-house campaigns, we will inspire and arouse the country to implement the resolutions and to hasten the fall of the Nationalist government within our lifetime.

16 *Deliver the Knockout Punch*

From *Contact*, May 4, 1961

The *Sunday Times* of the 26th March, 1961 acclaimed the All-in African Conference in Pietermaritzburg as the biggest political gathering of Africans in South Africa since the government banned the ANC and PAC last year. Almost all the country's leading dailies and periodicals conceded in varying degrees the success of this meeting. And so it was. The organizers had worked

for a target of just about 1,000 delegates. But with the much publicized withdrawal of a certain organization and individuals, the arrest of most members of the Continuation Committee which organized the conference, the view that became prevalent immediately thereafter, namely, that the arrests meant in effect that those who participated in the deliberations of the conference would be courting arrest and prosecution, and with the universal atmosphere of uncertainty that prevailed, the prospect of reaching even this target seemed very dim indeed. And yet 1,400 delegates from town and country and representing various shades of political and religious thought and from social, sporting, and cultural organizations, overcoming numerous difficulties, found their way to the conference hall. A remarkable achievement by any standard.

The view has been expressed that this conference was merely another meeting of the ANC and not in any way representative of the African point of view. Others put the matter in a slightly different way. They say that the so-called delegates did not represent anybody but themselves. The report of the credentials committee gave the names and addresses of the delegates that attended as well as that of the organizations they represented. It shows that more than half of these organizations are known to have existed years before the ANC was banned and there could be no question of the ANC having dissolved itself into these bodies. The Interdenominational African Ministers' Federation, the Southern Transvaal Football Association, the Apostolic Church in Zion, the Liberal party, are amongst those which sent delegates to the conference. This was undoubtedly the greatest demonstration of African unity and solidarity seen in recent years.

South Africa now knows that conference unanimously decided to call on the government to summon, before 31st May this year, a national convention of all South Africans, black and white, to draw up a new democratic constitution. Africans appreciate that one of the greatest weapons in their hands at present is the withdrawal of their labour power. Without a single dissenting voice, delegate after delegate called for this type of demonstration on the eve of 31st May, and numerous speakers urged that this time the demonstrations would be of such duration and so massive in scope as to rock the Nationalist party government to its foundations.

> Delegates warned that this decision involved much more than the forthcoming demonstrations. They urged that the noncollaboration provisions of the main resolutions open up a new chapter in the struggle of the African people against race discrimination. They meant the beginning of a long period of stubborn and militant mass campaigns in town and country to unseat this government.

What are the prospects? How powerful are we? What machinery is there to ensure success? How resilient is our organization? Is it capable of surviving the countermeasures the government might take?

To a certain extent all these questions have already been answered. In the conditions that prevail today in South Africa is it not astonishing that we

should be able to assemble so many delegates? Is it not surprising that these same delegates should pass such a challenging resolution?

Only twelve months ago seventy-five people were killed by the police in Vereeniging and Cape Town in the course of a peaceful demonstration against passes. Nine days thereafter a state of emergency was declared and the normal rights of citizens were suspended. Thousands of innocent people were arrested and detained in jails without trial. The ANC and PAC were suppressed, the army was mobilized to terrorize the political opponents of the government and to crush any form of opposition to its policies.

For a little more than four years, leaders of the ANC had faced a treason trial which only came to a dramatic end after the Pietermaritzburg conference. In recent years scores of our people have been forcibly removed from their homes and families and banished to remote parts of the country there to fend for themselves amongst strangers in a strange environment.

> Could there be anything more terrifying than this ordeal through which our country has just passed? Yet notwithstanding all these things opposition to the government continues to grow, and one of the most significant aspects of this growing opposition in the upsurge of political consciousness amongst the Coloured people. They have openly declared that there can be no compromise or collaboration with the present government and have thrown in their lot with the African people. In the light of these dynamic developments can anybody doubt what the propects are?

Since Pietermaritzburg, we have visited Bloemfontein, Port Elizabeth, Cape Town, and Durban, and we have been struck by the enthusiasm of all sections. We have spoken even to those of us who had certain reservations about this historic resolution and we are happy to indicate that we were able to find common ground on this issue.

WE FACE THE FORTHCOMING DEMONSTRATIONS TEMPERED AND STRENGTHENED BY THE KNOWLEDGE THAT WE HAVE BEEN ABLE TO ACHIEVE UNITY TO A DEGREE UNPRECEDENTED IN THE HISTORY OF THIS COUNTRY. THERE ARE SOME WHO ARE STILL ASSAILED BY DOUBTS AND HESITATIONS. WE SAY TO THEM THAT THE TIMES ARE CRITICAL AND MOMENTOUS. WE URGE THEM TO JOIN IN WITH US AND TOGETHER TO DELIVER THE KNOCKOUT PUNCH.

17 *An Appeal to Students and Scholars*

Excerpted from All-in African National Action
Council Flyer, 1961

Dear Friends;

I am writing this letter on the instructions of the All-in African National Action Council which was established in terms of a resolution passed by the

All-in African Conference held at Pietermaritzburg on the 25th and 26th March 1961.

This conference has been acclaimed throughout the country as an important landmark in the struggle of the African people to achieve unity amongst themselves. Its challenging resolution is a stirring call to an action which promises to be one of the most massive and stunning blows ever delivered by the African people against white supremacy.

In its efforts to enslave the African people the government has given particular attention to the question of education. The control of African education has been taken away from the provincial administrations and missionaries and is now vested in the Bantu Affairs Department so that it should conform with state policy. Instead of a free and progressive education calculated to prepare him for his responsibilities as a fully fledged citizen, the African is indoctrinated with a tribal and inferior type of education intended to keep him in a position of perpetual subservience to the whites. The matric results last year strikingly illustrated the disastrous effects of Bantu education and show that even more tragic consequences will follow if the Nationalists are not kicked out of power. We call upon the entire South African nation to close ranks and to make a supreme effort to halt the Nationalists and to win freedom. In this situation all students have an important role to play and we appeal to you to:

1. Participate in full in the forthcoming demonstrations.
2. Refuse to participate in the forthcoming Republican celebrations and in all ceremonies connected with them.
3. To popularise the Maritzburg resolution amongst other students, the youth in factories, farms, and in the streets, to your parents and relatives, and to all people in your neighbourhood.

If you take these measures you will have made an important contribution to the historic mission of transforming our country from a white-dominated one to a free and prosperous nation.

18 *Letter to Sir de Villiers Graaf, Leader of the United Party*

May 23, 1961

Sir,

In one week's time, the Verwoerd government intends to inaugurate its republic. It is unnecessary to state that this intention has never been endorsed by the nonwhite majority of this country. The decision has been taken by little over half of the White community; it is opposed by every articulate group

amongst the African, Coloured, and Indian communities, who constitute the majority of this country.

The government's intentions to proceed, under these circumstances, has created conditions bordering on crisis. We have been excluded from the Commonwealth and condemned 95 to 1 at the United Nations. Our trade is being boycotted, and foreign capital is being withdrawn. The country is becoming an armed camp; the government preparing for civil war with increasingly heavy police and military apparatus; the nonwhite population for a general strike and long-term noncooperation with the government.

None of us can draw any satisfaction from this developing crisis. We, on our part, in the name of the African people—a majority of South Africans—and on the authority given us by 1,400 elected African representatives at the Pietermaritzburg Conference on March 25th and 26th, have put forward serious proposals for a way out of the crisis. We have called on the government to convene an elected national convention of representatives of all races without delay and to charge that convention with the task of drawing up a new constitution for this country which would be acceptable to all racial groups.

We can see no workable alternative to this proposal, except that the Nationalist government proceeds to enforce a minority decision on all of us, with the certain consequence of still deeper crisis and a continuing period of strife and disaster ahead. Stated bluntly, the alternatives appear to be these: Talk it out, or shoot it out. Outside of the Nationalist party, most of the important and influential bodies of public opinion have clearly decided to talk it out. The South African Indian Congress, the only substantial Indian community organisation, has welcomed and endorsed the call for a national convention. So, too, have the Coloured people, through the Coloured convention movement which has the backing of the main bodies of Coloured opinion. A substantial European body of opinion, represented by both the Progressive and the Liberal parties, has endorsed our call. Support for a national convention has come also from the bulk of the English-language press, from several national church organisations, and from many others.

But where, Sir, does the United party stand? We have yet to hear from this most important organisation—the main organisation in fact of anti-Nationalist opinion amongst the European community. Or from you, its leader. If the country's leading statesmen fail to lead at this moment, then the worst is inevitable. It is time for you, Sir, and your party, to speak out. Are you for a democratic and peaceable solution of our problems? Are you, therefore, *for* a national convention? We in South Africa and the world outside expect an answer. Silence at this time enables Dr. Verwoerd to lead us onwards towards the brink of disaster.

We realise that aspects of our proposal raise complicated problems. What shall be the basis of representation at the convention? How shall the representatives be elected? But these are not the issues now at stake. The issue *now* is a simple one. Are all groups to be consulted before a constitutional change is made? Or only the white minority? A decision on this matter cannot be delayed. Once that decision is taken, then all other matters, of how, when, and

where, can be discussed, and agreement on them can be reached. On our part the door to such discussion has always been open. We have approached you and your party before and suggested that matters of difference be discussed. To date we have had no reply. Nevertheless we still hold the door open. But the need *now* is not for debate about differences of detail but for clarity of principle and purpose. For a national convention of all races? Or against?

It is still not too late to turn the tide against the Nationalist-created crisis. A call for a national convention from you now could well be the turning point in our country's history. It would unite the overwhelming majority of our people, white, Coloured, Indian, and African, for a single purpose—round-table talks for a new constitution. It would isolate the Nationalist government and reveal for all time that it is a minority government, clinging tenaciously to power against the popular will, driving recklessly onward to a disaster for itself and us. Your call for a national convention now would add such strength to the already-powerful call for it that the government would be chary of ignoring it further.

And if they nevertheless ignore the call for the convention, the interracial unity thus cemented by your call would lay the basis for the replacement of this government of national disaster by one more acceptable to the people, one prepared to follow the democratic path of consulting all the people in order to resolve the crisis.

We urge you strongly to speak out now. It is ten days to May 31st.

19 *The Struggle Is My Life*

Excerpted from a Press Statement Released
on June 26, 1961

Today is 26th June, a day known throughout the length and breadth of our country as Freedom Day. On this memorable day, nine years ago, eight thousand five hundred of our dedicated freedom fighters struck a mighty blow against the repressive colour policies of the government. Their matchless courage won them the praise and affection of millions of people here and abroad. Since then we have had many stirring campaigns on this date, and it has been observed by hundreds of thousands of our people as a day of dedication. It is fit and proper that on this historic day I should speak to you and announce fresh plans for the opening of the second phase in the fight against the Verwoerd republic and for a national convention.

You will remember that the Maritzburg Resolutions warned that if the government did not call a national convention before the end of May 1961, Africans, Coloureds, Indians, and European democrats would be asked not to collaborate with the republic or any government based on force. On several

occasions since then the National Action Council explained that the last strike marked the beginning of a relentless mass struggle for the defeat of the Nationalist government and for a sovereign multiracial convention. We stressed that the strike would be followed by other forms of mass pressure to force the race maniacs who govern our beloved country to make way for a democratic government of the people, by the people and for the people. A full-scale and countrywide campaign of noncooperation with the government will be launched immediately. The precise form of the contemplated action, its scope and dimensions and duration will be announced to you at the appropriate time.

At the present moment it is sufficient to say that we plan to make government impossible. Those who are voteless cannot be expected to continue paying taxes to a government which is not responsible to them. People who live in poverty and starvation cannot be expected to pay exorbitant house rents to the government and local authorities. We furnish the sinews of agriculture and industry. We produce the work of the gold mines, the diamonds, and the coal, of the farms and industry, in return for miserable wages. Why should we continue enriching those who steal the products of our sweat and blood? Those who exploit us and refuse us the right to organise trade unions? Those who side with the government when we stage peaceful demonstrations to assert our claims and aspirations? How can Africans serve on school boards and committees which are part of Bantu education, a sinister scheme of the Nationalist government to deprive the African people of real education in return for tribal education? Can Africans be expected to be content with serving on advisory boards and Bantu authorities when the demand all over the continent of Africa is for national independence and self-government? Is it not an affront to the African people that the government should now seek to extend Bantu authorities to the cities, when people in the rural areas have refused to accept the same system and fought against it tooth and nail? Which African does not burn with indignation when thousands of our people are sent to gaol every month under the cruel pass laws? Why should we continue carrying these badges of slavery? Noncollaboration is a dynamic weapon. We must refuse. We must use it to send this government to the grave. It must be used vigorously and without delay. The entire resources of the black people must be mobilized to withdraw all cooperation with the Nationalist government. Various forms of industrial and economic action will be employed to undermine the already-tottering economy of the country. We will call upon the international bodies to expel South Africa and upon nations of the world to sever economic and diplomatic relations with the country.

I am informed that a warrant for my arrest has been issued and that the police are looking for me. The National Action Council has given full and serious consideration to this question and has sought the advice of many trusted friends and bodies, and they have advised me not to surrender myself. I have accepted this advice and will not give myself up to a government I do not recognize. Any serious politician will realize that under present day conditions in this country, to seek for cheap martyrdom by handing myself to the police is

naive and criminal. We have an important programme before us, and it is important to carry it out very seriously and without delay.

I have chosen this latter course which is more difficult and which entails more risk and hardship than sitting in gaol. I have had to separate myelf from my dear wife and children, from my mother and sisters, to live as an outlaw in my own land. I have had to close my business, to abandon my profession, and live in poverty and misery, as many of my people are doing. I will continue to act as the spokesman of the National Action Council during the phase that is unfolding and in the tough struggles that lie ahead. I shall fight the government side by side with you, inch by inch, and mile by mile, until victory is won. What are you going to do? Will you come along with us, or are you going to cooperate with the government in its efforts to suppress the claims and aspirations of your own people? Or are you going to remain silent and neutral in a matter of life and death to my people, to our people? For my own part I have made my choice. I will not leave South Africa, nor will I surrender. Only through hardship, sacrifice, and militant action can freedom be won. The struggle is my life. I will continue fighting for freedom until the end of my days.

20 *Out of the Strike*

Excerpted from *Africa South-in-Exile*,
October–December 1961

South Africa is a house divided against itself. . . . The three-day strike at the end of May 1961 starkly emphasised the chronic state of disunity that has existed in the country since union.

To the Afrikaners the proclamation of a republican form of government represented the final triumph of their rancorous struggles against British dominion. . . . But to the 10,000,000 Africans and to the other nonwhite sections of the population, the republic was a form of government based only upon force and fraud. . . . The All-in African National Action Council, which was established in terms of a resolution of this [All-in-African] Conference, announced that the demonstrations would be held on 29, 30, and 31 May.

No political organisation in this country has ever conducted a mass campaign under such dangerous and difficult conditions. The whole operation was mounted outside—even in defiance of—the law. Because members of the Continuation Committee which organised the Pietermaritzburg Conference had been arrested, the names of the members of the National Action Council were not disclosed, while all council meetings and activities had to be secret. The government banned all meetings throughout the country. A special law was rushed through Parliament, empowering the government to arrest and imprison for twelve days anyone connected with the organisation of the dem-

onstrations. Our organisers and fieldworkers were closely trailed and hounded by members of the Special Branch and had to work in areas heavily patrolled by municipal and government police. Homes and offices of known government opponents were raided, while more than ten thousand Africans were arrested and imprisoned. The army was placed on a war footing, while white civilians, including women, were armed and organised to shoot their fellow South Africans.

In spite of all these obstacles, we succeeded in building up a powerful and effective organisational machine to promote a strike of protest and the demand for a national convention. Support for the strike grew stronger every day, and the demand for a national convention roared and crashed across the country. Political and religious organisations, university professors, and students all joined the cry for a convention.

Only after those first tense strike days had passed were more balanced assessments made of the extent of the strike, and reports filtered through that hundreds of thousands of workers had stayed away from work, while the students in schools and colleges throughout South Africa had adopted the campaign as their own.

On 3 June 1961, *Post*, a weekly newspaper that circulates throughout the country, published reports from its team of staff journalists and photographers, who had kept continuous watch in industrial centers and nonwhite areas and who had conducted extensive investigations on the effect of the strike. Said the newspaper: "Many thousands of workers registered their protest against the republic and the government's refusal to cooperate with nonwhites. THEY DID NOT GO TO WORK. They disrupted much of South African commerce and industry. Some factories worked with skeleton staffs, others closed, and many other businesses were shut down for the three days." The leading article in *New Age* of 8 June acclaimed the strike as the most widespread on a national scale that the country had ever seen.

News from outlying areas, especially country districts, is slow to percolate into the cities, and for days and weeks afterwards, reports continued to seep through of support for the strike on farm and in trading store.

A significant feature of the strike was the wide support it received from students of all races.

The Nationalist government was severely shaken, particularly by the militancy of African students, because it had trusted that Bantu education, intended to inculcate a spirit of servility, would permanently stamp out revolt and challenge amongst the African youth. The emphatic rejection by African students of the republic demonstrates not only the failure of Bantu education to smother the demands and desires in the bloodstream of every African but testifies to the vitality, the irrepressible resilience of African nationalism.

For the first time in many years the Coloured people emerged as an organised and powerful political force, to fight alongside their African and Indian colleagues. Nothing could be more disturbing to a government whose continued existence depends on disunity within the files of the oppressed themselves.

The Pan-Africanist Congress blundered right from the very beginning. After supporting the resolution calling for All-in African talks and for a multiracial national convention, and after serving for some time on the Continuation Committee which planned the Pietermaritzburg Conference, they took refuge in assiduous sniping at the campaign. Early in February, they called for mass demonstrations on 21 March this year, the anniversary of Sharpeville. No one responded to the desperate distraction, however, and, four days afterwards, 1,400 delegates from all over South Africa reacted to the call of the Continuation Committee by voting unanimously in favour of a national convention and for mass demonstrations. The PAC took an even more disastrous step by issuing pamphlets which attacked the demonstrations and so helped the government to break the strike. Almost all Africans, some of whom had previously supported the PAC, were deeply shocked by a rivalry which extended even to sabotage of the popular struggle. The three-year-old breakaway from the African National Congress will find further survival very difficult if it persists in wrecking what it cannot build.

Without doubt, this campaign remained an impressive demonstration of the strength of our organisation, of the high level of political consciousness attained by our people, and of their readiness to struggle against the most intimidating odds.

The strike itself was witness to the great political maturity of those struggling for their rights in South Africa. Here was a national strike organised not for immediate wage demands by an industrial working class nor a strike around an intensely emotional issue like the police shooting at Sharpeville. This was an overt political strike, to back a demand for a new national convention, a new constitution-making body, a demand for the full franchise, for the right to legislate, the right to chart a new path for South Africa. It was a strike for fundamental rather than immediate peripheral demands, a strike for the right, for the power, to solve our bread-and-butter, or mealie meal problems ourselves (though it has been said critically, and I concede the point has merit, that the day-to-day demands of the people could have been more closely linked and more brightly highlighted in the propaganda material for the strike).

The African people have a mature and developed understanding of the issue I outlined in my open letter (written on the eve of the strike) to the leader of the opposition United party.

The official opposition remained silent. There was, however, a widespread response to the call from Progressives and Liberals, churchmen, university professors, students, intellectuals, some sectors of business and industry, and, of course, the Congress Alliance. Since our call for the convention there have been talks across the colour line, proposals for consultation among leaders of the different sections of the population.

I welcome consultations, noncolour bar conferences, and have taken part in many. Multirace assemblies spread understanding, forge the unity of anti-Nationalist forces, thrash out common methods and a common approach. But the African people are not interested in mere talking for talking's sake. Their

own agony grows ever more acute. Our Pietermaritzburg resolution stipu-
lated—and we took much trouble over its formulation—that a national con-
vention must have sovereign powers to draft a new constitution, and we believe
that no such convention will ever take place without mass pressure, without
popular struggle.

The May strike and the demand for a national convention, all our demands
indeed, are inextricably linked with our decision to launch a campaign of
noncooperation against the government. The strike must be seen in this light.

There were those who cried: "The strike has failed. It was against the
Saracen Republic. It did not bring it down." The strike was directed at all that
is most hated in the policy of apartheid, to stake the claim of all our people to a
share in government and in determining the shape of our country. It was never
imagined—and our written and spoken word on the strike never implied—that
this *one* action, in *isolation*, could defeat the Nationalists. Only the most naive
and impatient can believe that a single campaign will create a wholly different
South Africa.

We see the position differently. South Africa is now in a state of perpetual
crisis. The government's show of force, its reliance on the tank, the bullet, and
the uniform, are a show not of strength but of weakness, revealing its basic
incapacity to face the challenge of a seething South Africa, a changing Africa, a
world in revolution.

The crisis will inevitably grow more acute. The people's movements will
continue, in city and country district alike, despite ban and intimidation,
learning new ways to struggle, new ways to survive. The May strike was one
fighting episode. From it, the people emerged more confident, unshaken by
prognoses that they had failed, that strikes could "no longer work." In the
centres where the strike met with popular response, the people themselves
learnt that they could not trust any verdict on their struggle but their own.
They have accordingly come out of the strike better steeled for the struggles
ahead. Their own organisations are not weaker but stronger, more resilient.
Future struggles lie ahead.

21 *Address to Conference of the Pan-African Freedom Movement of East and Central Africa*

Excerpted from Address in Addis Ababa, Ethiopia,
January 1962

The delegation of the African National Congress, and I particularly, feel
specially honoured by the invitation addressed to our organisation by the
PAFMECA to attend this historic conference and to participate in its delibera-
tions and decisions. The extension of the PAFMECA area to South Africa, the

heart and core of imperialist reaction, should mark the beginning of a new phase in the drive for the total liberation of Africa.

How strong is the freedom struggle in South Africa today? What role should PAFMECA play to strengthen the liberation movement in South Africa and speed up the liberation of our country? These are questions frequently put by those who have our welfare at heart.

The view has been expressed in some quarters outside South Africa that in the special situation obtaining in our country, our people will never win freedom through their own efforts. Those who hold this view point to the formidable apparatus of force and coercion in the hands of the government, to the size of its armies, the fierce suppression of civil liberties, and the persecution of political opponents of the regime. Consequently, in these quarters, we are urged to look for our salvation beyond our borders.

Nothing could be further from the truth.

It is true that world opinion against the policies of the South African government has hardened considerably in recent years. The All African People's Conference held in Accra in 1958, the Positive Action Conference for Peace and Security in Africa, also held in Accra in April 1960, the Conference of Independent African States held in this famous capital in June of the same year, and the conferences at Casablanca and Monrovia last year, as well as the Lagos Conference this month, passed militant resolutions in which they sharply condemned and rejected the racial policies of the South African government. It has become clear to us that the whole of Africa is unanimously behind the move to ensure effective economic and diplomatic sanctions against the South African government.

At the international level, concrete action against South Africa found expression in the expulsion of South Africa from the Commonwealth, which was achieved with the active initiative and collaboration of the African members of the Commonwealth. These were Ghana, Nigeria, and Tanganyika (although the latter had not yet achieved its independence). Nigeria also took the initiative in moving for the expulsion of South Africa from the International Labour Organisation. But most significant was the draft resolution tabled at the fifteenth session of the United Nations which called for sanctions against South Africa. This resolution had the support of all the African members of the United Nations, with only one exception. The significance of the draft was not minimised by the fact that a milder resolution was finally adopted calling for individual or collective sanctions by member states. At the sixteenth session of the United Nations last year, the African states played a marvellous role in successfully carrying through the General Assembly a resolution against the address delivered by the South African minister of foreign affairs, Mr. Eric Louw, and subsequently in the moves calling for the expulsion of South Africa from the United Nations and for sanctions against her. Although the United Nations itself has neither expelled nor adopted sanctions against South Africa, many independent African states are in varying degrees enforcing economic and other sanctions against her. This increasing world pressure on South Africa has greatly weakened her international posi-

tion and given a tremendous impetus to the freedom struggle inside the country. No less a danger to white minority rule and a guarantee of ultimate victory for us is the freedom struggle that is raging furiously beyond the borders of the South African territory; the rapid progress of Kenya, Uganda, and Zanzibar towards independence; the victories gained by the Nyasaland Malawi Congress; the unabated determination of Kenneth Kaunda's United National Independence party (UNIP); the courage displayed by the freedom fighters of the Zimbabwe African People's Union (ZAPU), successor to the now banned National Democratic party (NDP); the gallantry of the African crusaders in the Angolan war of liberation and the storm clouds forming around the excesses of Portuguese repression in Mozambique; the growing power of the independence movements in South-West Africa and the emergence of powerful political organisations in the High Commission territories— all these are forces which cannot compromise with white domination anywhere.

But we believe it would be fatal to create the illusion that external pressures render it unnecessary for us to tackle the enemy from within. The centre and cornerstone of the struggle for freedom and democracy in South Africa lies inside South Africa itself. Apart from those required for essential work outside the country, freedom fighters are in great demand for work inside the country. We owe it as a duty to ourselves and to the freedom-loving peoples of the world to build and maintain in South Africa itself a powerful, solid movement, capable of surviving any attack by the government and sufficiently militant to fight back with a determination that comes from the knowledge and conviction that it is first and foremost by our own struggle and sacrifice inside South Africa itself that victory over white domination and apartheid can be won.

The struggle in the areas still subject to imperialist rule can be delayed and even defeated if it is uncoordinated. Only by our combined efforts and united action can we repulse the multiple onslaughts of the imperialists and fight our way to victory. Our enemies fight collectively and combine to exploit our people.

The clear examples of collective imperialism have made themselves felt more and more in our region by the formation of an unholy alliance between the governments of South Africa, Portugal, and the so-called Central African Federation. Hence these governments openly and shamelessly gave military assistance consisting of personnel and equipment to the traitorous Tshombe regime in Katanga.

At this very moment it has been widely reported that a secret defence agreement has been signed between Portugal, South Africa, and the federation, following visits of federation and South African defence ministers to Lisbon, the federation defence minister to Luanda, and South African Defence Ministry delegations to Mozambique. Dr. Salazar was quoted in the Johannesburg *Star* of 8 July 1961 as saying: "Our relations—Mozambique's and Angola's on the one hand and the federation and South Africa on the other—arise from the existence of our common borders and our traditional friendships that unite our

governments and our people. Our mutual interests are manifold, and we are conscious of the need to cooperate to fulfil our common needs."

Last year, Southern Rhodesian troops were training in South Africa and so were Rhodesian Air Force units. A military mission from South Africa and another from the Central African Federation visited Lourenço Marques in Mozambique, at the invitation of the Mozambique Army Command, and took part in training exercises in which several units totalling 2,600 men participated. These operations included dropping exercises for paratroopers.

A report in a South African aviation magazine, *Wings* (December 1961), states: "The Portuguese are hastily building nine new aerodromes in Portuguese East Africa (Mozambique) following their troubles in Angola. The new 'dromes are all capable of taking jet fighters and are situated along or near the borders of Tanganyika and Nyasaland," and gives full details.

Can anyone, therefore, doubt the role that the freedom movements should play in view of this hideous conspiracy?

As we have stated earlier, the freedom movement in South Africa believes that hard and swift blows should be delivered with the full weight of the masses of the people, who alone furnish us with one absolute guarantee that the freedom flames now burning in the country shall never be extinguished.

During the last ten years the African people in South Africa have fought many freedom battles, involving civil disobedience, strikes, protest marches, boycotts, and demonstrations of all kinds. In all these campaigns we repeatedly stressed the importance of discipline, peaceful, and nonviolent struggle. We did so, firstly because we felt that there were still opportunities for peaceful struggle and we sincerely worked for peaceful changes. Secondly, we did not want to expose our people to situations where they might become easy targets for the trigger-happy police of South Africa. But the situation has now radically altered.

South Africa is now a land ruled by the gun. The government is increasing the size of its army, of the navy, of its air force, and the police. Pillboxes and road blocks are being built up all over the country. Armament factories are being set up in Johannesburg and other cities. Officers of the South African army have visited Algeria and Angola where they were briefed exclusively on methods of suppressing popular struggles. All opportunities for peaceful agitation and struggle have been closed. Africans no longer have the freedom even to stay peacefully in their houses in protest against the oppressive policies of the government. During the strike in May last year the police went from house to house, beating up Africans and driving them to work.

Hence it is understandable why today many of our people are turning their faces away from the path of peace and nonviolence. They feel that peace in our country must be considered already broken when a minority government maintains its authority over the majority by force and violence.

A crisis is developing in earnest in South Africa. However, no high command ever announces beforehand what its strategy and tactics will be to meet a situation. Certainly, the days of civil disobedience, of strikes, and mass demonstrations are not over, and we will resort to them over and over again.

But a leadership commits a crime against its own people if it hesitates to sharpen its political weapons which have become less effective.

Regarding the actual situation pertaining today in South Africa, I should mention that I have just come out of South Africa, having for the last ten months lived in my own country as an outlaw, away from family and friends. When I was compelled to lead this sort of life, I made a public statement in which I announced that I would not leave the country but would continue working underground. I meant it and I have honoured that undertaking. But when my organisation received the invitation to this conference, it was decided that I should attempt to come out and attend the conference to furnish the various African leaders, leading sons of our continent, with the most up-to-date information about the situation.

During the past ten months I moved up and down my country and spoke to peasants in the countryside, to workers in the cities, to students and professional people. It dawned on me quite clearly that the situation had become explosive. It was not surprising therefore when one morning in October last year we woke up to read press reports of widespread sabotage involving the cutting of telephone wires and the blowing up of power pylons. The government remained unshaken, and white South Africa tried to dismiss it as the work of criminals. Then on the night of 16 December last year the whole of South Africa vibrated under the heavy blows of Umkhonto we Sizwe (The Spear of the Nation). Government buildings were blasted with explosives in Johannesburg, the industrial heart of South Africa, in Port Elizabeth, and in Durban. It was now clear that this was a political demonstration of a formidable kind, and the press announced the beginning of planned acts of sabotage in the country. It was still a small beginning because a government as strong and as aggressive as that of South Africa can never be induced to part with political power by bomb explosions in one night and in three cities only. But in a country where freedom fighters frequently pay with their very lives and at a time when the most elaborate military preparations are being made to crush the people's struggles, planned acts of sabotage against government installations introduce a new phase in the political situation and are a demonstration of the people's unshakeable determination to win freedom, whatever the cost may be. The government is preparing to strike viciously at political leaders and freedom fighters. But the people will not take these blows sitting down.

In such a grave situation it is fit and proper that this conference of PAFMECA should sound a clarion call to the struggling peoples in South Africa and other dependent areas, to close ranks, to stand firm as a rock and not allow themselves to be divided by petty political rivalries whilst their countries burn. At this critical moment in the history of struggle, unity amongst our people in South Africa and in the other territories has become as vital as the air we breathe, and it should be preserved at all costs.

Finally, dear friends, I should assure you that the African people of South Africa, notwithstanding fierce persecution and untold suffering, in their ever-increasing courage will not for one single moment be diverted from the historic

mission of liberating their country and winning freedom, lasting peace, and happiness.

We are confident that in the decisive struggles ahead, our liberation movement will receive the fullest support of PAFMECA and of all freedom-loving people throughout the world.

22 Black Man in a White Man's Court

Excerpted from Courtroom Statement,
October 22, 1962

Your Worship, before I plead to the charge, there are one or two points I would like to raise.

Firstly, Your Worship will recall that this matter was postponed last Monday at my request until today, to enable counsel to make the arrangements to be available here today. Although counsel is now available, after consultation with him and my attorneys, I have elected to conduct my own defence. Some time during the progress of these proceedings, I hope to be able to indicate that this case is a trial of the aspirations of the African people, and because of that I thought it proper to conduct my own defence. Nevertheless, I have decided to retain the services of counsel, who will be here throughout these proceedings, and I also would like my attorney to be available in the course of these proceedings as well, but subject to that I will conduct my own defence.

The second point I would like to raise is an application which is addressed to Your Worship. Now at the outset, I want to make it perfectly clear that the remarks I am going to make are not addressed to Your Worship in his personal capacity, nor are they intended to reflect upon the integrity of the court. I hold Your Worship in high esteem, and I do not for one single moment doubt your sense of fairness and justice. I must also mention that nothing I am going to raise in this application is intended to reflect against the prosecutor in his personal capacity.

The point I wish to raise in my argument is based not on personal considerations, but on important questions that go beyond the scope of this present trial. I might also mention that in the course of this application I am frequently going to refer to the white man and the white people. I want at once to make it plain that I am no racialist, and I detest racialism, because I regard it as a barbaric thing, whether it comes from a black man or from a white man. The terminology that I am going to employ will be compelled on me by the nature of the application I wish to make.

I want to apply for Your Worship's recusal from this case. I challenge the right of this court to hear my case on two grounds.

I challenge it firstly because I fear that I will not be given a fair and proper trial. I challenge it in the second place because I consider myself neither legally nor morally bound to obey laws made by a Parliament in which I have no representation. In a political trial such as the present one which involves a clash of the aspirations of the African people and those of whites, the country's courts as presently constituted cannot be impartial and fair. In such cases whites are interested parties. To have a white judicial officer presiding, however high his esteem and however strong his sense of justice and fairness, is to make whites judge their own case. It is improper and against the elementary principles of justice to entrust whites with cases involving the denial by them of basic human rights to the African people. What sort of justice is this that enables the aggrieved to sit in judgement upon those whom they accused, a judiciary controlled entirely by whites and enforcing laws enacted by a white Parliament in which we have no representation: laws, which in most cases are passed in the face of unanimous opposition from Africans.

I was developing the point that a judiciary controlled entirely by whites and enforcing laws enacted by a white Parliament in which we have no representation, laws which in most cases are passed in the face of unanimous opposition from Africans, cannot be regarded as an impartial tribunal in a political trial where an African stands as an accused.

The Universal Declaration of Human Rights provides that all men are equal before the law and are entitled without any discrimination to equal protection of the law. In May 1951, Dr. D. F. Malan, then prime minister, told the Union Parliament that this provision of the declaration applies in this country. Similar statements have been made on numerous occasions in the past by prominent whites in this country, including judges and magistrates. But the real truth is that there is in fact no equality before the law whatsoever as far as our people are concerned, and statements to the contrary are definitely incorrect and misleading.

It is true that an African who is charged in a court of law enjoys on the surface the same rights and privileges as a white accused, insofar as the conduct of his trial is concerned. He is governed by the same rules of procedure and evidence as apply to a white accused. But it will be grossly inaccurate to conclude from this fact that an African consequently enjoys equality before the law. In its proper meaning, equality before the law means the right to participate in the making of the laws by which one is governed. It means a constitution which guarantees democratic rights to all sections of the population, the right to approach the court for protection or relief in the case of the violation of the rights guaranteed in the constitution, and the right to take part in the administration of justice as judges, magistrates, attorney general, prosecutors, law advisers, and similar positions. In the absence of these safeguards the phrase "equal before the law" insofar as it is intended to apply to us, is meaningless and misleading.

All the rights and privileges to which I have referred are monopolised in this country exclusively by whites, and we enjoy none of them. The white man makes all the laws; he drags us before his courts and accuses us; and he sits in

judgement over us. Now it is fit and proper to ask the question, Sir, what is this rigid colour bar in the administration of justice all about? Why is it that in this courtroom I am facing a white magistrate, confronted by a white prosecutor, escorted by white orderlies? Can anybody honestly and seriously suggest that in this type of atmosphere the scales of justice are evenly balanced? Why is it that no African in the history of this country has ever had the honour of being tried by his own kith and kin, by his own flesh and blood? I will tell Your Worship why: The real purpose of this rigid colour bar is to ensure that the justice dispensed by the courts should conform to the policy of the country, however much that policy might be in conflict with the norms of justice accepted in judiciaries throughout the civilised world.

I feel oppressed by the atmosphere of white domination that is around me in this courtroom. Somehow this atmosphere recalls to mind the inhuman injustice caused to my people outside this courtroom by the same white domination. It reminds me that I am voteless because there is a Parliament in this country that is white controlled. I am without land because the white minority has taken the lion's share of my country, and I am forced to occupy poverty stricken reserves which are overpopulated and overstocked. We are ravished by starvation and disease because our country's worth—

Your Worship, the next point which I want to make is this: I raise the question, how can I be expected to believe that this same racial discrimination which has been the cause of so much injustice and suffering right through the years should now operate here to give me a fair and open trial? Is there no danger that an African accused may regard the courts not as impartial tribunals, dispensing justice without fear or favour, but as instruments used by the white man to punish those amongst us who clamour for deliverance from the fiery furnace of white rule. I have grave fears that this system of justice may enable the guilty to drag the innocent before the courts. It enables the unjust to prosecute and demand vengeance against the just. It may tend to lower the standards of fairness and justice applied in the country's courts by white judicial officers to black litigants. This is the first ground for this application, that I will not receive a fair and proper trial.

Now the second ground for this application is that I consider myself neither morally or legally bound to obey laws made by a Parliament in which I have no representation. That the will of the people is the basis of the authority of government is a principle universally acknowledged as sacred throughout the civilised world and constitutes the basic foundation of freedom and justice. It is understandable why citizens who have the vote as well as the right of direct representation in the country's governing bodies should be morally and legally bound by the laws governing the country. It should be equally understandable why we as Africans should adopt the attitude that we are neither morally nor legally bound to obey laws which were not made with our consent, nor can we be expected to have confidence in courts that interpret and enforce such laws.

I am aware, Your Worship, that in many cases of this nature in the past South African courts have upheld the right of the African people to work for democratic changes. Some of our judicial officers have even openly criticised

the policy which refuses to acknowledge that all men are born free and equal and fearlessly condemned the denial of opportunities to our people. But such exceptions, Your Worship, exist in spite, not because of, the grotesque system of justice that has been built up in this country. These exceptions furnish yet another proof that even among the country's whites there are honest men, whose sense of fairness and justice revolt against the cruelties perpetrated by their own white brothers to our people. The existence of genuine democratic values among some of the country's whites in the judiciary, however slender they may be, is welcomed by me, but I have no illusions about the significance of this fact, healthy a sign as it may be. Such honest and upright men are few, and they have certainly not succeeded in convincing the vast majority of the rest of the white population that white supremacy leads to dangers and disasters.

Your Worship, I hate racial discrimination most intensely and in all its manifestations. I have fought it all along my life. I fight it now, and I will do so until the end of my days. I detest most intensely the setup that surrounds me here. It makes me feel that I am a black man in a white man's court. This should not be. I should feel perfectly free and at ease with the assurance that I am being tried by a fellow South African who does not regard me as inferior, entitled to a special type of justice. This is not the type of atmosphere most conducive to feelings of security and confidence in the impartiality of the court.

Now the court might reply to this part of my argument by assuring me that it will try my case fairly and without fear of favour, that in deciding whether or not I am guilty of the offence charged by the state, the court will not be influenced by the colour of my skin or by any improper motive. That might well be so. But such a reply will completely miss the whole point of my argument. As already indicated, my objection is not directed to Your Worship in his personal capacity, nor is it intended to reflect upon the integrity of the court. My objection is based upon the fact that our courts as presently constituted create grave doubts in the mind of an African accused whether he will receive a fair and a proper trial. This doubt springs from objective facts relating to the practice of unfair discrimination against the black man in the constitution of the country's courts. Such doubts cannot be allayed by mere verbal assurances from a presiding officer, however sincere such assurances may be. There is only one way, and one way only, of allaying such doubts: by removing discrimination, particularly in judicial appointments. This is my first difficulty.

I have yet another difficulty about similar assurances Your Worship might give. Broadly speaking, Africans and whites in this country have no common standard of fairness, morality, and ethics, and it will be very difficult for me to determine what standard of fairness and justice Your Worship has in mind. In relationships with us, South African whites regard as fair and just to pursue policies which have outraged the conscience of mankind, and of honest and upright men throughout the civilised world. They suppress our aspirations, bar our way to freedom, and deny us opportunities in our moral and material progress, to secure ourselves from fear and want. All the good things of life are

reserved for the white folk, and we blacks are expected to be content to nourish our bodies with such pieces of food as drop from the tables of men with a white skin. This is the white man's standard of fairness and justice. Herein lies his conception of ethics. Whatever he himself may say in his defence, the white man's moral standards in this country must be judged by the extent to which he has condemned the vast majority of its citizens to serfdom and inferiority.

We, on the other hand, Your Worship, regard the struggle against colour discrimination and for the pursuit of freedom as the highest aspiration of all men. Through bitter experience we have learnt to regard the white man as a harsh and merciless type of human being, whose contempt for our rights and whose utter indifference to the promotion of our welfare makes his assurances to us absolutely meaningless and hypocritical.

I have the hope and the confidence that Your Worship will not treat this objection lightly, nor regard it as a frivolous one. I have decided to speak frankly and honestly, because the injustices I have referred to tend to undermine our confidence in the impartiality of our courts in cases of this nature, and they contain the seeds of an extremely dangerous situation for our country and people. I make no threats, Your Worship, when I say that unless these wrongs to which I have pointed are remedied without delay, we might well find that even plain talk before the country's courts is too timid a method to draw attention to our grievances.

Finally, I need only say that the courts have said that the possibility of bias and not actual bias is all that need be proved to ground an application of this nature. In this application I have merely referred to certain objective facts, from which I submit that the possibility be inferred that I will not receive a fair and proper trial.

BY THE COURT:

Your application is dismissed. Will you now plead to your charges?

BY THE ACCUSED:

I plead NOT GUILTY to both charges, to all the charges.

23 *I Am Prepared to Die*

Excerpted from Courtroom Statement,
Rivonia Trial, April 20, 1964

I am the first accused.

I hold a bachelor's degree in arts and practised as an attorney in Johannesburg for a number of years in partnership with Oliver Tambo. I am a convicted prisoner serving five years for leaving the country without a permit and for inciting people to go on strike at the end of May 1961.

At the outset, I want to say that the suggestion made by the state in its opening that the struggle in South Africa is under the influence of foreigners or communists is wholly incorrect. I have done whatever I did, both as an individual and as a leader of my people, because of my experience in South Africa and my own proudly felt African background, and not because of what any outsider might have said.

In my youth in the Transkei I listened to the elders of my tribe telling stories of the old days. Amongst the tales they related to me were those of wars fought by our ancestors in defence of the fatherland. The names of Dingane and Bambata, Hintsa and Makana, Squngthi and Dalasile, Moshoeshoe and Sekhukhuni, were praised as the glory of the entire African nation. I hoped then that life might offer me the opportunity to serve my people and make my own humble contribution to their freedom struggle. This is what has motivated me in all that I have done in relation to the charges made against me in this case.

Having said this, I must deal immediately and at some length, with the question of violence. Some of the things so far told to the court are true and some are untrue. I do not, however, deny that I planned sabotage. I did not plan it in a spirit of recklessness, nor because I have any love of violence. I planned it as a result of a calm and sober assessment of the political situation that had arisen after many years of tyranny, exploitation, and oppression of my people by the whites.

I admit immediately that I was one of the persons who helped to form Umkhonto we Sizwe and that I played a prominent role in its affairs until I was arrested in August 1962.

In the statement which I am about to make I shall correct certain false impressions which have been created by state witnesses. Amongst other things, I will demonstrate that certain of the acts referred to in the evidence were not and could not have been committed by Umkhonto. I will also deal with the relationship between the African National Congress and Umkhonto, and with the part which I personally have played in the affairs of both organizations. I shall deal also with the part played by the Communist party. In order to explain these matters properly I will have to explain what Umkhonto set out to achieve, what methods it prescribed for the achievement of these objects, and why these methods were chosen. I will also have to explain how I became involved in the activities of these organizations.

I deny that Umkhonto was responsible for a number of acts which clearly fell outside the policy of the organization and which have been charged in the indictment against us. I do not know what justification there was for these acts, but to demonstrate that they could not have been authorised by Umkhonto, I want to refer briefly to the roots and policy of the organization.

I have already mentioned that I was one of the persons who helped to form Umkhonto. I, and the others who started the organization, did so for two reasons. Firstly, we believed that as a result of government policy, violence by the African people had become inevitable and that unless responsible leadership was given to canalise and control the feelings of our people, there would

be outbreaks of terrorism which would produce an intensity of bitterness and hostility between the various races of this country which is not produced even by war. Secondly, we felt that without violence there would be no way open to the African people to succeed in their struggle against the principle of white supremacy. All lawful modes of expressing opposition to this principle had been closed by legislation, and we were placed in a position in which we had either to accept a permanent state of inferiority or to defy the government. We chose to defy the law. We first broke the law in a way which avoided any recourse to violence; when this form was legislated against and when the government resorted to a show of force to crush opposition to its policies, only then did we decide to answer violence with violence.

But the violence which we chose to adopt was not terrorism. We who formed Umhkonto were all members of the African National Congress and had behind us the ANC tradition of nonviolence and negotiation as a means of solving political disputes. We believe that South Africa belonged to all the people who lived in it, and not to one group, be it black or white. We did not want an interracial war and tried to avoid it to the last minute. If the court is in doubt about this, it will be seen that the whole history of our organization bears out what I have said and what I will subsequently say when I describe the tactics which Umkhonto decided to adopt. I want, therefore, to say something about the African National Congress.

The African National Congress was formed in 1912 to defend the rights of the African people which had been seriously curtailed by the South Africa Act, and which were then being threatened by the Native Land Act. For thirty-seven years—that is until 1949—it adhered strictly to a constitutional struggle. It put forward demands and resolutions; it sent delegations to the government in the belief that African grievances could be settled through peaceful discussion and that Africans could advance gradually to full political rights. But white governments remained unmoved, and the rights of Africans became less instead of becoming greater. In the words of my leader, Chief Luthuli, who became president of the ANC in 1952, and who was later awarded the Nobel Peace Prize:

> Who will deny that thirty years of my life have been spent knocking in vain, patiently, moderately, and modestly at a closed and barred door? What have been the fruits of moderation? The past thirty years have seen the greatest number of laws restricting our rights and progress, until today we have reached a stage where we have almost no rights at all.

Even after 1949, the ANC remained determined to avoid violence. At this time, however, there was a change from the strictly constitutional means of protest which had been employed in the past. The change was embodied in a decision which was taken to protest against apartheid legislation by peaceful, but unlawful, demonstrations against certain laws. Pursuant to this policy the ANC launched the Defiance Campaign, in which I was placed in charge of volunteers. This campaign was based on the principles of passive resistance. More than 8,500 people defied apartheid laws and went to gaol. Yet there was

not a single instance of violence in the course of this campaign on the part of any defier. I, and nineteen colleagues were convicted for the role which we played in organizing the campaign, but our sentences were suspended mainly because the judge found that discipline and nonviolence had been stressed throughout. This was the time when the volunteer section of the ANC was established, and when the word *Amadelakufa* was first used: this was the time when the volunteers were asked to take a pledge to uphold certain principles. Evidence dealing with volunteers and their pledges has been introduced into this case, but completely out of context. The volunteers were not, and are not, the soldiers of a black army pledged to fight a civil war against the whites. They were, and are, the dedicated workers who are prepared to lead campaigns initiated by the ANC to distribute leaflets, to organize strikes, or do whatever the particular campaign required. They are called volunteers because they volunteer to face the penalties of imprisonment and whipping which are now prescribed by the legislature for such acts.

During the Defiance Campaign, the Public Safety Act and the Criminal Law Amendment Act were passed. These statutes provided harsher penalties for offences committed by way of protests against laws. Despite this, the protests continued and the ANC adhered to its policy of nonviolence. In 1956, one hundred and fifty-six leading members of the Congress Alliance, including myself, were arrested on a charge of High Treason and charged under the Suppression of Communism Act. The nonviolent policy of the ANC was put in issue by the state, but when the court gave judgment some five years later, it found that the ANC did not have a policy of violence. We were acquitted on all counts, which included a count that the ANC sought to set up a communist state in place of the existing regime. The government has always sought to label all its opponents as communists. This allegation has been repeated in the present case, but as I will show, the ANC is not, and never has been a communist organization.

In 1960, there was the shooting at Sharpeville, which resulted in the proclamation of a state of emergency and the declaration of the ANC as an unlawful organization. My colleagues and I, after careful consideration, decided that we would not obey this decree. The African people were not part of the government and did not make the laws by which they were governed. We believed in the words of the Universal Declaration of Human Rights, that "the will of the people shall be the basis of the authority of the Government" and for us to accept the banning was equivalent to accepting the silencing of the Africans for all time. The ANC refused to dissolve but instead went underground. We believed it was our duty to preserve this organization which had been built up with almost fifty years of unremitting toil. I have no doubt that no self-respecting white political organization would disband itself if declared illegal by a government in which it had no say.

In some of the evidence the M plan has been completely misrepresented. It was nothing more than a method of organizing, planned in 1953, and put into operation with varying degrees of success thereafter. After April 1960, new methods had to be devised, for instance, by relying on smaller committees. The

M plan was referred to in evidence at the treason trial, but it had nothing whatsoever to do with sabotage or Umkhonto we Sizwe and was never adopted by Umkhonto.

In 1960 the government held a referendum which led to the establishment of the republic. Africans, who constituted approximately 70 percent of the population of South Africa, were not entitled to vote and were not even consulted about the proposed constitutional change. All of us were apprehensive of our future under the proposed white republic, and a resolution was taken to hold an All-in African Conference to call for a national convention, and to organize mass demonstrations on the eve of the unwanted republic, if the government failed to call the convention. The conference was attended by Africans of various political persuasions. I was the secretary of the conference and undertook to be responsible for organizing the national stay-at-home which was subsequently called to coincide with the declaration of the Republic. As all strikes by Africans are illegal, the person organizing such a strike must avoid arrest. I was chosen to be this person, and consequently I had to leave my home and family and my practice and go into hiding to avoid arrest.

The stay-at-home, in accordance with ANC policy, was to be a peaceful demonstration. Careful instructions were given to organizers and members to avoid any recourse to violence. The government's answer was to introduce new and harsher laws, to mobilise its armed forces; and to send saracens, armed vehicles and soldiers into the townships in a massive show of force designed to intimidate the people. This was an indication that the government had decided to rule by force alone, and this decision was a milestone on the road to Umkhonto.

Some of this may appear irrelevant to this trial. In fact, I believe none of it is irrelevant because it will, I hope, enable the court to appreciate the attitude eventually adopted by the various persons and bodies concerned in the national liberation movement. When I went to gaol in 1962, the dominant idea was that loss of life should be avoided. I now know that this was still so in 1963.

I must return to June 1961. What were we, the leaders of our people, to do? Were we to give in to the show of force and the implied threat against future action, or were we to fight it and, if so, how?

We had no doubt that we had to continue the fight. Anything else would have been abject surrender. Our problem was not whether to fight but was how to continue to fight. We of the ANC had always stood for a nonracial democracy, and we shrank from any action which might drive the races further apart than they already were. But the hard facts were that fifty years of nonviolence had brought the African people nothing but more and more repressive legislation, and fewer and fewer rights. It may not be easy for this court to understand, but it is a fact that for a long time the people had been talking of violence—of the day when they would fight the white man and win back their country, and we, the leaders of the ANC, had nevertheless always prevailed upon them to avoid violence to pursue peaceful methods. When some of us discussed this in May and June of 1961, it could not be denied that our policy to achieve a nonracial state by nonviolence had achieved nothing and that our

followers were beginning to lose confidence in this policy and were developing disturbing ideas of terrorism.

It must not be forgotten that by this time violence had, in fact, become a feature of the South African political scene. There had been violence in 1957 when the women of Zeerust were ordered to carry passes; there was violence in 1958 with the enforcement of cattle culling in Sekhukhuniland; there was violence in 1959 when the people of Cato Manor protested against pass raids; there was violence in 1960 when the government attempted to impose Bantu authorities in Pondoland. Thirty-nine Africans died in these disturbances. In 1961 there had been riots in Warmbaths, and all this time the Transkei had been a seething mass of unrest. Each disturbance pointed clearly to the inevitable growth among Africans of the belief that violence was the only way out—it showed that a government which uses force to maintain its rule teaches the oppressed to use force to oppose it. Already small groups had arisen in the urban areas and were spontaneously making plans for violent forms of political struggle. There now arose a danger that these groups would adopt terrorism against Africans, as well as whites, if not properly directed. Particularly disturbing was the type of violence engendered in places such as Zeerust, Sekhukhuniland, and Pondoland amongst Africans. It was increasingly taking the form, not of struggle against the government—though this is what prompted it—but of civil strife amongst themselves, conducted in such a way that it could not hope to achieve anything other than a loss of life and bitterness.

At the beginning of June 1961, after a long and anxious assessment of the South African situation, I and some colleagues came to the conclusion that as violence in this country was inevitable, it would be unrealistic and wrong for African leaders to continue preaching peace and nonviolence at a time when the government met our peaceful demands with force.

This conclusion was not easily arrived at. It was only when all else had failed, when all channels of peaceful protest had been barred to us, that the decision was made to embark on violent forms of political struggle and to form Umkhonto we Sizwe. We did so not because we desired such a course, but solely because the government had left us with no other choice. In the manifesto of Umkhonto published on the 16th December 1961, which is Exhibit AD [Document 66], we said:

> The time comes in the life of any nation when there remains only two choices—submit or fight. That time has now come to South Africa. We shall not submit and we have no choice but to hit back by all means in our power in defence of our people, our future and our freedom.

This was our feeling in June of 1961 when we decided to press for a change in the policy of the national liberation movement. I can only say that I felt morally obliged to do what I did.

We who had taken this decision started to consult leaders of various organizations, including the ANC. I will not say whom we spoke to, or what they said, but I wish to deal with the role of the African National Congress in this phase of the struggle and with the policy and objectives of Umkhonto we Sizwe.

As far as the ANC was concerned, it formed a clear view which can be summarized as follows:

a. It was a mass political organization with a political function to fulfill. Its members had joined on the express policy of nonviolence.
b. Because of all this, it could not and would not undertake violence. This must be stressed. One cannot turn such a body into the small closely knit organization required for sabotage. Nor would this be politically correct, because it would result in members ceasing to carry out this essential activity: political propaganda and organization. Nor was it permissible to change the whole nature of the organization.
c. On the other hand, in view of this situation I have described, the ANC was prepared to depart from its fifty-year-old policy of nonviolence to this extent that it would no longer disapprove of properly controlled violence. Hence members who undertook such activity would not be subject to disciplinary action by the ANC.

I say "properly controlled violence" because I made it clear that if I formed the organization I would at all times subject it to the political guidance of the ANC and would not undertake any different form of activity from that contemplated without the consent of the ANC. And I shall now tell the court how that form of violence came to be determined.

As a result of this decision, Umkhonto was formed in November 1961. When we took this decision and subsequently formulated our plans, the ANC heritage of nonviolence and racial harmony was very much with us. We felt that the country was drifting towards a civil war in which blacks and whites would fight each other. We viewed the situation with alarm. Civil war could mean the destruction of what the ANC stood for; with civil war racial peace would be more difficult than ever to achieve. We already have examples in South African history of the results of war. It has taken more than fifty years for the scars of the South African War to disappear. How much longer would it take to eradicate the scars of interracial civil war, which could not be fought without a great loss of life on both sides?

The avoidance of civil war had dominated our thinking for many years, but when we decided to adopt violence as part of our policy, we realised that we might one day have to face the prospect of such a war. This had to be taken into account in formulating our plans. We required a plan which was flexible and which permitted us to act in accordance with the needs of the times; above all, the plan had to be one which recognised civil war as the last resort, and left the decision on this question to the future. We did not want to be committed to civil war, but we wanted to be ready if it became inevitable.

Four forms of violence are possible. There is sabotage, there is guerrilla warfare, there is terrorism, and there is open revolution. We chose to adopt the first method and to exhaust it before taking any other decision.

In the light of our political background the choice was a logical one. Sabotage did not involve loss of life, and it offered the best hope for future race relations. Bitterness would be kept to a minimum, and if the policy bore fruit,

democratic government could become a reality. This is what we felt at the time, and this is what we said in our manifesto (Exhibit AD):

> We of Umkhonto we Sizwe have always sought to achieve liberation without bloodshed and civil clash. We hope, even at this late hour, that our first actions will awaken everyone to a realisation of the disastrous situation to which the Nationalist policy is leading. We hope that we will bring the government and its supporters to their senses before it is too late, so that both the government and its policies can be changed before matters reach the desperate stage of civil war.

The initial plan was based on a careful analysis of the political and economic situation of our country. We believed that South Africa depended to a large extent on foreign capital and foreign trade. We felt that planned destruction of power plants, and interference with rail and telephone communications would tend to scare away capital from the country, make it more difficult for goods from the industrial areas to reach the seaports on schedule, and would in the long run be a heavy drain on the economic life of the country, thus compelling the voters of the country to reconsider their position.

Attacks on the economic life lines of the country were to be linked with sabotage on government buildings and other symbols of apartheid. These attacks would serve as a source of inspiration to our people. In addition, they would provide an outlet for those people who were urging the adoption of violent methods and would enable us to give concrete proof to our followers that we had adopted a stronger line and were fighting back against government violence.

In addition, if mass action were successfully organized and mass reprisals taken, we felt that sympathy for our cause would be roused in other countries and that greater pressure would be brought to bear on the South African government.

This then was the plan. Umkhonto was to perform sabotage, and strict instructions were given to its members right from the start, that on no account were they to injure or kill people in planning or carrying out operations.

The affairs of the Umkhonto were controlled and directed by a national high command, which had powers of cooption and which could, and did, appoint regional commands. The high command was the body which determined tactics and targets and was in charge of training and finance. Under the high command there were regional commands which were responsible for the direction of the local sabotage groups. Within the framework of the policy laid down by the national high command, the regional commands had authority to select the targets to be attacked. They had no authority to go beyond the prescribed framework and thus had no authority to embark upon acts which endangered life, or which did not fit into the overall plan of sabotage. For instance, MK members were forbidden ever to go armed into operation. Incidentally, the terms high command and regional command were an importation from the Jewish national underground organization Irgun Zvai Leumi, which operated in Israel between 1944 and 1948.

Umkhonto had its first operation on the 16th December 1961 when government buildings in Johannesburg, Port Elizabeth, and Durban were attacked. The selection of targets is proof of the policy to which I have referred. Had we intended to attack life we would have selected targets where people congregated and not empty buildings and power stations. The sabotage which was committed before the 16th December 1961 was the work of isolated groups and had no connection whatever with Umkhonto. In fact, some of these and a number of later acts were claimed by other organizations.

The manifesto of Umkhonto was issued on the day that operations commenced. The response to our actions and manifesto among the white population was characteristically violent. The government threatened to take strong action and called upon its supporters to stand firm and to ignore the demands of the Africans. The whites failed to respond by suggesting change; they responded to our call by suggesting the laager.

In contrast, the response of the Africans was one of encouragement. Suddenly there was hope again. Things were happening. People in the townships became eager for political news. A great deal of enthusiasm was generated by the initial successes, and people began to speculate on how soon freedom would be obtained.

But we in Umkhonto weighed up the white response with anxiety. The lines were being drawn. The whites and blacks were moving into separate camps, and the prospects of avoiding a civil war were made less. The white newspapers carried reports that sabotage would be punished by death. If this was so, how could we continue to keep Africans away from terrorism?

Already scores of Africans had died as a result of racial friction. In 1920 when the famous leader Masabala was held in Port Elizabeth gaol, twenty-four of a group of Africans who had gathered to demand his release were killed by the police and white civilians. In 1921, more than one hundred Africans died in the Bulhoek affair. In 1924 over two hundred Africans were killed when the administrator of South-West Africa led a force against a group which had rebelled against the imposition of dog tax. On the 1st May 1950, eighteen Africans died as a result of police shootings during the strike. On the 21st March 1960, sixty-nine unarmed Africans died at Sharpeville.

How many more Sharpevilles would there be in the history of our country? And how many more Sharpevilles could the country stand without violence and terror becoming the order of the day? And what would happen to our people when that stage was reached? In the long run we felt certain we must succeed, but at what cost to ourselves and the rest of the country? And if this happened, how could black and white ever live together again in peace and harmony? These were the problems that faced us, and these were our decisions.

Experience convinced us that rebellion would offer the government limitless opportunities for the indiscriminate slaughter of our people. But it was precisely because the soil of South Africa is already drenched with the blood of innocent Africans that we felt it our duty to make preparations as a long-term undertaking to use force in order to defend ourselves against force. If war were inevitable, we wanted the fight to be conducted on terms most favourable to

our people. The fight which held out prospects best for us and the least risk of life to both sides was guerrilla warfare. We decided, therefore, in our preparations for the future, to make provision for the possibility of guerrilla warfare.

All whites undergo compulsory military training, but no such training was given to Africans. It was in our view essential to build up a nucleus of trained men who would be able to provide the leadership which would be required if guerrilla warfare started. We had to prepare for such a situation before it became too late to make proper preparations. It was also necessary to build up a nucleus of men trained in civil administration and other professions, so that Africans would be equipped to participate in the government of this country as soon as they were allowed to do so.

At this stage it was decided that I should attend the Conference of the Pan-African Freedom Movement for Central, East, and Southern Africa, which was to be held early in 1962 in Addis Ababa, and because of our need for preparation, it was also decided that after the conference, I would undertake a tour of the African states with a view to obtaining facilities for the training of soldiers and that I would also solicit scholarships for the higher education of matriculated Africans. Training in both fields would be necessary, even if changes came about by peaceful means. Administrators would be necessary who would be willing and able to administer a nonracial state and so would men be necessary to control the army and police force of such a state.

It was on this note that I left South Africa to proceed to Addis Ababa as a delegate of the ANC. My tour was a success. Wherever I went I met sympathy for our cause and promises of help. All Africa was united against the stand of white South Africa, and even in London, I was received with great sympathy by political leaders, such as Mr. Gaitskell and Mr. Grimond. In Africa I was promised support by such men as Julius Nyerere, now president of Tanganyika; Mr. Kawawa, then prime minister of Tanganyika, Emperor Haile Selassie of Ethiopia; General Aboud, president of the Sudan; Habib Bourguiba, president of Tunisia; Ben Bella, now president of Algeria; Modiko Keita, president of Mali; Leophold Senghor, president of Senegal; Sekou Touré, president of Guinea; President Tubman of Liberia, and Milton Obote, prime minister of Uganda. It was Ben Bella who invited me to visit Oujda, the headquarters of the Algerian Army of National Liberation, the visit which is described in my diary, one of the exhibits.

I started to make a study of the art of war and revolution and, whilst abroad, underwent a course in military training. If there was to be guerrilla warfare, I wanted to be able to stand and fight with my people and to share the hazards of war with them. Notes of lectures which I received in Algeria are contained in Exhibit 16, produced in evidence. Summaries of books on guerrilla warfare and military strategy have also been produced. I have already admitted that these documents are in my writing, and I acknowledge that I made these studies to equip myself for the role which I might have to play if the struggle drifted into guerrilla warfare. I approached this question as every African nationalist should do. I was completely objective. The court will see that I attempted to examine all types of authority on the subject—from the

East and from the West, going back to the classic work of Clausewitz and covering such a variety as Mao Tse-tung and Che Guevara on the one hand, and the writings on the Anglo-Boer War on the other. Of course, these notes are merely summaries of the books I read and do not contain my personal views.

I also made arrangements for our recruits to undergo military training. But here it was impossible to organise any scheme without the cooperation of the ANC offices in Africa. I consequently obtained the permission of the ANC in South Africa to do this. To this extent then there was a departure from the original decision of the ANC, but it applied outside South Africa only. The first batch of recruits actually arrived in Tanganyika when I was passing through that country on my way back to South Africa.

I returned to South Africa and reported to my colleagues on the results of my trip. On my return I found that there had been little alteration in the political scene, save that the threat of a death penalty for sabotage had now become a fact. The attitude of my colleagues in Umkhonto was much the same as it had been before I left. They were feeling their way cautiously and felt that it would be a long time before the possibilities of sabotage were exhausted. In fact, the view was expressed by some that the training of recruits was premature. This is recorded by me in the document, which is Exhibit R. 14. After a full discussion, however, it was decided to go ahead with the plans for military training because of the fact that it would take many years to build up a sufficient nucleus of trained soldiers to start a guerrilla campaign, and whatever happened, the training would be of value.

One of the chief allegations in the indictment is that the ANC was a party to a general conspiracy to commit sabotage. I have already explained why this is incorrect but how, externally, there was a departure from the original principle laid down by the ANC. There has, of course, been overlapping of functions internally as well, because there is a difference between a resolution adopted in the atmosphere of a committee room and the concrete difficulties that arise in the field of practical activity. At a later stage the position was further affected by bannings and house arrests and by persons leaving the country to take up political work abroad. This led to individuals having to do work in different capacities. But though this may have blurred the distinction between Umkhonto and the ANC, it by no means abolished that distinction. Great care was taken to keep the activities of the two organizations in South Africa distinct. The ANC remained a mass political body of Africans only carrying on the type of political work they had conducted prior to 1961. Umkhonto remained a small organization recruiting its members from different races and organizations and trying to achieve its own particular object. The fact that members of Umkhonto were recruited from the ANC, and the fact that persons served both organizations, like Solomon Mbanjwa, did not, in our view, change the nature of the ANC or give it a policy of violence. This overlapping of officers, however, was more the exception than the rule.

Another of the allegations made by the state is that the aims and objects of the ANC and the Communist party are the same. I wish to deal with this and

with my own political position, because I must assume that the state may try to argue from certain exhibits that I tried to introduce Marxism into the ANC. The allegation as to the ANC is false. This is an old allegation which was disproved at the treason trial and which has again reared its head. But since the allegation has been made again, I shall deal with it as well as with the relationship between the ANC and the Communist party and Umkhonto and that party.

The ideological creed of the ANC is, and always has been, the creed of African nationalism. It is not the concept of African nationalism expressed in the cry "Drive the white man into the sea." The African nationalism for which the ANC stands, is the concept of freedom and fulfilment for the African people in their own land. The most important political document ever adopted by the ANC is the Freedom Charter. It is by no means a blueprint for a socialist state. It calls for redistribution, but not nationalisation, of land; it provides for nationalisation of mines, banks and monopoly industry, because big monopolies are owned by one race only, and without such nationalisation racial domination would be perpetuated despite the spread of political power. It would be a hollow gesture to repeal the Gold Law prohibitions against Africans when all gold mines are owned by European companies. In this respect the ANC's policy corresponds with the old policy of the present Nationalist party which, for many years, had as part of its programme the nationalisation of the gold mines which, at that time, were controlled by foreign capital. Under the Freedom Charter nationalisation would take place in an economy based on private enterprise. The realisation of the Freedom Charter would open up fresh fields for a prosperous African population of all classes, including the middle class. The ANC has never at any period of its history advocated a revolutionary change in the economic structure of the country, nor has it, to the best of my recollection, ever condemned capitalist society.

As far as the Communist party is concerned, and if I understand its policy correctly, it stands for the establishment of a state based on the principles of Marxism. Although it is prepared to work for the Freedom Charter, as a short-term solution to the problems created by white supremacy, it regards the Freedom Charter as the beginning, and not the end of, its programme.

The ANC unlike the Communist party, admitted Africans only as members. Its chief goal was and is for the African people to win unity and full political rights. The Communist party's main aim, on the other hand, was to remove the capitalists and to replace them with a working-class government. The Communist party sought to emphasize class distinctions whilst the ANC seeks to harmonise them. This is a vital distinction.

It is true that there has often been close cooperation between the ANC and the Communist party. But cooperation is merely proof of a common goal—in this case the removal of white supremacy—and is not proof of a complete community of interests.

The history of the world is full of similar examples. Perhaps the most striking illustration is to be found in the cooperation between Great Britain,

the United States of America, and the Soviet Union in the fight against Hitler. Nobody but Hitler would have dared to suggest that such cooperation turned Churchill or Roosevelt into communists or communist tools, or that Britain and America were working to bring about a communist world.

Another instance of such cooperation is to be found precisely in Umkhonto. Shortly after MK was constituted, I was informed by some of its members that the Communist party would support Umkhonto, and this then occurred. At a later stage the support was made openly.

I believe that Communists have always played an active role in the fight by colonial countries for their freedom, because the short-term objects of Communism would always correspond with the long-term objects of freedom movements. Thus Communists have played an important role in the freedom struggles fought in countries such as Malaya, Algeria, and Indonesia, yet none of these states today are Communist countries. Similarly in the underground resistance movements which sprung up in Europe during the last world war, Communists played an important role. Even General Chiang Kai-chek, today one of the bitterest enemies of Communism, fought together with the Communists against the ruling class in the struggle which led to his assumption of power in China in the 1930s.

This pattern of cooperation between Communists and non-Communists has been repeated in the national liberation movement of South Africa. Prior to the banning of the Communist party, joint campaigns involving the Communist party and the Congress movements were accepted practice. African Communists could, and did, become members of the ANC, and some served on the national, provincial, and local committees. Amongst those who served on the National Executive are Albert Nzula, a former secretary of the Communist party, Moses Kotane, another former secretary and J. B. Marks, a former member of the Central Committee.

I joined the ANC in 1944, and in my younger days I held the view that the policy of admitting Communists to the ANC, and the close cooperation which existed at times on specific issues between the ANC and the Communist party, would lead to a watering down of the concept of African nationalism. At that stage I was a member of the African National Congress Youth League and was one of a group which moved for the expulsion of Communists from the ANC. This proposal was heavily defeated. Amongst those who voted against the proposal were some of the most conservative sections of African political opinion. They defended the policy on the ground that from its inception the ANC was formed and built up not as a political party with one school of political thought but as a parliament of the African people, accommodating people of various political convictions, all united by the common goal of national liberation. I was eventually won over to this point of view and have upheld it ever since.

It is perhaps difficult for white South Africans, with an ingrained prejudice against Communism, to understand why experienced African politicians so readily accept Communists as their friends. But to us the reason is obvious. Theoretical differences amongst those fighting against oppression is a luxury

we cannot afford at this stage. What is more, for many decades Communists were the only political group in South Africa who were prepared to treat Africans as human beings and their equals, who were prepared to eat with us, talk with us, live with us, and work with us. They were the only political group which was prepared to work with the Africans for the attainment of political rights and a stake in society. Because of this, there are many Africans who today tend to equate freedom with Communism. They are supported in this belief by a legislature which brands all exponents of democratic government and African freedom as Communists and bans many of them (who are not Communists) under the Suppression of Communism Act. Although I have never been a member of the Communist party, I myself have been named under that pernicious act because of the role I played in the Defiance Campaign. I have also been banned and imprisoned under that act.

It is not only in internal politics that we count Communists as amongst those who support our cause. In the international field, Communist countries have always come to our aid. In the United Nations and other councils of the world, the Communist block has supported the Afro-Asian struggle against colonialism and often seeems to be more sympathetic to our plight than some of the Western powers. Although there is a universal condemnation of apartheid, the Communist block speaks out against it with a louder voice than most of the white world. In these circumstances, it would take a brash young politician, such as I was in 1949, to proclaim that the Communists are our enemies.

I turn now to my own position. I have denied that I am a Communist, and I think that in the circumstances I am obliged to state exactly what my political beliefs are.

I have always regarded myself, in the first place, as an African patriot. After all, I was born in Umtata, forty-six years ago. My guardian was my cousin, who was the acting paramount chief of Tembuland, and I am related both to the present paramount chief of Tembuland, Sabata Dalinyebo, and to Kaizer Matanzima, the chief minister of the Transkei.

Today I am attracted by the idea of a classless society, an attraction which springs in part from Marxist reading and, in part, from my admiration of the structure and organization of early African societies in this country. The land, then the main means of production, belonged to the tribe. There were no rich or poor, and there was no exploitation.

It is true, as I have already stated, that I have been influenced by Marxist thought. But this is also true of many of the leaders of the new independent states. Such widely different persons as Gandhi, Nehru, Nkrumah, and Nasser all acknowledge this fact. We all accept the need for some form of socialism to enable our people to catch up with the advanced countries of this world and to overcome their legacy of extreme poverty. But this does not mean we are Marxists.

Indeed, for my own part, I believe that it is open to debate whether the Communist party has any specific role to play at this particular stage of our political struggle. The basic task at the present moment is the removal of race

discrimination and the attainment of democratic rights on the basis of the Freedom Charter. Insofar as that party furthers this task, I welcome its assistance. I realize that it is one of the means by which people of all races can be drawn into our struggle.

From my reading of Marxist literature and from conversations with Marxists, I have gained the impression that Communists regard the parliamentary system of the West as undemocratic and reactionary. But on the contrary, I am an admirer of such a system.

The Magna Carta, the Petition of Rights, and the Bill of Rights are documents which are held in veneration by democrats throughout the world.

I have great respect for British political institutions and for the country's system of justice. I regard the British Parliament as the most democratic institution in the world, and the independence and impartiality of its judiciary never fail to arouse my admiration.

The American Congress, that country's doctrine of separation of powers, as well as the independence of its judiciary, arouse in me similar sentiments.

I have been influenced in my thinking by both West and East. All this has led me to feel that in my search for a political formula, I should be absolutely impartial and objective. I should tie myself to no particular system of society other than of socialism. I must leave myself free to borrow the best from the West and from the East.

There are certain exhibits which suggest that we received financial support from abroad, and I wish to deal with this question.

Our political struggle has always been financed from internal sources—from funds raised by our own people and by our own supporters. Whenever we had a special campaign or an important political case—for example, the treason trial—we received financial assistance from sympathetic individuals and organizations in the Western countries. We had never felt it necessary to go beyond these sources.

But when in 1961 the MK was formed and a new phase of struggle introduced, we realized that these events would make a heavy call on our slender resources and that the scale of our activities would be hampered by the lack of funds. One of my instructions, as I went abroad in January 1962, was to raise funds from the African states.

I must add that whilst abroad, I had discussions with leaders of political movements in Africa and discovered that almost every single one of them, in areas which had still not attained independence, had received all forms of assistance from the socialist countries, as well as from the West, including that of financial support. I also discovered that some well-known African states, all of them non-Communists and even anti-Communists, had received similar assistance.

On my return to the republic, I made a strong recommendation to the ANC that we should not confine ourselves to Africa and the Western countries but that we should also send a mission to the socialist countries to raise the funds which we so urgently needed.

I have been told that after I was convicted such a mission was sent, but I am

not prepared to name any countries to which it went, nor am I at liberty to disclose the names of the organizations and countries which gave us support or promised to do so.

As I understand the state case, and in particular the evidence of Mr. X, the suggestion is that Umkhonto was the inspiration of the Communist party which sought by playing upon imaginary grievances to enroll the African people into an army which ostensibly was to fight for African freedom, but in reality was fighting for a Communist state. Nothing could be further from the truth. In fact the suggestion is preposterous. Umkhonto was formed by Africans to further their struggle for freedom in their own land. Communists and others supported the movement, and we only wish that more sections of the community would join us.

Our fight is against real, and not imaginary, hardships, or to use the language of the state prosecutor, "so-called hardships." Basically, we fight against two features which are the hallmarks of African life in South Africa and which are entrenched by legislation which we seek to have repealed. These features are poverty and lack of human dignity, and we do not need Communists or so-called agitators to teach us about these things.

South Africa is the richest country in Africa and could be one of the richest countries in the world. But it is a land of extremes and remarkable contrasts. The whites enjoy what may well be the highest standard of living in the world, whilst Africans live in poverty and misery. Forty percent of the Africans live in hopelessly overcrowded and, in some cases, drought-stricken reserves, where soil erosion and the overworking of the soil make it impossible for them to live properly off the land. Thirty percent are labourers, labour tenants, and squatters on white farms and work and live under conditions similar to those of the serfs of the Middle Ages. The other 30 percent live in towns where they have developed economic and social habits which bring them closer in many respects to white standards. Yet most Africans, even in this group, are impoverished by low incomes and high cost of living.

The highest-paid and the most prosperous section of urban African life is in Johannesburg. Yet their actual position is desperate. The latest figures were given on the 25th March 1964 by Mr. Carr, manager of the Johannesburg Non-European Affairs Department. The poverty datum line for the average African family in Johannesburg (according to Mr. Carr's department) is R42.84 per month. He showed that the average monthly wage is R32.24 and that 46 percent of all African families in Johannesburg do not earn enough to keep them going.

Poverty goes hand in hand with malnutrition and disease. The incidence of malnutrition and deficiency diseases is very high amongst Africans. Tuberculosis, pellagra, kwashiorkor, gastroenteritis, and scurvy bring death and destruction of health. The incidence of infant mortality is one of the highest in the world. According to the medical officer of health for Pretoria, tuberculosis kills 40 people a day (almost all Africans), and in 1961 there were 58,491 new cases reported. These diseases not only destroy the vital organs of the body, but they result in retarded mental conditions and lack of initiative and reduce

powers of concentration. The secondary results of such conditions affect the whole community and the standard of work performed by African labourers.

The complaint of Africans, however, is not only that they are poor and the whites are rich but that the laws which are made by the whites are designed to preserve this situation. There are two ways to break out of poverty. The first is by formal education, and the second is by the worker acquiring a greater skill at his work and thus higher wages. As far as Africans are concerned, both these avenues of advancement are deliberately curtailed by legislation.

The present government has always sought to hamper Africans in their search for education. One of their early acts after coming into power was to stop subsidies for African school feeding. Many African children who attended schools depended on this supplement to their diet. This was a cruel act.

There is compulsory education for all white children at virtually no cost to their parents, be they rich or poor. Similar facilities are not provided for the African children, though there are some who receive such assistance. African children, however, generally have to pay more for their schooling than whites. According to figures quoted by the South African Institute of Race Relations in its 1963 journal, approximately 40 percent of African children in the age group between 7 to 14, do not attend school. For those who do attend school, the standards are vastly different from those afforded to white children. In 1960–61 the per-capita government spending on African students at state-aided schools was estimated at R12.46. In the same years, the per capita spending on white children in the Cape Province (which are the only figures available to me) was R144.57. Although there are no figures available to me, it can be stated, without doubt, that the white children on whom R144.57 per head was being spent all came from wealthier homes than African children on whom R12.46 per head was being spent.

The quality of education is also different. According to the *Bantu Education Journal*, only 5,660 African children in the whole of South Africa passed their JC in 1962, and in that year only 362 passed matric. This is presumably consistent with the policy of Bantu education about which the present prime minister said, during the debate on the Bantu Education Bill in 1953:

> When I have control of native education I will reform it so that natives will be taught from childhood to realise that equality with Europeans is not for them. . . . People who believe in equality are not desirable teachers for natives. When my department controls native education it will know for what class of higher education a native is fitted and whether he will have a chance in life to use his knowledge.

The other main obstacle to the economic advancement of the African is the industrial colour bar under which all the better jobs of industry are reserved for whites only. Moreover, Africans who do obtain employment in the unskilled and semiskilled occupations which are open to them are not allowed to form trade unions which have recognition under the Industrial Conciliation Act. This means that strikes of African workers are illegal, and that they are denied the right of collective bargaining which is permitted to the better-paid white

workers. The discrimination in the policy of successive South African govern-ments towards African workers is demonstrated by the so-called civilised labour policy under which sheltered unskilled government jobs are found for those white workers who cannot make the grade in industry, at wages which far exceeded the earnings of the average African employee in industry.

The government often answers its critics by saying that Africans in South Africa are economically better off than the inhabitants of the other countries in Africa. I do not know whether this statement is true and doubt whether any comparison can be made without having regard to the cost of living index in such countries. But even if it is true, as far as the African people are concerned it is irrelevant. Our complaint is not that we are poor by comparison with people in other countries but that we are poor by comparison with the white people in our own country and that we are prevented by legislation from altering this imbalance.

The lack of human dignity experienced by Africans is the direct result of the policy of white supremacy. White supremacy implies black inferiority. Legisla-tion designed to preserve white supremacy entrenches this notion. Menial tasks in South Africa are invariably performed by Africans. When anything has to be carried or cleaned, the white man will look around for an African to do it for him, whether the African is employed by him or not. Because of this sort of attitude, whites tend to regard Africans as a separate breed. They do not look upon them as people with families of their own; they do not realise that they have emotions—that they fall in love like white people do; that they want to be with their wives and children like white people want to be with theirs; that they want to earn enough money to support their families properly, to feed and clothe them and send them to school. And what "house boy" or "garden boy" or labourer can ever hope to do this?

Pass laws, which to the Africans are among the most hated bits of legisla-tion in South Africa, render any African liable to police surveillance at any time. I doubt whether there is a single African male in South Africa who has not at some stage had a brush with the police over his pass. Hundreds and thousands of Africans are thrown into gaol each year under pass laws. Even worse than this is the fact that pass laws keep husband and wife apart and lead to the breakdown of family life.

Poverty and the breakdown of family life have secondary effects. Children wander about the streets of the townships because they have no schools to go to, or no money to enable them to go to school, or no parents at home to see that they go to school, because both parents (if there be two) have to work to keep the family alive. This leads to a breakdown in moral standards, to an alarming rise in illegitimacy, and to growing violence which erupts, not only politically, but everywhere. Life in the townships is dangerous. There is not a day that goes by without somebody being stabbed or assaulted. And violence is carried out of the townships [into] the white living areas. People are afraid to walk alone in the streets after dark. Housebreakings and robberies are increas-ing, despite the fact that the death sentence can now be imposed for such offences. Death sentences cannot cure the festering sore.

Africans want to be paid a living wage. Africans want to perform work which they are capable of doing, and not work which the government declares them to be capable of. Africans want to be allowed to live where they obtain work, and not be endorsed out of an area because they were not born there. Africans want to be allowed to own land in places where they work, and not to be obliged to live in rented houses which they can never call their own. Africans want to be part of the general population, and not confined to living in their own ghettos. African men want to have their wives and children to live with them where they work, and not be forced into an unnatural existence in men's hostels. African women want to be with their men folk and not be left permanently widowed in the reserves. Africans want to be allowed out after 11 o'clock at night and not to be confined to their rooms like little children. Africans want to be allowed to travel in their own country and to seek work where they want to and not where the Labour Bureau tells them to. Africans want a just share in the whole of South Africa; they want security and a stake in society.

Above all, we want equal political rights, because without them our disabilities will be permanent. I know this sounds revolutionary to the whites in this country, because the majority of voters will be Africans. This makes the white man fear democracy.

But this fear cannot be allowed to stand in the way of the only solution which will guarantee racial harmony and freedom for all. It is not true that the enfranchisement of all will result in racial domination. Political division based on colour is entirely artificial, and when it disappears, so will the domination of one colour group by another. The ANC has spent half a century fighting against racialism. When it triumphs it will not change that policy.

This then is what the ANC is fighting. Their struggle is a truly national one. It is a struggle of the African people, inspired by their own suffering and their own experience. It is a struggle for the right to live.

During my lifetime I have dedicated myself to this struggle of the African people. I have fought against white domination, and I have fought against black domination. I have cherished the ideal of a democratic and free society in which all persons live together in harmony and with equal opportunities. It is an ideal which I hope to live for and to achieve. But if needs be, it is an ideal for which I am prepared to die.

TAMBO

24 Passive Resistance in South Africa

Excerpted from *Southern Africa in Transition*, ed.
J. A. Davis and J. K. Baker, 1966.

In its historical development, "passive resistance" in South Africa has been closely associated with the late Mahatma Gandhi and his philosophy. As early as 1907, he led the Indian community in South Africa in acts of passive resistance. In later years there were further passive-resistance campaigns by the Indian community. Mahatma believed in the effectiveness of what he called the "soul force" in passive resistance. According to him, the suffering experienced in passive resistance inspired a change of heart in the rulers. The African National Congress (ANC), on the other hand, expressly rejected any concepts and methods of struggle that took the form of a self-pitying, arms-folding, and passive reaction to oppressive policies. It felt that nothing short of aggressive pressure from the masses of the people would bring about any change in the political situation in South Africa. As a countermeasure to Mahatma Gandhi's passive resistance, the African National Congress launched, in 1952, the Campaign for the Defiance of Unjust Laws, or the "Defiance Campaign."

Before they were finally defeated and subjugated by sheer force of superior arms, our forefathers had been engaged in many bitter struggles against the white foreign invaders and colonial conquerors, both Boer and British. . . . Africans fought grimly in defense of their land and their national independence. The armed struggle was carried on intermittently for 127 years. In the end, however, the Africans were defeated, totally disarmed, and then shepherded into what are known as reserves. . . . [which] are usually in the poorest parts of the country and are utterly inadequate for their large populations.

But wounds could not be licked indefinitely. If the British and the Boers, despite the bitterness of a hard-fought war, could come together in a united front against the African people, why could not the Africans unite and face their common problems and enemy, no longer as individual and separate tribes but as a united people? The answer was found on January 8, 1912, when African chiefs, intellectuals, clergymen, workers, and peasants from every tribe in South Africa met in Bloemfontein and formed the African National Congress.

At the time of the formation of the ANC, there was no question of relying on armed force as a means of struggle. Only ten or so years previously, the Boers had tried that method against the British and failed. Bambata had resorted to arms in 1906 and also failed. Deputations, petitions, demonstrations, and conference resolutions were the order of the day. Besides, the Africans had been forcibly disarmed. The ANC, therefore, led the people into essentially peaceful and nonviolent forms of action.

The pattern of legislation passed by successive governments was distinctly discriminatory against the African people and aimed at establishing and perpetuating a servant-and-master relationship between black and white.

During World War II, Hitler became the hero, and Nazism the faith, of hundreds of Afrikaners. The fanaticism of the SS was a virtue to be emulated. As the Jews had been shown their place in Hitler's Germany, so would the Kaffirs in South Africa. But the Africans, heartened by the Allies' promise of a postwar world in which the fundamental rights of all men would be respected, became increasingly impatient with their lot.

The war ended, but repression continued unabated. In 1946, the African mine workers in Johannesburg and the Reef went on strike. The strike was ruthlessly repressed and several Africans were killed. . . . The growing African National Congress continued protesting against various forms of segregation. The government, on the other hand, adopted more repressive legislation.

It was in this atmosphere of discontent and expectation that the black cloud of reaction and brutal repression descended on South Africa: Dr. Malan's Nationalist party seized political power in May 1948. These were the disciples of Hitler. One year later, the shape of things to come was clear. Laws enacted by previous governments were reinforced with vicious amendments and were vigorously enforced by officials who, for sheer brutality, seemed to have been specially recruited from some prehistoric bush where cruelty was a highly prized virtue. Soon the expression became current among Africans that "The devil has been let loose on this country."

Responding to this new challenge, the ANC adopted in 1949 a "program of action" that stipulated that boycotts, strikes, noncollaboration, and "civil disobedience" would now be used as methods and forms of action in the political struggle. The program contemplated participation by the masses of the people.

On May 1, 1950, eighteen Africans were killed by the police during a one-day strike staged as the climax to a provincial campaign for universal adult suffrage. On June 26, 1950, the Africans' first national protest strike was called. The strike was the culmination of a countrywide campaign of protest against the Unlawful Organizations Bill introduced by the government and aimed at stamping out all opposition to its racial and oppressive policies.

The policy of uncompromising apartheid was carried out with vigor, violence, hate, and haste. This has remained the pattern of Nationalist party rule in South Africa to the present day. The country has been in a state of perpetual political crisis now since 1948. It has been the blackest period in the past sixty years and, for the Africans, the bloodiest since the Boer invasions of the eighteenth and nineteenth centuries. In fifteen short years, hundreds of innocent Africans have been shot dead by the police; many more have been wounded by police gunfire during raids, while under arrest, and while in prison; and many have been beaten to death on white-owned farms. In addition, millions of Africans have been convicted of petty offenses, and the average number sentenced to death annually for what are essentially political offenses has been higher than in any corresponding period since Jan van Riebeeck landed in the country in 1652.

At its conference in December 1951, the ANC decided to launch the Defiance Campaign. The story of this dignified, disciplined, and peaceful campaign is well known. It won many friends for the African cause in South Africa and abroad and served to focus the attention of influential sectors of world opinion on the South African political scene. Within South Africa, the Defiance Campaign strengthened the liberation movement and set the tone for future action. Although toward the end of the campaign the Africans were provoked into some violence, they had amply demonstrated their capacity for self-discipline and their readiness for militant struggle. This meant that it was possible, without resorting to violence, to force the government into a position in which its policy became unworkable. In the years following 1952, hundreds of leaders were banned from taking part in political activities or attending gatherings. Many were restricted to defined areas while others were banished from their homes. Scores were imprisoned, and meetings and processions were prohibited in many parts of the country. Despite all this, however, and despite the fact that the most influential leaders were cut off from the people, the pressures of mass political action throughout the country continued to rise, compelling the government to fall back on an ever-increasing list of repressive and restrictive laws. It made greater use of the police force, equipping it with a growing pile of arms ranging from locally produced pistols to tanks supplied by Great Britain.

When these measures failed, the government resorted to banning political organizations and placing the whole or parts of the country under a state of emergency. The reaction of the ANC to its banning in 1960 was to announce that it would conduct the liberation struggle underground.

The March 1961 conference of 1,500 delegates representing 145 organizations, at which Nelson Mandela was the main speaker, was organized largely under illegal conditions. It demonstrated the power of the underground organization and the unity of the people. Following this conference, preparations started for a three-day national strike to commence on May 29, 1961. The strike drew unprecedented support from the mass of the African population and was fully backed by the Indian and Coloured communities. Faced with this tremendous political demonstration—which was a triumphant breakthrough for a liberation movement operating under a cloud of repressive legislative prohibitions and restrictions—the Verwoerd government abandoned the political fight and took to arms. The unarmed demonstrators and would-be strikers were confronted with practically the entire South African Army, fully equipped and ready for war.

Today the oppressors are arming feverishly. . . . The army buildup and the new Anti-Sabotage Act have completely nullified the strategic value of nonviolence, leaving the African with no alternative but to pursue the goal of freedom and independence by way of taking a "tooth for a tooth" and meeting violence with violence.

It is hardly necessary to make the point that we would rather have avoided this course. But if the South African Hitlerites go berserk and seek to drown the country in innocent human blood before committing suicide after the

manner of their revered hero, no one should be surprised that the African should take effective and appropriate steps to defend himself and, by every method that he considers appropriate, to ensure the successful prosecution of his struggle for liberation. In this context, violence is an extension of, not a substitute for, the forms of political action employed in the past. Its use will be confined to the pursuit of the objective of freedom for the oppressed people.

AFRICAN NATIONAL CONGRESS

25 Announcement of the Formation of Umkhonto we Sizwe

From a Flyer, December 16, 1961

Units of Umkhonto we Sizwe today [December 16, 1961] carried out planned attacks against government installations, particularly those connected with the policy of apartheid and race discrimination.

Umkhonto we Sizwe is a new, independent body, formed by Africans. It includes in its ranks South Africans of all races. It is not connected in any way with a so-called Committee for National Liberation whose existence has been announced in the press. Umkhonto we Sizwe will carry on the struggle for freedom and democracy by new methods, which are necessary to complement the actions of the established national liberation organizations. Umkhonto we Sizwe fully supports the national liberation movement, and our members, jointly and individually, place themselves under the overall political guidance of that movement.

It is, however, well known that the main national liberation organizations in this country have consistently followed a policy of nonviolence. They have conducted themselves peaceably at all times, regardless of government attacks and persecutions upon them and despite all government-inspired attempts to provoke them to violence. They have done so because the people prefer peaceful methods of change to achieve their aspirations without the suffering and bitterness of civil war. But the people's patience is not endless.

The time comes in the life of any nation when there remain only two choices: submit or fight. That time has now come to South Africa. We shall not submit, and we have no choice but to hit back by all means within our power in defence of our people, our future, and our freedom.

The government has interpreted the peacefulness of the movement as weakness; the people's nonviolent policies have been taken as a green light for government violence. Refusal to resort to force has been interpreted by the government as an invitation to use armed force against the people without any fear of reprisals. The methods of Umkhonto we Sizwe mark a break with that past.

We are striking out along a new road for the liberation of the people of this country. The government policy of force, repression, and violence will no longer be met with nonviolent resistance only! The choice is not ours; it has been made by the Nationalist government which has rejected every peaceable demand by the people for rights and freedom and answered every such demand with force and yet more force! Twice in the past eighteen months, virtual martial law has been imposed in order to beat down peaceful, nonviolent strike

138

action of the people in support of their rights. It is now preparing its forces—enlarging and rearming its armed forces and drawing white civilian population into commandos and pistol clubs—for full-scale military actions against the people. The Nationalist government has chosen the course of force and massacre, now deliberately, as it did at Sharpeville.

Umkhonto we Sizwe will be at the front line of the people's defence. It will be the fighting arm of the people against the government and its policies of race oppression. It will be the striking force of the people for liberty, for rights, and for their final liberation! Let the government, its supporters who put it into power, and those whose passive tolerance of reaction keeps it in power take note of where the Nationalist government is leading the country!

We of Umkhonto we Sizwe have always sought—as the liberation movement has sought—to achieve liberation, without bloodshed and civil clash. We do so still. We hope—even at this late hour—that our first actions will awaken everyone to a realization of the disastrous situation to which the Nationalist policy is leading. We hope that we will bring the government and its supporters to their senses before it is too late, so that both government and its policies can be changed before matters reach the desperate stage of civil war. We believe our actions to be a blow against the Nationalist preparations for civil war and military rule.

In these actions, we are working in the best interests of all the people of this country—black, brown, and white—whose future happiness and well-being cannot be attained without the overthrow of the Nationalist government, the abolition of white supremacy, and the winning of liberty, democracy, and full national rights and equality for all the people of this country.

We appeal for the support and encouragement of all those South Africans who seek the happiness and freedom of the people of this country.

Afrika Mayibuye!

Issued by command of Umkhonto we Sizwe.

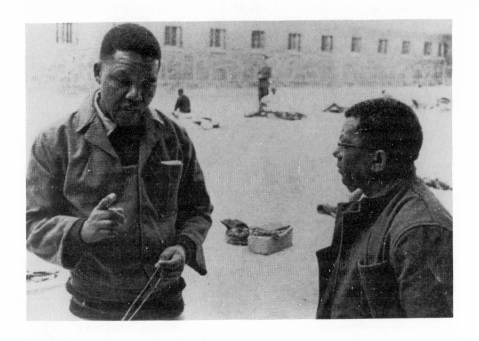

Nelson Mandela with Walter Sisulu, Robben Island Prison Yard, 1966.
(International Defence & Aid Fund for Southern Africa)

PART III

A LEADER AMONG PRISONERS, 1964–1990

In the first half of 1964 Nelson Mandela was in the public spotlight. His eloquent closing statement in the Rivonia trial on April 20 captured headlines in South Africa and overseas, as did the life sentences handed to him and the other Rivonia trialists on June 11. Once sentenced, however, Mandela was abruptly removed from any access to the public and transported to the government's maximum security prison on Robben Island. In harsh prison conditions Mandela and his fellow prisoners struggled to sustain the political cause for which they had been imprisoned and to keep contact with the opposition despite government repression in South Africa and the difficulties of linking with the distant ANC in exile. In the process they created a cohesive prison community which by the late 1970s came increasingly into the public eye. Mandela, its most prominent member, again became a center of attention and a symbol of an African nationalism that could not be suppressed.

Robben Island, fourteen miles off Cape Town in the cold waters of the South Atlantic, has been a place of exile for black rebels since shortly after Dutch settlement in 1652. As the enforced residence for early Khoikhoi resisters to Dutch rule, for exiled Muslim leaders from the Dutch East Indies who refused to acquiesce to Dutch colonialism in Asia, and for Xhosa warriors defeated by the British in the nineteenth century, the island became firmly fixed in black political consciousness as a symbol of black resistance to white domination. After an interlude of close to a century as a multiracial insane asylum, leper colony, and quarantine station, Robben Island was designated in 1959 by B. J. Vorster, then minister of justice, as a maximum security prison for "nonwhite" males, setting the stage for its renewed saliency in black political consciousness.

Nelson Mandela and his black Rivonia codefendants, other prominent leaders of the ANC and the rival PAC, militants of smaller opposition groups, and hundreds of rank-and-file members from all streams of the black opposition swelled the Robben Island prison population and were telling testimony to the extent and success of the intensified government repression of the 1960s. Although torn from the suppressed antiapartheid movement, the new wave of

long-term political prisoners refused to desist from politics. Through disciplined and determined struggle against the harsh prison regimen, many of the incarcerated activists bridged the political divisions that had divided them and forged a new strand of black resistance that increasingly came to inspire and interweave with mainstream black politics, particularly in the post-Soweto period.

South African prison authorities initially treated the hundreds of black political prisoners on Robben Island little differently from common-law criminals. (The notable exception was Mangaliso Robert Sobukwe, president of the PAC, who was kept on Robben Island in isolated detention in a small house after the expiration of his three-year sentence in 1963 until his conditional release to twelve-hour house arrest in Kimberley in 1969.) Mandela and other top ANC leaders, plus prominent imprisoned activists from the PAC and other groups, were kept in individual cells in a segregated section, and the bulk of the prisoners were thrown together with common-law criminals in communal cells. All political prisoners, from both areas, were subject to a standard sparse diet and regulation uniforms (differentiated for Africans, Coloreds, and Asians). Manacled while marching to and from excruciating work in the island's limestone quarries, the prisoners also suffered frequent searches and brutal treatment from white warders. Communication with the outside was restricted to one family visit and one censored letter of five hundred words each six months. Permission to enroll in approved university courses was granted, but access to reading materials was strictly controlled; no newspapers or radios were permitted.

From the beginning, Mandela and other ANC members organized to protest against their treatment. Demanding access to prison regulations and enforcement of them, Mandela refused to acquiesce to the demands of the authorities that complaints could be voiced only by individuals and not on behalf of the group. He insisted on raising general questions, in addition to specific complaints about the treatment of individual prisoners, with prison authorities as well as with officials from the International Red Cross on their infrequent inspection visits. Despite the opposition of the prison authorities, the prisoners organized a grievance committee with representatives from various political organizations; ultimately they did succeed in having the committee members make representations to the Prison Board for all prisoners regarding prison conditions. Under Mandela's leadership a document was carefully crafted and presented in April 1969 to the minister of justice, demanding status as political prisoners and thus treatment similar to that accorded to Afrikaner dissidents imprisoned for challenges to the state in both world wars and Nazi supporters sentenced to death in the 1940s (see Document 26).

Despite his prominent position within the ANC, Mandela (and other ANC leaders) insisted that no distinctions be made between their prison routine and that of the others in the single-cell section. Mandela received the same clothes, ate the same food, and performed the same hard labor in the limestone quarries. He cleaned his chamber pot ("bowly") each morning and assisted his sick colleagues, when necessary, in cleaning theirs.

Throughout the 1960s, prison conditions remained generally arduous, taking a turn for the worse in the early 1970s under a new prison commandant. Grudgingly granted study privileges were curtailed; physical harassment was increased; and regulations were tightened and strictly enforced. Despite the brutal behavior of prison personnel and the harsh conditions of labor, Mandela would not be intimidated, taking full advantage of the rare outside visitors permitted by the government to voice his grievances. In his first meeting in 1967 with Helen Suzman, then the lone Progressive party M.P., he articulated his complaints about behavior of a particular warder and about working conditions generally (see Document 38). David McNicoll, an Australian journalist and the first correspondent permitted to interview Mandela (in 1973), asserted that Mandela (allegedly referring to his high standard of living before his imprisonment) strongly protested differentiated food rations for Africans and non-Africans and the arbitrariness of prison authorities (see Document 33).

Undeterred from challenging actual prison conditions and from demanding nonracialism in the treatment of Africans, Coloreds, and Asians, Mandela and the ANC prisoners also vigorously organized to advance ANC political interests inside and outside prison. At work and in their living quarters, committees were designated, programs were planned, and study courses were organized. Despite censorship and enforced isolation, Mandela and other ANC prisoners used all possible opportunities to obtain information about the underground and external ANC. According to "Mac" Maharaj, a fellow ANC prisoner released in 1976, Mandela was at the center of ANC activities on Robben Island (see Document 27).

Mandela and other ANC leaders made particular efforts to reach beyond the ANC membership to establish links across the full spectrum of black politics represented among the prisoners. In the process Robben Island became like an "open university" in which prisoners of all political persuasions engaged in vigorous political debate. By their principled conduct and concern for the individual, the ANC leadership elicited respect from many who had previously been opponents of the organization in the Unity Movement, the PAC, and the Liberal party, including Eddie Daniels, a member of the Liberal party who had joined the African Resistance Movement (ARM) (see Document 28). When a younger generation of Black Consciousness militants, among them Dan Montsisi and Seth Mazibuko, began to join the stream of prisoners in the early and mid-1970s, Mandela and the ANC leadership provided role models for them as well (see Documents 29 and 30). Through their practice of inclusive politics and personal concern for individuals, including those from rival organizations, they were successful in attracting additional support for nonracialism and other goals of the ANC. Simultaneously, according to the reports of several of Mandela's fellow prisoners, he sharpened and deepened his own analysis of the South African situation while showing openness and tolerance to those who held divergent opinions (see Documents 27 and 28).

In the estimation of the rare outside visitors to Robben Island, Mandela continued physically active and mentally alert. Denis Healey, a British Labour

M.P. and former minister of defense and one of the first foreigners to see Mandela in prison, reported on the basis of an hour's conversation in late 1970 that he remained dedicated to the ANC cause (see Document 32). In his conversation with the Australian journalist David McNicoll in early 1973, Mandela showed keen awareness of current world events, testifying implicitly to the ability of the Robben Island inmates to thwart prison censorship to obtain outside news (see Document 33).

For ANC supporters in South Africa and the exiled ANC leadership, it was difficult to obtain regular and reliable information about the Robben Island prisoners because of the extensive government security measures. Reports by the few outside visitors such as Denis Healey and David McNicoll were not generally available inside South Africa. Nevertheless, through sympathetic warders and other still-undisclosed channels, information about Mandela and other leaders filtered out of South Africa to the exiled leadership (see Documents 31 and 42). In analogous fashion the Robben Island prisoners obtained news of ANC activities along with news of world affairs. The slow improvement of prison conditions from the mid-1970s onward, including more frequent letters and visitors, also permitted more information to be exchanged to and from the island. By the late 1970s and early 1980s the incarcerated leadership was communicating more regularly and successfully with its supporters inside South Africa and with the exiled ANC leadership. Although the Robben Island prisoners learned belatedly in August of the June 1976 Soweto uprising, they enthusiastically conveyed their support; after some delay their message was received and published (see Document 39).

By the early 1970s, prisoners from Robben Island were being released back into the townships upon completion of their sentences. For many of them the new form of struggle that they had developed on Robben Island had strengthened their determination to return actively to antiapartheid politics, despite the hazards of operating either clandestinely or legally in South Africa or the uncertainties of exile politics (see Document 27). The reappearance in the townships of the ex–Robben Island prisoners carrying direct accounts of the still-imprisoned leadership highlighted their appeal and legitimacy among the broad black public. Although Mandela, Walter Sisulu, and three other Rivonia trialists were abruptly transferred to Pollsmoor prison on the mainland near Cape Town on April 1982, Mandela and the remaining prisoners both on Robben Island and in Pollsmoor had become for antiapartheid South Africans not only symbols of resistance against overwhelming odds but also living representatives of a distinguished and tested leadership that could not be denied participation in any negotiations about postapartheid society.

MANDELA

26 *Release Us or Treat Us as Political Prisoners*

From a Letter to the Minister of Justice,
April 22, 1969 (Published by ANC in 1978)

Dear Sir,

My colleagues have requested me to write and ask you to release us from prison and, pending your decision on the matter, to accord us the treatment due to political prisoners. At the outset we wish to point out that in making this application we are not pleading for mercy but are exercising the inherent right of all people incarcerated for their political beliefs.

The persons whose names appear in schedule A attached to this letter live in the single-cell section of Robben Island Prison and are completely isolated from the rest of the prisoners on the island. For this reason we are unable to furnish you with a full list of all the persons on this island and in other prisons on behalf of whom this application is made.

Prior to our conviction and imprisonment we were members of well-known political organisations which fought against political and racial persecution and which demanded full political rights for the African, Coloured, and Indian people of this country. We completely rejected, as we still do, all forms of white domination, and more particularly the policy of separate development, and demanded a democratic South Africa free from the evils of colour oppression and where all South Africans, regardless of race or belief, would live together in peace and harmony on a basis of equality.

All of us, without exception, were convicted and sentenced for political activities which we embarked upon as part and parcel of our struggle to win for our people the right of self-determination, acknowledged throughout the civilised world as the inalienable birthright of all human beings. These activities were inspired by the desire to resist racial policies and unjust laws which violate the principle of human rights and fundamental freedoms that forms the foundation of democratic government.

In the past the governments of South Africa have treated persons found guilty of offences of this nature as political offenders who were released from prison, in some cases, long before their sentences expired. In this connection we refer you to the cases of Generals Christiaan de Wet, J. C. C. Kemp, and others who were charged with high treason arising out of the 1914 rebellion. Their case was in every respect more serious than ours. Twelve thousand rebels took to arms and there were no less than 322 casualties. Towns were occupied and considerable damage caused to government installations, while claims for damage to private property amounted to R500,000. These acts of violence were committed by white men who enjoyed full political rights, who belonged to political parties that were legal, who had newspapers that could publicise their

views. They were able to move freely up and down the country espousing their cause and rallying support for their ideas. They had no justification whatsoever for resorting to violence. The leader of the Orange Free State rebels, de Wet, was sentenced to six years' imprisonment plus a fine of R4,000. Kemp received a sentence of seven years and a fine of R2,000. The rest were given comparatively lighter sentences.

In spite of the gravity of their offences, de Wet was released within six months of his conviction and sentence, and the rest within a year. This event occurred a little more than half a century ago, yet the government of the day showed much less intransigence in its treatment of this category of prisoner than the present government seems prepared to do 54 years later with black politicians who have even more justification to resort to violence than the 1914 rebels. This government has persistently spurned our aspirations, suppressed our political organisations, and imposed severe restrictions on known activists and field workers.

It has caused hardship and disruption of family life by throwing into prison hundreds of otherwise innocent people. Finally, it has instituted a reign of terror unprecedented in the history of the country and closed all channels of constitutional struggle. In such a situation resort to violence was the inevitable alternative of freedom fighters who had the courage of their convictions. No men of principle and integrity could have done otherwise. To have folded arms would have been an act of surrender to a government of minority rule and a betrayal of our cause. World history in general, and that of South Africa in particular, teaches that resort to violence may in certain cases be perfectly legitimate.

In releasing the rebels soon after their convictions the Botha–Smuts government acknowledged this vital fact. We firmly believe that our case is no less different, and we accordingly ask you to make this privilege available to us. As indicated above, there were 322 casualties in the rebellion. By way of contrast, we draw attention to the fact that in committing acts of sabotage we took special precautions to avoid loss of life, a fact which was expressly acknowledged by both the trial judge and the prosecution in the Rivonia case.

An examination of the attached schedule shows that if we use de Wet's case as the standard, then every one of us ought to have been released by now. Of the 23 persons whose names are listed therein, eight are doing life imprisonment, ten are serving sentences ranging from ten to twenty years; and five between two and ten years.

Of those doing imprisonment for life, seven have completed four years ten months, and one has done four years and four months. The man with the longest sentence amongst those serving terms between ten and twenty years is Billy Nair, who has already completed a quarter of his sentence. Joe Gqabi, Samson Fadana, and Andrew Masondo, the first to be convicted in this group, have each completed six years of their respective sentences of twelve, eight, and thirteen years. The last men to be sentenced in the same group were Jackson Fuzile and Johannes Dangala, who received twelve and seven years, respectively. Fuzile has completed a quarter of his sentence, where as Dangala will

have done exactly half of his on 19 May 1969. Every one of those serving terms between two and ten years has at least completed a quarter of his sentence.

Our claim for release becomes even stronger when examined in relation to the cases of Robey Leibbrandt, Holm, Pienaar, Strauss, and others. Leibbrandt, a national of the Union of South Africa, arrived in the Union from Germany at a time when that country was at war with the Union. He then proceeded to set up a paramilitary underground organisation with the purpose of overthrowing the government and establishing in its place one modelled on that of Nazi Germany. He was found guilty of high treason and sentenced to death, later commuted to imprisonment for life. Holm, Pienaar, and Strauss were also imprisoned for high treason, it being alleged that they collaborated with the enemy in prosecuting the war against the Union and its allies. On coming to power, however, the present government released these and other prisoners sentenced for treason and sabotage, notwithstanding the fact that they had been arrested in circumstances which made them appear to many South Africans as traitors to their own country. Again by way of contrast, we draw attention to the fact that our activities were at all times actuated by the noblest ideals that men can cherish, namely, the desire to serve our people in their just struggle to free themselves from a government founded on injustice and inequality.

We further wish to remind you that in 1966 your predecessors released Spike de Keller, Stephanie Kemp, Alan Brooks, and Tony Trew, all of whom originally appeared jointly with Edward Joseph Daniels (whose names appear in the schedule) on a charge of sabotage. Kemp, Brooks, and Trew pleaded guilty to an alternative charge, and a separation of trial was ordered. The case against Daniels and de Keller proceeded on the main charge, and on 17 November 1964 they were found guilty and sentenced to fifteen and ten years, respectively. Kemp, Brooks, and Trew were found guilty on the alternative and sentenced five, four, and four years, respectively, each of which was partly suspended. We are informed that de Keller was released after he had served approximately two years or less of his sentence of ten years, whilst Kemp, Brooks, and Trew were also released before they had completed their sentences.

We do not in any way begrudge those who were fortunate enough to be released and who escape the hardship of prison life and are happy to know that they now lead a normal life. But we refer to their case for the limited purpose of showing that our request is reasonable and also to stress that a government is expected to be consistent in its policy and to accord the same treatment to its citizens.

There is one important difference between our case and that of de Wet and Leibbrandt. They were released only after the rebellion had been crushed and after Germany had been conquered and they were thus no threat to the safety of the state when they were freed.

In our case, however, it may be argued that our revolution is planned for the future and that security considerations require that we be treated differently. Add to this the fact that our convictions have not changed and our

dreams are still the same as they were before we were jailed, all of which would seem to confirm the opinion that our case is distinguishable from all the previous ones. We feel sure, however, that you will not be tempted to think along these lines, as such an argument would carry sinister implications. It would mean that if security considerations today require that we should be kept in prison, we would not be released when we complete our respective sentences, if the present situation remains unaltered or if the position worsens. The plain truth is that the racial strife and conflict that seriously threatens the country today is due solely to the shortsighted policies and crimes committed by the government.

The only way to avert disaster is not to keep innocent men in jail but to abandon your provocative actions and to pursue sane and enlightened policies. Whether or not evil strife and bloodshed are to occur in this country rests entirely on the government. The continued suppression of our aspirations and reliance on rule through coercion drives our people more and more to violence. Neither you nor I can predict the price the country will have to pay at the end of that strife. The obvious solution is to release us and to hold a round-table conference to consider an amicable solution.

Our main request is that you release us and, pending your decision, you treat us as political prisoners. This means that we should be provided with good diet, proper clothing outfit, bed and mattress, newspapers, radios, bioscope, better contact with our families here and abroad.

Treatment as political prisoners implies the freedom to obtain all reading material that is not banned and to write books for publication. We would expect to be given the option to work as one desires and to decide the trades one would like to learn. In this connection we wish to point out that some of these privileges were enjoyed both by the 1914 rebels as well as by Leibbrandt and colleagues, all of whom were treated as political prisoners.

The prison authorities attempt to answer our demand for treatment as political prisoners by pointing out that we were convicted by the courts for contravening the laws of the country, that we are like any other criminals and, therefore, cannot be treated as political offenders.

This is a spurious argument which flies in the face of the facts. On this view de Wet, Kemp, Maritz, Leibbrandt and others were ordinary criminals. Treason, sabotage, membership of an illegal organisation were all criminal offences then as now. Why then were they treated differently? It seems to us that the only difference between the two cases is one of colour.

Serious differences of opinion on a specific issue had emerged amongst the whites, and those who lost in the contest that flowed from these differences eventually found themselves behind bars. On all other issues, especially on the major question of colour, both victor and vanquished were in agreement. The conflict having been solved, it was possible for the government to adopt a conciliatory attitude and to extend to the prisoners all sorts of indulgences. But today the position is altogether different. This time the challenge comes not from the white man but mainly from black politicians who disagree with the

government on almost everything under the sun. The victory of our cause means the end of white rule.

In this situation the government regards the prison not as an institution of rehabilitation but as an instrument of retribution, not to prepare us to lead a respectable and industrious life when released and to play our role as worthy members of society, but to punish and cripple us, so that we should never again have the strength and courage to pursue our ideals. This is our punishment for raising our voices against the tyranny of colour. This is the true explanation for the bad treatment we receive in prison—pick-and-shovel work continuously for the last five years, a wretched diet, denial of essential cultural material and isolation from the world outside the jail. This is the reason why privileges normally available to other prisoners, including those convicted of murder, rape and crimes involving dishonesty, are withheld from political offenders.

We get no remission of sentence. Whilst the ordinary prisoner is classified in C group on admission, political offenders are put in D, which carries the least privileges. Those of us who managed to reach A group are denied privileges normally enjoyed by criminals in the same group. We are compelled to do pick-and-shovel work, are not allowed newspapers, radios, bioscope; contact visits and even groceries are given grudgingly.

As already indicated in the second paragraph above, I make this application on behalf of all my collegues on the island and in other jails, and I trust that any concessions that may be granted will be made available to all without exception.

The Prisons Act of 1959 gives you the necessary powers to grant the relief we seek. Under its provisions you are entitled to release us on parole or probation. De Wet and others were released under the former method. In conclusion, we place on record that the years we have spent on this island have been difficult years. Almost every one of us has had a full share in one way or another of the hardships that face nonwhite prisoners. These hardships have at times been the result of official indifference to our problems; other times they were due to plain persecution. But things have somewhat eased, and we hope even better days will come. All that we wish to add is that we trust that when you consider this application you will bear in mind that the ideas that inspire us, and the convictions that give form and direction to our activities, constitute the only solution to the problems of our country and are in accordance with the enlightened conceptions of the human family.

FELLOW PRISONERS

27 *Interview with "Mac" Maharaj* [Released in 1976]

Excerpted from Nelson Mandela, *The Struggle Is
My Life*, 1978

Q. *How do you assess the morale of Mandela and the other prisoners in the
special section, and on the island generally?*

A. In many ways, like all of us Nelson has been changing over the years. I think
that the basic change in Nelson is that as he has been living through prison his
anger and hatred of the system has been increasing, but the manifestations of
that anger have become less visible to a person. They are more subdued, more
tempered. They've become more cold and analytical in focusing on the evils of
the system. His morale has been such that he has been one of the men that has
inspired all who came into contact with him. He isn't the only one; there are
many who've played this role; in truth, all of us in our own small way have
helped each other, but Nelson has been outstanding. He has had the confidence
of all prisoners, whatever their political persuasion, and has been accepted by
all as a spokesman of the whole prisoner community. He has often sought and
guided us in the campaigns we've waged so that even though we were fighting
on losing ground, that is, ground controlled by the enemy, the campaigns we
waged would at least bring us some benefit.

His confidence in the future has been growing. I do not recall a time when
he showed any despondence or gave us any clue that he may be thinking in the
back of his mind that he would never live through prison. He has always shown
this belief in private and in public, and I believe I can say this, knowing him
intimately, not even when Winnie was in jail, detained, or when news came out
of her torture or whatever demoralising actions were taken by the enemy, has
Nelson flagged. His spirit has been growing, and I think the reasons for this
high morale amongst us are very deeply related to our conditions. First of all, I
believe that the enemy's treatment is counterproductive; it's a dead loser. You
never fail to be reminded every moment in prison that you are there not just as
a prisoner but as a black man, and that alone tells you that the only way to
survive, even if you haven't thought it out, is to fight back.

It is a very important element in our morale that we are able to find ways to
fight back: We feel we have something to do; we have a programme in prison;
we want to put our demands. Our central issues are: (a) release, uncondition-
ally; (b) interim treatment should be that of *political* prisoners; (c) remove all
racial discrimination. Now that on its own is a limited programme which we
know we cannot win altogether, since it is dependent on the wider struggle, but
it has given us something to fight for. The fact that we came to prison as
political fighters and are kept together gives us this opportunity to act as a
collective.

The next element has been the recognition that our freedom won't come from negotiation with the enemy. The enemy could only afford to release us from a position of strength, and any semblance of strength that it may have had, say betwen 1965 and 1969 when it could claim, as it kept on claiming, that South Africa was calm and peaceful—although this had been achieved at the cost of a terrible campaign of intimidation and terror—has now been lost. Today every day brings the regime more and more against the wall. So that any such act will be perceived as an act of weakness, and it is clear that our release won't come from them, and we see that it is related directly to the struggle outside. There our morale and spirit is helped by the fact that even with all the repression and intimidation, our operations have continued to survive underground. The struggle has carried on despite the blunders and the casualties. The jail doors have been drawing in more and more people, testifying to the presence of the organisation, to the fact that it continues to live, continues to fight. Then the mood of our people: The evidence from round about the 1970s of a mounting mass of campaigns from our people, a rising tide of anger culminating in the explosions of the Soweto and post-Soweto, all these have shown us that the conditions are there for our victory.

Q. *How is Mandela regarded by the other prisoners on the island?*

A. Well, first of all Nelson Mandela is accepted and recognised by the Congress and its allied bodies as one of its leading members. His image in prison is that of the first commander in chief of Umkhonto we Sizwe. He therefore is seen as symbolising the new phase in our struggle—a phase where we have turned our backs on the view that nonviolent struggle will bring us our victory. He therefore symbolises that spirit, that aspiration, and he symbolises the recognition that to talk of change by violence is not enough, that violence has got to be organised, and that campaign of violence has got to be rooted in the masses. This is the image that Nelson has. In prison of course his stature has grown, just as it has grown internationally. As I said, in the campaigns in prison, his guidance and leadership and advice have made him accepted by all political movements in prison as a spokesman of the prisoners. This was true too of the "younger generation" of prisoners, those who began to come in from the so-called black consciousness groups from 1973 and the young people imprisoned after Soweto. What was interesting was that after all these years of imprisonment, with the organisations driven underground and these young men and women growing up under Bantu education, educated by the enemy as he desires, exposed only to the propaganda of the enemy, with no knowledge of the history of our struggle and only surreptitious information given in darkness, nonetheless their first connection was Nelson Mandela, this was the first thing they'd ask you about. This indicated that his name was even by that generation accepted as a leader in the country. Of course this has interesting implications, because the enemy has tried to show that what happened in Soweto and post-Soweto was exclusively the work of some new crop, "historically unrelated," with no roots. But their very questions and interest and acceptance of Nelson show that there is an organic connection. Furthermore,

no black group which claims to be standing for the rights of the black man and for the ending of national oppression, however much they may differ even on tactics and theory and strategy, fails to mention Nelson Mandela when it talks of a future South Africa. Thus not only does the ANC recognise him as a leader, but he is accepted as a national leader in the country as a whole by all the people whatever their colour, and no future plans can afford to exclude him from their calculations.

Q. *How much does Mandela know of what is happening in South Africa and in the world as a whole?*

A. My comrades, myself, and others who have come out of prison have indicated we were very aware of things happening outside. But now that I've been out of prison for a year and a half I've become increasingly aware of how uninformed we were. But I think that it is fair and correct to say that comrades like Mandela and others in prison are pretty well in touch with the basic lines of development inside the country. We have been obliged by the forced inactivity of prison life to sit back and look at the whole scene. In prison one is pulled out from the rush of everyday activity where one only sees one corner of one's world, the corner and sphere in which one is active. This opportunity therefore has given us the chance to see the general direction. There are times when we do not know the detailed manoeuvres of the enemy or of the struggling forces, but I think on basic issues we have managed successfully to see the general direction of developments and changes. So I think all in all, despite the news censorship, we have kept abreast. Sometimes in certain respects we have done this better than our colleagues abroad, especially those who are concerned with some specific aspects of work in the underground, but I cannot claim that we know more than our comrades outside. We've recognised this from prison, too; they have not only the same general perspective that we have but have more of the flesh on the bones. We prisoners may know it in its bone and marrow form, but I think the comrades outside have it in a fuller form.

Q. *Has Mandela changed in any of his major political attitudes over the years, for example, does he still think that international sanctions against the apartheid regime are so vital?*

A. When Nelson spoke of sanctions in the 1962 speech at the Addis Ababa conference, he called for total sanctions, but he emphasised that even total sanctions will not bring the regime down, that the real struggle is inside the country. Now the perspective within which he sees the role of international sanctions is very clearly understood by him, and as we have switched over from nonviolent forms of struggle to the armed struggle, we have been able publicly to articulate our position more clearly and forthrightly. Nelson clearly grasps this point. He does not see sanctions or any other form of struggle even inside the country as being a form of struggle that has to be seen in isolation.

Nelson's view, as he put it to me in conversation, is that the armed struggle is central to our liberation but that sanctions will play a very important subsidiary role by helping to alter the tactical balance of forces involved in the

struggle, by depriving the regime of the underpinning that international trade and investment give it.

Nelson's views, in so far as conditions have allowed, have been developing and changing: changing in a sense that even his understanding has been deepening, and I think that in this process the fact that he has been put together with all those comrades, given the opportunity to exchange ideas, has also led to his benefiting from it.

There have, for example, been questions of the tactics of the struggle. Now we in prison, Nelson included, have felt that it is not our role to determine the tactics, that these are matters to be determined on the basis of actual concrete conditions obtaining at any given time, and that given the dearth of information and the fact that our smuggled information is derived from enemy sources, it is quite inappropriate for us to work out tactics. Nelson has been absolutely clear on this point. Nelson's position, and the position of comrades in the ANC and in the prison, has been unqualified support for the leadership of the ANC, be it inside the country or outside; we see no distinction between the ANC and its allies on that basis. We give them complete support, but this support is not just an act of faith; we try always to recognise and develop the basis of our support. So when you get an item of news, you will be concerned whether the right tactics are being employed, and this is particularly so of those who came from the heat of battle: people like Nelson who sat in the innermost councils of the movement in determining strategy and tactics. The most punishing thing about prison life is that you are outside that area; you now have to accept that you are in that sense on the sidelines, you have to trust to your comrades. But the fact that you can trust them is because you know those comrades and, in the case of someone like Nelson, you helped to develop those who are now at the helm.

When it comes to the manoeuvres of the government, there have been a large number of rumours which I've become aware of since I came out of prison—reports in the press, statements by some of the Bantustan puppets like Matanzima that he was going to demand the release of Nelson Mandela and all Xhosas. The strongest of these, one of the most pernicious and persistent rumours, has been that Nelson has been approached by the Transkeian regime; that they will make representations to have him freed on the basis that he will come out and be given a job in the Transkei cabinet. The facts of the matter are that Nelson was never approached (at least up to November 1976) by the Transkeian regime—no offer was made to him. The most that happened was that in December 1973 for the first time in the history of our imprisonment a cabinet minister visited the island and met us—that was Jimmy Kruger. We had discussions with him; we sent deputations to see him and make representations on our conditions. He saw Nelson and the deputation from the single cells which I led. When we compared notes and reported back to our comrades, one of the things that intrigued us was why Kruger had chosen to come, and as we examined the interviews it became clear. On the face of it he conducted the discussions in his typical fashion which seems to endear him to his white *laager* electorate—he came at us like a bulldog. But in working out

his objectives we thought it possible that he had come there on a kite-flying mission to find out whether there was scope amongst us political prisoners and the leading people—without betraying his hand—that possibly the regime could find a negotiating base on the basis that separate development would be the accepted principle. He went back without gaining anything—our answers quite clearly proved that we cannot compromise on separate development.

Kruger also tried to put us on the carpet on the armed struggle, and Nelson put him on the carpet instead when Kruger confessed that he was not aware of the history of our struggle and the efforts we had made through the ANC, even when we were driven underground and Nelson led the strike of 1961. We still entertained the possibility of a peaceful transformation through the strikes and the letters written to the prime minister. So the interview ended with Nelson saying to Kruger, "I think you'd better go back to the prime minister's files and see the letters written by the ANC": letters written by Nelson himself, letters written by Chief Lutuli, letters written by various presidents of the ANC at different times and during different campaigns. But the purpose of this visit seemed to be a possibility that Kruger came there to say—he said so bluntly at one point—if you are prepared to accept separate development I will be prepared to allow you to function politically within that thing, even though you disagree with me.

When he left some of us argued the matter—was he being honest and sincere? Many of us realised and argued that he was being insincere; some were inclined to say: Look, grant him the benefit of the doubt. But of course, his actions immediately after he left the island betrayed his position. He made a statement in Parliament—from the protection of Parliament against a prisoner who had no access to the court—with a statement saying Nelson Mandela was a card-carrying Communist (which he has never been able to prove, and they never even succeeded in having Nelson named as a Communist), so we think that it was just a kite-flying exercise as we saw it at the time. Our answers and Nelson's were unequivocal: That he will not be prepared to entertain any basis of discussion or negotiation with the regime if it meant that separate development remains: We could only talk on the basis that separate development must go.

Our approach has always been that Nelson does not hold views to be acted upon by himself in a public capacity except if he is in consultation with the leadership of the ANC outside prison, and that means specifically with President General Oliver Tambo and the national executive of the ANC. We have always maintained the position that if the conditions should arise where, because we are hostages and the enemy tries to exploit us, whatever designs it has, our duty would be never to give an answer to the regime, no matter how attractive the package offered, except to say: If the package justifies it on the surface then we must be allowed to consult the leadership of the ANC and put what has been put to us to them. In fact, our short answer is: "Go to the accredited leadership of the movement which is conducting the struggle."

Helen Suzman put the matter the other way to Nelson in 1969. We wrote a petition signed by 22 of us on behalf of all prisoners, demanding our release—

the main signatory and draftsman was Nelson. Helen Suzman as a Progressive party M.P. visited the island, and he explained to her very cogently the demands we put to the then minister (Pelser). We had argued very cogently, using South African historical experience, how white political prisoners who had taken to arms had been sentenced to far shorter periods in prison and had been released before they had even served as much as a third of their sentence, and we demanded the same. We had shown how Nazis like Robey Leibbrandt in the service of Nazi Germany had been sentenced to death, had their sentences commuted to life imprisonment then, when the Nats. came to power, were released after serving nothing more than four to five years. Having outlined those cases, showing that our treatment was discriminatory because it was the black man now in revolt, we demanded our release. Helen Suzman in a discussion with Nelson said, "The difference, Nelson, is, are you prepared to say that you'll abandon violence and the armed struggle? Because your struggle is ongoing—true, the rebels of 1914 were released, the Robey Leibbrandts had been released, but their struggle had been defeated, now yours is ongoing, it weakens your case, and I cannot demand your release." Nelson's answer to this, made in 1969 and he stands by it to the present, is that we are never prepared to do that. Because this demand for our release is a politically motivated demand, and he and all of us are prepared to sit on in prison. We will never put an impediment to the development of the armed struggle.

In short, I would say that whether we look at the cosmetic changes, whether we look at the manoeuvres of the government, whether we look at the buildup of pressures from certain Western countries who are trying to create a negotiating position with the regime in order to influence changes, Nelson's position has grown stronger and firmer. His position is, centrally (a) that the changes will not come solely through outside work and pressure; outside pressure is merely a subsidiary and adjunct to our main struggle; (b) that no pressures which seek to bring about a change of heart in the regime will bring about changes initiated by the regime in the correct direction; those are not possible in our situation; (c) that the armed struggle will be central to our struggle.

He is completely opposed to collaboration with the regime and acceptance of bantustans or any of these manoeuvres which aim to divide our black people, whether they be Indian, Coloured, or African. I would go further to say that Nelson made many statements in the past showing how he changed in the early 1950s from a position of narrow nationalism—almost appearing to carry racialistic undertones *vis-à-vis* other population groups—and from a sectarian position in the sense of being anti-Communist. But what is interesting in his development has been his analysing of the situation in the country. Today he analytically tries to see problems on the regime's side and on the side of the people. His approach to the regime's side is that we must look for the contradictions in there in order to see how we can widen them, so as to narrow the social base of the regime. But amongst the people his approach has been we must look for the unifying points and therefore also the danger points that the enemy may use to disunite us, and here he has consistently isolated anti-

Communism, and he has gone further and tried relating it to its social basis. He has gone on to analyse the question of racialism and tribalism; and again in prison as he has reflected on these issues he has again related them to the social and material basis which allow these divisive ideas to thrive. So he has become more conscious of the need to fight against these divisive positions, not just in theory but to fight them daily.

My own impression, having read his past writings before he went to prison, is that Nelson has deepened his outlook on these matters, even though our information as prisoners is not up-to-date and does not enable us to feel intimately the pulse of what is happening in our country and the international community. But we are very clear and he is clear: that the way we analyse things in prison is in order to keep informed so that our loyalty to the struggle and to the ANC is not blind but is reasoned.

28 *Account by Eddie Daniels* [Released in 1978]

From *Weekly Mail*, March 21–27, 1986

I spent my full fifteen years with Nelson from the very first day until the last when I was taken to Pollsmoor and discharged. Nelson is a tremendous figure, an inspiration. He is everything that is noble and good. How do you describe a person who, when you are at rock bottom, is a shining example of how to behave in adversity, who by his walk would inspire you, by his touch would inspire you, by his little talks would inspire you.

I joined Nelson in a special section of the prison. It was a bit rough. The food wasn't up to much. We slept on a cement floor, with three blankets that were very thin. If I held my blanket up I could see through [it]. The setting was quite grim. The aim of the authorities was to destroy our morale by giving us very poor food, very thin blankets, and poor clothing. When one is very, very cold, one does feel a bit demoralized.

All the political prisoners at that time were allowed one visit and one letter every six months. Strange as it may seem, even though we were allowed only one letter every six months, sometimes those letters were accidentally "lost" and our families might get a permit too late, so you might not get a visit or a letter for a full year. Times have changed, because the political prisoners fought very hard, and we succeeded in bringing about changes in the prison.

In this rather grim setting, a man like Nelson stood out like a shining star. There were other leaders of other political organizations. I was a member of the Liberal party [and] the only member of the African Resistance Movement in prison, and there were other organisations, [including] the PAC and the Unity movement. With due respect to all of them, the leadership of the

ANC, namely, Nelson Mandela and Walter Sisulu, was really in a class of its own.

There were occasions when we went on hunger strike, when we used to challenge the authorities for some reason or other, and the warders would always come to Nelson and challenge him, [asking] why this was taking place. Nelson would always have to face the thrust of the authorities, and he always carried himself with dignity, no matter what the situation was like.

It is said by the government that Nelson is a terrorist. He is no terrorist. He is a kind, honest, humble, and peace-loving man. Nelson is a family man. He has been pushed into this position, and being a man of calibre, he has accepted it. He is prepared to carry out what he considers to be his duty. Nelson will never give undertakings that will demean him. If Nelson gives an undertaking, he will honour it. He is that type of a person. Nobody in the government can compare to him.

Nelson, like me, was pushed over the edge by the cruel laws of the land.

We have two people in this country, Chief Albert Luthuli and Bishop Tutu, who have been awarded the Nobel Peace Prize. Chief Luthuli, in his book *Let My People Go*, said after 35 years of knocking on closed doors, pleading for the people: "The doors have still not opened."

Bishop Tutu last week went to see the government after the trouble in Alexandra Township, pleading with the cruel people who make these cruel laws, asking them for mercy.

Nelson felt he could not take that road. Nelson founded Umkhonto we Sizwe.

The government talks about negotiations with the ANC. Negotiations have been going on a long time. Jimmy Kruger came to see Nelson on the island. Le Grange came to see Nelson on the island. Brigadier Aucamp was actually a political appointment by the government as a go-between the ANC and Pretoria.

When we used to face the Prison Board, they would often ask us political questions, and the ANC made the point that we are not prepared to discuss political matters with them. Under the leadership of Mandela, we said, "Send your political representatives to us, and we will talk to them. We will only discuss prison matters with you."

Here is another example which shows you the kind of man that Mandela is. I had a diary in which I had noted the names of warders involved in assaults and their victims. The warders captured it in a raid. We had a very bad officer in command at that time. The police were putting people in straitjackets, beating people, and jumping on them. I was next in line, and I was quite frightened. I found it very difficult to sleep that night, and the next morning I was still full of fear. I went into the yard to fetch my plate of porridge, and when I came back Nelson was sitting in my cell. I got such a thrill seeing him sitting there, and then he said to me: "Eddie, you just go ahead and face them the way you want to face them." Nelson was an inspiration.

And another small point will give more insight into Nelson: There is a shrine on Robben Island for a political prisoner who died there many years ago. Nelson

got the permission of the commanding officer for us to go and pay our respects. When we went to the shrine, under guard, someone walked in wearing his shoes. Nelson said, "Please let us respect this shrine," and so we all removed our shoes and paid our respects and went back with a bit of inner peace.

Nelson was very good at negotiations and everybody, including the warders and the commanding officers, all held him in high esteem. They always greeted him, and he is a very courteous person and always replied.

Nelson is, of course, a nonracialist. After the death of John Harris (a member of the ARM hanged for the 1964 bomb at the Johannesburg station), I had a memorial service in my cell. There was an occasion at around that time when Nelson made a speech in which he mentioned John Harris. He said, "Here is a white man who died fighting apartheid." Nelson would always give credit where credit was due, and he especially made this point because there were a number of organisations present that were very antiwhite. He wanted to press the point . . . that a person is not judged on the color of his skin but on what kind of person he is.

Among the post-1976 political prisoners, there was a strong antiwhite element. One day in 1979 this led to fighting in the cells, and a number of the ANC people were stabbed and hurt. The authorities arrested some of the other men, and when the court case came up, the men had to give evidence against the others. Nelson said he wouldn't give evidence, and the whole case was dropped. This shows the kindness and the greatness of Nelson, and the move won the respect and even the applause of everyone else in the prison—in this way a lot of what may have been hostility between the young and the old guard or between one organization and another was actually done away with.

When I was ill one day, lying in my bed pretty helpless, Nelson came into my cell. I remember he had his bowly (chamber pot) under his arm, and he bent down and picked up my bowly and said: "Eddie, I will see you later." And he took my bowly to clean it.

Again you see he is a giant of a man, a giant that can walk with beggars and with kings and be at home in any company. And here was I, an insignificant individual and this great man, an international figure, came down to clean my bowly.

There is a joke Nelson tells about himself quite often. When he was a lawyer in Johannesburg he saw a lady, a white lady, trying to park her car. Nelson, being the kind and honest gentlemen that he is, came to help her. Eventually she parked the car and offered him a sixpence. Nelson said, "No, thank you," and she replied, "Well, if you want a shilling, I will give you nothing now." Nelson loved telling jokes about himself.

He is tremendous. The way he walks, the way he talks. When he touches you, he is an inspiration. When one is rock bottom one looks for something to lift you, to warm you, and I often think to myself that Nelson and Walter have this power to lift others.

Mandela's commitment is to his country. He will die for what he believes in. This is the man Mandela who I know, a man who I am proud to have met, a man who inspired me, and a man who has won my lasting respect.

29 *Account by Dan Montsisi* [Released in 1983]

Excerpted from *Weekly Mail*, June 13-19, 1986

He served his four years on Robben Island and regards the experience as one of the most important of his life.

"There was an administration block on the island," he recalls, "and there one could meet Mandela, Sisulu, Mbeki, Kathrada, and others. For us young people who had heard so much about them it was a wonderful experience, and we made sure we discussed as much as we could with them.

"It was amazing to us that in spite of so many years on the island, they were still so courageous, mentally alert, and determined to fight on. We developed a deep comradeship with them through discussions and understanding of the problems we face in South Africa. We also felt great respect. They were like fathers to us. It was the type of relationship that cannot be broken by the system, and the experience of the island is one that no other individual can take away from you."

Montsisi says the period of incarceration honed his own political perceptions. "For example, my understanding of the Freedom Charter had not been that thorough before. It was on the island that we could look back and learn from our history. One was able to put into correct perspective those pieces of the jigsaw puzzle which had been missing all along.

"We began to understand that we young people were not the first to take this kind of action—we found out about the old ANC Youth League, for example, and the African Student Organisation. We drew from the rich history of the struggle and were able to recognise the authentic leadership and people's movement."

30 *Account by Seth Mazibuko* [Released in 1984]

Excerpted from *Newsweek*, June 23, 1986

"In my personal struggle against apartheid," Mazibuko says today, "I consider the Boer sending me to 'The Island' an honor. What it did for me! How I changed! All because I met Nelson Mandela and learned from him and the others. I had been brought up to believe that Mandela was an animal. Our parents taught us: 'Don't get involved in politics because you'll end up a terrorist and go to prison like that Mandela.' But how I learned! The Boers brought us in, a bunch of us together on the boat, and I heard this voice, deep and strong, saying, 'Which ones are Seth, Murphy, and Dan?' I looked up and there was Mandela."

Mazibuko was awed by Mandela's presence. "He was tall, over six feet, and

spoke with this deep but gentle voice," Mazibuko recalls. "What an impression he made!" Mandela, who had been imprisoned for 15 years by then, tutored the new arrivals with the help of fellow prisoners from the ANC. "He wanted to unite," says Mazibuko. "It was then that I began to question some of my Black Consciousness beliefs, because here was our leader preaching unity and non-racialism. He and another man, whom we called simply 'The Old One,' really affected me. As Black Consciousness leaders we wanted to defy everything the white man told us to do. We would not wash, we would not clean our cells, we would not *do* anything. But the old man came to me and told me that in this struggle we were prisoners of war and that we had to be disciplined and ordered. I looked at how different this was from Black Consciousness. The island changed me, because eventually I came to the decision that I had to follow Mandela and nonracialism."

31 *Accounts by Ahmed Kathrada, Elias Motsoaledi, and Walter Sisulu* [Released in 1989]

From *New York Times*, October 19, 1989

Walter Sisulu and two of his freed colleagues from the outlawed African National Congress talked today about their 26 years in prison and how their captors had tried at first to break them with hard labor, midnight searches, informers, and humiliation.

Mr. Sisulu, who is now 77 years old, Ahmed Kathrada, 60, and Elias Motsoaledi, 65, were among eight political prisoners released unconditionally by the government on Sunday. They had been sentenced with their comrade, Nelson Mandela, to life imprisonment in June 1964 for conspiring to commit sabotage and overthrow the government and sent to Robben Island, South Africa's equivalent of Alcatraz, and then to Pollsmoor Prison on the mainland in 1982.

As they related their experiences to a group of American and French reporters in a small hall of Holy Cross Anglican Church near Mr. Sisulu's home, several hundred chanting schoolchildren gathered outside in hope of glimpsing Soweto's newest heroes.

Mr. Sisulu disclosed that the authorities started talking discreetly to Mr. Mandela before he was transferred from Robben Island to Pollsmoor in 1982 and that discussions grew more serious after he was moved to a prison farm outside Cape Town last December after recovering from a near-fatal bout of tuberculosis. Mr. Sisulu did not give any details.

But he denied speculation that Mr. Mandela was remaining in prison as part of a deal worked out with the government that would lead to eventual negotiations. Mr. Sisulu said Mr. Mandela "would have gladly gotten out with us" but had put the release of his comrades first.

Mr. Sisulu said negotiations are impossible until Mr. Mandela is freed and doubted that his own behavior would influence the government. "They have no choice," Mr. Sisulu said. "They will release him if the situation demands it."

Mr. Sisulu described Robben Island and Pollsmoor as providing the best kind of political education. And the men said they had learned that pressure, whether from inside prison or abroad, was the way to force an end to apartheid. As a result, they said the struggle "in all its aspects"—an allusion to guerrilla attacks— and economic sanctions against South Africa should be intensified.

"It really confirmed our belief that the South African authorities do not suddenly undergo a change of heart," Mr. Kathrada said. Every concession the government has made "has been under some pressure or another."

Mr. Kathrada said his group had been prepared psychologically for prison because they expected to be arrested at some stage. But when they were deposited on Robben Island, which lies in chilly, shark-infested Atlantic waters off Cape Town, he contended that their captors wanted to break them. "From the security police to the prison authorities, they tried to instill into our minds that we would be forgotten in a few years' time," Mr. Kathrada said. "They did everything to crush our morale."

For the first six months, he said, Mr. Mandela and the other prisoners were put to work breaking stones with hammers. Then they were sent to work in the prison's lime quarry, performing hard labor that Mr. Kathrada said lasted more than a decade.

At one point before conditions improved, Mr. Kathrada said, Mr. Mandela and Mr. Sisulu were put on a meager ration of rice gruel as punishment for allegedly not working hard enough.

Mr. Kathrada, who is of Indian descent, said that initially he and the mixed-race convicts were issued long trousers, but black convicts like Mr. Mandela and Mr. Sisulu had to wear shorts, however cold the weather, and were not given socks. He also said blacks were not given bread with their food.

After the day's labor, Mr. Sisulu said, the convicts had to strip naked outside and wash down with cold seawater, even in winter.

Mr. Kathrada vividly recalled one night—he said the date was May 28, 1971—when the warders, "many of them very drunk," descended on their cells to rouse the convicts, stripped them, and forced them against the wall for a particularly rough search in which he said Govan Mbeki, a prisoner released in 1987, nearly suffered a heart attack. But Mr. Kathrada said they were spared physical brutality that was inflicted on less prominent prisoners.

The men insisted that the intended humiliation only stiffened their defiance. "Because we were so close to the oppressor, it helped to keep us united," Mr. Kathrada said.

They went on hunger strikes to force concessions. The former prisoners also credited the International Red Cross and Helen Suzman, a liberal white legislator who focused attention in Parliament on the plight of political prisoners, with having improved conditions.

Such pressure, they said, gradually improved their lives in prison. In 1980, after 16 years on Robben Island, they were allowed to read newspapers. They

were subsequently permitted radios, although not shortwave receivers for foreign broadcasts, and television and videocasette recorders in 1986. Mr. Kathrada said permission was also "reluctantly granted" to study by correspondence, read books, watch films, and own musical instruments.

They tried to keep up with events outside by talking to new prisoners, reading smuggled letters and "begging, stealing, and bribing" for information. "Political prisoners give top priority to keeping themselves informed," Mr. Kathrada said, but they sometimes went without news for several months.

He said they did not learn about the uprising touched off by Soweto schoolchildren in June 1976 until August. Mr. Motsoaledi said he was upset to learn that two of his children's playmates died in the violence.

Mr. Sisulu said he never felt despair in his prison years, "but there were moments when I felt very much in high spirits." He said he was "inspired" by events like the 1976 Soweto rebellion and the formation of the Congress of South African Trade Unions and the United Democratic Front, which form the core of the antiapartheid movement and have links to the African National Congress in exile.

"It was not easy, but we did communicate with the ANC," Mr. Sisulu said. His group briefed prisoners who were being freed, to pass along messages to the movement's leadership in exile in Lusaka, Zambia. He said they used a second channel that he could not divulge. And he said they conducted extensive political indoctrination of other prisoners on behalf of the Congress.

The released prisoners sounded occasionally nostalgic for the old camaraderie that bound them together for the last quarter-century. "In prison, the best comes out and the worst comes out as well, because of the deprivation and suffering," Mr. Kathrada said. He joked about having to live with Mr. Sisulu's taste for pop music in their last three and a half years as cellmates.

Mr. Sisulu said the "enriching experience" of confinement had matured them all. "There has been never a greater university for political education than there was in prison."

PRISON VISITORS

32 Interview with Denis Healey, British Labour M.P. [Visited in 1970]

Excerpted from *Sechaba*, January 1971

Q. *Mr. Healey, you were recently on a visit to South Africa and able to see Nelson Mandela. Can you tell us about your visit and your impression?*

A. My visit to Robben Island? Yes, I had about an hour talking to Nelson Mandela in the governor's office in the presence of the prison commandant and the deputy commissioner of prisons and the British ambassador, so that inevitably our conversation was slightly circumscribed. But having known Nelson Mandela nine years ago when he was in exile, I was relieved to find that intellectually, morally, and physically he was fighting fit. He wasn't in any way cast down by his experiences of the last eight years. He was completely confident of the victory of his cause and I couldn't help feeling that the obvious respect in which he was held by his gaolers owed a little to the possibility that he might, like so many in prison before him, go from prison to the presidency. He has lost weight since he was in jail, but physically he looks very fit. His morale is obviously high, and he talks about getting out of prison some time. He is of course very indignant, as I am too, that he and his fellow political prisoners get no remission for good conduct.

Q. *Were there any restrictions on what you could talk about?*

A. No. Only that imposed by natural discretion. I told him I had come to South Africa to make a speech to the students of Durban University and that it had been very well received by them but very badly received by the government. He asked if he could have a copy of it, and I proposed, and the prison commandant agreed, that I should send a copy through the authorities. I added that if the latter didn't think it suitable for Mr. Mandela, it would nevertheless do the commandant a lot of good to read it.

Q. *The authorities must have found it a little embarrassing that a former British minister of defence should want to visit Mandela—what made you seek him out?*

A. Well, he is, as you know, the outstanding leader of the African nationalist movement in South Africa. I had formed a great respect and friendship for him when I met him with Oliver Tambo in 1961. I was very anxious to see him in order to ensure that his treatment was correct. My impression is that he and his fellow prisoners in the particular group are reasonably properly treated, and as you know, they are visited annually by representatives of the International Red Cross. They have also been visited twice by Helen Suzman.

Q. *Was he adequately clothed? For a long time he had no shoes and only short trousers to wear.*

A. Well, it was spring when I was there, and he was wearing a khaki uniform with a high collar and he was wearing shoes. He didn't complain about his personal treatment, but he did say that he's not allowed to study the things that interest him most. He is studying law in prison and is receiving law books.

33 *Account by David McNicoll, Australian Journalist [Visited in 1973]*

Excerpted from *The Observer*, April 22, 1973

Mandela came in first, shook hands again, made himself comfortable in an armchair, asked me for my visiting card, and gave me a big smile.

As with all Africans it is hard to guess his age. I would say mid-forties. His skin is smooth, his eyes alert and humorous. He wore well-fitting fawn mole-skin coat and trousers, comfortable soft brown leather shoes, and red-and-blue striped woollen socks. His hands showed no particular signs of hard work. He explained to me at the start his pleasure at the improvement in his working conditions.

"Years ago it is true I could seldom see the coast or the sea or anything but walls. But things have improved. Diet and clothing are better. The improvements are not of a substantial nature, but they have removed some complaints.

"In 1965 I used to work in the quarry, where I could only see the sky. Then in 1968 I was moved to another lime quarry—but at least I could see Cape Town. Then, in November 1971, I was put on to collecting seaweed. This is the most popular job—you can see the sea, and feel it, and watch the ships coming and going."

Mandela didn't take long before he started putting forward his complaints. The principal one was the difference between the diet arranged for the Indians and Coloured prisoners and that for Africans. "It is intolerable," he said, "that Coloured and Indians get bread every day with butter or ghee, and we get it only twice a week. And they get milk, too. I am a man who likes milk. I like to eat well. When I was put in prison I was earning 4,000 rand a year and paying 400 rand a year income tax. That gives you some indication of the standard of living I enjoyed in the early sixties. Yet I am not allowed to have the same bread and milk as Indian and Coloured prisoners, merely because there is a general African scale."

"Do you get any world news? Do you get to hear what is happening in the other African states? Do you hear about the changes everywhere?" I asked.

"Mr. McNicoll," he said, very straightfaced, "you must realise we get no papers, we have no radios, we are never allowed to read anything critical of the

government. All our magazines are censored. You will never believe it, but recently they gave me a *Reader's Digest*, and they'd censored 20 of the articles in it. In the *Reader's Digest*! What is safer than the *Digest*?

"So you see, we get no information." Then Mandela looked slyly across at the commandant. "But we are intelligent people, and we manage to keep in touch with world affairs."

As Mandela kept talking it was apparent that his knowledge of what was happening in the world was widespread and reasonably accurate. How the prisoners get the information is a mystery to the camp officials. But they know everything. Mandela discussed John Gorton, Bill McMahon, then asked what sort of a job Whitlam was making of Australia.

"Do you get depressed?" I asked him. "No," said Mandela. "We devise our own ways of obtaining information, and this stops us from getting depressed. On this island we abound in hope.

"I can say I have never had a single moment of depression, because I know that my cause will triumph. I am satisfied with the way things are proceeding.

"And may I say that Australia stands high in my esteem, as it is in the forefront of denouncing the evils of racialism. Now, you have asked me many questions. I would like you to listen to some complaints. These refer to earlier days on this island, before the present commandant came and things improved.

"Often they were bad. Prisoners were mercilessly beaten up. I was on one occasion stripped and made to stand at attention, stark naked, for an hour. This is no way to treat someone of my standing. We have had a bad time because of the arbitrariness of the authorities. For instance, we are all supposed to receive a copy of prison regulations. We have never received one, only a small summary. So we are never properly aware of our rights."

My hour with Mandela was up.

34 *Account by Lord Nicholas Bethell,*
British House of Lords
[Visited in 1985]

From *Mail on Sunday*, January 27, 1985

I waited for Nelson Mandela in the governor's office in the maximum security block of Cape Town's Pollsmoor Prison. Senior officers in yellow khaki uniforms with gold stars on their epaulettes, some with peaked caps pulled over their eyes like guards sergeant majors, scurried in and out talking excitedly in Afrikaans. At last, three men entered the room, and one came towards me. "How do you do?" he said. I greeted him in return. "You must be related to Winston Churchill," he went on, hinting presumably at my need to lose a few pounds in weight. "Anyway, I'm very pleased and honored to receive you."

He was anxious to put me at my ease, and he invited me to sit down at the desk where I was ready to make my notes. It was a second or two before I realized that this was the man I had come to see.

A six-foot-tall, lean figure with silvering hair, an impeccable olive-green shirt and well-creased navy blue trousers, Mandela could almost have seemed like another general in the South African prison service. Indeed, his manner was the most self-assured of them all, and he stood out as obviously the senior man in the room. He was, however, black. And he was a prisoner, perhaps the most famous prisoner in the world, the man they write songs about in Europe and name streets after in London, the leader of the African National Congress, a body dedicated to the destruction of the apartheid system, if necessary by force.

He is the black man's folk hero, his fame made all the greater by the fact that he has been out of sight behind prison bars for nearly twenty-two years. All this time virtually no one other than his lawyers and his immediate family have been permitted to see him or talk to him. Newspapers have speculated about the harshness of his prison regime, about his political views and his chances of release. Our meeting gave me the chance to set the record straight for the first time on all these points.

"In my first ten years on Robben Island," Mandela recalled, "conditions were really very bad. We were physically assaulted. We were subjected to psychological persecution. We had to work every day in the lime quarry from 7 A.M. to 4 P.M. with a one-hour break, wearing shorts and sandals, with no socks or underwear and just a calico jacket. It was hard, boring, unproductive work, and on rainy days in the winter it was very cold.

"The guards pushed us all the time to work harder, from dawn to sunset, and we could get solitary confinement if they thought we were slacking. The diet was maize porridge for breakfast with half a teaspoon of sugar, boiled grain for lunch, with *puzamadla*—a drink made out of maize that is, to put it mildly, an acquired taste—and porridge with vegetables in the evening. There was a lot of tension between guards and prisoners."

Helen Suzman, who has campaigned for the black man's rights throughout her thirty-two years in the South African Parliament, remembers with horror her visits to Robben Island in the 1960s. "Guards with Alsatian dogs on leads, and sometimes with swastikas tattooed on their wrists, would drive the men to work," she told me. "I remember one prisoner complaining to me that he had been assaulted. I was noting down the details when the guard in question came running up saying, 'Ah, it was really nothing, Mrs. Suzman, it was only a kick up the arse.'"

Then around 1974 there were dramatic improvements in the treatment of "security prisoners," as those convicted of threatening South Africa's system are known. This is confirmed by Helen Suzman, by Red Cross officials in Geneva, who today describe Mandela's treatment as "broadly satisfactory," and by Mandela himself.

"Things can now be made significantly better by dismantling the whole South African system," he told me. "For instance, it would be good if some of the country's senior prison officers were black as well as white. But how can this happen under apartheid?"

"I am in good health. It is not true that I have cancer. It is not true that I had a toe amputated. I get up at 3:30 every morning, do two hours' physical exercise, work up a good sweat. Then I read and study during the day. I get the South African newspapers as well as the *Guardian Weekly* and *Time* magazine. We have a radio in the cell—VHF only, unfortunately, so that we can only get African stations, not the BBC. I cultivate my garden. We grow vegetables in pots—tomatoes, broccoli, beans, cucumbers, and strawberries."

He gestured expansively to his right: "The major, here, has been tremendously helpful. He is really an excellent gardener." The major in question, Fritz van Sittert, who guards Mandela and his cellmates and was detailed to supervise our meeting, did not react or even utter a word throughout the entire two hours. We spent the time, just the three of us, in the functional office with its G-Plan furniture, dominated by a large glass-topped desk, and overlooked by a picture of State President P. W. Botha wearing a silver order and an orange sash. The major was there not to censor the conversation, which was unhindered, but to make sure that no document or other object passed between us.

I had been asked, for instance, to obtain Mandela's signature on a paper authorizing his name to go forward in the election of the rectorship of Edinburgh University. He was not allowed to sign the paper, but he agreed verbally to be a candidate. "I am very flattered. I am a politician and of course I like to win elections, but in this case it is such a kind gesture that I really don't mind if I win or lose."

Mandela had kind words, too, for Pollsmoor's governor, Brigadier F. D. Munro. "The brigadier does his best to solve our little problems. But, poor man, he has very little authority. Everything concerning the six of us he has to refer to Pretoria. For instance, a year ago my sister died, and I wrote to my brother-in-law about her funeral. They blocked the letter. Why? I suppose because he is a policeman in Transkei and they don't want me to make contact with him. His name is Russell Piliso. They also blocked my letter to Bishop Tutu congratulating him on winning the Nobel Prize. A few days ago a friend of mine here received a letter completely cut to ribbons. It's not the poor brigadier, it's the politicians. Still, conditions here are quite reasonable, better than on the island. The food is good and there are no problems with the staff, racial or otherwise."

It was to enable me to confirm the conditions of Mandela's imprisonment that the South African minister of justice, H. J. Coetsee, authorized my visit, making it clear that I would not be allowed to bring press or television with me. Coetsee wanted the point to be made that Mandela was in good health and being well treated. And I can confirm that generally speaking, that is the case. Even so, it was an unusual concession to a foreign parliamentarian.

Pollsmoor consists of a dozen long buildings built in the 1970s, each one a separate unit. It looks from the outside like a huge, gloomy campus of a comprehensive school or red-brick university. "This is the white women's section. This is the Coloured men's section," explained the deputy commissioner of security, Major General "Bertie" Venter, as we drove past the main barrier along roads lined with grass and flower beds, toward the governor's dining room. Over lunch—steak and chips cooked and served by convicted men—the commissioner of prisons, Lieutenant General "Willie" Willemse, presented his case that South African conditions are up to North American or West European standards. Each man, black or white, receives a minimum of 10,571 kilojoules per day. Prisoners have decent clothes, family visits, recreation, and the possibility of parole. "If only people abroad knew the facts," he said, "we in South Africa would not be so harshly judged."

Mandela's quarrel with South Africa is not one of prison conditions, however. "Things get exaggerated because of lack of communication," he told me. "A little time ago I was wearing size eight shoes. Once they gave me size nine. It was okay, but they bothered me for a bit, and I mentioned it to my wife. She was upset and there was a fuss in the press. They even mentioned it in the song 'Free Nelson Mandela.' I was sorry for all the trouble caused. If I'd had a phone I'd have called her up and said, 'Don't worry, my dear, it's all right,' only I didn't have a phone and that's the sort of thing that happens.

"I wish that the senior men who make the real decisions would come and see us. Louis Le Grange, when he was minister of justice, and Commissioner Steyn used to come at least every year. Now the minister and commissioner don't come. It is worrying, because when the top men stay away it sometimes means a move toward a tougher policy. And if they came we could discuss our little problems, and I am sure we could convince them.

"My other complaints are about cell conditions. There is a damp patch on the wall. There must have been a fault in the way it was built. And it is wrong for the six of us to be segregated from all the other prisoners. We would like more companions. But I have not asked for more to be brought here, as I am not sure that the other political prisoners on Robben Island—there are 230 of them—would like the regime here.

"I would like greater privacy, too, for my studies. In fact, our basic demand, which we made in 1969, is for political status, for instance, the right to keep a diary and to be visited by the family. I mean the African family, not just wives, brothers and children, which is the family in the European sense."

The problem is, therefore, not one of brutal prison conditions. It is that Mandela and his friends are in prison at all. Mandela and other top ANC officials have spent eighteen years on Robben Island and three in Pollsmoor—all for no worse a crime than conniving at the destruction of property. It is a punishment that far exceeds the offense, even if one ignores the argument that they had every right to use force against apartheid, deprived as they were of the right to vote, to stand for election or to reside where they wish in their own country. They are in prison now, it is clear, not as an act of justice or punishment, but because it does not politically suit the South African state to release them.

The problem is that Mandela still supports the armed struggle. This is why some human rights bodies—for instance, Amnesty International—will not campaign for his release. Also, his case does not appeal to the Parole Board, since he shows no repentance for his past actions. Rather, the contrary: He makes no secret of his wish to return to the fray. This provides the authorities with the ideal pretext for not putting his name forward to State President Botha for clemency.

"The armed struggle," Mandela told me, "was forced on us by the government. And if they want us now to give it up, the ball is in their court. They must legalize us, treat us like a political party, and negotiate with us. Until they do, we will have to live with the armed struggle. It is useless simply to carry on talking. The government has tightened the screws too far.

"Of course, if there were to be talks along these lines, we in the ANC would declare a truce. This is what SWAPO did in Namibia. But meanwhile we are forced to continue, though within certain limits. We go for hard targets only, military installations and symbols of apartheid. Civilians must not be touched.

"This is why I deeply regret what happened in Pretoria on May 23, 1983. A bomb went off and more than a dozen civilians were killed. Something must have gone wrong with the timing. It was a tragic accident. On the other hand, the incident that took place in Vryheid [in Natal] a few weeks ago, when a South African lieutenant was killed, was quite justified. Some ANC members were in a house, and the security forces came looking for them. We have reason to believe that their policy now is to shoot to kill rather than try to arrest our men. So they opened fire in self-defense and the lieutenant was killed, as were several of our soldiers.

"We aim for buildings and property. So it may be that someone gets killed in a fight, in the heat of battle, but we do not believe in assassinations. I would not want our men to assassinate, for instance, the major here. I would only justify this in the case of an informer who was a danger to our lives. And all this can end as soon as talks begin. It would be humiliating, though, for us simply to lay down our arms."

It is this "humiliating" condition that the South African government requires and that blocks any progress toward a political settlement and Mandela's release.

Louis Le Grange, now South Africa's minister of law and order, told me his government is "not so weak as to agree to talks with the ANC at the moment. But if they will forgo the armed struggle and enter the political arena we will talk to them. As for Mandela, if you ask me whether I should recommend his release so that he can carry on where he left off, I say no. I can't give such advice unless he gives some assistance through his own attitude. Things are at a sensitive stage in South Africa. We have changed our constitution and are contemplating further changes. So we must have proper law and order. As things are, Mandela's release would invite a lot of problems and trouble."

Justice Minister Coetsee, while agreeing that "objectively speaking, it would be better if Mandela were not in prison," also made it clear that for the moment, reasons of state prevent his release.

The authorities may have recently tried to find a way out of this impasse.

Mandela has been told by his wife Winnie that his nephew Chief Kaiser Matan-
zima would give him sanctuary in the semiautonomous black "homeland" of
Transkei if Mandela would give up political activity. But "I completely rejected
the idea," Mandela told me. "I have served twenty-two years in prison for fighting
against the policy of Bantustans. There is no way that I could then go and live in
a Bantustan. I would also reject an offer to go abroad. My place is in South
Africa, and my home is in Johannesburg. If I were released, I would never obey
any restriction. If they confined me, for instance, to the Cape area, I would break
the order and walk to my home in Soweto to be with my wife and daughter. I
would only leave my home if the ANC leadership ordered me to do so."

Meanwhile, Mandela wants to see the ANC develop as a widely based
national movement. "Personally, I am a socialist, and I believe in a classless
society. But I see no reason to belong to any political party at the moment.
Businessmen and farmers, white or black, can also join our movement to fight
against racial discrimination. It would be a blunder to narrow it.

"I appreciate the Soviet Union only because it was the one country that long
ago condemned racialism and supported liberation movements. It does not mean
that I approve of their internal policy. I was grateful, too, by the way, to Emperor
Haile Selassie of Ethiopia, who received me in 1962. He was a feudal ruler, but he
supported our movement, and I was grateful to him. Britain, too, has helped us,
under Mrs. Thatcher as well as under socialist governments, by condemning
apartheid on principle. We may have different views about the methods that
should be used, but the most important thing is to condemn apartheid outright.
And this, as I understand it, is what your prime minister does."

Our talks drew to a close, and Brigadier Munro invited me to visit Mandela's
cell in the isolated wing of the long, low buildings. So we walked in slow
procession up flights of stairs and around corners, with Mandela leading the
way as if showing me around his home. He did not open doors for me; this was
done by sergeants with heavy keys after much saluting and clanking. Always,
though, Mandela was the one who showed the way, inviting me to go first
through every door and plying me with questions on Britain and the world,
anxious, apparently, to supplement the information he gets from the radio and
press he has in his cell.

Did I think that Gorbachev's recent visit to England would relax East–West
tensions? What were my hopes for the Shultz–Gromyko talks? Would the
Liberals at last make a breakthrough in British politics? What was Mrs.
Thatcher's secret of success? Who was now leader of the Labour party?

And so we reached the "Mandela enclosure" on the third floor, a large room
with beds, plenty of books, and adequate facilities for washing and toilet. The cell
door is open almost all day. The prisoners have access to a long, L-shaped roof
yard surrounded by high white walls. As well as the vegetable pots, there is a
ping-pong table and even a small-scale tennis court, apparently unused.

Mandela proudly showed me his vegetables, like a landowner showing me his
farm. As for the yard, he wished only that it was less monotonously black, white,
and grey. As a rural man, he longed for green, and he understood, he said, what
Oscar Wilde meant by "the little tent of blue that prisoners call the sky."

He showed me the damp patch on the cell wall and introduced me to his cellmates, who apologized for being informally dressed. He explained who I was and briefly what we had been discussing. In spite of the brigadier's mild protests, he then showed me the letter that had been so badly savaged by the censor. And he joked as we prepared to leave, "Aren't there any other complaints? Doesn't anyone want to go home?"

And so we walked the last few yards toward the end of the enclosure. And I prepared to say goodbye to this remarkable man whom I have begged the South African government to release, on humanitarian grounds if for no other reason. A sergeant opened the grey, heavy steel door. Mandela said, "Well, Lord Bethell, this is my frontier, and this is where I must leave you." We shook hands, and I told him I would be writing. I walked through all the other steel doors, down the stone staircases, out through the front door into the fine Cape summer, feeling poorer for being so suddenly deprived of this man's exhilarating company.

35 *Account by Samuel Dash, Chief Counsel to the U.S. Senate Watergate Committee*
[Visited in 1985]

Excerpted from *New York Times Magazine*,
July 7, 1985

From the outset, Mandela demonstrated a knowledge of current affairs that belied his many years of confinement. In greeting me, he complimented me on my former role as counsel to the Senate Watergate committee and commented at length about the proceedings of the conference I had just attended. He also talked knowledgeably about the Geneva arms talks, which he follows with interest.

Turning to the problems of South Africa, Mandela left me with no doubt that although he intended his statements for my ears, he wanted me to relay them to the white authorities. For throughout his imprisonment, he said, the white government has refused to talk with him about his and the African National Congress's intentions and policies. I did not take notes during the interview, but Mandela's responses to my questions are reconstructed below.

I asked Mandela if he took hope from suggestions that the government might repeal laws banning interracial marriage and ease laws that limit black entry into urban areas. He smiled. "You are speaking about pinpricks," he said. "Frankly, it is not my ambition to marry a white woman or to swim in a white pool. The central issue is political equality."

"Our program is clear," Mandela said. "It is based on three principles: (1) a unified South Africa—no artificial 'homelands'; (2) black representation in the central parliment—not membership in the kind of apartheid assemblies that have been newly established for the Coloreds and Asians; (3) one man, one vote."

I asked Mandela how his program would affect South African whites, many of whom fear that political equality will mean subjugation at the hands of an embittered black majority. He stressed that this was an essential concern of the African National Congress's leadership. "Unlike white people anywhere else in Africa, whites in South Africa belong here—this is their home," Mandela said. "We want them to live here with us and to share power with us."

Speaking energetically in a soft British accent, Mandela emphasized that balance and restraint were essential to the task of dismantling apartheid and building a cohesive multiracial society. Noting the difficulty, for instance, of integrating Johannesburg's white urban areas and outlying black townships after a century of segregation, Mandela said he would not press for an uncontrolled movement of blacks into the city: "We want Johannesburg to remain the beautiful and thriving city that it is now. Therefore, we are willing to maintain separate living until there are enough new employment opportunities and new homes to allow blacks to move into Johannesburg with dignity."

I asked Mandela how he reconciled such moderate positions with his organization's avowed goal of overthrowing the South African regime by force. He said he wished the changes he sought for South Africa could be achieved peacefully. And he conceded that blacks would suffer most if they resorted to violence. "However," he said, "if white leaders do not act in good faith toward us, if they will not meet with us to discuss political equality, and if, in effect, they tell us that we must remain subjugated by the whites, then there is really no alternative for us other than violence. And I assure you we will prevail."

Acknowledging the military power of the South African government, Mandela conceded that blacks could not defeat the white regime in direct combat. "However," he said, "over time, and with the help of others on our borders, the support of most other nations in the world, and the continued training of our own people, we can make life most miserable for them."

Mandela dismissed charges that the African National Congress is controlled by the Soviet Union or by the South African Communist party, emphasizing the congress's independence and discipline and comparing its Communist members to radicals in Britain and other Western democracies.

36 *Account by John Lofton and Cal Thomas, American Journalists* [Visited in 1985]

Excerpted from *Washington Times*, August 22, 1985

The party was taken to the warden's office for the interview. Mr. Mandela—the warden calls him "Nelson"—answered the questions in a soft, determined voice, making these points:

South Africa President Pieter W. Botha was correct when he said in a major address in Durban August 15 that he would consider releasing him from prison if he "gives a commitment that he will not make himself guilty of planning, instigating, or committing acts of violence for the furtherance of political objectives."

In that speech, President Botha said if Mr. Mandela agreed to this, he would, "in principle, be prepared to consider his release."

Mr. Mandela said he rejects this appeal "outright" because "I didn't come to prison because I wanted to." The conditions which prevailed in the 1960s, when he was jailed, he said, compelled him to come to prison. "As far as I can follow from political events, conditions are much the same now, if not worse."

He would be back in prison "in a day," he said, because "I can't fold my arms. I want to live like a free human being. There is no alternative to taking up arms. There is no room for peaceful struggle."

All that President Botha wants, he said, is to "entrench white supremacy."

Asked if he is saying explicitly, that he will not renounce violence and would again be jailed because he would do the same thing he was convicted of doing, he says yes, this is precisely his position.

Mr. Mandela said that he is "definitely not" a Marxist or a communist but an African nationalist who has been influenced by the idea of a classless society.

He is a Christian, he said, a member of the Methodist church who was educated in Methodist schools. He believes violence is compatible with Christianity, depending on the situation: "We have no choice. We are compelled to defend ourselves."

As a Christian, he argued that he can justify violence against civil authorities by the example of Christ's driving the money changers from the temple. "They were evil," he said, "and I have the right to use force against evil."

He said the question of force against civil authorities should not be pressed, because Christian countries have gone to war to fight against various forms of injustice. He does not read the Bible regularly, he said, but prays monthly when he is visited by the Rev. Dudley Moore.

Communism is "better" than apartheid because communism has no color bar, he said. Communism "gives equal opportunity to everybody," and under communism "everybody would be living better."

He considers himself a "political prisoner" who was convicted on "technical violations" in the course of government persecution for his politics. He is aware that Amnesty International has refused to classify him as a so-called prisoner of conscience.

Reminded that Martin Luther King, Jr., professed a strategy of nonviolence to achieve equal treatment for blacks in America, Mr. Mandela said that conditions in South Africa are "totally different" from conditions in the United States in the 1960s. In the United States, he said, democracy was deeply entrenched, and the people struggling then had access to institutions that protected human rights. The white community in the United States was more liberal than whites in South Africa, and public authorities were restrained by law.

In South Africa, he said, there are two worlds: for whites, democracy, but for blacks there is only "a colonial power crawling on crutches out of the Middle Ages."

On the question of disinvestment, economic sanctions against South Africa, Mr. Mandela said he is "definitely" for this strategy "very strongly" because it has "agitated the powers that be." He said of the argument that disinvestment would hurt blacks most: "We have to tighten our belts. There must be sacrifice for liberation." He said he is not familiar with economic facts and figures of the issue.

37 *Report of the Commonwealth Eminent Persons Group* [Visited in 1986]

Excerpted from *Mission to South Africa*, 1986

During the preliminary visit, General Obasanjo was permitted to see Mr. Mandela. Thereafter the full group met with him on two occasions, although not with other detainees. In all these meetings we were conscious of our responsibility to Nelson Mandela himself. As recently as 10 February 1985, when referring to suggestions for his conditional release, he had referred to the constraints that custody imposes: "Only free men can negotiate," he said. "Prisoners cannot enter into contracts." It was essential, we felt, that we should meet and talk with him. We were equally determined that those conversations should neither compromise nor embarrass him. We reiterate that intent in drawing on those conversations for the purposes of our report.

The group approached the meetings with Mr. Mandela with another measure of care. It was impossible not to be aware of the mythology surrounding him, but equally, we were determined that it should not colour our impressions or influence our judgment. As far as possible, we resolved to approach these meetings with an open mind.

We were first struck by his physical authority—by his immaculate appearance, his apparent good health, and his commanding presence. In his manner he exuded authority and received the respect of all around him, including his gaolers. That in part seemed to reflect his own philosophy of separating people from policy.

His authority clearly extends throughout the nationalist movement, although he constantly reiterated that he could not speak for his colleagues in the ANC, that apart from his personal viewpoint, any concerted view must come after proper consultation with all concerned, and that his views could carry weight only when expressed collectively through the ANC.

There was no visible distance of outlook, however, between Nelson Mandela and the ANC leadership of Lusaka. He was at pains to point out that his

own authority derived solely from his position within the organization and insofar as he was able to reflect the popular will.

Second, we found his attitude to others outside the ANC reasonable and conciliatory. He did not conceal his differences with Chief Buthelezi, and he was conscious of the divisions which had arisen among the black community. Nevertheless, he was confident that if he were to be released from prison, the unity of all black leaders, including Chief Buthelezi, could be achieved. The ANC, as the vanguard of the liberation movement, had particular responsibilities, but the fact that freedom fighters belonged to a variety of organizations was both a challenge to, and an indictment of, the ANC. He stressed repeatedly the importance of the unity of the whole nationalist movement.

In our discussions Nelson Mandela also took care to emphasize his desire for reconciliation across the divide of colour. He described himself as a deeply committed South African nationalist but added that South African nationalists came in more than one colour—there were white people, coloured people, and Indian people who were also deeply committed South African nationalists. He pledged himself anew to work for a multiracial society in which all would have a secure place.

He recognized the fears of many white people, which had been intensified by the government's own propaganda, but emphasized the importance of minority groups being given a real sense of security in any new society in South Africa.

That desire for goodwill was palpable. The minister of justice, together with two senior officials, was present at the start of our second meeting, and Mr. Mandela pressed him to remain, saying he had nothing to hide and no objection to the minister hearing the discussion. It was his strongly stated view that if the circumstances could be created in which the government and the ANC could talk, some of the problems which arose solely through lack of contact could be eliminated. The fact of talking was essential in the building of mutual confidence.

Third, we were impressed by the consistency of his beliefs. He emphasized that he was a nationalist, not a communist, and that his principles were unchanged from those to which he subscribed when the Freedom Charter was drawn up in 1955. Those principles included the necessity for the unity and political emancipation of all Africans in the land of their birth; the need for a multiracial society, free from any kind of racial, religious, or political discrimination; the paramountcy of democratic principles and of political and human rights; and equality of opportunity. He held to the view that the Freedom Charter embodied policies which amounted to a devastating attack on discrimination in all its ramifications—economic, social, and political.

While it called for a new order, this was not to be on the basis of any change in the system of production apart from certain key sectors. He argued that he and his colleagues had been to court because of the Freedom Charter, that the court had deliberated for four years before giving its verdict that the Crown had failed to establish its case, and the Freedom Charter was not a document designed to establish even socialism in South Africa. He recognized it was a

document which some might not consider "progressive" enough; it was nonetheless one to which he still subscribed and which, he believed, could have a wide appeal to whites as well as to blacks.

Our fourth impression was that Nelson Mandela was a man who had been driven to armed struggle only with the greatest reluctance, solely in the absence of any other alternative to the violence of the apartheid system, and never as an end in itself. It was a course of action which he argued had been forced upon him, as he explained at his trial in 1964: "A time comes in the life of any nation when there remains only two choices—submit or fight. That time has now come to South Africa. We shall not submit, and we have no choice but to hit back by all the means in our power in defence or our people, our future and our freedom."

At that trial he had gone to great lengths to show that Umkhonto we Sizwe's policy was to avoid hurting civilians and instead to concentrate on damaging property. That policy was apparently maintained up until 1983, when the ANC's first car bomb exploded at air force headquarters in Pretoria. Yet Mr. Mandela even then had expressed his sadness over the incident and had said from prison: 'It was a tragic accident . . . we aim for buildings and property. It might be that someone gets killed in the fire, in the heat of battle, but we do not believe in assassination.'

We questioned Nelson Mandela extensively about his views on violence. The ANC, he said, had for many years operated as a nonviolent organization and had been forced into armed struggle only because it became the unavoidable response to the violence of apartheid. He stressed that violence could never be an ultimate solution and that the nature of human relationships required negotiation. He was not in a position to renounce the use of violence as a condition of his release, and we recognized that in the circumstances currently prevailing in South Africa it would be unreasonable to expect that of him or anyone else.

Fifth, there was no doubting Nelson Mandela's welcome for the Commonwealth initiative and his personal desire to help. While emphasizing that he could not speak for the ANC, he expressed his personal acceptance of the group's negotiating concept as a starting point. He made it clear that his personal acceptance stood, regardless of whether or not it was acceptable to the South African government, but he wanted his views to be those of the movement and not simply his own, and there would be need for consultation with his fellow prisoners (both in Pollsmoor and on Robben Island) and with the ANC in Lusaka.

He believed that if a positive response by the ANC and the government were to be synchronized—the government withdrawing the army and the policy from the townships and taking other agreed steps, while the ANC agreed, at the same time, to a suspension of violence and to negotiations—there should be no difficulty with implementation. He acknowledged, however, that his release would not be enough to lessen violence. He and his colleagues would have to take on the active role of persuading people to call off violent

activities and to respect the negotiating process. This meant that the negotiating process had to be fully credible and kept so by the government.

Our sixth, and final, impression was of a man who yearned for his freedom and who longed to be reunited with his family, but who would never accept it under what he called "humiliating conditions." As he put it in his statement of 10 February 1985:

> I cherish my own freedom dearly, but I care even more for your freedom. Too many have died since I went to prison. Too many have suffered for the love of freedom. I owe it to their widows, to their orphans, to their mothers and their fathers who have grieved and wept for them.
>
> Not only have I suffered during these long lonely wasted years. I am no less life loving than you are. But I cannot sell the birthright of the people to be free.
>
> Only free men can negotiate. Prisoners cannot enter into contracts. Your freedom and mine cannot be separated.

38 *Recollections by Helen Suzman, Progressive Federal M.P.* [First Visited in 1967]

October 1988 (Not Previously Published)

The first time I met Nelson Mandela was in 1967 on Robben Island, a maximum security prison some 14 miles off the South African mainland. He had commenced serving the sentence of life imprisonment imposed on him by the courts three years previously for sabotage. This first encounter with this remarkable man, then, was long before he became "the world's most famous political prisoner." The last time I saw Nelson Mandela was in August 1988 at the plush Constantiaberg Clinic on the mainland where he had been sent to convalesce after treatment for tuberculosis. By then his fame was such that the clinic was surrounded by TV cameramen from many countries, monitoring his visitors and hoping in vain to catch a glimpse of him. In the interim, I had been allowed several visits to Mandela by successive ministers of justice, both to Robben Island and to Pollsmoor Prison, on the mainland near Cape Town, another maximum security prison, to which he had been transferred together with four other "lifers," in 1982.

All except the last two visits were limited to discussion on prison conditions. But the impression Mandela created on me the first time we met went far beyond paying attention to the formal complaints he voiced, with no inhibitions whatsoever, despite the presence of a senior official from the Prisons Department and the commanding officer of the prison. Here was a man with great dignity, tall, with a very upright stature and undeniable leadership

qualities. That these qualities were recognised both by his fellow prisoners—who immediately directed me to his cell—and by the prison authorities, who treated him with respect bordering on deference, was immediately evident. Mandela's complaints on that first occasion mainly concerned the behaviour of a warder and the hard labour which the prisoners were forced to do in the stone quarry. My threat to expose in Parliament the treatment meted out to the prisoners by this brutal warder led to the removal of the man by the then minister of justice. Hard labour was eventually abolished for this category of prisoners. On subsequent visits, too, Mandela had no hesitation in voicing complaints to me in the presence of prison officials. By then we had developed a very cordial relationship. Over the ensuing years, conditions on Robben Island and elsewhere for "political" prisoners have improved considerably as the attitude of the authorities became more enlightened. I used what influence I had as a parliamentarian to persuade the minister to allow newspapers to be ordered by these prisoners, as absence of news other than broadcasts over the state-controlled radio service was a severe deprivation to these educated and politically aware men. Two other improvements which I can claim to have played a part in initiating for them are contact visits with close relatives, and their inclusion for consideration of remission of sentence.

Mandela has studied for several degrees through U.N.I.S.A.—South Africa's vast extramural university—during his years in prison: He is in fact extremely well informed, and it is amazing that a man who has not been "outside" for 26 years should be so conversant with both South African and international affairs and with the issues at stake.

In 1985 State President P. W. Botha offered to release Mandela if he would reject violence—an offer Mandela refused. Since then the state president has made some rather more equivocal statements in this regard, saying that renunciation of violence is not the sole factor—it is only one of the factors which would be taken into account in considering Mandela's release—health and humanitarian factors also play a part, as do attitudes and his prison record, said the state president.

Mandela's age (he recently turned 70) and present state of health could well provide the state president with a face-saving device to release Mandela, for it is clear that under no circumstances will Mandela agree to a conditional release. My last visit to him, at the clinic, where he has a private ward and sitting room, confirmed all my earlier impressions. This dignified man has an exceptional understanding of the South African dilemma. He is not a Communist. He is an African nationalist. Should he be released, should the African National Congress, of which he is the titular head, be unbanned, he would have a lawful organisation through which to pursue his unshaken determination to continue the struggle against apartheid. Then, too, could a truce be called with no further violence from either the South African Government or the ANC, and a start be made with a negotiated settlement. Above all, Nelson Mandela told me at the clinic, he harbours a desire to "normalise South Africa" by which he means, no doubt, the extension of universal adult franchise to all

citizens and the removal of all racially discriminatory laws from the statute book—aims I share with him.

Only Mandela—the great folk hero—has the status and authority to control the extremists among politicised blacks. Mandela's unconditional release would remove one of the rallying points for hostility against South Africa from the rest of the world.

Most important of all, he would provide the government with a recognised leader of the blacks with whom the dismantling of apartheid could be negotiated.

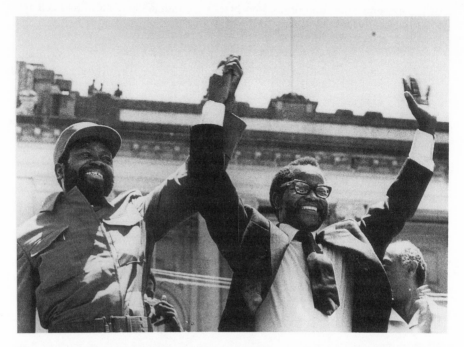

Oliver Tambo with the late Samora Machel celebrating the liberation of Mozambique in the mid-1970s.

 (International Defence & Aid Fund for Southern Africa)

MANDELA, TAMBO, AND POST-RIVONIA POLITICS, 1964–1990

Soweto, like Sharpeville, was a watershed. Like Sharpeville and its aftermath in 1960, it was an explosive outburst of intensified black resistance met by sustained government repression. Yet unlike Sharpeville, Soweto was not followed by the elimination of effective black opposition organizations and the enhancement of the government-sponsored bantustans. In contrast, Soweto marked the opening of a new era of accelerating black challenge that continued through the 1980s. Even in the face of determined government opposition, black resistance organizations multiplied rapidly throughout the country, further eclipsing the already discredited bantustans. With steady support from headquarters in exile, the ANC reestablished itself internally.

The Legacy of the 1960s

The capture of the leadership of Umkhonto we Sizwe in Rivonia and its subsequent conviction were part of a determined and ultimately successful government drive to destroy all nationwide African opposition organizations. The prime targets were the banned ANC and its rival, the PAC. The government sought to thwart the hurried attempts by both organizations to establish rudimentary underground structures. More urgently, it moved to crush the first efforts to sabotage and organized violence mounted by Umkhonto we Sizwe (the military wing of the ANC), Poqo (the more amorphous PAC armed movement), and the Armed Resistance Movement (a small underground group formed predominantly of white members of the Liberal party who also turned from nonviolent extraparliamentary protest to selective sabotage).

Armed with an ever-expanding range of empowering statutes, (commencing with the Sabotage Act of 1962, followed by annual General Law Amendments acts, and culminating in the Terrorism Act of 1967) and brutally backed by full license given to the security forces to employ psychological and physical torture, the government apprehended and imprisoned not merely the top leadership of the black resistance, symbolized on Robben Island by Mandela

and his ANC associates and by Sobukwe of the PAC, but also thousands of other activists. Thousands more were banned or otherwise restricted and intimidated from political activity. Exile provided escape from direct persecution but little immediate prospect for effective challenge to apartheid.

It was in this unpromising setting that Oliver Tambo and a small number of other prominent leaders of the ANC and its Congress Alliance allies labored to construct an effective external ANC, simultaneously burdened with the tasks of worldwide diplomatic representation, the organization and supply of a nascent guerrilla force, negotiations with host governments for facilities and funds, and the maintenance of morale among uprooted South Africans thousands of miles from home. Maintaining contact with the disorganized internal forces through the tightened state security net was daunting and often uncertain. Although Zambian independence in 1964 provided a potentially useful haven much closer than the more distant Tanzania, ANC representatives still had to travel regularly throughout Africa to obtain support. Beyond the African continent they solicited arms and material support from all possible sources, finding only the Soviet Union and its allies willing to supply weapons. They also sought to mobilize locally based foreign antiapartheid sentiment to persuade Western European and North American governments to pressure the South African government to abandon apartheid.

Unsuccessful Guerrilla Campaigns

By the mid-1960s the banned and fragmented ANC remained largely invisible inside the country, unable to conduct even sabotage after the destruction of its hastily organized underground cells. Dogged ANC efforts in exile were unevenly visible. In 1967-68 the ANC captured headlines when joint guerrilla forces of the ANC and its new ally, the Zimbabwe African People's Union (ZAPU), undertook to penetrate northwest Rhodesia, provoking the Rhodesians to call the South African military for help. Oliver Tambo heralded the attacks as "the beginning of the armed struggle for which we have been preparing since the early 1960s." He asserted that despite opposition from the United States, Western Europe, and Japan to ANC efforts to isolate the South African government through diplomacy and sanctions, the exiled ANC leadership had successfully advanced its cause by establishing essential links in Africa and beyond, especially with socialist countries and Asia (see Document 45).

The joint ANC-ZAPU guerrilla campaigns of 1967-68 foundered in the face of superior Rhodesian-South African military power and internecine struggles within the ranks of ZAPU. In 1969-70 Prime Minister B. J. Vorster's first major diplomatic campaign northward into Africa further exposed the vulnerability of the ANC. The campaign drew some positive response, not only from the maverick President Hastings Kamuzu Banda of Malawi (whose government recognized South Africa in 1967), but also from leaders of governments in West Africa, particularly those closely linked with the French government. South African initiatives for dialogue with black ruled states, by both

the Nationalist government and its opponents, including Helen Suzman, then the lone parliamentary representative of the Progressive party, provoked renewed calls by Tambo for unity inside and outside South Africa against apartheid and rejection of any dialogue with South Africa. Prospective African interlocutors from francophone Africa and elsewhere were attacked as "Bantu commissioners," analogous to chiefs who had sold their own people into slavery (see Document 46).

Strategy and Tactics Rearticulated

By the end of the 1960s the apartheid regime appeared self-assured, relentlessly implementing separate development inside the country and embarking on new diplomatic initiatives outside it. The exiled leadership was forced to recognize that its guerrilla incursions into Rhodesia had not succeeded, and it faced discontent among its recruits in training camps. Against this backdrop, more than seventy representatives of the exiled ANC and its allies, including white, Indian, Colored, and African members of the South African Communist party (SACP), convened in Morogoro, Tanzania, in April 1969 for the First National Consultative Conference of the ANC.

The conference cut the size of the National Executive Committee and created a new Revolutionary Council responsible for overseeing Umkhonto we Sizwe and reestablishing an effective ANC presence in South Africa. More significantly, in light of the centrality of both African nationalism and non-racialism in the ANC, the delegates agreed to open membership in the ANC to non-Africans, while reserving membership on the National Executive Committee for Africans. The shift in membership policy marked a new stage in the ANC's nonracialism, blurring organizational lines based on race formalized in the 1950s by the multiracial Congress Alliance, while at the same time symbolically reaffirming the ultimate preeminence of African nationalism as the motor of its struggle. Simultaneously, the inclusion of whites and Indians in the new Revolutionary Council, while excluding them from the National Executive Committee, testified both to the readiness of the ANC to recognize individual revolutionaries by their attitude rather than by their skin color and to its willingness to share oversight of some of its most sensitive activities with non-African communist allies.

In the published statement *Strategy and Tactics of the South African Revolution*, the most extensive public document issued by the ANC in the 1960s and 1970s, the conference outlined both the ANC's goals and the means by which they were to be achieved (see Document 58). The opening sentence of the statement placed the ANC's struggle for "national liberation" directly in "the international context of transition to the socialist system," but it subsequently elaborated at length why the first imperative was the destruction of apartheid and the establishment of a national democratic regime in which the goals of "national emancipation" enunciated in the Freedom Charter could be realized. It asserted that the relatively advanced state of the South African

working class would permit a reasonably speedy transition from "national emancipation" to "economic emancipation." The ANC reiterated its commitment to military force, spelling out why it had necessarily turned from nonviolence to sabotage and armed struggle (amplifying earlier arguments of Mandela and Tambo—see Documents 23 and 24). It reiterated its conviction that guerrilla warfare would be necessary to destroy the apartheid state, but only as a component of an overarching strategy of broad political mobilization through educational and agitational activity among the population at large, undergirded by effective organizational structures, both underground and above ground. At all stages the ANC's political authority was to shape and direct both Umkhonto we Sizwe and all other organizations and activities.

The document considered the nature of class, racial, and national divisions and alignments, recognizing that all three had to be taken into account in fashioning strategy and tactics in the unique South African situation. It lent great importance to the mobilization and effective organization of the working class in view of its members' "doubly oppressed and doubly exploited" status as blacks and workers, but it recognized that racial (and national) divisions had become central in South Africa. Thus, it asserted that African grievances, not working-class concerns, were the most powerful force for mobilization and that focused efforts were necessary to further "a deepening of national confidence, national pride, and national assertiveness" among the African majority of the population. Yet "the Coloured and Indian people were to see themselves as an integral part of the liberation movement and not as mere auxiliaries," given their racially based oppression. Whites who identified with the liberation struggle through their actions could also be recognized as revolutionaries, although currently they were few. Nevertheless, the ANC vowed that it "must continually stress in the future (as it has in the past) that there is room in South Africa for all who live in it but only on the basis of absolute democracy."

The rearticulation of ANC aspirations in *Strategy and Tactics of the South African Revolution* reflected democratic, nationalist, nonracialist, and socialist strands in the ANC in exile. The ANC reaffirmed the Freedom Charter as a democratic and nonracialist blueprint for postapartheid South Africa, but it also emphasized that racially based grievances, affecting Africans most intensely, would be the wellspring for deepened mobilization of the population against apartheid. Class-based action was also given heightened recognition, particularly as a potential force to ensure that any new regime would move beyond formal political democracy to economic democracy in which "the basic wealth and the basic resources are at the disposal of the people as a whole and are not manipulated by sections or individuals, be they white or black."

New Strengths for Marxism and Communism

The saliency of class analysis in *Strategy and Tactics of the South African Revolution*, in contrast with its limited visibility in the Freedom Charter and other pre-1960 ANC policy statements, reflected the impact of exile conditions

on the ANC leadership. Historically linked with the strongly pro-Soviet SACP, the ANC in exile was thrown into even closer proximity to an ally with experienced and skilled exiled personnel of all races, including not only Indians and whites such as Yusuf Dadoo and Joe Slovo, but also longtime African Communists, such as Moses Kotane and J. B. Marks, respected members of the ANC leadership since the 1940s. At all levels of the ANC they continued to carry out tasks assigned by the ANC leadership.

The continuing presence of SACP members ensured that Marxist discourse remained audible in internal ANC debates, in both the ANC press and elsewhere. Undoubtedly the SACP connection facilitated contacts with the Soviet Union and the German Democratic Republic, which by the mid-1960s were prime suppliers of arms and training facilities to the ANC. Initially promising contacts in the early-1960s with the People's Republic of China withered in the heat of the Sino-Soviet conflict, with the PAC successfully monopolizing Chinese patronage until the late 1970s and early 1980s. The overlapping exiled leaderships of the ANC and the SACP worked closely together, redefining and repeatedly reaffirming their alliance. Whether speaking before the SACP or to an audience of primarily white South Africans, Oliver Tambo remained ready to defend both the independence of the ANC and its continued willingness to work closely with the SACP and its members within ANC ranks (see Documents 49 and 52).

Association with other nationalist movements of southern Africa brought the ANC into contact with another strand of African Marxism. Drawn together by their common opposition to the alliance of South Africa, Portugal, and Rhodesia, the movements found affinity through their common lobbying in United Nations and Third World forums and their shared necessity to take arms and training facilities from the Soviet Union and its allies (and/or the People's Republic of China). Broadly similar experiences and a shared English language cemented bonds with ZAPU of Zimbabwe and SWAPO of Namibia. Of more long-term significance were new ties initiated in 1963 with the Portuguese-speaking African nationalists, organized together in the Conferencia de Organizacoes Nacionalistas das Colonias Portuguesas (CONCP), including the Frente de Libertacao de Mocambique (Frelimo) and the Movimento Popular de Libertacao de Angola (MPLA). Through CONCP the ANC drew closer to the nationalist movements of Angola and Mozambique which shared its commitment to the necessity of armed struggle. Frelimo and MPLA were also committed to a Marxist-inspired program of revolutionary transformation, arrived at by internal debate among nationalist movements in territories where there was no long-established Communist party participation, as had been the case in South Africa. Before and after Morogoro the ANC strengthened its ties with Frelimo and MPLA, forging links that assumed crucial logistical importance and deeper ideological significance after 1975 when both movements acceded to power as the governments of their countries.

The heightened saliency of Marxism in the ANC, particularly as it was manifested in the prominent activities of non-African SACP members, provoked discontent among some longtime African ANC members, analogous to

what had festered in the legal ANC in the 1950s and had ended with the breakaway of the PAC in 1959. In 1975 eight well-known African members went public with their criticisms, leading to their expulsion by the National Executive Committee. Unlike the 1950s the dissenters found little support within the ranks of the exiled ANC membership. The close alliance with the SACP (and with Frelimo and the MPLA) continued.

Black Politics in South Africa

In the tightly constricted internal political arena, the activities of the exiles found little visible reflection, yet by the late 1960s new types of African opposition activity reversed the quiescence of the decade's early years. In the early 1970s, more and more blacks dared to express their opposition, but the form and articulation of their resistance bore little resemblance to the mass politics of the 1950s, interrupted by Sharpeville and its aftermath.

The accelerated creation of institutions of separate development through the 1960s counterpointed the repression of African nationalism. Few supporters of the ANC (or the PAC) were willing to participate in the new homelands; it was mostly a middle-aged generation of chiefs and previously politically inactive Africans who responded to government incentives for African participation. Most of the leaders of the newly created bantustans quietly accepted government favors, with only occasional questioning of the terms of the devolution of limited autonomy. A notable exception was Chief Gatsha Buthelezi, a contemporary of Nelson Mandela and a former ANC Youth League member. As head of the KwaZulu homeland, Buthelezi simultaneously gathered to himself the limited powers of local authority conceded by Pretoria while rhetorically challenging the legitimacy of apartheid itself. Skillfully playing on his followers' strong sense of Zulu pride yet also voicing broader African grievances about the inequities and failings of separate development, Buthelezi moved to seek a national black following. Supported clandestinely by the ANC, which sought to use the platforms provided by the bantustans for mobilization toward a mass-based movement, Buthelezi in 1975 reconstituted Inkatha, a Zulu cultural organization of the 1920s, as a political movement open to all Africans. By the mid-1970s Buthelezi and Inkatha had established a strong presence in Natal, and their activities were receiving wide coverage in the national and overseas press.

The other pole of African political activity, straddling the boundaries of government toleration and militantly opposed to ties with any who participated in government-sponsored bantustans, was Black Consciousness. It drew support primarily from the new generation of African, Indian, and Colored students whose political formation had been almost completely within the "Bantu education" system and in the repressive atmosphere of post-Sharpeville black politics. Black Consciousness was organizationally centered in the South African Student Organization (SASO), a body formed by African, Asian, and Colored university students, who were no longer willing to participate in the

National Union of South African Students (NUSAS), the predominantly white liberal student organization. Analyzing the black situation in South Africa, Black Consciousness adherents drew inspiration from the history of African resistance to white intrusion in the eighteenth and nineteenth centuries, assertive African nationalism elsewhere on the continent, American black power tracts, and radical black theology.

In the late 1960s and early 1970s, Black Consciousness adherents, sparked by SASO and its charismatic leader, Steven Biko, fashioned a political stance that focused on heightened black self-awareness and self-reliance to be achieved through "psychological liberation" and the creation of local community organizations. Black Consciousness redefined black to include all South Africans suffering oppression on the basis of their color. Cooperation with white antiapartheid activists was explicitly rejected—it was argued that whites should work exclusively in the white community to end apartheid—as was cooperation with government-sponsored institutions. Lively debates ensued regarding the appropriate forms of democracy and socialism for a postapartheid South Africa. Black Consciousness gained support among a new generation of students and among older members of the educated black elite repelled by separate development. With the calling of the Black People's Convention (BPC) in 1972, Black Consciousness spawned the first national black political organization since the banning in 1960 of the ANC and the PAC. Emphasizing psychological assertiveness and community programs rather than mass political organization and endorsing black exclusiveness and rejection of cooperation with any white opponents of apartheid, Black Consciousness seemed directly to challenge fundamental tenets of the ANC. Through workshops, community projects, and the expansion of its primarily student-oriented organizations, Black Consciousness became a loosely structured movement that opened new channels for radical political discourse and action.

Yet it was neither Black Consciousness nor its bitter foes, Gatsha Buthelezi and Inkatha, that provided the spur for renewed black mass demonstrations. Instead, the enforced quiescence that prevailed through the 1960s was broken in the early 1970s by a new assertiveness among the growing urban working class. Waves of spontaneous strikes spread through Durban in 1973, bringing tens of thousands of workers out of factories in orderly demonstrations that resulted in increased wages. For the first time since the 1940s, black workers' actions had brought an immediate improvement in working conditions. Although black trade unions remained unrecognized and often harassed, both African and white radical activists in the mid-1970s stepped up their efforts to organize.

The continuing surge of black activity in the face of government opposition was buttressed by the growing awareness and sophistication of an urban population with much greater access to both national and international developments than had been the case in the 1950s and 1960s. Black-oriented newspapers, supplemented by the "white" English-language press, provided often critical and informed reportage, including political coverage of domestic and exile black politics, to supplement the informal channels of the townships.

For an increasingly active and aware African population in South Africa the disintegration of Portuguese colonialism in the mid-1970s had emotional significance far beyond its direct impact on South African affairs. By mid-1974 it seemed almost certain that a Frelimo government would come to power in neighboring Mozambique, a prospect that encouraged Black Consciousness advocates to sponsor a rally at Currie's Fountain in Durban in September 1974, whose leaders were subsequently charged and prosecuted by the state. South Africa's intervention in late 1975 in Angola against the MPLA demonstrated the high stakes that the government placed on thwarting militant Marxist-oriented nationalism. The subsequent withdrawal of the South African military in early 1976 in the face of apparently superior Cuban forces fueled hopes that white South Africa was vulnerable and that the southward flowing tide of liberation might be sustained.

The Soweto Uprising and Its Significance

It was in this climate that the Ministry of Bantu Education decreed in mid-1976 that Afrikaans would become a mandatory language of instruction in African secondary schools. In response, secondary school student activists in Soweto, many of whom had been active in the South African Student Movement (SASM), a Black Consciousness group, called for protest demonstrations on June 16. Despite being teargassed and shot at, the students reorganized and extended their demonstrations throughout Soweto, attacking government offices and installations owned by black participants in the Urban Bantu Councils, the township version of separate development. Quickly the demonstrations spread throughout the major urban centers of the Transvaal, Natal, and the Cape, drawing in not only Africans but also large numbers of Coloreds in the western Cape. Calling for stay-at-homes on selected dates, the student organizers succeeded in eliciting widespread support, including many from initially hesitant older generations, despite massive police presence. Official (and conservative) government estimates placed the death toll at 547 and the injured well above 2,000. Although the demonstrations at no point threatened government control, their extent, the degree to which they rallied popular support, and the sustained fearlessness of the demonstrators in the face of overwhelming state military supremacy conveyed to all South Africans that a new era of political activism had commenced.

For blacks the significance of the Soweto uprising and the challenges to white authority that it sparked throughout South Africa lay in the emergence of a new generation of youthful activists who proved themselves ready to confront armed white power, even with little immediate prospect of success. The demonstrations showed that a powerful wellspring of direct defiance could be tapped among blacks from all population groups, all generations, and all economic groupings. There is little evidence that the ANC was initially directly involved, although its leadership and supporters immediately identified with the uprising, both on Robben Island as well as in exile (see Document 39).

More significantly, the intensified mobilization engendered by Soweto created invaluable new opportunities for the ANC to augment its guerrilla forces externally and to extend its underground organization internally.

For many whites, Soweto started a process of questioning the invincibility of white power and considering how black power might be recognized and accommodated. For the government, Soweto represented a spreading wildfire of black resistance that had to be contained.

Post-Soweto Repression

Faced in 1977 with the prospects of renewed boycotts and defiance, the government continued to ban meetings, restrict activists, and detain leaders, from both the leadership of Black Consciousness movement organizations and the ranks of ANC supporters. On May 16 Winnie Mandela was banished for seven years from Soweto to the small Orange Free State town of Brandfort, and was further restricted by overnight and weekend house arrest. Steve Biko's brutal death on September 12 at the hands of the security police dramatized the extent of police repression. Fears that black anger, roused by the revelation of Biko's death, would erupt into renewed mass demonstrations led the government to ban seventeen organizations (most in the Black Consciousness movement but also including the Christian Institute) on October 19, 1977. As in the 1960s, the government hoped that the elimination of organized opposition would end the expression of dissent. While the government employed its traditional tactics of repression, it also moved to devise new techniques to foil black opposition in a setting that it, too, recognized as irrevocably changing. A series of government commissions were constituted to consider questions of constitutional reform (headed by former Minister of Justice Alwyn Schlebusch), labor control (headed by economic adviser Pieter Reikert), and black trade unions (headed by Professor Nico Wiehahn).

During the same period, the government of Prime Minister B. J. Vorster was also beset by attacks from both the white parliamentary opposition and National party critics in its own ranks as successive press reports and government investigations revealed that a secret government fund for enhancing South Africa's image had been used to purchase media influence overseas and to pad the expense accounts of high officials in the Department of Information. Minister of Information Connie Mulder was forced to resign and subsequently, in September 1978, Prime Minister Vorster, although not directly implicated, agreed to step down as prime minister to accept the ceremonial post of state president.

In the wake of the Muldergate scandal the National party parliamentary caucus elected P. W. Botha, longtime National party worker, parliamentarian, and defense minister, to head the government. Hinting that a potential reorientation was inevitable, he urged South Africans to "adapt or die." Yet he made no move to dismantle the repressive security machinery put firmly in place during the 1960s.

For black activists the bannings of 1977 meant an end to the loose confederation of national organizations of the Black Consciousness movement, but not an end to efforts to challenge apartheid. In 1978 Black Consciousness supporters who were not in detention, prison, or exile reconstituted a national body, the Azanian People's Organization (AZAPO), in an attempt to carry forward within the Black Consciousness approach. The vigorous debates over strategy and tactics that had unalterably shifted the language of antiapartheid political discourse continued, in print when possible, but also out of print and informally. Questions were raised about mobilizing support exclusively by invocation of race and color, and heightened interest was expressed in the organization of workers and the realization of socialism. The term *racial capitalism* as a characterization of the existing system increasingly punctuated Black Consciousness rhetoric. It was a concept that suggested both the importance of the black worker-led class struggle against a white-dominated capitalist order and the imperative of immediate socialist revolution rather than merely movement toward nonracial democracy.

Counterpointing the ideological disputations of Black Consciousness adherents was an explosive growth of youth, worker, and cultural groups, many broadly identifying with the goals of the Black Consciousness movement but working organizationally at the grass-roots level to mobilize particular segments of the black population in support of community-defined activities, including school boycotts and self-help projects. Complementing the community-based organizations were black trade unions, led by labor activists drawn from many strands of the antiapartheid movement, including Black Consciousness supporters, but also longtime black trade unionists identifying with the ANC, blacks new to the trade union movement, and white radicals. Among the increasingly skilled black work-force labor organizers found a heightened readiness to support factory-based trade unions. The formation of the Federation of South African Trade Unions (FOSATU) in 1978 and the Council of Unions of South Africa (CUSA) in 1980 symbolized the emergence of new national centers of African trade unionism, determined to set their own agenda and priorities for both political and economic action to advance the interests of their worker membership. In the sporting field, antiapartheid organizations, oriented toward both the underground ANC and the proscribed Black Consciousness movement, campaigned for both nonracial support and the exclusion of racially based South African teams from international competition.

Even within the government-approved structures of separate development, increasingly forceful antiapartheid statements were heard, particularly from Sonny Leon of the Labour party (the largest group in the Coloured Representative Council) and from Gatsha Buthelezi, who used both the platforms of KwaZulu government bodies and public Inkatha rallies in the Transvaal to criticize government policy and to urge the release of political prisoners and the unbanning of the ANC. Buthelezi, who refused to take the "independence" offered by the government (and accepted by Kaiser Matanzima of the Transkei in 1976), took the lead in 1978 in creating the South African Black Alliance (SABA), bringing together Inkatha with the Labour party and other smaller

Indian and African groups critically participating in government-created institutions.

The Resurgence of the ANC

In this politically effervescent environment the ANC moved with success to reestablish its clandestine presence in South Africa. Through the 1970s, long-time ANC activists imprisoned during the clampdown of the early 1960s, including those who had served time with Nelson Mandela on Robben Island, had been quietly released upon completion of their prison terms. Although some went into exile to augment the external ANC organization, others began to resume activity internally, despite restrictions and stringent police surveillance, offering support and encouragement to the new generation of militants whose initial inspiration came through Black Consciousness. Contacts were established with prominent Black Consciousness leaders, with a view to arranging consultations with the exiled ANC leadership.

The outflow of young Soweto militants in late 1976 through 1977, once the government reasserted control over the townships, proved a boon to the ANC in exile. Its careful efforts of more than a decade to forge effective administrative structures had put it in a position to offer immediate support to those fleeing apartheid. With the PAC in disarray and the Black Consciousness movement lacking external organization and funding, the ANC was able to attract to its ranks large numbers of young exiles eager for the educational and military training that the ANC was able to offer in its camps in Zambia, Tanzania, and, since 1976, Angola. The independence of Mozambique under a sympathetic Frelimo government facilitated a channel for return once training was completed, for both the new recruits and the earlier generation. In the wake of the banning of the Black Consciousness movement in October 1977, underground activity seemed, to many, even more necessary. By the late 1970s the ANC was again able to undertake an expanding sabotage campaign, striking at government targets especially visible to African township residents.

The reassertion of the ANC's clandestine organizational and military presence in the country was paralleled by increasingly vigorous ANC activity in exile. Convinced that the ANC was riding a rising tide of revolutionary change in southern Africa, Oliver Tambo warmly identified with the new Angolan regime as he continued his diplomatic activities throughout the continent (see Document 47). Tambo also welcomed the advances of the Zimbabwean nationalist guerrillas and the end of the Rhodesian regime as an inspiration to antiapartheid South Africans, but he also recognized that the advent of majority-ruled Zimbabwe could harden Pretoria's opposition to change (see Document 48).

The resurgence of the underground ANC, the evident dynamism of the exiled ANC, and the impending transfer of power in Zimbabwe to a leadership of "prison graduates" drew new attention to the continuing incarceration of African nationalists in South Africa. Percy Qoboza, editor of the *Sunday Post*, who had been detained for three months in 1977, seized the occasion on March

9, 1980, to issue a front page call to "Free Mandela," initiating a campaign taken up widely by black and white opponents of the government to free all political prisoners. Although his words could not be quoted and he had been imprisoned for eighteen years, Mandela was once again regularly in the headlines as both the symbol of the resurgent ANC and the putative leader of a black majority government that could succeed Botha, just as the decisively victorious Robert Mugabe was succeeding Ian Smith in independent Zimbabwe.

The greater visibility of Nelson Mandela as a focal point for political mobilization across a broad spectrum of antiapartheid opposition was underlined dramatically by the scale and daring of activities of the expanded cadre of trained Umkhonto we Sizwe guerrillas. Two widely reported incidents involving guerrillas in early 1980, an apparently unplanned hostage taking in a bank in Silverton (a white Pretoria suburb) and a rocket attack on a police station in Booysens (a white working-class Johannesburg suburb), were followed on June 1 by the sabotage of the Sasolburg refinery. The blasts literally illuminated the Transvaal veld, suggesting new sophistication and capability for the ANC's "armed propaganda" to dramatize its presence in the country. Without gaining the same front-page coverage, other Umkhonto we Sizwe teams continued to attack other government installations. For the first time since the 1950s the ANC was becoming a visible and central actor in internal politics. Its internal and exile activities were widely publicized through selective reportage in the pro- and antigovernment media.

Reform and Mobilization Compete

As the 1980s advanced, both the ANC and the Botha government accelerated their campaigns to win support among black South Africans. The hallmarks of ANC activities were further expansion of Umkhonto we Sizwe activity in the country, encouragement of broad mobilization of opponents of apartheid into popular organizations extending to all areas and all population groups, and intensified overseas diplomacy to increase international pressure on South Africa. To counter the ANC (and all antiapartheid opposition) the Botha government pursued a two-track policy. Recognizing that the pre-1976 apartheid formulas were no longer viable, it stepped up its highly touted reform program, permitting new opportunities for legal black trade union activity, relaxation of segregation and influx control measures in major urban areas, dispensation of residence and freehold rights to established urban residents, and promises of constitutional reforms to permit some form of black participation in government. At the same time the government strengthened its defense and security capabilities and reiterated its determination to thwart the ANC which, in its propaganda, remained the central bogey of a Soviet communist-inspired "total onslaught" on South Africa. In the confrontation between the two competing strategies, further extensive black mobilization opened even more possibilities for ANC advances.

The exiled ANC consistently attacked the government's reforms as a ploy to maintain white domination in a new form (see Documents 48 and 51). Throughout South Africa, supporters of the ANC found fertile soil as black groups took new initiatives, both within and beyond the new space offered by the government. During the recrudescence of school boycotts in the 1980s, widespread backing was manifested in Colored communities in the western Cape, augmenting the actions taken by African students there and elsewhere in the country. Indian activists, many associated historically with the South African Indian Congress, organized a boycott of elections to the government-created advisory South African Indian Council in November 1981. The sponsors of the boycott were linked with other antiapartheid activists in the Charter Movement, a loose multiracial coalition of more than one hundred organizations, reminiscent of the Congress Alliance of the 1950s, endorsing nonracialism and the political and social demands of the Freedom Charter.

An upsurge of sustained activity by growing numbers of community-based bodies in the African townships also swelled the stream of black resistance. In an effort to create new township versions of the institutions of separate development to replace the discredited Urban Bantu Council system which had collapsed in 1976–77, the government pushed forward with the establishment of new elected Community Councils. Unlike the earlier advisory Urban Bantu Councils, the new Community Councils were given administrative responsibilities for housing and township services with the requirement that they be self-financing. Deprived of central government subsidies, the Community Councils were forced to cut back on services at the same time that they had to raise rents and other charges. Anticouncil grass-roots organizations sprouted across South Africa to protest the policies of the new government-created Community Councils. New techniques of boycott were enthusiastically adopted in many townships as inhabitants refused to pay rent to the new council administrations, and consumer boycotts were organized against white merchants and African participants in the new council system.

The sustained spirit of defiance and resistance evident in the boycott movement and in the lively grass-roots organizations complemented the assertiveness of the burgeoning national black trade union organizations, FOSATU and CUSA. Amidst spirited debate whether or not to accept the terms of the Wiehahn Commission for registration as legally recognized trade unions and, subsequently, the formal recognition of procedures for collective bargaining and strikes set out in the Labor Relations Amendment Act of 1981, trade union leaders and worker activists utilized and stretched the new possibilities for legal organization and strikes. The still-expanding black labor force was pushing unevenly upward into semiskilled and skilled posts previously occupied by white workers who now held an even smaller minority of positions on the factory floor (increasingly concentrated in mining and selected state-owned enterprises). Black workers were readily responding to new organizing efforts and to calls for strike action to back up demands for better working conditions and higher wages. Although longtime trade unionists were deeply involved in the new wave of unionization, its greatest strength lay in the sturdy shop floor-

based organizational muscle of a new generation of black workers, supported also by diverse groups of Black Consciousness and white radical activists who were also novices in trade union activity.

Rapid black trade union growth was paralleled by increasingly articulate opposition to apartheid by black Christians, who now comprised the majority of the membership of both the Catholic church and the major Protestant denominations. In the late 1960s and early 1970s black and liberation theologies were widely read and discussed by the growing numbers of black clergy in both Catholic and mainline Protestant churches at a time when significant numbers of white church leaders were also rethinking how both individual Christians and organized churches could more actively and effectively bear witness against apartheid practices that had been long condemned on theological grounds. The new currents among clergy and in the denominations were reflected in the elevation of blacks to positions of national leadership, most dramatically by the election of Bishop Desmond Tutu as secretary of the South African Council of Churches (SACC) in 1978. Even in the Dutch Reformed church new dissidents joined the Reverend Beyers Naude to question its continued endorsement of apartheid. The Reverend Dr. Allan Boesak of the Colored branch of the Reformed church forthrightly condemned apartheid at home while simultaneously mounting a successful international campaign in the World Alliance of Reformed Churches (whose president he had become) to declare apartheid a heresy. Both Bishop Tutu and Dr. Boesak enthusiastically endorsed the "Free Mandela" campaign at the same time that they, and many other black (and white) clergy, more frequently participated in antigovernment protests and organizations. In carefully phrased comments, Bishop Tutu observed that those regarded by whites as terrorists were considered heroes and martyrs by many blacks.

Because since 1976 all outdoor political meetings required government permission, the funerals of activists associated with the ANC became central rallying points in both urban and rural townships for the rising popular identification with the banned ANC. Amidst banners of black, green, and gold (the ANC colors) and the spirited shouting of ANC slogans, speakers no longer referred to the ANC euphemistically but explicitly expressed support for it and the goals articulated in the Freedom Charter. The display of ANC colors at the February 13, 1982, funeral procession of Neil Aggett, the young white physician and trade union organizer, who was the first white to die in detention, and the subsequent half-hour employer-tolerated work stoppage by some 200,000 workers demonstrated the coalescence of a broad nonracial movement. It characterized itself as "democratic," "progressive," or "charterist," uniting black workers with a wide spectrum of antiapartheid groups.

Repression, Reform, and Destabilization

The government response to expanding opposition was a reiteration of both repression and reform. It backed its internal efforts with aggressive moves against neighboring states thought to be giving effective sanctuary to the ANC.

The security forces, reorganized in the National Security Management System, a countrywide coordination mechanism linking security services and the police under military supervision, continued their efforts to apprehend Umkhonto we Sizwe cadres and ANC organizers and to restrict overt political activities. They used the techniques of banning, detention, and restriction, codified anew in the Internal Security Act of 1982, and reinforced them with tactics of intimidation and physical and mental torture developed in the 1960s.

Externally, South Africa used its military and economic muscle to enforce its regional hegemony. The South African Defense Force (SADF) and security forces cooperated in an expanding regional campaign of destabilization. The campaign combined retaliatory direct raids on Maputo (Mozambique), Maseru (Lesotho), and other alleged ANC targets in neighboring states in the wake of a number of ANC sabotage successes with less visible support of antigovernment guerrilla movements, including RENAMO in Mozambique and UNITA in Angola. Selective withdrawal of trade incentives and transportation facilities complemented the government's military intimidation of South Africa's dependent and vulnerable neighbors.

In South Africa the government continued with reforms that challenged additional apartheid shibboleths. Among these reforms were further desegregation of public facilities in major urban centers, acceptance of black trade union organization and strikes, and offers of long-term leasehold rights to African township residents. Most significant, however, were concrete government proposals for constitutional reform following the report of the Schlebusch Commission and subsequent debates in the National party. The reforms, symbolizing willingness to soften the rigid political separate development of the past by granting limited Colored and Asian participation in the highest levels of national government, were formalized in the new South African Constitution of 1983, with its centerpiece of a tricameral legislature in which whites, Coloreds, and Asians were to be represented in proportion to their population (while the African majority was to remain unrepresented). The exclusion of Africans revealed the limits of the new government dispensation, while simultaneously spurring further mobilization of its opponents among all racial groups.

Sixteen Afrikaner National Party M.P.s, invoking the Verwoerdian formula of rigid apartheid in all spheres, crossed the floor into opposition. They constituted themselves into the Conservative party to mobilize and channel the discontent of those white voters—concentrated among Afrikaner workers, civil servants, and farmers—who could not accept National party reforms coopting blacks and diluting systematic racial separation.

In the eyes of the black opposition the government's constitutional proposals did not begin to address their major demand: an end to segregation and political participation for the black majority. Both Black Consciousness supporters and those who identified with the nonracial charterist stance reacted by establishing national organizations to mobilize opposition. The result was the emergence of the first large-scale, nationally organized, antiapartheid movement since 1960.

Black Consciousness supporters called for a new national movement, and in June 1983, the National Forum Committee was formed, animated primarily by AZAPO supporters. It was an exclusively black body, drawing together longtime Black Consciousness adherents but also including among its patrons activists and churchmen of other persuasions, such as Bishop Tutu and Reverend Manas Buthelezi of the Evangelical Lutheran church.

Almost immediately the National Forum Committee was overshadowed by the activities of the United Democratic Front (UDF), another new national umbrella organization founded primarily to mobilize broad extraparliamentary opposition to the new constitution. Culminating months-long organizational efforts, twelve thousand South Africans of all races met in early August in Cape Town to launch the UDF, claiming the affiliation of over four hundred organizations with memberships of more than a million and a half of all races. The large turnout and the high number of affiliates testified to the energy and commitment of the UDF organizers as well as to the rapid growth in the 1980s of grass-roots antiapartheid organizations. The adherents of the UDF included many who had been prominent in the ANC and the Congress Alliance in the 1950s, but its ranks also numbered many blacks who had been engaged with Black Consciousness in the 1960s and 1970s as well as individual whites, many of whom were not previously linked formally with black-led opposition movements.

From the start, the UDF placed itself in the charterist movement that had emerged in the early 1980s, identifying with the goals expressed in the Freedom Charter and emphasizing the mobilization of the broadest possible coalition of antiapartheid groupings dedicated to the establishment of a nonracial and democratic South African regime. In contrast, the National Forum Committee, supported by AZAPO, focused more narrowly, advocating an exclusively black movement in which the goal of a socialist South Africa, replacing "racial capitalism," was to be given precedence over the struggle for democratic rights.

Although Gatsha Buthelezi and Inkatha also expressed their opposition to the new constitution, they remained isolated. Their hopes of a united opposition of those already participating in government-sponsored separate development were shattered when the Colored leadership of the Labour party broke ranks in SABA to participate in elections for the new tricameral legislature. Adherence to the National Forum Committee was blocked as its primarily Black Consciousness movement supporters regarded Buthelezi and Inkatha irrevocably tainted by their participation in bantustan politics. Participation in the UDF was also foreclosed as Buthelezi and Inkatha opposed school boycotts and other UDF initiatives, insisting that they alone should organize in KwaZulu and Natal. Buthelezi's increasingly shrill opposition to the underground ANC and to sanctions also further distanced him from the growing mainstream of opposition.

For the next year a heady new style of politics engulfed South Africa. As the government frantically sought to woo black support for its new constitutional order, its opponents seized all opportunities afforded by the opening of

government-sanctioned debate. UDF affiliates throughout the country orga-
nized well-attended mass rallies urging Colored and Indian boycotts of elec-
tions to the new tricameral legislature. Students supported the campaign with
renewed school boycotts, and local community organizations stepped up their
struggles. The low turnout of Indian and Colored registered electors (18
percent and 21 percent, respectively) in August 1984 underlined the govern-
ment's failure to stem the rising tide of black resistance spearheaded by the
UDF.

The transformation of the black opposition was reflected not merely in the
number and diversity of organizations but also in the nature of their activities
and the new patterns of political linkage that they established across South
Africa. Student organizations, linked with both AZAPO and the UDF, re-
cruited membership among black secondary and university students through-
out the country. In so doing, they established new channels of political
communication, not merely for school boycotts (which engaged tens of thou-
sands, especially in 1980 and again in 1983–84), but also for other resistance
activities. Other youth bodies, linked with the students, reached out to school
dropouts and others not in school, including the growing numbers of young
unemployed and underemployed. Township organizations continued to mobi-
lize residents of all ages around local issues, especially to boycott rent in-
creases. In the unauthorized squatter communities burgeoning around all the
major urban centers, symbolized by Crossroads near Cape Town, residents
also joined to resist threats of relocation and destruction. The proliferation of
these new networks of activism, linked now by national organization, created
unprecedented possibilities for resistance. Never under apartheid had so many
blacks been so directly and visibly involved in its active opposition.

For Oliver Tambo and the leadership of the exiled ANC, the 1983–84
upsurge was a dramatic confirmation of the strategy articulated in Morogoro
in 1969 combining armed struggle with mass politicization. With greater
resources and sophistication, Umkhonto cadres stepped up their attacks,
aiming more daringly for symbolic military targets. The car bomb explosion
in front of air force headquarters in Pretoria in March 1983, killing nineteen
and injuring over two hundred, rallied black opinion at the same time that
it provoked new questions about the use of violence by the ANC. For the
first time the ANC seemed willing to risk the loss of civilian and black lives
in attempts to inflict damage on "hard" military targets, creating a new cli-
mate of uncertainty about bomb attacks in the heart of urban white South
Africa.

The Pretoria attack led to an immediate punitive air raid on alleged ANC
facilities in Maputo and hardened the government's determination to cut the
links between the external ANC and its clandestine networks into and within
South Africa. Accelerating its campaign against Mozambique by increasing its
support for the anti-Frelimo guerrillas of RENAMO, the South Africans
brought a vulnerable Mozambique to agree, at Nkomati in March 1984, to a
mutual noninterference pact. Under the terms of the Nkomati accords South

Africa was to cease its support for RENAMO; in return Mozambique was to close ANC transit facilities for guerrillas. It was Pretoria's belief that loss of the Mozambican infiltration route to South Africa would cripple the ANC's ability to operate inside South Africa.

As 1984 progressed Pretoria found little ground for its post-Nkomati hopes of decreased black opposition in South Africa. On the contrary, the fires of resistance flared throughout the country. On September 3, 1984, the day the new constitution was promulgated, Sharpeville once again captured the headlines. This time a local rent boycott, organized by the Vaal Civic Association, a UDF affiliate, to protest the increased charges imposed by the new Community Council, spilled over into violence. Boycott supporters attacked both African councilors, symbolizing the new order of government reform, and black policemen and their families.

Resistance Deepens and Expands

The southern Vaal campaign typified the new pattern of protest that grew throughout the South African summer of 1984–85. It consisted of stay-at-homes, roving demonstrations challenging the police patrolling the townships, and attacks on the businesses, houses, and persons of Africans charged with collaborating in the new Community Council system. Local grievances became the vehicle for protest against the apartheid system as a whole, spreading from township to township through a population thoroughly mobilized by student participation in school boycotts and broader involvement in the anticonstitution campaigns. At the same time, the existence of national bodies such as the UDF provided new means for coordination of protest, epitomized in the Transvaal stay-at-home of November 5–6, 1984, in which an estimated 800,000 participated.

Shortly thereafter the black resistance was given a new lift when the Nobel Peace Committee announced that Bishop Tutu had been awarded the Nobel Peace Prize, joining Chief Luthuli as the second South African to be so recognized. By providing additional publicity for the antiapartheid cause, Bishop Tutu gave new impetus to both internal and external opponents of the government. His message of the urgent necessity for change in government policy, including the release of political prisoners and the end of the ban on political organizations, was punctuated into 1985 by ongoing Umkhonto sabotage attacks, demonstrating that the Nkomati accord had not blocked the ANC's ability to operate inside the country.

Mandela Captures the Spotlight

Although Mandela remained in prison, Tambo in exile, and the ANC banned and demonized by the government, the organization's stature in South Africa had never been higher. Mandela posed a distinctive quandary for the govern-

ment—could his unquestioned symbolic importance as an imprisoned national figure be diminished by freeing him on terms that would limit his potential role in the opposition movement? In 1982, government representatives initiated discussions with Mandela. Press reports indicated that Mandela refused offers to accept release to the Transkei. Early in 1985 the government permitted Lord Bethell, a British Conservative M.P., to interview Mandela in Pollsmoor, the mainland prison to which he and five others had been transferred in 1982. In the published account of his conversation Lord Bethell reported that an alert and well-informed Mandela was prepared to support a truce in the ANC armed campaign in return for the lifting of the ban on the ANC (see Document 34). Lord Bethell joined those urging the South African government to release Mandela in the interests of achieving a negotiated solution. On January 31, 1985, President Botha responded by offering to free Mandela in return for his renouncing the use of violence.

In a carefully crafted response, delivered publicly by his daughter Zindzi to a rally of UDF supporters on February 10, Mandela rejected Botha's conditions (see Document 41). Arguing that "only free men can negotiate," he reaffirmed his commitment to the ANC and its goals, and he demanded that the government renounce violence, release all political prisoners, and end the ban on the ANC. Mandela's continued principled stand further enhanced his stature and deepened Botha's dilemma. Botha's unsuccessful public exchange with his most prominent political prisoner implicitly confirmed Mandela's centrality in the political process. Subsequent interviews by Samuel Dash, counsel to the U.S. Senate Watergate Committee, and by John Lofton and Cal Thomas, conservative American journalists, strengthened the image of Mandela as a committed ANC member, loyal to the leadership and the policy of armed struggle yet ready to discuss how South Africa might be transformed into a social democracy guaranteeing democratic rights and equal opportunities to all its citizens (see Documents 35 and 36).

Increasingly harsh government reaction to the mass unrest of 1984–85 counterpointed the semipublic indirect negotiation with Mandela. In its customary fashion, the government sought to blunt its opposition by detaining leaders of the UDF, sixteen of whom it charged with treason and terrorism. In late 1984, also for the first time since 1960, it deployed the military in the townships to augment overextended police patrols. Poorly trained in crowd control, the police and soldiers increasingly resorted to live ammunition in place of teargas and rubber bullets. As the toll of dead and injured mounted and with the continued ban on all political meetings, funerals became ever more the rallying points for antigovernment outpourings. Under sharp attack many black community councilors and policemen were forced to seek sanctuary outside the townships, and the administrative structures of most of the Community Councils disintegrated. From both the perspective of the approximately 250 ANC delegates at the Second National Consultative Conference held in Kabwe, Zambia, on June 16–23, 1985 (see Document 59), and the perspective of the National party government, it did seem that the African townships were becoming ungovernable.

Ungovernability Brings a State of Emergency

Faced with the collapse of its authority in the townships, the continuing prospect of spreading violence, and an increasingly uneasy white population, the government responded with further repression. On July 20, 1985, it declared its first state of emergency since the Sharpeville crisis of 1960, in the thirty-six most affected magisterial districts. Security forces received expanded powers of arrest and detention and full immunity for their actions. Hundreds of arrests followed.

The strength and breadth of black resistance in late 1984–85 had a profound psychological impact on broad segments of the white population; not only was white domination again under sustained challenge, but for the first time ever it seemed conceivable to many that the existing status could not be maintained and that new means must be found to address African demands. In the eyes of many, the political initiative was shifting from the government to the black resistance.

Prevented from talking with the imprisoned ANC leadership in South Africa or the clandestine guerrilla leaders, various prominent whites sought ways to engage in dialogue with the ANC. Delegations of white South Africans, ranging from leading English-speaking businessmen, to Progressive Federal party politicians, to clergymen, traveled to the headquarters of the ANC in Lusaka. They found a responsive exile leadership, eager to present its point of view directly to the South African public. Returning to South Africa they conveyed both the spirit of give-and-take and the reasonableness that had pervaded their discussions, despite the deep differences over the appropriate course for a postapartheid South Africa. In this spirit, Oliver Tambo gave a lengthy interview in London to the editor of the *Cape Times* in October 1985, in which he patiently explained the ANC's reluctant and restrained commitment to the use of violence, the nature of its alliance with domestic and foreign communists, its continuing adherence to the Freedom Charter, and its desire to find a way to realize its goals with a minimal loss of lives. Challenging the prohibition on printing any statement by a banned individual, the *Cape Times* printed Tambo's full interview (see Document 52). Although the government criticized the direct contacts with the exiled ANC and even blocked the visits of Afrikaner student leaders by withdrawing their passports, it was clear that representatives of both the white opposition and the white establishment were ready to explore directly with the ANC what accommodation might be found.

The quickening of direct contacts between white South Africans and the ANC in exile occurred against a backdrop of escalating black defiance and internal unrest. Umkhonto we Sizwe guerrillas continued to attack targets. Winnie Mandela defied her banning order and in August 1985 moved back to Soweto from internal exile in Brandfort. Embarking on a lengthy public campaign of challenge and embarrassment to the government, she succeeded in July 1986 in getting her banning order lifted. Local UDF affiliates continued to organize rent boycotts and consumer boycotts of white-owned shops. School boycotts spread even to rural communities, with new demands for

"people's education." Despite the state of emergency, black protestors remained unintimidated in challenging government forces in the townships.

Throughout the world, television viewers were treated daily to graphic shots of unarmed black demonstrators, teargassed and wounded by the South African police and military. In addition, the media periodically carried defiant press conferences by Winnie Mandela, in which she eloquently reported on her husband's status after her most recent visit to Pollsmoor and forthrightly condemned government actions. South Africa's image was further harmed by the accelerating capital flight and a precipitous drop in the value of the rand. Finally, on October 25, 1985, the South African government banned all television and media coverage of demonstrations. At the same time it stepped up its efforts to detain activists and prevent demonstrations. In a more sinister pattern, the police apparently encouraged violence between UDF supporters and their rivals in AZAPO and Inkatha while black vigilantes and Community Council supporters received tacit police license to attack black opposition figures, particularly in those townships where opposition had been the fiercest.

Yet the South African government remained sensitive to the need to sustain its embattled economy. Thus, it acceded to business pleas to permit trade unions to continue to operate as a vital channel for maintaining communication with workers in the interests of ensuring production. As a result, South Africa's largest national trade union gathering was able to take place in December 1985 to found the Congress of South African Trade Unions (COSATU), which brought together FOSATU, the rapidly growing National Union of Mineworkers, and smaller independent unions in a half-million-strong national black trade union federation. AZAPO-oriented trade unions, centered in CUSA, refused to join, subsequently merging with other smaller like-minded independent unions into a rival National Council of Trade Unions (NACTU). Longtime ANC-oriented activist Elijah Barayi was elected president of COSATU. Responding to demands from its membership, COSATU condemned the pass laws and other apartheid measures, giving notice that it would not focus simply on wages and working conditions. COSATU's power was emphatically demonstrated on May 1, 1986, when an estimated million and a half workers responded to its call for a stay-at-home.

Efforts to end the bitter school boycott echoed trade union activism in stretching the limits of the state of emergency bans on political activity. Working intensively with student activists, the middle-aged leadership of the newly created National Education Crisis Committee, speaking dramatically through Zwelakhe Sisulu, son of Mandela's longtime ANC associate and fellow prisoner, persuaded students to return to school against a backdrop of vague government promises of reform and a commitment of black organizations to establish alternative and parallel structures of popular education. Throughout the antigovernment demonstrations, activist Christian leaders, including Bishop Tutu and the Reverend Boesak, played prominent roles, in both articulating opposition to government and protecting alleged collaborators from further injury at the hands of angry township crowds.

The Threat of Popular Uprising

The hallmark of the new upsurge, however, was the direct action by township activists to create new popular institutions in place of the discredited Community Councils and to confront alleged collaborators. Newly formed street committees coordinated implementation of the programs of local grass-roots bodies and facilitated mobilization for protest. In some areas *ad hoc* "people's courts" brought their own judgments against residents perceived as government collaborators. Ongoing rent strikes and selective consumer boycotts of white merchants, as well as the continuing disintegration of Community Council services, further testified to the deepening impact of the new style of protest. From the ranks of the highly mobilized youth of the townships, came the "comrades" who provided muscle for attempts to enforce the writs of new popular institutions in response to the call from the exiled ANC to establish "people's power." It was also the "comrades" who were at the forefront of attacks on councilors, policemen, and other alleged collaborators.

Increasingly spontaneous popular passions outran the organizational capacity of local grass-roots bodies to channel anger against the system. In numerous well-publicized incidents, the symbol of the new wave of resistance became the "necklace," the gasoline-soaked tire placed around the neck of an alleged collaborator who was tried on the spot by his accusers and then set alight to burn to death. Black militants were clearly seizing the initiative from the government and setting their own agendas, a development that marked a new and higher stage of black resistance. From the exiled ANC came calls for a "people's war," reflecting an assessment that the potential existed for a revolutionary insurrection to topple the government. In the government, hard-liners who opposed any suggestions of accommodation gained ascendancy.

Negotiation as a device to find accommodation with the black resistance had never been foremost in government strategy, yet from 1982 onward the government engaged in unreported discussions with Mandela. The abortive attempts by Botha in early 1985 to tempt Mandela to accept his terms for release bespoke government hopes that somehow ANC leaders would become partners in a government-defined dialogue. The Consultative Conference of the ANC in June 1985 recognized that even though the government was attempting to use the prospect of negotiations for its own ends, the principle of negotiation should not be rejected. It further determined that one precondition for negotiations was the release of all political prisoners (see Document 59).

On March 7, 1986, the government ended the partial state of emergency. Its action took place against the backdrop of Commonwealth efforts to mediate between the South African government and its opponents. The Commonwealth Conference in October 1985 had established a seven-member Eminent Persons Group (EPG) for a fact-finding mission to South Africa to devise a formula for a negotiated settlement. The South African government, under the threat of possible Commonwealth-mandated economic sanctions, gave the EPG unprecedented access during several visits to South Africa during late 1985 and early 1986. Conversations were held with cabinet ministers and

Mandela (see Document 37), and the EPG hammered out a "negotiating concept" under which Mandela and other political prisoners were to be freed and the bans on the ANC and other organizations lifted in return for the "suspension" of violence during negotiations on further measures. Mandela endorsed the concept, as did the exile ANC leadership in principle, but the cabinet ultimately refused to accept it. The government instead launched simultaneous raids on alleged ANC facilities in Gaborone (Botswana), Harare (Zimbabwe), and Lusaka (Zambia) on May 19, the day the EPG arrived back in South Africa after discussions with the ANC in London. The EPG mission withdrew as the government orchestrated with force its unwillingness to engage in negotiations on any terms other than its own.

State of Emergency Tightened

Challenged by continuing unrest throughout the country and facing the tenth anniversary of Soweto on June 16, the government followed up its renewed strikes at the ANC in exile by imposing a draconian nationwide state of emergency on June 12. Sweeping through the townships, the police apprehended and held incommunicado hundreds of activist leaders and detained thousands of youth and children (some as young as nine years), sending many to newly created reeducation camps for indoctrination. Africans prepared to cooperate in the Community Councils received added protection. The authorities also gave new encouragement to pro-government vigilantes and created new black township police forces (*kitskonstabels*) from hastily trained recruits. By a combination of decapitating the resistance leadership and empowering pro-government elements, the white authorities hoped to obtain acquiescence and support in the townships. Through a newly created Bureau of Information, the government also further restrained the media to ensure that the outside world would have even more limited access to the townships.

For three years from mid-1986 to mid-1989 the government relentlessly pursued its drive to quash the semilegal open antiapartheid struggle. Seeking to push the clock back to the early 1970s, before the upsurge of mass mobilization on a national scale, the government employed both old and new techniques of intimidation. In addition to bannings and detention (more than thirty thousand were detained through 1988, including eight thousand children and three thousand women), the use of black vigilantes continued. Activists mysteriously disappeared, and offices of major antiapartheid organizations, including COSATU and the SACC, were firebombed. On February 24, 1988, the government restricted the UDF and sixteen other organizations from any political activity (although not formally banning the organizations), forbade COSATU and other trade unions from engaging in any activity deemed political by the government, and gave notice that the independent press would be further curtailed in its ability to report and comment on opposition activities.

The government's primary goal was the destruction of the new organizations that had emerged in the 1980s, particularly those that it linked with the

ANC. Although the ANC admitted that the government had achieved considerable success in disrupting both grass-roots and national organizations, it also believed that the spirit of resistance was continuing to strengthen (see Document 61). In 1987 both the UDF and COSATU endorsed the Freedom Charter. Hundreds of thousands of blacks supported national stay-at-homes, called by the UDF to coincide with the May 1987 white elections and by COSATU for May Day, 1988. Despite heightened intimidation, many leaders not in detention or underground continued with forthright condemnations of government policy whenever possible. In the absence of other permitted channels for political expression, Bishop Tutu and other church leaders stepped to the fore, notably defying government regulations banning any advocacy of boycotts. The Community Council elections of October 26, 1988, effectively demonstrated the depth of opposition to government policy. Despite antiboycott regulations and the full mobilization of government resources urging black participation, only approximately 3 percent of the total eligible black electorate actually voted.

The ANC Encourages Dialogue

Outside South Africa the ANC pushed forward in its campaign to establish dialogue with the United States and Western European governments and business while simultaneously continuing its condemnation of their extensive economic links with South Africa and policies seen as supporting the South African government. In its rhetoric the ANC invoked its close identification with the democratic and revolutionary traditions of American and European political thought, comparing black South Africans with Americans who had no other choice but to take up arms against British colonial oppression. In this vein, Tambo hailed the surge in antiapartheid sentiment that culminated in the Comprehensive Anti-Apartheid Act of 1986, passed over President Ronald Reagan's veto (see Document 53). Placing the ANC squarely in the traditions of the French and American revolutions and contending that the roots of democratic advance were in the struggles of the oppressed majority against the privileged minority, Tambo reiterated his condemnation of Western policies (particularly those of the Reagan and Thatcher governments) and identified with the worldwide struggle of blacks in Africa and the diaspora against slavery and colonialism (see Document 55). Despite antagonism to the policies of Western governments, the ANC accepted invitations to meet with representatives of the Reagan and Thatcher governments which had previously refused to talk directly with the ANC. In February 1987 Tambo visited the United States, meeting Secretary of State George Shultz as well as appearing in public to articulate the ANC viewpoint before American audiences (see Document 53). Resuming the informal meetings with foreign businessmen begun in the United States in 1981, Tambo began a direct dialogue in an address to the Business International Conference in London in May 1987 (see Document 54).

In analogous fashion, the ANC extended its dialogue with white South Africans who opposed apartheid but were unwilling to identify fully with the UDF. Despite the continuation of sabotage and bombing attempts (escalating to over three hundred in the peak year of 1988), including incidents at nonmilitary targets in which civilians of all races were killed, white South Africans continued to seek out Oliver Tambo and the ANC exile leadership for consultation and dialogue. On February 7, 1986, van Zyl Slabbert dramatically resigned from Parliament and from the leadership of the Progressive Federal party. Proclaiming parliamentary politics irrelevant to the solution of South Africa's problems, van Zyl Slabbert set up the Institute for a Democratic Alternative in South Africa (IDASA) to bring together for direct dialogue South Africans of various political persuasions. In August 1987 some fifty Afrikaner businessmen, professionals, and academics traveled under IDASA auspices to Dakar, Senegal, for an unprecedented five-day dialogue with selected leaders of the ANC. In May 1988 IDASA sponsored another meeting between ANC leaders and liberal Afrikaners, including four members of the predominantly Afrikaner National Democratic Movement. In August the ANC released *Constitutional Guidelines for a Democratic South Africa*, an updating of the Freedom Charter outlining basic principles for a future constitution. The *Guidelines*, published in the South African press, endorsed a unitary nonracial, multiparty democracy based on universal suffrage and the principle of one person, one vote, an entrenched bill of rights, and a mixed economy (see Document 62).

In mid-October 1988, three and a half months after two whites were killed in a bomb explosion outside Ellis Park (the Johannesburg rugby stadium), Danie Craven, the Afrikaner president of the predominantly white South African Rugby Board, led a delegation to Harare to conclude, under the auspices of the ANC, negotiations initiated secretly in Europe in March with the predominantly black South African Rugby Union. The two parties agreed to form a single nonracial union as the first step toward the readmission of South African rugby to international competition. Although Craven subsequently retracted his own actions under pressure from the government, his abortive effort to engage with the ANC in exile remained mute testimony to the irrepressibly enhanced prestige of the still-banned organization. The ANC remained explicitly committed "to build the broadest possible united front against apartheid for a democratic South Africa" (see Document 61).

The government's dilemma, tacitly recognizing the renascent ANC but unwilling to negotiate with it, was embodied in its continuing but unsuccessful efforts to find a way of releasing Mandela from prison on its own terms. Having rejected the formula of the EPG that would have led to Mandela's release, the government subsequently experimented with the release of other prominent aging political activists. On November 5, 1987, the government released the ailing seventy-seven-year-old Govan Mbeki from Robben Island. Mbeki, a Rivonia codefendant and a longtime ANC leader like Mandela but, unlike Mandela, also a member of the CPSA, was permitted to conduct a news

conference and meet with longtime activists but was shortly thereafter restricted in his political activities. President Botha stated that the renunciation of violence was not a necessary condition for release but that questions of health and cooperation with the authorities would also be taken into consideration in individual cases. When the government transferred Mandela to a hospital on August 12, 1988, for the treatment of tuberculosis, and then subsequently to a luxury multiracial private clinic for further recuperation, renewed speculation emerged about an imminent release, particularly when President Botha referred to his "excellent cooperation" which could lead to "positive results." On November 26 the government unexpectedly released Zephania Mothopeng, the sixty-nine-year-old ailing president of the Pan-Africanist Congress and Harry Gwala, seventy-five-year-old ANC veteran, both apparently also without conditions.

On December 7 Mandela was transferred to a bungalow for prison officials on the grounds of Victor Verster prison near Cape Town. Government spokesmen announced that he would have unlimited access to his family (an offer subsequently rejected by Winnie Mandela until it would be offered to all political prisoners). That Mandela was not yet released unconditionally in 1988, as were other ailing prisoners, testified to his continuing refusal to accept any conditions and to the government's unwillingness to release him unconditionally out of fear that it could not contain popular demonstrations and mobilization. Yet his new setting opened the way for the government to permit him to meet with an increasingly broad range of visitors.

Events in the National party in 1989 gave further momentum to government efforts to find a solution to its dilemma. President P. W. Botha's stroke on January 18 precipitated a leadership struggle in the National party which by midyear resulted in the emergence of F. W. de Klerk as party leader and president-designate. F. W. de Klerk, the leader of the Transvaal branch of the party, represented both a new generation (he was fifty-three years old) and a new, more open style, emphasizing consensus building in the party and a reaching out to opposition to determine whether a common ground for dialogue existed. During the succession struggle President Botha attempted to reassert his dwindling authority, flying outside the country to meet the leaders of the Ivory Coast, Malawi, and Zaire, as well as engaging in a direct conversation with Nelson Mandela early in July, at which Mandela reaffirmed his willingness to seek a peaceful solution to South Africa's problems while reiterating the position that he had held since 1961, that dialogue with the government could take place only if genuine representatives of the opposition, particularly the ANC, were included. F. W. de Klerk, in his capacity as head of the National party and then as president-designate, also engaged in international diplomacy, meeting with Western European leaders, including Prime Minister Margaret Thatcher, as well as with President Kenneth Kaunda of Zambia, assuring them of his determination to pursue a policy of dialogue with opponents of the government once he was formally elected president.

Despite pleas to end the state of emergency, the government refused to do so. Undaunted, the charterist antiapartheid opposition in the country, regroup-

ing in the amorphous Mass Democratic Movement (MDM), began planning a new defiance campaign, reminiscent of that of the 1950s. At the end of June five top leaders of the UDF, including President Albertina Sisulu, traveled to the United States, where they were received by Secretary of State James Baker and in the White House by President George Bush, marking the first time that an American president had officially received UDF (or ANC) leaders.

Away from the public eye in his bungalow at Victor Verster prison, Nelson Mandela continued his own efforts to advance a solution, through consultations with both a widening circle of leaders of the emerging MDM as well as cabinet ministers. In a lengthy statement in July to President P. W. Botha (made public only in January 1990 shortly before his release from prison), Mandela took the initiative, arguing that it was "in the national interest for the African National Congress and the government to meet urgently to negotiate an effective political settlement." Pointedly rejecting government demands that the ANC first renounce violence, break with the SACP, and abandon demands for majority rule in a unitary state, Mandela reaffirmed at length his views (and those of the ANC) that the end of violence would only come as a result of negotiations between the ANC and the government, that the ANC would continue its policy of accepting support from Communists and Marxists (including the Soviet Union) while steadfastly maintaining its nonalignment and independence, and that the principle of majority rule was not negotiable. He concluded by suggesting a two-stage negotiating process in which the ANC and the government would work out together preconditions for a proper climate for negotiations to be followed by actual negotiations, and urging President Botha to seize the opportunity which he had offered him "to lay the foundations for a new era in our country, in which racial discrimination and prejudice, coercion and confrontation, death and destruction will be forgotten" (see Document 43). The statement set the parameters for Mandela's remarks to Botha at their meeting in early July.

The external ANC continued to expand its contacts with prominent white South Africans. In early July in Lusaka, 50 ANC leaders hosted a delegation of 115 whites, representing thirty-five organizations, including parliamentarians and other prominent professionals. Later in the month an ANC cultural delegation met in Zimbabwe with a delegation of Afrikaner writers.

More significantly the ANC launched a major diplomatic offensive to rally international support for its approach to negotiations. A document that it had drafted provided the text for a declaration adopted at a meeting of the Organization of African Unity (OAU) in Harare in August. The document, referred to subsequently as the "Harare Declaration" by the ANC, endorsed negotiations, provided that the South African government met six preconditions—lifting the state of emergency, ending restrictions on political activity, releasing detainees held without trial, legalizing all political organizations, releasing political prisoners, and offering clemency to those on death row—and then would be willing to join the ANC in suspending violence for elections to be held for a constituent assembly that would draft a new South African constitution (see Document 63). The Harare Declaration of the OAU reflected

the views of the ANC National Executive Committee on negotiations, adopted in October 1987 (see Document 60) and reaffirmed in June 1989. They were reiterated by Oliver Tambo in one of his last public appearances (see Document 56) before his stroke in early August, which sidelined the ANC's most visible external leader in London at a time of quickening activity. Nelson Mandela, apprised of the National Executive Committee's views on negotiation, also accepted them as binding for the initiative which he had taken in his direct communication with President P. W. Botha (see Document 43). Subsequently the ANC supported the adoption of the Harare Declaration by the triannual Non-Aligned Movement meeting in Belgrade, Yugoslavia, in September. The Harare Declaration also was the focal point of discussion at the October Commonwealth Summit in Malaysia and at the December special meeting of the United Nations General Assembly.

Inside the country, the MDM, drawing leaders from both the charterist camp and its AZAPO-oriented rivals, called for civil disobedience. Its most prominent spokespersons were religious leaders and trade unionists, less circumscribed than the leaders of UDF and AZAPO affiliates who had been restricted by the tightened government restrictions of February 1988. The new campaign first focused on health facilities, with black participants presenting themselves to segregated white hospitals and clinics and demanding treatment. As the segregated September 6 elections neared, the focus shifted to demonstrations urging release of political prisoners and boycott by Coloreds and Asians of the elections that excluded Africans. In a series of well-publicized marches, several led by (now) Archbishop Tutu and Reverend Boesak, the government briefly detained the leaders; on the eve of elections the police attacked less prominent demonstrators with whips and water cannons in Cape Town and its suburbs. The breadth of support for the activities of the MDM was revealed on September 5–6 when hundreds of thousands of black workers in major cities responded to calls for a stay-at-home to protest the elections.

Successfully defending the National party majority in the white election of September 6 against both the right-wing Conservative party and the new moderate Democratic party (both of which gained seats, thereby reducing the number of National party seats from 123 to 93), de Klerk quickly moved to ease tensions and to create a climate for dialogue. Faced with continuing demonstrations called by the MDM, the government quietly gave permission for peaceful antigovernment marches to be permitted in the center of Cape Town and elsewhere in South Africa. The police were forbidden to use whips against demonstrators. On October 10 de Klerk announced the release of eight prominent prisoners, including Walter Sisulu and the remaining Rivonia trialists; and on October 11 de Klerk met with Archbishop Tutu, Reverend Boesak, and Reverend Frank Chikane (general secretary of the SACC) in what a government spokesperson described as "talks about talks" to consider how the government and the opposition might proceed. Sisulu and the other released prisoners were not restricted from political activity, and on October 29 they presided over a rally of seventy thousand ANC supporters in Soweto, representing the largest crowd ever assembled in South Africa in support of the still-

banned organization. From his convalescence in London Oliver Tambo sent a message to the rally, conveying his appreciation for the participation of Sisulu, Mandela, and other prisoners in the long and ongoing struggle and urging even greater activism to force the de Klerk government to accept the terms for negotiation set forth in the Harare Declaration (see Document 57).

On December 9–10 a reported 4,462 delegates from throughout the country participated in the Conference for a Democratic Future, held at the University of Witwatersrand in Johannesburg, representing the fruition of efforts of the MDM which had been blocked earlier by the Botha government. The bulk of the delegates came from bodies with a charterist orientation, including the UDF and the COSATU. Yet the participants also included representatives from a range of religious organizations, white liberal groups, AZAPO-oriented bodies, and several of the bantustans. The three coleaders of the new liberal white parliamentary opposition, the Democratic party, attended as observers, as did diplomatic representatives from the United States and several European countries, plus two Soviet academicians. The newly formed Pan-Africanist Movement, a successor to the PAC, refused to attend, objecting to common participation with whites and reiterating the long-held Africanist slogan, "Africa for the Africans." At the last minute, the NACTU, the Africanist-oriented trade union rival of the COSATU, also refused to attend, in protest against the participation of the bantustan representatives; nevertheless, eight NACTU-affiliated unions were represented. Inkatha, led by Gatsha Buthelezi and viewed by the conference organizers as the perpetrator of the ongoing violence in Natal, was not invited. Despite the absence of some antiapartheid groups, the conference included the broadest range of antiapartheid groups brought together since the banning of the ANC and the PAC in 1960. Walter Sisulu, the keynote speaker, welcomed the diversity of the delegates and urged an even broader unity for expanded campaigns of the MDM. The conference endorsed the Harare Declaration (see Document 63) and formally declared that "only a united, democratic nonracial South Africa is acceptable"; the maximum unity of antiapartheid forces also was urged, along with continued internal and external pressure on the South African government.

Although Mandela had clearly been closely involved in discussions leading to the release of his coprisoners and their subsequent activities, he remained in prison amidst speculation that he would be released in early 1990. Permission to visit Mandela in confinement was further extended to include an even wider range of antigovernment labor and political leaders, including the leadership of the UDF, and on December 13 President de Klerk received Mandela, at the latter's request, in his Cape Town office. The government's actions, reflecting a type of "salami" tactics that permitted progressively greater access to Mandela and his ANC associates, appeared to be a continuation of government policy designed to minimize the possibility of an explosive black reaction once Mandela was finally released and to create a climate conducive to negotiations with African representatives, including the ANC, about further constitutional reform.

The MDM and the ANC urged the de Klerk government to accept its preconditions for the opening of negotiations, yet they remained skeptical that

it would do so (see Documents 56 and 57). In this spirit the ANC continued to adhere to its two-track strategy of ever-broader organized activities challenging the government, without renouncing the use of Umkhonto we Sizwe. In 1989, however, the emphasis was on the mass mobilization campaigns of the MDM. In contrast with the unrelenting repression of the 1960s, 1970s, and mid-1980s the de Klerk government was willing to give space to its opposition, including the MDM, to express itself. It explicitly indicated that the ANC should be included among the black groups with which it wished to discuss its plans for further reform. Whereas the ANC in the Harare Declaration spelled out a process for transition to a nonracial democracy based on one person–one vote, the de Klerk government seemed to envisage a grand *indaba*, invoking the model of a traditional African assembly called by tribal authorities, in which all opinions for a future South Africa could be aired.

Early in 1990 the pace of the shadow boxing between the ANC and the government quickened. After an emotional meeting in Lusaka in mid-January, attended by Walter Sisulu and six other recently released ANC leaders, the ANC reiterated its adherence to the conditions of the Harare Declaration, including the continuation of armed struggle, but also explicitly "reaffirmed the preference of the ANC for a settlement arrived at by political means." On January 25, Mandela's July 1989 statement to President Botha on negotiations was published in full in a Cape Town newspaper. Eight days later on February 2, in an opening address to Parliament, President de Klerk announced the lifting of the bans on the ANC, PAC, and SACP, the relaxation of some emergency regulations, and the government's intention to release Nelson Mandela unconditionally. Nine days later on February 11, before a worldwide television audience, Nelson Mandela walked to freedom through the gates of Victor Verster prison. A new era in South African politics had begun.

MANDELA

39 Unite! Mobilize! Fight On! Between the Anvil of United Mass Action and the Hammer of the Armed Struggle We Shall Crush Apartheid!

Message from Robben Island After the Soweto
Uprising (Published by ANC)

RACISTS RULE BY THE GUN!

The gun has played an important part in our history. The resistance of the black man to white colonial intrusion was crushed by the gun. Our struggle to liberate ourselves from white domination is held in check by force of arms. From conquest to the present, the story is the same. Successive white regimes have repeatedly massacred unarmed defenceless blacks. And wherever and whenever they have pulled out their guns, the ferocity of their fire has been trained on the African people.

Apartheid is the embodiment of the racialism, repression, and inhumanity of all previous white supremacist regimes. To see the real face of apartheid we must look beneath the veil of constitutional formulas, deceptive phrases, and playing with words.

The rattle of gunfire and the rumbling of Hippo armoured vehicles since June 1976 have once again torn aside that veil. Spread across the face of our county, in black townships, the racist army and police have been pouring a hail of bullets killing and maiming hundreds of black men, women, and children. The toll of the dead and injured already surpasses that of all past massacres carried out by this regime.

Apartheid is the rule of the gun and the hangman. The Hippo, the FN rifle, and the gallows are its true symbols. These remain the easiest resort, the ever-ready solution of the race-mad rulers of South Africa.

VAGUE PROMISES, GREATER REPRESSION . . .

In the midst of the present crisis, while our people count the dead and nurse the injured, they ask themselves: What lies ahead?

From our rulers we can expect nothing. They are the ones who give orders to the soldier crouching over his rifle: Theirs is the spirit that moves the finger that caresses the trigger.

Vague promises, tinkerings with the machinery of apartheid, constitution juggling, massive arrests, and detentions side by side with renewed overtures aimed at weakening and forestalling the unity of us blacks and dividing the forces of change—these are the fixed paths along which they will move. For they are neither capable nor willing to heed the verdict of the masses of our people.

THE VERDICT OF JUNE 16!

That verdict is loud and clear: Apartheid has failed. Our people remain unequivocal in its rejection. The young and the old, parent and child, all reject it. At the forefront of this 1976–77 wave of unrest were our students and youth. They come from the universities, high schools, and even primary schools. They are a generation whose whole education has been under the diabolical design of the racists to poison the minds and brainwash our children into docile subjects of apartheid rule. But after more than twenty years of Bantu education the circle is closed, and nothing demonstrates the utter bankruptcy of apartheid as the revolt of our youth.

The evils, the cruelty, and the inhumanity of apartheid have been there from its inception. And all blacks—Africans, Coloureds, and Indians—have opposed it all along the line. What is now unmistakeable, what the current wave of unrest has sharply highlighted, is this: that despite all the window dressing and smooth talk, apartheid has become intolerable.

This awareness reaches over and beyond the particulars of our enslavement. The measure of this truth is the recognition by our people that under apartheid our lives, individually and collectively, count for nothing.

UNITE!

We face an enemy that is deeprooted, an enemy entrenched and determined not to yield. Our march to freedom is long and difficult. But both within and beyond our borders, the prospects of victory grow bright.

The first condition for victory is black unity. Every effort to divide the blacks, to woo and pit one black group against another, must be vigorously repulsed. Our people—African, Coloured, Indian and democratic whites—must be united into a single massive and solid wall of resistance, of united mass action.

Our struggle is growing sharper. This is not the time for the luxury of division and disunity. At all levels and in every walk of life we must close ranks. Within the ranks of the people differences must be submerged to the achievement of a single goal—the complete overthrow of apartheid and racist domination.

VICTORY IS CERTAIN!

The revulsion of the world against apartheid is growing, and the frontiers of white supremacy are shrinking. Mozambique and Angola are free, and the war of liberation gathers force in Namibia and Zimbabwe. The soil of our country is destined to be the scene of the fiercest fight, and the sharpest battles to rid our continent of the last vestiges of white minority rule.

The world is on our side. The OAU, the UN, and the antiapartheid movement continue to put pressure on the racist rulers of our country. Every effort to isolate South Africa adds strength to our stuggle.

At all levels of our struggle, within and outside the country, much has been achieved and much remains to be done. But victory is certain!

WE SALUTE ALL OF YOU!

We who are confined within the grey walls of the Pretoria regime's prisons reach out to our people. With you we count those who have perished by means

of the gun and the hangman's rope. We salute all of you—the living, the injured, and the dead. For you have dared to rise up against the tyrant's might.

Even as we bow at their graves we remember this: The dead live on as martyrs in our hearts and minds, a reproach to our disunity and the host of shortcomings that accompany divisions among the oppressed, a spur to our efforts to close ranks, and a reminder that the freedom of our people is yet to be won.

We face the future with confidence. For the guns that serve apartheid cannot render it unconquerable. Those who live by the gun shall perish by the gun.

UNITE! MOBILISE! FIGHT ON!
Between the anvil of united mass action and the hammer of the armed struggle, we shall crush apartheid and white minority racist rule.

AMANDLA NGAWETHU! MATLA KE A RONA!

40 Letter Smuggled to Mrs. Manorama Bhalla, Secretary of the Indian Council for Cultural Relations

Excerpted from *Sechaba*, October 1981

In the upsurge of anticolonial and freedom struggles that swept through Asia and Africa in the postwar period there would hardly be a liberation movement or national leader who was not influenced in one way or another by the thoughts, activities, and example of Pandit Nehru and the All-India Congress. If I may presume to look back on my own political education and upbringing, I find that my own ideas were influenced by his experience.

While at university and engrossed in student politics, I first became familiar with the name of this famous man. In the forties I for the first time read one of his books, *The Unity for India*. It made an indelible impression on my mind, and ever since then I procured, read, and treasured any one of his works that became available.

When reading his autobiography or *Glimpses of World History*, one is left with the overwhelming impact of the immense scope of his ideas and breadth of his vision. Even in prison he refused to succumb to a disproportionate concern with mundane matters or the material hardships of his environment. Instead he devoted himself to creative activity and produced writings which will remain a legacy to generations of freedom lovers.

"Walls are dangerous companions," he wrote, "They may occasionally protect from outside evil and keep out an unwelcome intruder. But they also make you a prisoner and a slave, and you purchase your so-called purity and

immunity at the cost of freedom. And the most terrible of walls are the walls that grow up in the mind which prevent you from discarding an evil tradition simply because it is old, and from accepting a new thought because it is novel."

Like most young men in circumstances similar to ours, the politically inclined youth of my generation too were drawn together by feelings of an intense, but narrow form of nationalism. However, with experience, coupled with the unfurling of events at home and abroad we acquired new perspectives and, as the horizon broadened, we began to appreciate the inadequacy of some youthful ideas. Time was to teach us, as Panditji says, that:

> nationalism is good in its place but is an unreliable friend and an unsafe historian. It blinds us to many happenings and sometimes distorts the truth, especially when it concerns us and our country

In a world in which breathtaking advances in technology and communication have shortened the space between the erstwhile prohibitively distant lands, where outdated beliefs and imaginary differences among the people were being rapidly eradicated, where exclusiveness was giving way to cooperation and interdependence, we too found ourselves obliged to shed our narrow outlook and adjust to fresh realities.

Like the All-India Congress, one of the premier national liberation movements of the colonial world, we too began to assess our situation in a global context. We quickly learned the admonition of a great political thinker and teacher that no people in one part of the world could really be free while their brothers in other parts were still under foreign rule.

41 *I Am Not Prepared to Sell the Birthright of the People to Be Free*

Statement in Response to President Botha's Offer
of Conditional Release, Read by Zindzi Mandela
at Rally in Jabulani, Soweto, February 10, 1985

I am a member of the African National Congress. I have always been a member of the African National Congress and I will remain a member of the African National Congress until the day I die. Oliver Tambo is much more than a brother to me. He is my greatest friend and comrade for nearly fifty years. If there is any one amongst you who cherishes my freedom, Oliver Tambo cherishes it more, and I know that he would give his life to see me free. There is no difference between his views and mine. I am surprised at the conditions that the government wants to impose on me. I am not a violent man. My colleagues and I wrote in 1952 to Malan asking for a round-table conference to find a solution to the problems of our country, but that was

ignored. When Strijdom was in power, we made the same offer. Again it was ignored. When Verwoerd was in power, we asked for a national convention for all the people in South Africa to decide on their future. This, too, was in vain.

It was only then, when all other forms of resistance were no longer open to us, that we turned to armed struggle. Let Botha show that he is different than Malan, Strijdom, and Verwoerd. Let him renounce violence. Let him say that he will dismantle apartheid. Let him unban the people's organization, the African National Congress. Let him free all who have been imprisoned, banished, or exiled for their opposition to apartheid. Let him guarantee free political activity so that people may decide who will govern them.

I cherish my own freedom dearly, but I care even more for your freedom. Too many have died since I went to prison. Too many have suffered for the love of freedom. I owe it to their widows, to their orphans, to their mothers, and to their fathers who have grieved and wept for them. Not only I have suffered during these long, lonely wasted years. I am not less life loving than you are. But I cannot sell my birthright, nor am I prepared to sell the birthright of the people to be free. I am in prison as the representative of the people and of your organization, the African National Congress, which was banned.

What freedom am I being offered while the organization of the people remains banned? What freedom am I being offered when I may be arrested on a pass offense? What freedom am I being offered to live my life as a family with my dear wife who remains in banishment in Brandfort? What freedom am I being offered when I must ask for permission to live in an urban area? What freedom am I being offered when I need a stamp in my pass to seek work? What freedom am I being offered when my very South African citizenship is not respected?

Only free men can negotiate. Prisoners cannot enter into contracts. Herman Toivo ja Toivo, when freed, never gave any undertaking, nor was he called upon to do so.

I cannot and will not give any undertaking at a time when I and you, the people, are not free.

Your freedom and mine cannot be separated. I will return.

42 Message to the Second National Consultative Conference of the ANC

Message from ANC Leaders Imprisoned
in Pollsmoor and Robben Island, 1985

We were most delighted to hear that the ANC will soon have another conference. We sincerely hope that such an occasion will constitute yet another milestone in our history. It is most satisfying, especially in our present position,

to belong to a tested organisation which exercises so formidable an impact on the situation in our country, which has established itself firmly as the standard bearer of such a rich tradition, and which has brought us such coveted laurels.

As you know we always try to harmonise our own views and responses with those of the movement at large. For this reason, we find it rewarding indeed to know that despite the immense distance and the years which separate us, as well as the lack of effective communication channels, we still remain a closely knit organisation, ever conscious of the crucial importance of unity and of resisting every attempt to divide and confuse.

We feel sure that all those delegates who will attend will go there with one central issue uppermost in their minds: that out of the conference the ANC will emerge far stronger than ever before. Unity is the rock on which the African National Congress was founded; it is the principle which has guided us down the years as we feel our way forward.

In the course of its history, the ANC has survived countless storms and risen to eminence partly because of the sterling qualities of its membership and partly because each member has regarded himself or herself as the principal guardian of that unity. All discussions, contributions, and criticism have generally been balanced and constructive and, above all, they have been invariably subjected to the overriding principle of maximum unity. To lose sight of this basic principle is to sell our birthright, to betray those who paid the highest price so that the ANC should flourish and triumph.

In this connection, the positions taken by Oliver Tambo on various issues, and also stressed by Joe Slovo, inspired us tremendously. Both drew attention to vital issues which, in our opinion, are very timely. They must be highlighted and kept consciously in mind as we try to sort out the complicated problems which face the movement and as we try to hammer out the guidelines for future progress.

These remarks are the clearest expression of that enduring identity of approach of members of the movement wherever they may be and a summary of achievements of which we are justly proud. In particular we fully share the view that the ANC has raised mass political consciousness to a scale unknown in our experience. It is in this spirit that we send you our greetings and best wishes. We hold your hands firmly across the miles.

43 *Statement to President P. W. Botha*

July 1989

The deepening political crisis in our country has been a matter of grave concern to me for quite some time and I now consider it necessary in the

national interest for the African National Congress and the government to meet urgently to negotiate an effective political settlement.

At the outset I must point out that I make this move without consultation with the ANC. I am a loyal and disciplined member of the ANC, my political loyalty is owed, primarily, if not exclusively, to this organisation and particularly to our Lusaka headquarters where the official leadership is stationed and from where our affairs are directed.

The Organisation First

In the normal course of events, I would put my views to the organisation first, and if these views were accepted, the organisation would then decide on who were the best qualified members to handle the matter on its behalf and on exactly when to make the move. But in the current circumstances I cannot follow this course, and this is the only reason why I am acting on my own initiative, in the hope that the organisation will, in due course, endorse my action.

I must stress that no prisoner irrespective of his status or influence can conduct negotiations of this nature from prison. In our special situation negotiation on political matters is literally a matter of life and death which requires [that it] be handled by the organisation itself through its appointed representatives.

The step I am taking should, therefore, not be seen as the beginning of actual negotiations between the government and the ANC. My task is a very limited one, and that is to bring the country's two major political bodies to the negotiating table.

My Release Not the Issue

I must further point out that the question of my release from prison is not an issue, at least not at this stage of the discussions, and I am certainly not asking to be freed. But I do hope that the government will, as soon as possible, give me the opportunity from my present quarters to sound the views of my colleagues inside and outside the country on this move. Only if this initiative is formally endorsed by the ANC will it have any significance.

I will touch presently on some of the problems which seem to constitute an obstacle to a meeting between the ANC and the government. But I must emphasise right at this stage that this step is not a response to the call by the government on ANC leaders to declare whether or not they are nationalists and to renounce the South African Communist Party (SACP) before there can be negotiations. No self-respecting freedom fighter will take orders from the government on how to wage the freedom struggle against that same government and on who his allies in the freedom struggle should be.

To obey such instructions would be a violation of the long-standing and

fruitful solidarity which distinguishes our liberation movement, and a betrayal of those who have worked so closely and suffered so much with us for almost seventy years. Far from responding to that call my intervention is influenced by purely domestic issues, by the civil strife and ruin into which the country is now sliding. I am disturbed, as many other South Africans no doubt are, by the spectre of a South Africa split into two hostile camps; blacks (the term "blacks" is used in a broad sense to include all those who are not whites) on one side and whites on the other, slaughtering one another; by acute tensions which are building up dangerously in practically every sphere of our lives, a situation which, in turn, preshadows more violent clashes in the days ahead. This is the crisis that has forced me to act.

Current Views Among Blacks

I must add that the purpose of this discussion is not only to urge the government to talk to the ANC, but it is also to acquaint you with the views current among blacks, especially those in the Mass Democratic Movement.

If I am unable to express these views frankly and freely, you will never know how the majority of South Africans think on the policy and actions of the government; you will never know how to deal with their grievances and demands. It is perhaps proper to remind you that the media here and abroad have given certain public figures in this country a rather negative image not only in regard to human rights questions, but also in respect to their prescriptive stance when dealing with black leaders generally.

The impression is shared not only by the vast majority of blacks but also by a substantial section of the whites. If I had allowed myself to be influenced by this impression, I would not even have thought of making this move. Nevertheless, I have come here with an open mind and the impression I will carry away from this meeting will be determined almost exclusively by the manner in which you respond to my proposal.

It is in this spirit that I have undertaken this mission, and I sincerely hope that nothing will be done or said here that will force me to revise my views on this aspect.

Obstacles to Negotiation

I have already indicated that I propose to deal with some of the obstacles to a meeting between the government and the ANC. The government gives several reasons why it will not negotiate with us. However, for purposes of this discussion, I will confine myself to only three main demands set by the government as a precondition for negotiations, namely that the ANC must first renounce violence, break with the SACP, and abandon its demand for majority rule.

Renunciation of Violence

The position of the ANC on the question of violence is very simple. The organisation has no vested interest in violence. It abhors any action which may cause loss of life, destruction of property, and misery to the people. It has worked long and patiently for a South Africa of common values and for an undivided and peaceful nonracial state. But we consider the armed struggle a legitimate form of self-defence against a morally repugnant system of government which will not allow even peaceful forms of protest.

It is more than ironical that it should be the government which demands that we should renounce violence. The government knows only too well that there is not a single political organisation in this country, inside and outside parliament, which can ever compare with the ANC in its total commitment to peaceful change.

Right from the early days of its history, the organisation diligently sought peaceful solutions and, to that extent, it talked patiently to successive South African governments, a policy we tried to follow in dealing with the present government.

Apartheid Violence

Not only did the government ignore our demands for a meeting, instead it took advantage of our commitments to a nonviolent struggle and unleashed the most violent form of racial oppression this country has ever seen. It stripped us of all basic human rights, outlawed our organisations, and barred all channels of peaceful resistance. It met our demands with force and, despite the grave problems facing the country, it continues to refuse to talk to us. There can only be one answer to this challenge: violent forms of struggle.

Down the years oppressed people have fought for their birthright by peaceful means, where that was possible, and through force where peaceful channels were closed. The history of this country also confirms this vital lesson. Africans as well as Afrikaners were, at one time or other, compelled to take up arms in defence of their freedom against British imperialism. The fact that both were finally defeated by superior arms, and by the vast resources of that empire, does not negate this lesson.

But from what has happened in South Africa during the last 40 years, we must conclude that now that the roles are reversed, and the Afrikaner is no longer a freedom fighter, but is in power, the entire lesson of history must be brushed aside. Not even a disciplined nonviolent protest will now be tolerated. To the government a black man has neither a just cause to espouse nor freedom rights to defend. The whites must have the monopoly of political power, and of committing violence against innocent and defenceless people. That situation was totally unacceptable to us and the formation of Umkhonto we Sizwe was intended to end that monopoly, and to forcibly bring home to the government

that the oppressed people of this country were prepared to stand up and defend themselves.

It is significant to note that throughout the past four decades and more especially over the last 26 years, the government has met our demands with force only and has done hardly anything to create a suitable climate for dialogue. On the contrary, the government continues to govern with a heavy hand, and to incite whites against negotiation with the ANC. The publication of the booklet *Talking with the ANC* . . . which completely distorts the history and policy of the ANC, the extremely offensive language used by government spokesmen against freedom fighters, and the intimidation of whites who want to hear the views of the ANC at first hand, are all part of the government's strategy to wreck meaningful dialogue.

Pretoria Not Ready for Talks

It is perfectly clear on the facts that the refusal of the ANC to renounce violence is not the real problem facing the government. The truth is that the government is not yet ready for negotiation and for the sharing of political power with blacks. It is still committed to white domination and, for that reason, it will only tolerate those blacks who are willing to serve on its apartheid structures. Its policy is to remove from the political scene blacks who refuse to conform, who reject white supremacy and its apartheid structures, and who insist on equal rights with whites.

This is the real reason for the government's refusal to talk to us, and for its demand that we should disarm ourselves, while it continues to use violence against our people. This is the reason for its massive propaganda campaign to discredit the ANC and present it to the public as a communist-dominated organisation bent on murder and destruction. In this situation the reaction of the oppressed people is clearly predictable.

Armed Struggle

White South Africa must accept the plain fact that the ANC will not suspend, to say nothing of abandoning, the armed struggle until the government shows its willingness to surrender the monopoly of political power and to negotiate directly and in good faith with the acknowledged black leaders. The renunciation of violence by either the government or the ANC should not be a precondition to, but the result of, negotiation.

Moreover, by ignoring credible black leaders, and imposing a succession of stillborn negotiation structures, the government is not only squandering the country's precious resources but it is in fact discrediting the negotiation process itself and prolonging civil strife. The position of the ANC on the question of violence is, therefore, very clear. A government which used violence against blacks many years before we took up arms has no right whatsoever to call on us to lay down arms.

The South African Communist Party

I have already pointed out that no self-respecting freedom fighter will allow the government to prescribe who his allies in the freedom struggle should be, and that to obey such instructions would be a betrayal of those who have suffered repression with us for so long.

We equally reject the charge that the ANC is dominated by the SACP and we regard the accusation as part of the smear campaign the government is waging against us. The accusation has, in effect, also been refuted by two totally independent sources. In January 1987, the American State Department published a report on the activities of the SACP in this country which contrasts very sharply with the subjective picture the government has tried to paint against us over the years.

The esence of that report is that, although the influence of the SACP on the ANC is strong, it is unlikely that the Party will ever dominate the ANC.

The same point is made somewhat differently by Mr. Ismail Omar, member of the President' Council, in his book *Reform in Crisis* published in 1988, in which he gives concrete examples of important issues of the day over which the ANC and the SACP have differed.

He also points out that the ANC enjoys greater popular support than the SACP. He adds that, despite the many years of combined struggle, the two remain distinct organisations with ideological and policy differences which preclude a merger of identity.

These observations go some way toward disproving the accusation. But since the allegation has become the focal point of government propaganda against the ANC, I propose to use this opportunity to give you the correct information, in the hope that this will help you to see the matter in its proper perspective, and to evaluate your strategy afresh.

Cooperation between the ANC and the South African Communist party goes back to the early twenties and has always been, and still is, strictly limited to the struggle against racial oppression and for a just society. At no time has the organisation ever adopted or cooperated with communism itself. Apart from the question of cooperation between the two organisations, members of the SACP have always been free to join the ANC. But once they do so, they become fully bound by the policy of the organisation set out in the Freedom Charter.

As members of the ANC engaged in the antiapartheid struggle, their Marxist ideology is not directly relevant. The SACP has throughout the years accepted the leading role of the ANC, a position which is respected by the SACP members who join the ANC.

Firmly Established Tradition

There is, of course, a firmly established tradition in the ANC in terms of which any attempt is resisted, from whatever quarter, which is intended to undermine cooperation between the two organisations.

Even within the ranks of the ANC there have been at one time or another, people—and some of them were highly respected and influential individuals—who were against this cooperation and who wanted SACP members expelled from the organisation. Those who persisted in these activities were themselves ultimately expelled or they broke away in despair.

In either case their departure ended their political careers, or they formed other political organisations which, in due course, crumbled into splinter groups. No dedicated ANC member will ever heed a call to break with the SACP. We regard such a demand as a purely divisive government strategy.

It is in fact a call on us to commit suicide. Which man of honour will ever desert a lifelong friend at the instance of a common opponent and still retain a measure of credibility among his people?

Which opponent will ever trust such a treacherous freedom fighter? Yet this is what the government is, in effect, asking us to do—to desert our faithful allies. We will not fall into that trap.

ANC Is Nonaligned

The government also accuses us of being agents of the Soviet Union. The truth is that the ANC is nonaligned, and we welcome support from the East and the West, from the socialist and capitalist countries. The only difference, as we have explained on countless occasions before, is that the socialist countries supply us with weapons, which the West refuses to give us. We have no intention whatsoever of changing our stand on this question.

The government's exaggerated hostility to the SACP and its refusal to have any dealings with that party have a hollow ring. Such an attitude is not only out of step with the growing cooperation between the capitalist and socialist countries in different parts of the world, but it is also inconsistent with the policy of the government itself, when dealing with our neighbouring states.

Not only has South Africa concluded treaties with the Marxist states of Angola and Mozambique—quite rightly in our opinion—but she also wants to strengthen ties with Marxist Zimbabwe. The government will certainly find it difficult, if not altogether impossible, to reconcile its readiness to work with foreign Marxists for the peaceful resolution of mutual problems, with its uncompromising refusal to talk to South African Marxists.

The reason for this inconsistency is obvious. As I have already said, the government is still too deeply committed to the principle of white domination and, despite lip service to reform, it is deadly opposed to the sharing of political power with blacks, and the SACP is merely being used as a smoke screen to retain the monopoly of political power.

The smear campaign against the ANC also helps the government to evade the real issue at stake, namely, the exclusion from political power of the black majority by a white minority, which is the source of all our troubles.

Personal Position

Concerning my own personal position, I have already informed you that I will not respond to the government's demand that ANC members should state whether they are members of the SACP or not.

But because much has been said by the media, as well as by government leaders regarding my political beliefs, I propose to use this opportunity to put the record straight.

My political beliefs have been explained in the course of several political trials in which I was charged, in the policy documents of the ANC, and in my autobiography, *The Struggle Is My Life*, which I wrote in prison in 1975.

I stated in these trials and publications that I did not belong to any organisation apart from the ANC. In my address to the court which sentenced me to life in prison in June 1964, I said:

> Today I am attracted by the idea of a classless society, an attraction which springs in part from Marxist reading and in part from my admiration of the structure and organisation of early African societies in this country.

> It is true, as I have already stated, that I have been influenced by Marxist thought. But this is also true of many leaders of the new independent states. Such widely different persons as Gandhi, Nehru, Nkrumah, and Nasser all acknowledge this fact. We all accept the need for some form of socialism to enable our people to catch up with the advanced countries of the world and to overcome their legacy of poverty.

My Views Still the Same

My views are still the same. Equally important is the fact that many ANC leaders who are labelled communists by the government embrace nothing different from these beliefs. The term "communist" when used by the government has a totally different meaning from the conventional one. Practically every freedom fighter who receives his military training or education in the socialist countries is, to the government, a communist.

It would appear to be established government policy that, as long as the National party is in power in this country, there can be no black freedom struggle, and no black freedom fighter. Any black political organisation which, like us, fights for the liberation of its people through armed struggle, must invariably be dominated by the SACP.

This attitude is not only the result of government propaganda. It is a logical consequence of white supremacy. After more than three hundred years of racial indoctrination, the country's whites have developed such deep-seated contempt for blacks as to believe that we cannot think for ourselves, that we are incapable of fighting for political rights without incitement by some white agitator.

In accusing the ANC of domination by the SACP, and in calling on ANC members to renounce the party, the government is deliberately exploiting that contempt.

Majority Rule

The government is equally vehement in condemning the principle of majority rule. The principle is rejected despite the fact that it is a pillar of democratic rule in many countries of the world. It is a principle which is fully accepted in the white politics of this country.

Only now that the stark reality has dawned that apartheid has failed, and that blacks will one day have an effective voice in government, are we told by whites here, and by their Western friends, that majority rule is a disaster to be avoided at all costs. Majority rule is acceptable to whites as long as it is considered within the context of white politics.

If black political aspirations are to be accommodated, then some other formula must be found provided that formula does not raise blacks to a position of equality with whites.

Yet majority rule and internal peace are like the two sides of a single coin, and white South Africa simply has to accept that there will never be peace and stability in this country until the principle is fully applied.

It is precisely because of its denial that the government has become the enemy of practically every black man. It is that denial that has sparked off the current civil strife.

Negotiated Political Settlement

By insisting on compliance with the above-mentioned conditions before there can be talks, the government clearly confirms that it wants no peace in this country but turmoil; no strong and independent ANC but a weak and servile organisation playing a supportive role to white minority rule, not a nonaligned ANC but one which is a satellite of the West and which is ready to serve the interest of capitalism.

No worthy leaders of a freedom movement will ever submit to conditions which are essentially terms of surrender dictated by a victorious commander to a beaten enemy and which are really intended to weaken the organisation and to humiliate its leadership.

The key to the whole situation is a negotiated settlement, and a meeting between the government and the ANC will be the first major step toward lasting peace in the country, better relations with our neighbour states, admission to the Organisation of African Unity, readmission to the United Nations and other world bodies, to international markets and improved international relations generally.

An accord with the ANC, and the introduction of a nonracial society, [are]

the only way[s] in which our rich and beautiful country will be saved from the stigma which repels the world.

Two central issues will have to be addressed at such a meeting; firstly, the demand for majority rule in a unitary state; secondly, the concern of white South Africa over this demand, as well as the insistence of whites on structural guarantees that majority rule will not mean domination of the white minority by blacks.

The most crucial task which will face the government and the ANC will be to reconcile these two positions. Such reconciliation will be achieved only if both parties are willing to compromise. The organisation will determine precisely how negotiations should be conducted. It may well be that this should be done in at least two stages. The first, where the organisation and the government will work out together the preconditions for a proper climate for negotiations. Up to now both parties have been broadcasting their conditions for negotiations without putting them directly to each other. The second stage would be the actual negotiations themselves when the climate is ripe for doing so. Any other approach would entail the danger of an irresolvable stalemate.

Overcome the Current Deadlock

Lastly, I must point out that the move I have taken provides you with the opportunity to overcome the current deadlock and to normalise the country's political situation. I hope you will seize it without delay. I believe that the overwhelming majority of South Africans, black and white, hope to see the ANC and the government working closely together to lay the foundations for a new era in our country, in which racial discrimination and prejudice, coercion and confrontation, death and destruction, will be forgotten.

44 Speech on Release from Prison

February 11, 1990

Amandla! Amandla! i-Afrika, mayibuye! [Power! Power! Africa, it is ours!]

My friends, comrades, and fellow South Africans, I greet you all in the name of peace, democracy, and freedom for all. I stand here before you not as a prophet but as a humble servant of you, the people.

Your tireless and heroic sacrifices have made it possible for me to be here today. I therefore place the remaining years of my life in your hands.

On this day of my release, I extend my sincere and warmest gratitude to the millions of my compatriots and those in every corner of the globe who have campaigned tirelessly for my release.

I extend special greetings to the people of Cape Town, the city which has been my home for three decades. Your mass marches and other forms of struggle have served as a constant source of strength to all political prisoners.

I salute the African National Congress. It has fulfilled our every expectation in its role as leader of the great march to freedom.

I salute our president, Comrade Oliver Tambo, for leading the ANC even under the most difficult circumstances.

I salute the rank-and-file members of the ANC. You have sacrificed life and limb in the pursuit of the noble cause of our struggle.

I salute combatants of Umkhonto we Sizwe, like Solomon Mahlangu and Ashley Kriel, who have paid the ultimate price for the freedom of all South Africans.

I salute the South African Communist party for its steady contribution to the struggle for democracy. You have survived 40 years of unrelenting persecution. The memory of great Communists like Moses Kotane, Yusuf Dadoo, Bram Fischer, and Moses Mabhida will be cherished for generations to come.

I salute the General Secretary Joe Slovo, one of our finest patriots. We are heartened by the fact that the alliance between ourselves and the party remains as strong as it always was.

I salute the United Democratic Front, the National Education Crisis Committee, the South African Youth Congress, the Transvaal and Natal Indian Congresses. And COSATU. And the many other formations of the mass democratic movement.

I also salute the Black Sash and the National Union of South African Students. We note with pride that you have acted as the conscience of white South Africans. Even during the darkest days in the history of our struggle, you held the flag of liberty high. The large-scale mass mobilization of the past few years is one of the key factors which led to the opening of the final chapter of our struggle.

I extend my greetings to the working class of our country. Your organized stance is the pride of our movement. You remain the most dependable force in the struggle to end exploitation and oppression.

I pay tribute—I pay tribute to the many religious communities who carried the campaign for justice forward when the organizations of our people were silenced.

I greet the traditional leaders of our country. Many among you continue to walk in the footsteps of great heroes like Hintsa and Sekhukhuni.

I pay tribute to the endless heroes of youth. You, the young lions. You the young lions have energized our entire struggle.

I pay tribute to the mothers and wives and sisters of our nation. You are the rock-hard foundation of our struggle. Apartheid has inflicted more pain on you than on anyone else. On this occasion, we thank the world—we thank the world community for their great contribution to the antiapartheid struggle. Without your support our struggle would not have reached this advanced stage.

The sacrifice of the front-line states will be remembered by South Africans forever.

My salutations will be incomplete without expressing my deep appreciation for the strength given to me during my long and lonely years in prison by my beloved wife and family.

I am convinced that your pain and suffering was far greater than my own.

Before I go any further, I wish to make the point that I intend making only a few preliminary comments at this stage. I will make a more complete statement only after I have had the opportunity to consult with my comrades.

Today the majority of South Africans, black and white, recognize that apartheid has no future. It has to be ended by our own decisive mass actions in order to build peace and security. The mass campaigns of defiance and other actions of our organizations and people can only culminate in the establishment of democracy.

The apartheid destruction on our subcontinent is incalculable. The fabric of family life of millions of my people has been shattered. Millions are homeless and unemployed.

Our economy—our economy lies in ruins and our people are embroiled in political strife. Our resort to the armed struggle in 1960 with the formation of the military wing of the ANC, Umkhonto we Sizwe, was a purely defensive action against the violence of apartheid.

The factors which necessitated the armed struggle still exist today. We have no option but to continue. We express the hope that a climate conducive to a negotiated settlement would be created soon so that there may no longer be the need for the armed struggle.

I am a loyal and disciplined member of the African National Congress. I am, therefore, in full agreement with all of its objectives, strategies, and tactics.

The need to unite the people of our country is as important a task now as it always has been. No individual leader is able to take all these enormous tasks on his own. It is our task as leaders to place our views before our organization and to allow the democratic structures to decide on the way forward.

On the question of democratic practice, I feel duty bound to make the point that a leader of the movement is a person who has been democratically elected at a national conference. This is a principle which must be upheld without any exceptions.

Today, I wish to report to you that my talks with the government have been aimed at normalizing the political situation in the country. We have not as yet begun discussing the basic demands of the struggle.

I wish to stress that I myself had at no time entered into negotiations about the future of our country, except to insist on a meeting between the ANC and the government.

Mr. de Klerk has gone further than any other Nationalist president in taking real steps to normalize the situation. However, there are further steps as outlined in the Harare Declaration that have to be met before negotiations on the basic demands of our people can begin.

I reiterate our call for inter alia the immediate ending of the state of emergency and the freeing of all, and not only some, political prisoners.

Only such a normalized situation which allows for free political activity can

allow us to consult our people in order to obtain a mandate. The people need to be consulted on who will negotiate and on the content of such negotiations.

Negotiations cannot take place—negotiations cannot take up a place above the heads or behind the backs of our people. It is our belief that the future of our country can only be determined by a body which is democratically elected on a nonracial basis.

Negotiations on the dismantling of apartheid will have to address the overwhelming demand of our people for a democratic nonracial and unitary South Africa. There must be an end to white monopoly on political power.

And a fundamental restructuring of our political and economic systems to insure that the inequalities of apartheid are addressed and our society thoroughly democratized.

It must be added that Mr. de Klerk himself is a man of integrity who is acutely aware of the dangers of a public figure not honoring his undertakings. But as an organization, we base our policy and strategy on the harsh reality we are faced with, and this reality is that we are still suffering under the policies of the Nationalist government.

Our struggle has reached a decisive moment. We call on our people to seize this moment so that the process toward democracy is rapid and uninterrupted. We have waited too long for our freedom. We can no longer wait. Now is the time to intensify the struggle on all fronts.

To relax our efforts now would be a mistake which generations to come will not be able to forgive. The sight of freedom looming on the horizon should encourage us to redouble our efforts. It is only through disciplined mass action that our victory can be assured.

We call on our white compatriots to join us in the shaping of a new South Africa. The freedom movement is the political home for you, too. We call on the international community to continue the campaign to isolate the apartheid regime.

To lift sanctions now would be to run the risk of aborting the process toward the complete eradication of apartheid. Our march to freedom is irreversible. We must not allow fear to stand in our way.

Universal suffrage on a common voters' roll in a united democratic and nonracial South Africa is the only way to peace and racial harmony.

In conclusion, I wish to go to my own words during my trial in 1964. They are as true today as they were then. I wrote: I have fought against white domination and I have fought against black domination. I have cherished the idea of a democratic and free society in which all persons live together in harmony and with equal opportunities. It is an ideal which I hope to live for and to achieve. But if needs be, it is an ideal for which I am prepared to die.

My friends, I have no words of eloquence to offer today except to say that the remaining days of my life are in your hands.

I hope you will disperse with discipline. And not a single one of you should do anything which will make other people say that we can't control our own people.

TAMBO

45 *Southern Africa, South Africa, and the ANC*

Excerpted from *Sechaba*, April 1968

SECHABA: *You were Nelson Mandela's legal partner in Johannesburg. Is there hope for the victims of the Rivonia trial?*

MR. TAMBO: It is true that I was a legal partner of Nelson Mandela, but I was, even more importantly, his partner in the struggle for liberation. His imprisonment and that of other leaders and members has, of course, deprived the struggle of the important contribution of a powerful body of leaders. Nevertheless, all reports we get from our colleagues on Robben Island, in Pretoria Gaol and other South African prisons, are consistent in affirming the high morale of these leaders and their great expectation for the success of the struggle which has resulted in their incarceration.

SECHABA: *At what stage is the ANC? What are its real perspectives and prospects?*

MR. TAMBO: For a long time the ANC conducted a militant struggle by nonviolent methods. This became particularly intense during the 1950s and gradually led to a stage at which the movement switched over from nonviolence to the phase of armed struggle. During 1967 the first armed clashes occurred between, on the one hand, the combined forces of the Smith and Vorster regimes and, on the other hand, the united guerrillas of the ANC and ZAPU. It can be said that for the ANC this is the beginning of the armed struggle for which we have been preparing since the early 1960s.

It is a phase in which we can rightly claim to have scored victories by virtue of the superiority which our fighters demonstrated over the racist forces, sending a wave of panic throughout the area dominated by the racist regimes and arousing the masses to a new revolutionary mood. This is, however, only a small beginning in terms of the bitterness and magnitude of the revolution which is unfolding and which embraces the whole of southern Africa. But it is an impressive and effective beginning, providing what I consider a guarantee for the success of the armed struggle.

Although the armed conflicts to which I have referred took place in Rhodesia, they involved South Africa because South African troops, personnel, and finance are already involved in maintaining and sustaining the Smith regime. And the problems of the oppressed peoples of Zimbabwe and South Africa are becoming progressively identical. An armed struggle in Rhodesia is an armed struggle against part of the racist combine which is the Rhodesia–South Africa axis. This explains why the South African regime was rocked by the striking power of the guerrillas in Rhodesia as violently as if these battles had taken place within the borders of South Africa. And this explains why we

regard the clash between the people's guerrillas and the racists as the beginning of the armed struggle for which the masses of our people have been preparing.

SECHABA: *Which countries support your movement?*

MR. TAMBO: As a liberation movement, we endeavour to secure the support of all countries, organizations, and peoples throughout the world. We have been successful, I think, in focusing international attention on the evils of the South African racist regime; and there are many countries, governments, and organizations which support not only the struggle of our people against racism and oppression generally but support the ANC as the movement leading the liberation struggle in South Africa. The degree of support of course varies from country to country. In the African continent, all the members of the OAU support the ANC, although some are supporters in addition of smaller parties in South Africa. We have the support of all the socialist countries with a few exceptions. Practically the whole of anti-imperialist Asia supports the ANC. And in Europe, America, and Canada we enjoy the support of all important organizations. We are supported by leading movements in Latin America and the revolutionary government of Cuba.

SECHABA: *What is your programme of action?*

MR. TAMBO: Our programme of struggle is geared to what is known as the Freedom Charter, which is a statement of the objectives of our political struggle. It sets out the kind of South Africa we shall establish upon taking over power. In terms of that programme, we fight for a South Africa in which there will be no racial discrimination, no inequalities based on colour, creed, or race—a nonracial democracy which recognizes the essential equality between man and man. We shall abolish all the machinery whereby a few live and thrive on the exploitation of the many. The wealth of our country, which is abundant, will accrue to the equal benefit of all the people of South Africa. The power of government will rest in the hands of the majority of the people, regardless of considerations of race. But our first and immediate task is to win over the power to rule our country as it should be ruled, that is, to replace the regime which consists of a white minority with a people's government enjoying a mandate from all the people. It is the people who will decide on the methods and the techniques for putting into effect the principles set out in the Freedom Charter.

SECHABA: *What are the liberation movements that support the ANC? Is there coordination between the ANC and these movements, especially regarding the armed struggle?*

MR. TAMBO: It has been a cardinal feature of the policy of the ANC from its very inception to work for the unity of the people engaged in the common struggle for attainment of common objectives. In pursuance of this policy, within South Africa the ANC has rallied within the liberation movement all organizations and parties opposed to the South African racist regime and prepared to struggle for its total overthrow. Thus it is that the ANC embraces within itself a number of progressive and militant organizations, who accept its

leadership and programme of action. Outside South Africa it has sought to pursue the same policy of unity and coordination of activities among liberation movements and has established very close working relationships with the fighting movements of southern Africa, and with the majority parties in other parts of Africa.

SECHABA: *Is there no gap between the leaders outside the country and the people inside?*

MR. TAMBO: The fact some leaders of the liberation movement are outside their respective countries means that in varying degrees there is a break between them and the leaders involved in the struggle within these countries. It is a gap forced upon the liberation movement by adverse circumstances and constitutes one of the problems which the liberation movement must solve. But it does not represent a total break. There is communication between leaders outside and those within the country, and it is one of the tasks of the liberation movement as a whole to strengthen and consolidate these communications. At a certain stage of every liberation struggle, the need arises for the movement conducting the revolution to be in firm contact with the forces outside its country. This involves placing some of the leaders outside the country, and the effectiveness of the arrangement always depends on the strength and durability of the lines of communication between the leaders inside and outside the country. It is to be expected that these lines of communication constitute one of the main targets of attack by the enemy.

SECHABA: *In what form do the United Nations decisions help you, especially those concerning economic sanctions?*

MR. TAMBO: It was at the instance of the ANC that sanctions against the South African regime came to be considered at the United Nations. Thanks to the vigilance and consistent support of the African states as well as Asian and socialist countries, the United Nations has taken a correct position in adopting resolutions supporting sanctions against South Africa. To the extent that these sanctions have so far not been applied with any appreciable effect on South Africa, the resolutions have not helped us. But they have failed to take effect precisely because South Africa's major trading partners have persisted in their policy of economic support for apartheid, despite these resolutions, and have as a result sabotaged their effective execution.

There are many countries, however, in Africa and elsewhere, who have honoured these resolutions and, in doing so, have helped us not only to weaken the South African regime but also to maintain the type of international pressure which is of considerable assistance to our cause. The decision to apply sanctions against South Africa was vigorously opposed by Britain and is still being opposed. But its correctness as a method of international attack on an evil regime was demonstrated by Britain herself, when at her own instance the United Nations invoked sanctions against Smith. But these sanctions also failed precisely because to succeed they would have had to be applied against South Africa as well. This would be to the detriment of apartheid, in the enforcement of which Britain and other powers would play a vital role.

SECHABA: *How do you conceive the struggle against the arms race of the South African racist regime and the supply of weapons by the big powers?*

MR. TAMBO: As a liberation movement we are part of an international movement against racism, colonialism, and imperialism. We enjoy the support of peoples the world over, including the U.S.A., Britain, West Germany, France, and Japan, the main suppliers of the South African regime. The struggle is one struggle waged by all right-thinking and freedom-loving peoples of the world against the South African regime, as being part of and an instrument of the forces that are hostile to the interests of mankind. Our share of this common battle is to fight and destroy the enemy within South Africa with the assistance and support of all our friends; but our international friends have also their own special share of this burden, that is, to get their governments to disengage from South Africa. What is even more important, they should not permit their governments to send arms, which are expressly intended for the liquidation of the people. They must not give their labour to the manufacture of weapons, helicopters, armoured cars, and submarines for export to South Africa. To participate in these ventures against the workers whose cause we fight is to commit an act of betrayal against us. At this time in particular, we expect antiracists, anticolonialists and antiimperialists everywhere to play parts in the armed struggle.

46 *Message to the External Mission*

Excerpted from *Sechaba*, March 1971

Today, it is ever more important that we continue to hold in our hands the weapon of unity we have, in the past, wielded with such dramatic results in our external work. It is the weapon with which we have built up a volume of international support for our struggle and a mountain of international pressure against the racists, such as cannot but give great satisfaction to our colleagues who languish in South African goals. With that weapon of unity we have stood firm in the face of sustained and powerful enemy attacks—attacks mounted from different points, at different angles, and with different methods. With that weapon in our hands, we have gone to war, and it inspired the gallants of Umkhonto we Sizwe in the historic battles of Wankie and Sipolilo. They fought and fell; they punished and routed the imperialist agents under the banners of the ANC in the name of a united and suffering people. With that weapon we shall fight and fall, we shall conquer and be free.

It is a weapon the enemy has sought to take from the oppressed people. The colour bars and job reservations, the Bantustans, the Coloured and Indian councils, the group areas and ethnic groupings, the Fort Hares and Turf-loops,—all these attack the weapon of unity. "Hold fast on it," Chief Luthuli

cries from the grave. "Hold it fast." It is not yours, it belongs to the suffering people, to posterity; it is the key to posterity. "Hold it!" That is the call from Mini, Saloojee, Florence, Solwandle, and others; from Mercy Tshabala, Paul Petersen, and Patrick Molaoa; from Nelson, Walter, Goldberg, Mlangeni, Billy, Govan, Motsoaledi, Dorothy. Bram, Ramotse and millions of our people. And we shall hold it.

We who are free to eat and sleep at will, to write, to speak, to travel as we please; we who are free to make or break a revolution, let us use our comparative freedom, not to perpetuate the misery of those who suffer, nor to give indirect aid to the enemy they fight by withholding our own contribution.

We have an unequalled capacity for rallying to the banners of the ANC and consolidating our ranks when danger threatens. And danger does threaten. The campaign to break Africa's resistance to apartheid and her support for the liberation struggle in southern Africa has scored significant successes. Vorster, Suzman, and lesser agents of colonialism have turned Africa into a veritable hunting ground for stooges and indigenous agents of racism. Mrs. Suzman deserves special mention. This sweet bird from the blood-stained south flew into Zambia and sung a singularly sweet song:

I am opposed to apartheid;
I am opposed to the isolation of South Africa;
I am opposed to violence;
I am opposed to guerrillas;
I am opposed to the Lusaka Manifesto;
I am opposed to the decision of the World Council of Churches;
I know the Africans can do nothing to cause political change in South Africa;
I am in favour of change;
I am clearly in favour of change,
But determined to prevent change.

Some African leaders have been offering their services as Bantu commissioners in the political power structure of the racist regime. Encouraged by France, they see themselves sitting at a table with the racists, talking about the "Bantu," after the fashion of all Bantu commissioners—the "Bantu" who are not credited with the ability to talk for themselves.

A dialogue over the heads of the South African oppressed and over their leaders will never take place, unless it is a dialogue where a black chief sells his people into slavery as some black chiefs did centuries ago. But we refused to be sold then, and we refuse to be sold now. "No sale in the south!" we say to our brothers. "No more Bantu commissioners either—we have enough and to spare!"

What Vorster's African campaign amounts to is a counteroffensive to isolate our people and our movement from the solidarity forces we have built and which have placed South Africa in relative isolation. A recognition of this danger among others welds us into a united force.

Our militants are active both in and outside South Africa. The progress of our underground activities confirms the irrevocable commitment of our

members to the cause of freedom, and to the armed struggle as an essential precondition for the achievement of that cause. In their work, our organizers are inspired by the fighting mood of the oppressed masses themselves.

The enemy's own creations—the so-called Transkei Parliament, the Coloured Legislative Council, the Zulu Bantustan, the Urban Bantu Councils—these have become battlegrounds of freedom, where the true representatives of the people are fighting the racists and rejecting their regime. What we see and hear is but the tip an iceberg of revolutionary resentment against white rule. But although our people are fighting courageously, our own history of political struggle has taught us that they fight without arms. Hence the people's faith in the prospects of an armed struggle, which we launched in Zimbabwe, and for which white children and white women in South Africa are being prepared. Let them prepare hard and fast—they do not have long to wait.

In the mean time the black people of racist South Africa must recognize that freedom for South Africa will come only when they rise as a solid black mass, rising from under the heel of the oppressor and storming across colour barriers to the citadels of political and economic power. Then only shall the noble principles enshrined in the Freedom Charter see the light of day and turn South Africa into a happy home not only for black people at last, but for all people.

Let us, therefore, be explicit. Power to the people means, in fact, power to the black people—the gagged millions who cannot set foot in the Cape Town Parliament where Bantustans and Coloured councils are made; the most ruthlessly exploited, the tortured victims of racial hatred and humiliation. Let the blacks seize by force what is theirs by right of birth and use it for the benefit of all, including those from whom it has been taken. And who are the blacks in South Africa? They are the people known, and treated, as "kaffirs," "coolies," and "hotnots," together with those South Africans whose total political identity with the oppressed Africans makes them black in all but the accident of skin colour. Where this identity is not merely reformist but is revolutionary, there you have, in my view, a black man. This type of black man in South Africa is rare today. But he will grow in numerical strength, as we drive our point deeper and deeper with the Spear of Nation.

There may be some controversy over the views I have expressed. Any such controversy will be welcome, if it springs from differences of honest opinion on how best to exploit the revolutionary potential of the masses of the people and employ it in the destruction of a monster that has been terrorizing them for centuries. What seems clear in my own mind is that the black man is a vital and decisive factor in the survival or demise of fascist South Africa—indeed, as vital and decisive as his cheap labour is to the economic might of the fascist state.

What does all this mean for those of us who for the time being operate outside South Africa? As I see it, it means we must work together, hand in hand, to build and consolidate power at the mass base, which in the South African context is black. As members of the ANC external mission—by which I understand the political militants and activists who are together outside

South Africa under the leadership of the ANC—as mature members of this external mission of our movement, let us go out to the world, and back to the urban and rural areas of our common homeland, as one man, with one voice and one cause, which is power to the black people of fascist South Africa! Maatla! Mayihlome.

47 *A Future Free of Exploitation*

Excerpted from Address to the First Congress of
the MPLA, December 1977, in *Sechaba*,
April–June 1978

This first Congress of MPLA is a victory of the Angolan people. It is also a victory of all the peoples, including the peoples of South Africa, who are pledged to fight for the creation of new socioeconomic systems which will be characterized by the abolition of exploitation of man by man through ownership of productive wealth by the people themselves; characterized as well by the self-government of the ordinary working people through the institution of popular power and characterized also by a commitment to strive for a world that has been rid of the parasites that have imposed on all of us; fascism, racism, and apartheid, deprivation and backwardness, ignorance, superstition, and destructive wars.

Angola's orientation towards the social emancipation of her people has therefore, like Mozambique, brought to the fore, in our region, the confrontation between the liberating theory and practice of socialism and the oppressive, exploitative, and antihuman system of capitalism. This latter social system is of course represented, par excellence, by racist South Africa itself. Hence today the open and sharp confrontations between People's Angola and Mozambique on the one side and fascist South Africa and colonial Rhodesia on the other.

Given such a juxtaposition of two diametrically opposed social systems within the same region of southern Africa, conflict and confrontation become inevitable. But of major importance for us in understanding the nature of this confrontation is the fact that the victories of the MPLA and Frelimo have become a key factor in the politics of the racist regime.

These victories have helped to deepen the general crisis of the apartheid colonial system: They have in the actuality of South African politics helped to strengthen the forces of progress and severely weaken the forces of reaction. In that fact lies the fundamental reason for the desperate determination of the Vorster regime to destroy these two people's republics. In that also lies essentially the reason why we of the African National Congress join voices with Comrade President Neto in saying the victory of the Angolan people is indeed truly our own as well.

In the very first hours of its existence, people's Angola had to defend itself against the massive military onslaught of a mature but decaying imperialist system. The trials that confronted the MPLA even before 11 November 1975, right through to 1976 when the racist oppressor army of the Vorster regime was evicted from Angola, were not a test solely of the valour and military preparedness of MPLA and the people of Angola.

More significant in the longer term, the attempted military destruction of the People's Republic posed the question on the battlefield, had the time come for the birth of the new liberating social system in Angola? Or was the balance of forces still such that moribund imperialism, with its oppressive and exploitative system of social relations, would continue to hold sway, dictating to the people of Angola what kind of independence they should have?

The results of that contest have now become a matter of proud historical record. Progress triumphed over reaction, thanks to the heroic sacrifices of the people of Angola, supported by their progressive African allies, by Cuba, the Soviet Union and other socialist countries, and by all peoples advancing towards progress.

What started as a triumphant march by the forces of reaction into the heart of Angola ended up with a deeper crisis for the Vorster regime inside South Africa itself: the humiliating defeat of Vorster's social system for which that army had been created, trained, and armed to defend. The myth of the invincibility of the racist army was destroyed forever. For the fascist regime of John Vorster, whose ultimate and principal means of survival is naked brute force, this was a stunning blow.

It proved to our own people, as well as to the more far-seeing sections of the oppressor population, including especially the youth, that in the confrontation with the forces of progress, the fascist state is destined inevitably to lose, wherever that confrontation takes place, but above all, and especially, within South Africa itself.

Today the fascist regime is haunted by the spectre that large sections of the white population will, as the struggle intensifies, refuse to be used as cannon fodder to protect the interests of big capital and fascist domination. Already, thousands of white South Africans have left and are leaving the country. The regime stands in dread fear of the further narrowing of the social base of the system of apartheid domination. In this context, therefore, the so-called landslide victory scored by the Afrikaner Nationalist party during the recent racist elections in South Africa can only be fragile and temporary.

Terrified at the prospect of the victory of the forces of progress within the country in the aftermath and as a direct continuation of the popular victory in Angola, the Vorster regime unleashed the bloody terror that is today symbolized by Soweto. By this brutal means the enemy thought he would solve that part of his crisis which is characterized by the ready acceptance among our people of the liberating ideas and the revolutionary practice of the MPLA.

The regime also thought that through the ruthless massacre of our people, it would once again reestablish the terrorist military and political authority

that the regime's armed forces lost on the battlefields of Angola. Inevitably, the racist regime has failed dismally to achieve any of these objectives. So entrenched has the spirit of revolution among the people become that the enemy has been compelled to take extreme measures against even those who still preached peaceful transition to democratic rule.

The African National Congress with its allies is the representative inside apartheid South Africa of the kind of life that the people of Angola and Mozambique are striving to build, the kind of life that all peoples advancing towards progress aim for. Exactly because of this, its authority among the broad masses of our people has risen so high and has proved so indestructible that the enemy himself has had to admit this fact openly and repeatedly.

Instead of submitting to an already disproved invincibility of fascist arms, the best sons and daughters of our people have responded with enthusiasm to our call to them to swell the ranks of Umkhonto we Sizwe, our own people's army, the military wing of the ANC, and to confront the enemy with revolutionary arms now. The African National Congress therefore continues to find confirmation of the correctness of its positions from the historical experience of the MPLA.

48 Unity in Action—Decisive

Excerpted from *New African*, March 1980

■ *As Zimbabwe moves to elections and majority rule, how do you view the new regional situation? How will it affect South Africa's own liberation struggle?*

An independent Zimbabwe will, by the mere fact of its existence, by standing out as a product of the sacrifices that the people of Zimbabwe have made, affect our people as a material factor affirming that our own sacrifices will surely bring us liberation. Such was the effect also of the liberation of Mozambique and Angola.

However, it would be wrong to give the impression that because of the progress achieved in Zimbabwe, our struggle, and the continuing struggles of the peoples of Southern Africa will thereby become easier. Indeed, the victories scored make the enemy more desperate. It is not by accident that the military has assumed leadership of the ruling fascist group in South Africa. The Botha strategy to set up a "constellation" of client states throughout Southern Africa comes at this time as part of the enemy's counteroffensive to the victories we have won in this region. The vicious military campaign to destabilise Lesotho and to overthrow the government of that country is also part of this counter-

offensive. So is the sentencing to death of James Mange for being "obnoxious" to his fascist judge.

The open threat of the apartheid regime to invade and occupy Zimbabwe in the event of the electoral victory of the patriotic forces, the continuing stubbornness of that regime over the issue of Namibia, its explosion of a nuclear device in the area of the Antarctic—all these are indications of what the apartheid regime has in store for the peoples of Southern Africa.

I would say that the victories scored on the Zimbabwe front must and will result in a heightened offensive to liberate the rest of Southern Africa and call for greater efforts to secure the gains already won elsewhere in the region.

Yet, exactly because the forces of liberation are an immediate threat to apartheid South Africa itself, the very bastion of imperialist property and aggression in the region and in Africa, the new victories that are indeed certain, will become harder, will cost more lives throughout the region, but will also, by that very fact, lead ultimately to an unqualified defeat of the enemy and the genuine rather than a false liberation of our people.

■ *Briefly, what is the ANC's strategy for liberation? And have any recent government moves, characterised as reforms, indicated a need to change this strategy?*

The so-called reforms that have earned the South African regime an accolade in Western circles are neither intended to nor could they do anything to change the nature of that regime. It remains a white minority fascist regime, the same regime that massacred the children of Soweto. The so-called reforms that it has brought about are designed exactly to win the sort of accolade which British Prime Minister Thatcher has already voiced, as part of a whole campaign to extend the life expectancy of this enemy of humanity.

Our strategy for liberation from this tyrannical regime, given its nature, which it is now trying very unsuccessfully to camouflage, is based on the concept and the practice that our liberation can only come through the united mass action of the people, fighting as a united force under the leadership of the African National Congress. By this we mean a combination of united mass political action and people's armed struggle for the seizure of power by the people themselves.

It is a strategy which aims to defeat and destroy the fascist dictatorship and not to reform the apartheid system or to make our oppression less reprehensible. The nature of the enemy has not changed. The nature of our oppression has not changed. We have no cause to change the nature of the instruments by which we will rid ourselves of our enemy and his policies.

■ *Recent trials in South Africa have shown the world that the armed struggle is intensifying. But is more happening than we hear of? What effect will an intensifying struggle have on South Africa's military resources? What are the targets for Umkhonto cadres at present and are they likely to change as the struggle develops?*

Indeed, armed struggle is intensifying and must intensify. Our people's

army, Umkhonto we Sizwe, has broken for all time the monopoly of modern weapons and the science of warfare that the enemy has sought to retain for a whole century. Our combatants have proved this time and again in many widely dispersed areas of our country. As he must, the enemy has tried to hide many of these operations. He has simultaneously sought to represent his losses as minimal and ours as catastrophic.

However, the extent to which the enemy reckons with reality despite his propaganda is shown by a number of extraordinary measures that he is undertaking. These include the linking of all white families to police stations and army posts by means of radio transceivers; financial incentives to white farmers to move back into their farmhouses, particularly along the borders of the country; the placing of armed soldiers among the African people as teachers, doctors, engineers, and other technical personnel; and measures to secure all police stations throughout the country.

I do not think I will be disclosing a secret if I say that military science, if not ordinary common sense, dictates that we must at this stage aim to achieve the position in which Umkhonto we Sizwe is present among our people throughout the country, trained and armed to carry out operations in all parts of our country, based among the people, fighting together with them, and, in the first instance, seeking to provide the means to reply to the enemy's attacks against the people. The tactical and strategic objectives that Umkhonto pursues must therefore depend on its capabilities on the ground, inside the country.

■ *Recent labour movement victories, like that at Ford's, have been heartening. How do you assess the importance of this aspect of the struggle?*

It is most important to bear in mind that the economy of South Africa is the bedrock on which rests the apartheid state machinery, supplying the racist regime with the material means to perpetuate our oppression. It has, therefore, always been important that the black workers who keep this economy going should use the strike weapon as part of our total arsenal of weapons for liberation.

The militant explosion at Ford's as other struggles before—such as the one at Fatti's and Moni's, at Rainbow Chicken, the bus boycott at Ladysmith and Port Shepstone and so on—are a confirmation of the readiness of the millions of black workers to take their destiny into their own hands. These struggles show exactly what the black workers of our country think of such deceitful schemes as the so-called code of conduct and the new trade union legislation.

It is clear that there is a new upsurge of militant mass struggles throughout the country. Already, among the rural people, the Batlokwa people in the northern Transvaal have raised high the banner of militant mass resistance to forced removals. A significant feature of the struggle at Ford's as at Fatti's and Moni's and at Crossroads, is the extent to which these struggles drew in other sections of our population. Though not directly affected, they nonetheless

joined in support actions such as collecting strike funds, boycotting the goods of the affected firms, contributing funds for legal costs, and so on.

■ *What impact are the leaders of the Bantustans and those who profit from the Bantustan system having on black unity?*

Even before the ANC was formed, during the period of the wars of resistance, our people were already striving very hard to achieve unity. Since then, the ANC has scored irreversible successes in the task of building up the national consciousness and unity of our people. Furthermore, our people have for a century shared a common experience of oppression and exploitation, brought together by the development of mining and manufacturing industry especially. In our millions we have fought common battles together, recognising quite clearly that our strength lies in our unity.

There is no way in which the enemy or his agents can succeed to unscramble what has been achieved. You can go anywhere among our people and ask them who their national leaders are and they will tell you it is Mandela, Sisulu, Mbeki, and others of our heroes. That also is a measure of how much they refuse to accept so-called leaders who are hand picked and paid by the enemy to perpetuate our oppression.

■ *How does the ANC view Chief Buthelezi's Inkatha organisation? Buthelezi seems keen to imply an agreement with the ANC: Is there any truth in this? Further, new, legal black groups, under the umbrella heading of "Black Consciousness" have recently come into being in South Africa. What is the ANC's attitude towards, for instance, AZAPO?*

The African National Congress is continuously encouraging our people to organise themselves into all manner of formations to continue the struggle and to raise the level of confrontation. We, therefore, welcome the emergence of all organisations that seek to unite our people in the struggle against the fascist dictatorship. Our principal objective then becomes that of ensuring that such organisations are activised into struggle.

We always insist that what is of decisive importance is unity in action— action which draws the masses of the people into struggle against white minority domination and exploitation. Naturally we do everything in our power to bring this about.

This applies as much to Inkatha as to all other legal organisations, such as AZAPO, AZASO, COSAS, FOSATU, NIC, the Labour party, and so on.

The strategic outlook we project and encourage is one which focuses on mass struggle against the apartheid regime for the liberation of our people. There can be no question of agreements with anybody outside of this framework. As we said before, our activists, whether functioning at the legal or the illegal level—and we have to function at both these levels—adhere to our strategic concept of drawing the masses of the people into conscious, organised, and united action. Functioning at both these levels, it is their task to win into one common front of united action all organisations that are opposed to

the apartheid system and are fighting for genuine national and social liberation.

49 *Our Alliance Is a Living Organism That Has Grown Out of the Struggle*

Excerpted from Address on the Occasion of the
Sixtieth Anniversary of the South African
Communist Party, July 30, 1981, in *Sechaba*,
September 1981

We salute the SACP, particularly in the name of the combatants who have fallen in the course of our struggle as well as on behalf of the national leaders and militants presently held in the enemy's prisons. We congratulate the SACP on this occasion, particularly for the dedication and commitment of its leaders and cadres that has ensured its survival these 60 years, despite intensive repression and desperate attempts to destroy it. We applaud your achievements, for the SACP has not only survived but is today stronger and increasingly makes more significant contributions to the liberation struggle of our people.

The ANC speaks here today not so much as a guest invited to address a foreign organization. Rather, we speak of and to our own. For it is a matter of record that for much of its history, the SACP has been an integral part of the struggle of the African people against oppression and exploitation in South Africa. We can all bear witness that in the context of the struggle against colonial structures, racism, and the struggle for power by the people, the SACP has been fighting with the oppressed and exploited.

Notwithstanding that it has had to concentrate on thwarting the efforts to destroy it, cadres of the SACP have always been ready to face the enemy in the field. Because they have stood and fought in the front ranks, they have been amongst those who have suffered the worst brutalities of the enemy, and some of the best cadres have sacrificed their lives. And so your achievements are the achievements of the liberation struggle. Your heroes are ours. Your victories, those of all the oppressed.

The relationship between the ANC and the SACP is not an accident of history, nor is it a natural and inevitable development. For as we can see, similar relationships have not emerged in the course of liberation struggles in other parts of Africa. To be true to history, we must concede that there have been difficulties as well as triumphs along our path, as, traversing many decades, our two organizations have converged towards a shared strategy of struggle. Ours is not merely a paper alliance, created at conference tables and

formalized through the signing of documents and representing only an agreement of leaders. Our alliance is a living organism that has grown out of struggle. We have built it out of our separate and common experiences. It has been nurtured by our endeavours to counter the total offensive mounted by the National party in particular against all opposition and against the very concept of democracy. It has been strengthened through resistance to the vicious onslaught against both the ANC and the SACP by the Pretoria regime; it has been fertilized by the blood of countless heroes—many of them are unnamed and unsung. It has been reinforced by a common determination to destroy the enemy and by our shared belief in the certainty of victory.

This process of building the unity of all progressive and democratic forces in South Africa through united and unified action received a particularly powerful impetus from the outstanding leadership of Isitwalandwe Chief Albert J. Luthuli, as president-general of the ANC. The process was assisted and supported by the tried and tested leadership of such stalwart revolutionaries as Isitwalandwe Yusuf Dadoo and Isitwalandwe, the late Moses Kotane, revolutionaries of the stature of J. B. Marks and Bram Fischer.

Today the ANC and SACP have common objectives in the eradication of the oppressive and exploitative system that prevails in our country: the seizure of power and the exercise of their right of self-determination by all the people of South Africa. We share a strategic perspective of the task that lies ahead. Our organizations have been able to agree on fundamental strategies and tactical positions, whilst retaining our separate identities. For though we are united in struggle, as you have already pointed out, Comrade Chairman, we are not the same. Our history has shown that we are a powerful force because our organizations are mutually reinforcing.

It is often claimed by our detractors that the ANC's association with the SACP means that the ANC is being influenced by the SACP. That is not our experience. Our experience is that the two influence each other. The ANC is quite capable of influencing, and is liable to be influenced by, others. There has been the evolution of strategy which reflects this two-way process. In fact, the ANC was quite within its rights to tell the SACP that we are sorry we cannot release Comrade Moses Mabhida from his tasks in the ANC—find another comrade to be general secretary. Yet we agreed he would make a good general secretary for the SACP. He was not grabbed. This kind of relationship constitutes a feature of the South African liberation movement, a revolutionary movement, a feature of the SACP which helps to reinforce the alliance and to make it work as it is working. It is a tribute to the leadership of the SACP.

We are therefore talking of an alliance from which in the final analysis, the struggle of the people of South Africa for a new society and a new social system has benefited greatly. Within our revolutionary alliance each organization has a distinct and vital role to play. A correct understanding of these roles, and respect for their boundaries, has ensured the survival and consolidation of our cooperation and unity.

50 *Our Bases Are Inside South Africa*

Excerpted from *Journal of African Marxists,*
February 1984

AIM: *The apartheid government's military intelligence was undoubtedly aware that there are no ANC bases in Matola, or elsewhere in Mozambique for that matter. Why then do you think they launched their air raid on Matola?*

OLIVER TAMBO: Their target was the minds of their supporters. This was to divert the attention of the white population in South Africa away from the real cause of the Pretoria explosion, to point to a false cause. Mozambique, the ANC somewhere in Mozambique. And that being the purpose, they did not even have to find the ANC. They simply had to execute an act and then go to the public and say "we have killed 64 terrorists." They knew that they had not done anything of the sort. This was a psychological action for the benefit of the shocked white population.

The correct question was: What caused the Pretoria bomb? And the correct answer was not Maputo or Matola or even the ANC—because why did the ANC do it? The correct answer is in the whole system. One of the journalists did ask that question: What makes people carry out this kind of action? What is the matter with our system? That was the correct question.

It has been part of the regime's defence strategy to suggest that there is perfect peace, calm, stability, and contentment within South Africa. Everybody is satisfied with everything: The only trouble comes from outside, from neighbouring countries, or from the ANC which, for them, is something different from the masses of the people, something external to the people of South Africa. South Africa is all perfect. All the trouble comes from outside from this "total onslaught" which is being promoted by the Soviet Union. That is their explanation all the time. Therefore, when an explosion occurs inside, hurting even a lot of innocent people, the regime must react in terms of this legend, that the problem comes from outside. Therefore, attack outside. They have been doing this all the time, and they had to be consistent. I think that this myth about the ANC having bases in neighbouring countries will soon be disproved by reality.

AIM: *Since the ANC has no bases in Mozambique, where then does it have its bases?*

OLIVER TAMBO: In South Africa. A base for the ANC does not mean a place where you have an army and equipment in an independent country, and you go away and you come back there. We don't have that. Any such bases are inside South Africa, secret places we go to, we go in and out of, secret places from which we do our reconnaissance of targets and to which we return.

Our bases are the ordinary people themselves who are at work every day, who are cadres of our army. And a lot of training is going on in the country,

not of the best sort naturally, in those conditions, but there are a lot of cadres around. They carry out these actions. A bomb explodes in Pretoria. The activists have never even come out of South Africa. They are trained in there, but the regime comes to Mozambique. Our bases are inside South Africa. The regime knows this. But of course they never concede it—except that now and then they find small caches of arms. Well, who are those intended for? The people who use these arms, when the time comes, are in South Africa.

AIM: *Many observers feel that in South Africa the ANC is opening new forms of military and political struggle without models ready to hand, notably with respect to urban guerrilla warfare. Could you comment on this? Secondly, do you consider workers' struggles and those of community groups to be more important than guerrilla struggle at this stage, or do they all have equal weight in the overall struggle?*

OLIVER TAMBO: First of all, I think that although guerrilla struggles have been guided by certain models and have reflected a certain pattern, that did not alter the essential fact about guerrilla warfare—which is that it adapts to the objective and even subjective conditions in which it is being carried out. It must take into account and modify the situation that obtains.

Now it so happens that the other liberation movements have had the benefit of revolutionary rear bases provided by independent countries who were ready to provide camps and so on where the guerrillas could develop themselves and, after a period, begin to clear liberated areas. In our situation, we are governed by the reality that the countries which have borders with South Africa do not have the possibility to provide us with bases, to give us revolutionary support to the extent that other liberation movements, virtually all of them, received. This affects our strategy. We must develop a strategy and tactics which correspond to our real situation. That is why there would be features in our struggle which have not been observed elsewhere. It is simply because we have had to adjust to our own conditions.

One of these conditions is, of course, that we have had to develop tremendous striking power, because the system is strong and it will take really heavy blows to destroy it. Also, because we could not rely on bases outside South Africa, we had to place more reliance on the popular masses in the country. We have had, as part of our struggle, to develop political organization and mass mobilization, and do this with concentration and consistency, building this political base to replace a base outside the country. So I think it is possibly true that the level of political activity inside South Africa, the level of mass mobilization, is higher than in most countries where liberation wars were fought except, perhaps, towards the end when victory was in sight.

Our country is highly industrialized. The oppressed population is the proletariat, the working people. The struggle for liberation is a struggle of the workers who constitute the proletariat. They constitute the most powerful contingent in our struggle, and we have had to devote attention to their organization and mobilization. It is clear to us, as it is to the enemy, that it is

not enough to have a militant working class: It has to be well organized. This process of organization is developing rapidly. And it is clear to us, as it is to the enemy, that the workers, the black workers especially, constitute a force that could pose a serious threat to the regime.

But we don't see this as having exclusive importance. The armed struggle is indispensable, but strategically it would be a terrible mistake to rely on armed struggle alone. In our situation we have to attach equal importance, at this stage, to organizing the exploited workers, organizing the oppressed masses. Therefore we operate on three fronts: the labour front, the front of mass popular actions, as well as the front of armed actions.

AIM: *Is there an organic link between these three?*

OLIVER TAMBO: There is. Over the years we have developed this organic link, and we think that they knit together to constitute a force which the enemy will find very difficult to contain.

AIM: *Would you, then, say that the regime, as well as the more conservative forces around the regime, can no longer make an absolute separation between trade union struggles and the national liberation struggle?*

OLIVER TAMBO: That is no longer possible. They have become part of the same broad front of action.

51 *Testimony of Oliver Tambo and Thabo Mbeki*

Excerpted from Their Testimony Before the
Foreign Affairs Committee, House of Commons,
October 29, 1985

[Numbers 1–4, 6–8, 11–13, 15–17, 19, 21, and 29–34 have been omitted.]

5. We all feel a great repugnance for violence from whatever source, but it is especially unhelpful, in terms of British public opinion, when we see violence of black against black, we understand that city councillors and town councillors have been murdered, and we see regularly on our television screens the real problems in some of the townships. Do you support and encourage that attitude—that people should turn on one another within a township—or is this something which you also agree is unhelpful to your cause?

(MR. TAMBO.) We think it is unavoidable, in a way. It is a product of the violent system in which we live. The councillors, some of whom have been killed, were collaborators with the regime at a very bad time, at a time when people were being killed for their resistance. Angers were aroused. Councillors were called upon to resign from these councils. Many of them did. Others were

determined to operate structures which the people had always opposed. At a time when there was violence against the people, it was inevitable that their anger should vent itself against those who persisted in collaborating and sustaining these unwanted councils.

9. Then you had the agreement between Mozambique's president and South Africa, which meant that you were no longer able to operate. You were exercising military violence from across the border, were you not? What do you mean by the "new violence" which was agreed in June of this year at your ANC meeting? What do you mean by it? What do you mean by "the soft targets" and "the people's war"? Mr. Lester mentioned the interblack struggle which is going on, the policemen who are killed, the officials who are killed and their houses burnt, and that sort of thing. Is that something that you say is part of the ANC policy? Do you not condemn it?

(MR. TAMBO.) That, of course, was going on when we met in June. That had started a year earlier. No, what we decided in June was to intensify the struggle. We recognised that if the struggle is intensified beyond the levels that we had maintained for 20 fruitless years of selected sabotage—if it was to be intensified—it was inevitable that life would then be lost. Even in the course of attacking military establishments, the army, the police, there would be bloodshed, that would involve bloodshed, and you would be reaching a level of conflict in which, as happens in all conflicts, the innocent would be hit not deliberately but unavoidably. We would be fighting an intense struggle with arms, and it was unavoidable. This is what we decided in June, that now there is going to be more bloodshed than there has ever been before. But we recognise that we have been the victims of violence, there has been bloodshed on our side all the time. Now, this question of black versus black is generally misunderstood, I am afraid. The South African government uses black police which it arms and which shoot at our people, so they have got an area of conflict between black and black, but it is not really between black and black, it is between the agencies of the regime—its armed police force killing civilians who are unarmed, and this has been presented as a conflict between black and black. It is not really, it is conflict between, on the one side, the victims of the apartheid system and the forces that represent and defend the apartheid system on the other. In the course of all this, of course, there are excesses which we do not condone, but we understand the circumstances in which all this is happening. There has been such an onslaught on our people by the Pretoria regime, there has been so much killing and shooting—shooting of children who do not have to be killed, they are killed because they are taking a stone and throwing a stone, they cannot hurt anybody throwing a stone, but in return for it they are shot and killed. This enrages the people and makes them more angry, and we can understand that they can go to excesses in the way that they respond to this unbridled violence by apartheid.

10. The children of black policemen and black officials have been killed and their houses have been burned. You say you do not condone it. Are you willing to condemn it?

(MR. TAMBO.) What I condemn with all the vehemence I can muster is the fact that for 70 years now—75 years this year, three-quarters of a century this year—we have been the victims of white minority rule which has progressively become more and more violent against us up to the point where it now assumes the forms that we are witnessing. It is that violence, that is where it all starts. I condemn that because if the apartheid system stopped—and it is violent; it maintains itself by violence—if it stopped, all this would not be happening. No child would be shot dead, none would be killed even by a petrol bomb. All this is the precise result of what people, South African journalists and writers, reporters and editorial writers have been warning the apartheid regime about. They have said during the 1970s already that unless the Pretoria regime changes, there is trouble ahead, and the constant message was "Change before it is too late." They did not change before it was too late. We have had Soweto only in 1976, a few years ago, and we have had this persistent violence which we have witnessed ever since Botha came into power. Now, all that must be taken into account before one condemns an individual act. I regret all these things, I regret them, but I would refuse to be asked to condemn individual acts when I know that those acts would not have been there in the first instance had there not been this criminal system, this crime against humanity. We think this is where we should focus. We should focus on the cause, not the symptom, but the cause of all this, and the cause is the apartheid system.

14. Chairman, I would like to ask two questions, if I may, one supplementing a question of Mr. Thomas's and one supplementing the last question of Mr. St. John-Stevas. The first is this. Did I understand aright when I thought that in replying to Mr. Thomas what you were in fact saying was that if one of your people attacks or counterattacks a black policeman, that is not a black man attacking a black man, it is a black man attacking a policeman? Would I be right in that?

(MR. TAMBO.) I was trying to move away from the idea that this thing is essentially black versus black. I was saying that if the South African army employs blacks, puts them into uniform, and orders them to shoot blacks, then the blacks that are being shot see an enemy in that policeman who is firing at them. That is not a question of really black versus black, it is the apartheid system functioning in its normal way. The struggle of those who are being shot at is really a struggle against the violent system that they want to remove from the country.

18. Then can I move on to the question that you have raised today? You told us that the violent attacks were confined to attacking economic installations. It really looked as though you were saying that however bad the violence had been in the past, you were now wanting to concentrate on purely economic and presumably military installations. If that is so, will you disown all attacks in the ANC's name on African security policemen, community councillors, former ANC members who have turned state's witnesses, any bombing in city centres, shopping areas, public buildings and places of entertainment? Are any such future acts to be condemned by you and the ANC?

(MR. TAMBO.) Let me go back a little to the first part of this question that you have raised and what I said in 1981 and subsequently. In 1981 one of our most outstanding leaders was assassinated by South African agents—by South African agents. In that year South Africa had raided our people—raided Mozambique—and massacred very brutally some 13 of our people who were simply living in houses in Mozambique. That was 1981. In 1982 the South African army invaded Lesotho and massacred not 19 people but 42 people shot at point-blank range—42—12 of them nationals of Lesotho. So there was this mounting offensive against the ANC. I think your question fails to relate to this aspect; that we were the victims of assassinations, of massacres, and in return for what? We were not killing anybody. We were not killing anybody. An armed struggle is an armed struggle. People die. It has been fortunate perhaps, in that time, that there have not been so many people dying on the other side of the conflict, but many on our side. They have been hanged, they have been sentenced to long terms of imprisonment, for exploding a bomb that destroyed a pylon; sentenced to life imprisonment. That is violence. This is what we are going through. As to these other people you are mentioning, we cannot condemn it. That is part of the struggle. The enemy is the enemy. The enemy is the enemy. This country has fought a war 45 years ago. How many children were not killed when the RAF was bombing away in Germany and other places? How many? Why is this so strange with us? After all, we have got a fascist nazist regime that came into power in 1948 immediately after the defeat of Nazism in Germany. We are confronted with that. We have decided to fight and in fighting people will be killed. There must be no mistake, gentle-men, no mistake at all; we do not love violence, we dislike violence, and we keep saying that this thing was thrust upon us, that we have rejected and resisted it for 10 long years. We never thought we would ever be violent for about half a century. We have restrained ourselves for a further 20 years, and it cannot go on like that. The other liberation movements have taken up arms and intensified their struggles and won their independence on our borders; while we are picking out pylons they were fighting a war. A war is a war. We have delayed it, but we cannot delay it indefinitely. Apartheid is a crime against humanity, and it is more a crime against us. We have suffered under it. We have got to fight it. We will fight it as resolutely as the British people fought Nazi Germany, as resolutely—and in the process we want to make no mistake about this. We are carrying on a struggle which others elsewhere have carried on, and it is an armed struggle, but it has been an armed struggle with so much restraint that we have tended to draw attention to the few acts of violence that we have carried out, diverting attention from the massive violence that comes from the operation of the apartheid system. Our people are certain about this, and I would like to make the position of the ANC absolutely clear: We have acted with a great deal of restraint, and I think that that should be recognised, and if we are being pushed to intensify that struggle, it is simply because we feel the need to get rid of that system that much more urgently.

20. Do you see any signs of progress towards change in the South African government's current programme of political reform?

(MR. MBEKI.) No, we do not see any change. The Botha regime is not addressing any of the substantive questions that our people want addressed. They are tinkering around with issues which they decide are important. For instance, there is a lot of noise which has been made about the restoration of common citizenship. It is not of such significance to us because even when they said, "You have ceased to be citizens of South Africa," we did not think we had ceased to be citizens of South Africa, and in any case, if they do say, "All right, you have now got your citizenship back," still it does not mean anything. What are you going to do with citizenship if you have no right to govern this country? So they take away one document and give you another document defining citizenship. In a situation in which you still have a Bantustan policy in place, it is tinkering around. I think it is significant that it is during the presidency of Botha—this great reformer—that you have got the levels of struggle that you have got today. It is because people are giving their response to what is supposed to be a process of reform and the people do not want that. We have been saying that to negotiate a resolution of the South Africa problem would require for one that all political prisoners should have been released, released so that they could consider the question together with everybody else in the country of how to resolve the South Africa problem. It is a very simple thing for Botha to instruct his jailors to open the gates and let the prisoners out, but clearly Botha is not interested. The conditions he has placed, like the political prisoners having to undertake not to engage in political activity which is likely to lead to their arrest, are ridiculous when you have an apartheid system continuing because, if Mandela decides, "I am not going to carry this reference book any more," he is liable to arrest.

22. Would you be prepared to engage in power sharing? That is another of the subjects being talked about very much within the Botha government at the moment.

(MR. MBEKI.) It is an expression which we do not use. It suggests to us a continuation of a continued fragmentation of the population of our country, so that you would say, "Here is a white population; here is a Zulu population; here is a coloured population; and between them they constitute distinct groups and must share power amongst themselves." It is an expression that we do not use. Certainly the perspective that the ANC has would not be a perspective which would be based on the continuation of these group distinctions (as they are called). We have said, talking to many of our own people in South Africa—white people in South Africa—that, for instance, the ANC would be very much in favour of an entrenched bill of rights in a new constitution for South Africa, but entrenching the rights of individuals not the rights of groups, because those groups would get defined in the same way that the apartheid structure is defined today. So certainly, as the African National Congress, I am sure the African National Congress would be perfectly happy

to participate in any action. I am quite certain, as far as the ANC membership is concerned, and as far as a platform of M.P.s is concerned, that they would be South Africans of all national groups.

23. Mr. Mbeki, does your last answer mean that you rule out a federal constitution such as many other countries have—for example, Yugoslavia?

(MR. MBEKI.) We would not want to federate these constitutional units that the apartheid system has created. We cannot say we need a federal structure which must recognise the reality of the Bantustans. We do not want Bantustans. We want to abolish Bantustans. Bantustans are part of the apartheid structure. That is what we will not do. We are against group areas. We are against a system which distinguishes whites—"Whites can stay there, Indians there." It is wrong. That has got to go. We cannot have a new system which entrenches exactly that arrangement.

24. So you are against a federation based upon race?

(MR. MBEKI.) Based on race and on ethnic divisions in most circumstances.

MR. MIKARDO: Then, in other words, you prefer the British system to the Yugoslav, is that it?

25. May I ask, very briefly on this, are you saying that it must be units of South African states; there is no chance at all of discussing political systems in different areas of South Africa; it must be a unitary South Africa state? Are you saying that that is the ANC's position on South Africa?

(MR. MBEKI.) Yes, certainly, we are saying a united, democratic, and nonracial South Africa.

CHAIRMAN: Then perhaps we could turn to the question of sanctions.

26. The ANC has consistently called for economic sanctions. Could you elaborate on exactly what kind of sanctions you would like to see? Would it involve an economic boycott of South Africa by countries like the United Kingdom, or could you specify exactly what kind of sanctions you would like to see?

(MR. TAMBO.) We have been calling for comprehensive, mandatory sanctions, therefore total sanctions, total severance of economic and other links with the South African regime, in all economic areas. This is what we think would be most effective. However, we have also, as part of that, addressed the question of specific sanctions which would be the most effective in the interim, like disinvestment form of sanctions. Recently we have had the experience of banks' withholding loans. So that all falls within the concept of total sanctions. An oil embargo, arms embargo—this is part of sanctions. Severance of trade relations. In other words, total sanctions. Some of these have been mentioned—for example, such as stopping flights from and to South Africa. However, all these would be a whole package of what would amount to total sanctions, ideally enforced by the Security Council, but otherwise by countries individually.

27. To what extent do you think such sanctions would help to bring about peaceful democratic change in South Africa?

(MR. TAMBO.) The thing about sanctions is that it really aims to aid a peaceful resolution of the South African problem. That is the primary aim of sanctions: to make the process of transition through struggle as limited as possible in terms of the scale of the conflict, to limit the scale of the conflict. What happens without sanctions is that we are confronted with the might of the regime and have to rely on our own struggle, on our own sacrifices, and we have to mount our struggle, if you like, we have to sacrifice more. It has got to become increasingly violent and escalate to very disastrous levels, involving a lot of destruction of property and life. That is what would happen if we had to do it unaided. However, there is a peaceful way in which we could be aided, which would operate to weaken the system and make it less capable of resisting our struggle and encourage an early resolution of the problem, without our having to draw on everything we can to bring it down. So sanctions are fundamentally aimed at limiting the escalation, limiting the scope of the conflict, before the problem is solved.

28. Critics of sanctions in this country and elsewhere sometimes claim that sanctions would hurt the black people of South Africa, and indeed, black people in neighbouring states such as Swaziland and Lesotho which have got close economic links with South Africa. What would you say to these critics?

(MR. TAMBO.) This has never been correct. It has never been correct, because under apartheid people are suffering and are suffering very badly, from this system, so much so that they would want to do anything they can to put an end to it. What would they suffer if sanctions are employed? We have been told they would lose their jobs. There are three million unemployed already, without the use of sanctions. It is part of our life. It has been like that all the time. People who are prepared to die for their liberty must be prepared to make a sacrifice of going without food, of being unemployed, because even that unemployment is with them all the time precisely because of the apartheid system. There have been opinion polls taken in South Africa recently which really confirm what I am saying, that the majority of the people are saying sanctions. Naturally—I think it is natural—it is a sacrifice they can make. Apartheid kills; sanctions will not kill them. As far as the countries around South Africa are concerned, they have said they would not oppose sanctions because they agree that sanctions would bring a speedier end to the apartheid system than a struggle without the support of sanctions. They also recognise that the growing conflict is bound to spill over and affect them anyway, and they would suffer more from such a conflict than from sanctions. President Kaunda has said there is an explosion that is building up in South Africa. Sanctions can interrupt that process, but without sanctions, that explosion will affect the whole region. So they are clear that sanctions are the best way the international community can intervene on the South African situation.

35. Is not the most effective sanction you can employ the internal withdrawal of labour? I was in Soweto in 1975 when Soweto did not go to work for three days, and Johannesburg totally closed down. That is surely within your

control, and that is something you can organise within the country without the external pressure, if people feel as strongly as you suggest they do.

(MR. TAMBO.) No, we do not conceive of sanctions as a substitute for our own struggle and our own sacrifices; it is additional. So we will continue; we will certainly embark on massive strike actions; we will do all the things that we can and must do for our own freedom, but sanctions are additional, and sanctions alone would not bring about any results. We have to be involved in the two pressures from inside and from outside.

36. On a slightly different subject, could you tell us where the ANC gets most of its arms and support from, and indeed, what your relations are with the Soviet Union on the one side and the United States on the other?

(MR. TAMBO.) Well, may I say that I came out of South Africa in 1961 and the first country I came to, of course, was Britain. Next I went to the United States and sought support there. I spent the rest of the time in Western Europe seeking support for our struggle. I was asking for a boycott of South African goods and all that. In 1963 I went to the Soviet Union. The Soviet Union responded to our request for arms. It was made clear to us we would have to buy weapons if we wanted weapons in Western Europe; we could not afford that, so we went where we could get these weapons free. The Soviet Union was willing to give them to us. We do not rely on weapons only. You know, this armed struggle thing is really an extension of our political struggle, a part of our political struggle. Our struggle is a political struggle which involves violence. So there are other areas in which we can be assisted, and are being assisted. In Western Europe, virtually all the countries of Western Europe are giving us assistance (not arms). Our relationship with all these countries—the Soviet Union, Sweden, Denmark, Italy—is simply based on their support for our struggle, with what they can give by way of support, and we accept what they can give us. In no case are there any strings attached. As a liberation movement, we must go everywhere. Now we have gone to the United States, and what has happened in the United States is that we have had the people of the United States taking up our issue very, very forcibly—for instance, in the formation of the Free South Africa Movement which has challenged the policy of constructive engagement and the alliance declared between the United States administration and South Africa. So they are giving us that kind of support, which we appreciate. Again, it is without strings. It is support which we must have as a liberation movement, and we take what we are given.

37. And China?

(MR. TAMBO.) China too, yes. We have been to China as well.

CHAIRMAN: We come to the last question now.

38. I would like, Chairman, to go back to the very important question of sanctions at the present moment and to the crucial point that was put by my colleague Mr. Lester, namely, that the only effective sanction is going to be an internal sanction, and the implication of that is that external sanctions simply will not work. Can you, Mr. Tambo, give us an example where external sanctions have actually achieved their purpose? What they achieve is surely

that they make the people who impose them feel moderately better, but they do not in fact bring about their result. Is not it therefore reasonable to say that the policy being followed by Britain at the moment, and by Mrs. Thatcher, at least has the merit of being honest and realistic and practical, in the sense that it is resting on the basis that it is easier to persuade South Africa to moderate its internal policies by persuasion without sanctions, rather than arousing the increased hostility of South Africa and the resort to substitution which would be the answer to sanctions?

(MR. TAMBO.) That is part of the problem: that the whole world has been pleading with South Africa from 1946 and very intensively since the apartheid era, 1948, all over the world, from everywhere. I do not think there is a single country which has been under greater international pressure, as well as internal pressure, for change, with no change coming. This is part of the problem. It is not going to help to continue on this basis. South Africa is no longer concerned about, for instance, the denunciation of its policies. We welcome it, but we know that they have become insensitive to condemnation, it does not mean anything. They are bent on change, but on change at their own pace. We have got to force that pace. We cannot rely on asking them. They have been asked all the time by the British government. They have been asked to release Nelson Mandela, by the British government. They have not done that. They are not doing that. The only thing that has not been tried is sanctions—not seriously enough. However, they are very, very concerned now, since the positions taken by the United States, since the positions taken by the banks. In fact, the withdrawal of loans, the refusal to grant loans or to roll them over, has demonstrated that sanctions can be effective. One of the consequences of this has been that the business community in South Africa has now been moved not by appeals but by the reality of the threat of sanctions, of disinvestment, to take very firm positions against the Botha regime. That is part of it, because the business community is convinced that sanctions will hurt. That is the only reason they are concerned about it. What has happened is that sanctions have not been tried; they have been rejected on the ground that they are going to hurt us, we who are asking for sanctions. However, they have not been tried. If they were tried, the effect would be immediate.

52 *Interview with Anthony Heard*

From *Cape Times*, November 4, 1985

The ANC is officially portrayed in South Africa as a communist, terrorist-type organization, almost presented to the public as demons. Now, since the public have no access to your views, how would you answer this, particularly the charge of being a communist-controlled organization?

It is important to observe that this has been a persistent portrayal of the ANC by many people who are opposed to us. But the ANC is as ANC as it ever was. It is true that the ANC has members of the Communist party who are members of the ANC. That has been the case almost since time immemorial. The ANC was established in 1912 and the SA Communist party in 1921, and so there has been an overlapping of membership all along the line. But ANC members who are also members of the SACP make a very clear distinction between these two independent bodies. We cooperate a lot; but the ANC is accepted by the SACP as leading the struggle. There is absolute loyalty to that position. It is often suggested that the ANC is controlled by the Communist party . . . by communists. Well, I have been long enough in the ANC to know that that has never been true.

The Communist party has its positions and the ANC has its positions. The ANC is guided in its policy and all its members are loyal to the Freedom Charter, and that is where you find all the positions of the ANC. They are reflected in the Freedom Charter. We don't depart from the Freedom Charter. So, there is no problem of the ANC being controlled. Now this is also extended to control by the Soviet Union: much of this is propaganda. We go to the Soviet Union as we go to Sweden and to Holland and to Italy to ask for assistance in one form or another. And in all these countries we do get assistance, and assistance is given quite unconditionally. The Western countries, who do support us and we very much appreciate the assistance they give us, do not give us weapons, of course, because they generally do not approve and their laws do not allow it. But in the socialist countries we get the weapons, so we go there to get what we can't get elsewhere. And that's all there is in it.

Are you getting more support from the West now?

We are getting a great deal of support from the West, increasing support, in material terms, too; that support is growing.

So the charge that you are a communist organization, you would reject strongly?

We would reject that. We would say that there is a communist party. So we are fortunate because if one is looking for a communist party it is there, but the ANC is not the Communist party.

Now, the other aspect of being terrorists: Again, there is a lot of exaggeration about this terrorism. Long before we had injured a soul, when we were very, very careful in our sabotage actions to avoid hurting anybody, and that is what we have been doing for the better part of 20 years now . . . even when we started, this was called terrorism. We knew what terrorism was and we thought that the people of South Africa are being misled about what terrorism was. We could have been terrorists if we had wanted to, but we chose not to be. So even that has been an exaggeration. It is true that more recently, as for instance in May 1983 when a bomb exploded and others were attempted, this was stepping up things. It is proper to recognize that this was after 20 years at it. We started in 1961, and 20 years later you get a bomb exploding. We could have done this much, much earlier on numerous occasions. We did not want to be seen as

terrorists: We are trying to put on pressure. And we have been notoriously restrained in our armed actions—notoriously.

What future do you see for whites in the future South Africa?

The ANC, and all of us in the ANC, have always considered and accepted that whites like ourselves belong to our country. They are compatriots, fellow citizens. We took the earliest opportunity to dispel the notion that we were fighting to drive the whites out to somewhere, and we made it clear that they belong to South Africa. They had their role to play as we would like to think we had a role to play, although we are excluded. And so this has been basic. We have asked whites to join us in the struggle to get rid of the tensions that come with the apartheid system. We have hoped that we could together build the future nonracial South Africa, and by nonracial we really do mean nonracial. We mean a society in which each one feels he or she belongs together with everybody else, where the fact of race and colour is of no consequence, where people serve according to their abilities and their skills, where we together work to unite our people, and we have adopted policies which discouraged the polarization of our people either into ethnic groups or into white versus black.

And do you distinguish between any particular white group?

No, no. Our charter says that South Africa belongs to all who live in it, and we say that people who have chosen SA as their home are welcome there. There is plenty of room for them, and we should accept them as South Africans, and they in turn should accept us as South Africans. This is the kind of society that we are hoping will emerge.

Is there any reassurance or assurance that you could give whites about their physical safety, their jobs, and their home security under an ANC-led government? How would you address the question of their insecurity, which is manifest at the moment?

What we would hope our white compatriots will learn to understand is that we don't really see them as whites in the first instance. We see them as fellow South Africans in the first instance. They are as good as black. In fact, let us say, they are Africans. We see them as Africans. We are all born there in that country, or most of us are. We live on this continent. It is our country. Let's move away from these distinctions of Europeans and non-Europeans, whites and non-whites.

So, it is security for all, as it were?

It is. It is security for all, and it would be in the interests of all of us that everybody feels secure. Everyone's property is secure; everyone's home is secure. The culture is secure. We believe our cultures will begin to merge. We have got a rich variety which, when it comes together, is really going to be something we can put out to the world. So all this would be respected. There would be room for it all. But the main thing is, and the sooner we begin to grapple with this problem the better, not to proceed on the basis that the Africans are going to do something to the non-Africans, but to begin on the basis that we all belong to

that country. Let us not look at one another's colour. Let us not address that. Let us see one another merely as fellow citizens.

How do you view the business leaders, the PFP, the dominees who have been seeking talks with the ANC? How do you feel about this?

We feel very good indeed because, you see, in the fifties, when we were a legal organization, we were getting across very effectively to the white community. The ANC was getting accepted and its objectives were getting generally accepted among the whites. We were uniting the country where apartheid separated it. Now this is because we had access.

I recall Chief Albert Luthuli (the late ANC leader) going to Cape Town. And do you remember the effect he had, the impact he made? Well, when he came back to Johannesburg from that trip, there were thousands of white people at Park Station, thousands who came to meet him as a result of the impact he had made. So this is the kind of situation that had developed. Then we got banned, and this contact was broken. And now the white community has been brought up to regard the ANC as something very, very dangerous. The one effect of this visit by the business people has been to open the lines of communication because I am sure they saw us as something very different from the way we had been projected all the time, and I think they said as much.

Are you keeping in touch?

We do keep in touch. And then we next looked forward to the visit of the young people. We thought what a good thing that they should get together and begin to look at their future together. This was a very good thing. And the contribution is not one sided. It is not as if we are giving or receiving all the time. I think we are enriching one another with views about what should be done with our situation. We had hoped to see the ministers of religion who wanted to come. We thought that was another opportunity. Then, of course, the PFP came along, and we had very good exchanges with them. All this is much-needed communication, especially at this time because at some point we have got to agree on what to do about our own future.

Could you briefly set out your economic theory, particularly on questions like nationalization and wealth redistribution?

I don't know if I would call it a theory. It appears in our charter, and all we do is to interpret what the charter says. We have not attempted to depart from that in any way. We start with what the charter says, and broadly the interpretation is that the state would control some of the industries, solely with a view to ensuring an equitable distribution of the wealth that we have, and I think that this was at the back of the minds of the people who drew up the charter, and it was more than the ANC. We said our country is very wealthy, [but] our country is poverty stricken as far as the blacks are concerned, and by blacks I mean coloureds and everybody else. They are very poor. Even the whites are not really wealthy, but the wealth is contained in the hands of a few. And we

look at the country; 13 percent overcrowded by millions of landless people who are starving and dying.

What do you do about this? Where do you get the land from to give them? You have got to address that question. You have got to say how to end this poverty, how do we handle the wealth we produce in such a way that we can relieve some of these problems. The solution we saw was one of nationalization, and of course, when we meet the business people, they say that nationalization will destroy the South African economy.

Do they accept some measure of redistribution?

They seemed to. Yes, they do. They accept some measure of redistribution. It is the method, the mechanism, how to achieve it—this is of course, where we did not agree and could not agree. But they accepted, they understood, what we were trying to get at: That you cannot have a new South Africa which does not address this problem.

What about private property; how far would nationalization extend, as you see it?

It would be a mixed economy. And certainly nationalization would take into account the situation as we find it at the time—the realities of the situation in which we find ourselves. But there would be private ownership, there would be levels of private enterprise, and it would all be geared to the situation that obtains at the time. Also, we don't envisage fighting in the streets over it. We think that we will have to approach this from the point of view of what the people want. If the people want one form of distribution above another, well, it must be like that.

There would be a debate about the level of nationalization?

Yes, there would be a debate.

What sort of environment could that debate take place in? Would you see free media, free expression, freedom of newspapers?

Absolutely.

What about violence? In what circumstances would you as leader of the ANC be prepared to renounce violence and start talks? What are the circumstances that can bring that about, because I think that's what, frankly, everyone wants, on all sides; in other words, the violence, on all sides, to stop. I am sure that no one wants it to go on forever.

No, not even we. This question of violence worries many people. The unfortunate thing is that people tend to be worried about the violence that comes from the oppressed. And so the tendency is to want to know, as you want to know, on what terms would we end violence. Really, there would be no violence at all if we did not have the violence of the apartheid system. And even if there was, and there has been for two decades, it's been restrained. But if you look at what comes from the other side, during those two decades there has been massive violence. So we then have to say to ourselves: Of course we can stop our

struggle, we can stop even our violent actions, but on that basis what would be the reason for that? And in return for what?

Is there a possibility of a truce?

There is always a possibility of a truce. We see the possibility of a truce. It would be very, very easy if, for example, we started negotiations. We have said that negotiations can start, serious negotiations.

With the government?

Yes, with the government, when they are ready, because at the moment we think they are not ready. And we have said to them that if you wanted negotiations, we would not go into that without Nelson Mandela and the other political leaders and the political prisoners. Now, a serious indication of readiness for negotiations would be the release of all these leaders, because they have got to be part of the process of preparation for serious negotiations, which will not just be talks for the sake of talking. It is quite conceivable that in that situation of preparing for negotiations and looking at necessary conditions and so on, this question could arise. But we have had a problem about just saying we are now suspending our struggle, which is what it would mean.

On one side, as it were?

On one side, without any indication on the other side of their willingness to do anything about what every one of us knows is their violence. We have said: Lift the state of emergency, pull out the troops from the townships, and the police. and release the political prisoners. We have even said unban the ANC. Do all these things to create a climate.

Which you would welcome?

We would welcome a climate of that kind, and if the rest of the leaders were there, I think it would be time to get together and put the question: Can we really do anything about this? Everybody would then be there. But we are getting this persistent refusal on the part of Botha either to release Nelson Mandela and the other political prisoners, and we say: What are you going to do with treason trials . . . it is simply a form of repression. Who are you going to negotiate with if you want to negotiate? If he withdrew the treason trials and did all these things by way of lifting the pressures that rest on us, we would begin to see that the other side are ready to talk.

 But we have argued that it is not necessary for hostilities to cease before negotiations start. . . . Before the Nkomati accord, there were lengthy negotiations between the South Africans and others before there was any signing of an agreement. The agreement that was signed in Lusaka between the South Africans and the Angolans was preceded by a series of meetings and negotiations.

Is anything going on at the moment, that is, talks about talks between the ANC and the South African government?

No, nothing at all. Which is why we think that they are not ready to have any talks. They are not even ready for other people to talk to us. We are South

Africans. If we meet, we can only talk about our country. We are not going to fight about it. We talk about it, and they don't like this. But I think what they do not like is that in meeting we get to understand each other better, and we, the ANC, certainly benefit from these talks, and we would think that those we talk to also benefit. So this is moving in the direction of resolving our problems, but they are not prepared for that.

Violence against people, civilians. What is the ANCs attitude on this, bearing in mind the fact that down the years the ANC has, in my opinion, held back to a great extent on what one might call indiscriminate violence or going for soft targets?

I am glad you have put it that way, because it is often forgotten that we have been at the receiving end all the time, and we have held back. And it is not conceivable that we could go on like that indefinitely without anything changing. But one must see in this holding back the reluctance of the ANC on questions of violence. But when once, of course, we have decided we have got to fight, then we must fight.

What about soft targets?

The question of soft targets has been exaggerated out of all proportion. As I have once had occasion to observe, when the police go into a township and shoot, when they did on the 21st March, repeating Sharpeville, they were hitting soft targets, and this whole year has been a year of shootings of, really, soft targets. So people are being killed. It has never been quite like this. But they are being shot and even children are being killed . . . so when the ANC talks about soft targets, this creates an alarm, and yet the ANC is going no further than saying that we have got to intensify our struggle if we are in a struggle. If we stop, we stop. But if we are in struggle and we feel the demand of the situation is that we struggle, then we must intensify that struggle. We have held back for too long. Now, if we do intensify, we are not going to be choosing carefully to avoid hurting anybody, but we will move into military personnel, police, and so on.

But you won't go for civilians as such?

No, we will not go for civilians as such. We think that civilians will be hit as they are hit always. They were hit in Zimbabwe.

In a crossfire situation?

A crossfire situation, in any war situation.

But not cinemas and supermarkets and . . . ?

We will not go into cinemas and bars and places like that. We won't do that. But we will certainly be looking for military personnel, police and so on.

Why will you hold back, because often in a guerrilla war the limits do get more and more extended? Is it a moral feeling about killing civilians, or what?

Because we are not fighting against people, we are fighting against a system, and we can't kill people. Why? Why would we kill them? We cannot even kill whites because we are not fighting whites at all. We are fighting a system.

On foreign policy, do you see SA as a pro-Western, nonaligned, or as a Soviet socialist-leaning country? For instance, in the sale of minerals and raw materials—would these be denied to anyone? What about Commonwealth membership? Where do you see South Africa standing in the world?

First of all, nonaligned in terms of East–West, developing trade with all the countries of the world, strengthening trade links, so maintaining the lines of trade for mutual benefit.

So the Americans can be sure of getting their needs?

The Americans will be sure to get it, if they are willing to pay for it. We would want to trade with all the countries of the world, in the interests of our own economy.

We would come back to the Commonwealth because the basis for the exclusion of South Africa would have gone. And we will establish very peaceful relations with countries. We will work very closely with the rest of the African continent, and certainly with the countries of Southern Africa. We would become members of SADDC, or it might be called another name by then, and we could build together a small common market of our own. South Africa would therefore be admitted into this wider economic grouping that we have in Southern Africa. And we would be a very influential country in the world.

Do you feel this would unleash resources that we have not been able to unleash?

I am certain. I think the economy itself would be stimulated by the energies that would be unleashed, and the prospects of peace and stability. We think the country would be transformed, politically and socially and economically.

I presume you favour sanctions. Do you to the point where people lose jobs and the economy suffers seriously?

We think the economy must be put into difficulties because the economy strengthens the regime. It enables them to do all the things that they want to do. This question of losing jobs, for the victims of apartheid it is nothing. To be a victim of apartheid means to be many, many things above losing a job which you are losing all the time anyway. And the way we look at it is: The more effective the sanctions are, the less the scope and scale of conflict.

If there was a new grouping in SA white politics, with liberal Afrikaners who were formerly Nationalists and Progressive Federal party people like Slabbert forming a new bloc, would you be prepared to deal with them and on what basis?

We have met Van Zyl Slabbert, and we hope to meet various leaders of organizations. An organization that is opposed to the apartheid system we regard as on our side. I don't think that we would refuse contact with such an organization because we would see it moving in the direction that we are. We do, of course, encourage our white countrymen to mobilize and make their

contribution to changing the apartheid system and on that basis we ought to be able to find a *modus operandi* with them.

You strike me as a somewhat reluctant revolutionary. With what measure of enthusiasm did you turn to accept that there had to be violence? How did you yourself personally respond to this?

I suppose I was angry and frustrated, like we all were, and I continued to be angry and frustrated, to feel that this system must be fought. But I was a full supporter of the policy of nonviolence because we thought it would bring us the fulfilment of our objective. When that failed, then we had to look for an alternative. We found the alternative in combining political and armed actions, and it is one of those things that you have to do, as there is no alternative. I don't think I am peculiar in this respect. I think that many people in the ANC would be glad if there was no need for violence, but the need is there, and we have got to go ahead with it, bitter as it is.

It is painful to see anybody being killed, to see children being killed, no matter who kills them. The death of children is a painful thing, and you do have to say what brought us to this situation where these things are happening. We naturally feel that it is the system that has made it impossible for us to avoid what we strove to avoid with such resolve when we were first confronted with this violence. But as individuals, and certainly as an individual, I don't like violence.

You are enjoying great attention in London. To what do you ascribe this?

I think generally, in many parts of the world there is a lot of interest in what is happening in SA, and people are discussing it. And when a member of the ANC in my position is around, many people want to try and understand where we go from here. What is more, the discussion now revolves around the question of what sort of South Africa. In the past there was just denunciation of apartheid and so on, but a new interest has emerged, an interest in what takes the place of what we are seeing now and how do we move from the present to something different. This represents real movement forward for us. We have reached the point where people are expecting change and are beginning to reflect what that change involves, and this has been part of interest. People want to know, when apartheid goes (because they are sure apartheid is going), what takes its place.

To what extent is the current internal unrest in South Africa orchestrated by the ANC, and to what extent is it spontaneous?

Both words are not very applicable. There is a great deal of spontaneity in the sense that when you shoot at people they are angered and want to do something in retaliation. You would not say that the ANC is orchestrating all these responses. They are almost natural. So there is an element of spontaneity. But I would not use the word orchestrated. I would say that the ANC has called on our people, and in some cases they are very disciplined about it; in others there are excesses; the ANC has said let us destroy these structures of separation and

apartheid. That is where it starts. Now in this process other factors come in. The authorities come in and shoot, and the people respond . . . and you have a situation of escalation which can tend to conceal the true nature of the conflict as being the people resisting the implementation of the apartheid system and preventing it from working. This is the essence.

53 *Speech Delivered at Georgetown University*

January 27, 1987 (Excerpts)

We have come here today to speak about racism, to reflect on the bitter experience of our people as victims of the pernicious system of apartheid. We would also like to convey to you something of the resolve of the despised millions of our country to be victims no longer, to emancipate themselves and to free their oppressors from the burdens that all who practice injustice impose upon themselves. It is our hope that in the difficult days ahead, you will stand with us, lending your intellectual excellence to the accomplishment of these objectives, and that using the power you derive from the discovery of the truth about racism in South Africa, you will help us to remake our part of the world into a corner of the globe of which all humanity can be proud.

One of the ideas that has inspired many of us in my generation of black South Africans is that race should cease to be a category that governs relations between and among peoples. Scientific enquiry and social experience have combined to bury the primitive notions that skin pigmentation was a factor which affects the intellectual capacity of individuals and an element that determines people's natural place in society. One hopes that never again will science prostitute itself to serve the ignoble purposes of those who have, in the past, argued in favor of false theses about the natural superiority of white over black people, of so-called Aryans over non-Aryans, of one race over another.

South Africa is in the grip of a life-and-death conflict to bring to an end a social order based on exactly these notions. In action, the majority of the people are saying that our country should no longer be home to the brutalizing practice of white minority domination. Our struggle seeks to end one of the truly unspeakable crimes of our time, to dismantle a social system whose demise is long overdue.

In our country, racism is more than an expression of prejudice and the practice of discrimination. It is based on the definition of the black people as subhuman, a specific creature of the animal world available for use by those who are described as truly human and to be disposed of as befits the desires and the perceived interests of these superbeings. Apartheid is therefore inherently an act of violence. Its practice is necessarily tyrannical. The perpetuation

of its relations of domination and, therefore the system itself, demands the use of repressive force.

In practice, what we are talking about is a system of virtually genocidal violence. The entire life of a whole people consists of a desperate struggle to survive a degree and extent of the daily use of violence that constitutes a truly repulsive obscenity. We speak here not only of the horrendous slaughter of those who are fighting for liberation, as you have seen from reports carried by the mass media.

We refer also to the violence perpetrated against millions of people through such apartheid policies as the bantustan system, forced removals, and the imposition of a system of education designed to prepare the black youth for a life of subservience. We are talking of the deliberate impoverishment of the majority which has resulted in millions of children dying from sheer starvation. Those who survive are condemned to become deformed adults solely because of deliberately imposed malnutrition. And as you know, when the young rebel against these genocidal policies, they are shot down like flies, imprisoned in the thousands, as is the case today, and sent to special brainwashing camps to be transformed into mindless agents of the apartheid army and police.

This violence has also become a permanent fact of life for the rest of the peoples of the region of southern Africa. There is, for instance, the untold story of the atrocities carried out by the Pretoria regime against the people of Namibia, both inside their country and in their refugee settlements in Angola. Angola itself has suffered immense losses in numbers of people killed and property destroyed, thanks to the predatory war carried out by the South African militarists and their surrogates, the so-called UNITA of Jonas Savimbi. The people of Mozambique are suffering from a similar catastrophe, with tens of thousands killed and the economy reduced to a shambles as a result of the hostile actions of the Pretoria regime and its surrogate MNR bandit force. The other countries of southern Africa are also prey to the violence of the apartheid system.

Recently, the horror of this violence has been illustrated in a dramatic fashion by the death on South African territory of former Mozambique president, Samora Machel. We remain convinced that Pretoria is responsible for this tragedy. We are also certain that directly or indirectly, this regime assassinated the former cabinet ministers of Lesotho, Vincent Makhele and Desmond Sixishe, as well as their wives.

All this, and much more, constitutes an expression of the system of apartheid, a manifestation of its true nature, a condition for its existence as well as its survival. In short, apartheid is violence.

Consequently, to end violence in our country and in southern Africa as a whole means one thing, and one thing only. The apartheid system has to be liquidated. It must be ended in its entirety. Correctly categorized by the international community as a crime against humanity, no part of this system can and shoud be left intact. A crime cannot be reformed or amended. It either is or is not. It cannot be made tolerable by changes to any of the elements that make up its totality.

We therefore take issue with those who argue that to end violence in South Africa, the ANC must abandon armed struggle. We say so precisely because this would neither alter the nature of the apartheid system nor serve as moral pressure on the Pretoria regime, inducing it to abandon this system.

We speak in this manner on the basis of our own experience. For almost fifty years after its foundation in 1912, the ANC adhered strictly to a policy of nonviolence. For thirteen years after the present ruling group took power, we continued with this policy in the face of the escalating violence that it imposed on our country. As our nonviolent struggle mounted, so did the violence against us increase. The more vigorously we campaigned peacefully for a democratic and nonracial South Africa, the more fervently did the regime work to expand and entrench the violent apartheid system.

Let it not be forgotten that those who were shot down at Sharpeville in 1960 were peaceful protestors without so much as a stone in their hands. Neither should the fact be ignored than when the ANC was declared an illegal organization in the same year, it was committed to a policy of nonviolent struggle. Again in 1976, unarmed schoolchildren were mown down in their hundreds in the infamous Soweto massacre. Since 1960, when the ANC was banned, other organizations have been proscribed. All of these were, without exception, engaged in nonviolent struggle. Today, tens of thousands of our people are in prison, detained despite the fact that they too were involved in unarmed struggle.

The fact of the matter is that all resistance in South Africa is, according to the apartheid statutes, an illegal act. There is no constitutional provision that guarantees us the inalienable right to organize the most peaceful of demonstrations. Excluded as we are from all political processes, except as administrators of the apartheid system, we have no constitutional power to change this brutal reality. How then is it expected that we can use constitutional means when the law specifically provides that we should have no access to such means?

Apartheid has decreed that any resistance can only be outside the parameters of the law. Through its practice, it imposed on us the obligation to choose whether we accept this challenge or we submit and surrender. We chose not to submit but to fight back, arms in hand. We believe that anybody else faced with this situation would have taken the same path, the way forward that your forebears took when they fought for the independence of the United States of America.

Despite the fact that we too had to make this hard choice, as your founding fathers did, we have not become slaves to the idea of violence. In the past, we resisted the efforts of the apartheid regime to draw us into an armed conflict. We resisted because we view all wars as a matter of ultimate and last resort. We are as opposed now to the killing of people, whether black or white, as we were then. Our political outlook and perspectives demand that we protect and reaffirm life. As its opponents, we cannot borrow the practices and the ethics, if that is the right word, of the apartheid regime, which has to kill daily in order to maintain a system of racial tyranny. Anybody with the slightest knowledge of our history will know how hard we have tried to reduce the level of

bloodshed. We remain committed to that position. In the meantime, we have no alternative but to intensify our armed resistance because, as your Declaration of Independence says, in the face of systematic tyranny it becomes the duty and right of the people to take up arms.

We should here make the observation that those who are opposed to democratic rule inevitably develop a cult of violence. They try to imbue the use of force against the people with an aura they hope would justify and legitimate the use of terror. To the Nazis, the best among themselves were those who thrived on the act of murder. The best products of the apartheid system are, to the architects of this system, those who have come to view every massacre they carry out as the highest contribution they can make to humanity. Surely it can never be that we who struggle for a system of government by consent of the governed should ourselves make a fetish of violence and transform the use of armed force into a matter of principle. To seek a democratic society is to reject the use of violence as a means of ordering relations among people.

We seek to create a united, democratic, and nonracial society. We have a vision of a South Africa in which black and white shall live and work together as equals in conditions of peace and prosperity. To this end, we repeat that we are ready to seize any opportunity that may arise to negotiate, with the aim of creating such a society. We are speaking from the position of the oppressed, who have a painful awareness of the meaning of domination and dictatorship. And yet we say it would help our people enormously if none among the political forces in our country sought to dictate terms. To do so is to seek surrender and therefore to perpetuate conflict.

The Pretoria regime seeks to do exactly this. It refuses to accept the idea that South Africa should become a united, democratic, and nonracial country. It rejects the idea that there can be a legitimate political entity that represents this perspective. Rather, the Botha regime believes that it alone must set the parameters for any discussion. It must decide what are permissible political views and accordingly issue licences determining who can participate in the political process.

The racist regime denounces as communist those political views and organizations which fall outside the boundaries it wishes to set. By this means, it hopes to persuade the Western world to act against us and to come to its assistance. It also seeks to justify the persecution of the democratic movement of our country—the murder, torture, and imprisonment of its opponents. Despite the false charges it has laid against us, the Pretoria regime knows full well what the ANC stands for.

It knows that we want to see a political system in which all South Africans will have the right to vote and to be voted to any elective position without reference to color, race, sex, or creed. We are committed to the birth of a society in which all democratic freedoms would be guaranteed, including those of association, of speech and religion, the press, and so on. We wish to guarantee the rule of law and ensure the protection of the rights of the individual as a fundamental feature of any new constitutional arrangement.

At the same time, we are convinced that the new democratic order will have to address such other burning questions as freedom from hunger, disease, ignorance, homelessness, and poverty. For this to be translated into reality will demand that we address seriously the question of increased production and equitable distribution of wealth. In a situation in which virtually all wealth in our country is in the hands of the white minority, we must necessarily find ways and means to redress this gross imbalance to create the situation in which it is possible radically to improve the standard of living of the millions of our people. As we see it, this situation will require that we have a mixed economy, having both a state and a private sector.

These are some of our perspectives which the Pretoria regime categorizes as communist. In its view, for us to be noncommunist, we must accept the apartheid practice of defining our people as separate racial and ethnic entities which must then "share power" as groups. We must also accept as sacrosanct the distribution of the land such that as the situation obtains today, 87 percent belongs by law to the whites who constitute less than 20 percent of our population. Of course, we shall never agree to any of this but will remain committed to the objective of a truly democratic South Africa.

We consider it a matter of some concern that the falsifications peddled by the Pretoria regime about the political nature and purposes of the ANC seem to find ready acceptance among some circles in this country. We have never hidden these and are puzzled that there are people today who ascribe to us a secret agenda. We have none, and even the law courts of apartheid South Africa, despite all manner of supposed evidence presented by the secret police, have repeatedly failed to discover any such agenda.

We cannot seek to establish and build relations with the people of this country on the basis that you accept our experience as the sole and authentic basis on which you should organize yourselves and order your lives. We believe that it contributes nothing to the resolution of the South African problem for you in this country to insist that we must remake ourselves in your image. We fight for democracy because that is what our people need. We work to unite all our people around this objective because that is what our situation demands. You, too, entered into your own alliances against Nazi Germany because that was a requirement of victory. What we wish of this country, as of the rest of the world, is that we act together to achieve the common objective of bringing into being a democratic South Africa.

We believe that our common action should proceed from the starting point that we both seek to end the apartheid system in the shortest time possible and with the minimum cost in terms of loss of human lives and destruction of property. Practically, this means that we must intensify both the internal and the international offensive against apartheid.

The reality is that the pressure exerted against Pretoria is as yet insufficient. We are convinced that the international community has to impose comprehensive sanctions to reduce the bloodshed and to raise the cost of maintaining the apartheid system to a level that is unacceptable even to those who benefit from this system.

We have been greatly inspired by the sanctions imposed by the U.S. Congress. We take this opportunity to convey our appreciation to both the Democratic and Republican parties and to the American people as a whole. A good start has been made, but more remains to be done. Of especial importance is the need to ensure that no opening is given to the Botha regime to adjust to the present set of selective sanctions and thus convince itself and its followers that sanctions do not work.

The American people have given the people of Africa hope by their activity over the past two years. First, they have come down on the right side of history by moving Congress not only to pass sanctions against apartheid South Africa but also to override President Reagan's veto. Secondly, they have helped to save millions of lives by the humanitarian aid given during the great drought in Africa. Now the American people can move to save hundreds of thousands more lives by acting to help bring about the dismantling of apartheid and the establishment of a nonracial and democratic society in South Africa.

We are also convinced that the time has come that the U.S. administration reviews its policy with regard to southern Africa as a whole. This country has the possibility to make an important contribution to the resolution of the problems afflicting our region. That, however, requires that among other things, these problems should be dealt with on their merits and not viewed through the distorting prism of the East–West conflict. We, for our part, are ready to deal with the U.S. government honestly and openly for the sake of the cause of justice in our country and peace in southern Africa.

The battle that is raging in South Africa aims to rid humanity of the apartheid system which is a cancerous growth on the world body politic. Our people are conscious of their duty both to themselves and the rest of the world. We shall live up to that responsibility and expand the frontiers of democracy to our country as well. To carry out this task which faces all humankind, we count on your support. We are certain you will not fail us.

Thank you.

54 *Strategic Options for International Companies*

Excerpted from Address to the Business
International Conference, May 27, 1987

We are encouraged that the business community within as well as outside our country, and governments, have begun to rethink their positions in relation to the South African struggle. And we believe that the dialogue arising from this process will positively reflect upon our struggle and the future of our country, as well as upon the entire southern African region. Encouraging as

these tendencies are, they are as yet wholly inadequate. Today no one dares defend apartheid. But statements of rejection and condemnation are not enough.

Within South Africa the business community persists in believing that reform is a realistic path to change. Their programmes of reform, however boldly they have begun to challenge the credos of apartheid, shy away from the fundamental political demand of the black people, namely, one person, one vote.

Internationally, business executives and bankers are becoming less confident of the status quo in South Africa that they have been defending and more reluctant to invest any more. If one may be permitted to characterize the present stage of rethinking, the tendency is one of beginning to hedge your bets rather than to change sides.

Disinvestment and economic sanctions have emerged as an unmistakable tendency. As the crisis deepens and the struggle in South Africa intensifies, this tendency will grow. The majority of the people throughout the world, and in particular the Western world, recognize that apartheid is a crime against humanity and that investment, trade, technology transfer, and military collaboration with the Pretoria regime are indefensible. In the meantime, the escalating struggle inside South Africa, combined with a stagnant economy moving towards bankruptcy, necessarily increases the risk to investments and inexorably whittles away the profit ratios that have hitherto made collaboration with Pretoria and investment in the apartheid economy such an attractive proposition.

Many companies and some banks have in the recent period begun to disinvest. And many governments have imposed limited and selective sanctions. Whilst the tendency is encouraging, it is also true that the process is much of a mixed bag. Essential to the support that we are seeking is not only a stoppage of the flow of funds into the apartheid economy but an effective withdrawal of funds from that economy. Secondly, we insist that the flow of technology into the apartheid economy be arrested and frozen. Whilst some of the pullouts are clearly genuine, most are highly problematic and it is understandable that we should look at these with a high degree of suspicion. While some of the creditor banks claim that the three-year rescheduling agreement was unilaterally forced on them, some of them are actively considering converting their short-term loans to longer-term claims that will be repaid in ten years, thereby diluting the pressure potential that had been built up by the initial refusal to reschedule. Some companies have gone so far as to transfer money into South Africa and arranged for purchasers to repay out of future profits on extremely favourable terms! Is this not a case of business as usual, except in name? Perhaps this is more a case that illustrates the capacity of those in business to acknowledge backhandedly the growing power of the campaign for disinvestment and sanctions.

It is difficult for us to accept the argument of business both inside and outside the country that it is politically impotent. Business has chosen until

now to align itself with and benefit from the economic and military state that is part of the apartheid system. Let us for a moment pause to look at the ways in which business is enmeshed in the repressive machinery of the state by legislation and practice.

All companies in South Africa, including multinationals and subsidiaries of foreign concerns, are integrated into Pretoria's strategic planning and directly into the repressive machinery. This is done institutionally by their participation on committees and boards, by complying with legislation, and by financial and other support.

In addition to taxes and purchase of defence bonds, most companies top-up the salaries of their white employees while they are doing their national service in the South African Defence Force. No law requires them to do so. It would appear that only a few small companies have desisted from engaging in this practice. From a study of the national service pay scales, it is clear that business enterprises are directly and voluntarily subsidizing the South African Defence Force. This practice means that some of the SADF soldiers occupying the townships and Namibia and engaged in aggressive military actions, particularly against Angola, are being paid in part by the companies that employ them in civilian life. Though there is widespread concern about the role that the South African Defence Force is playing in the black townships and against internal so-called unrest, it would seem that business prefers to rationalize its direct subsidizing of the SADF on the grounds that it also has to take into account the so-called needs of employees who are performing national service!

Representatives of 21 employers' organizations sit on the Defence Manpower Liaison Committee, which succeeded the Defence Advisory Council in 1982. The 1982 Defence White Paper states that this committee "meets regularly and consists of the chief of staff personnel, the chiefs of staff personnel of the four arms of the service and representatives of 21 employer organizations, and its aim is to promote communication and mutual understanding between the SADF and commerce and industry with regard to a common source of manpower." The Defence Manpower Liaison Committee is reproduced at the regional levels, and it has been easy to establish that the regional committees deal with a variety of issues, including intelligence briefings aimed at placing, and I quote, "controversial subjects into the correct perspective."

In addition to the Defence Manpower Liaison Committee, business leaders also sit on the various key policymaking bodies of the country—all of which place many of them at the heart of the South African military–industrial complex, both profiting from it and indebted to it. In terms of the National Procurement Act there are ministerial powers to compel any company to supply, manufacture, and process goods. In most cases the minister does not have to use his powers. Their mere existence has been sufficient for companies to supply whatever is requested, be it vehicles, tents, or oil for the SADF.

Hundreds of installations and areas have been designated national key-

points under the National Keypoints Act. Owners of these factories or plants are required to train and equip their own militia. Usually, but not always, made up of white employees, these are trained in "counterinsurgency and riot control." The companies have to provide access for SADF units to their premises and to incorporate their own militia in regional so-called defence planning. They also have to provide storage facilities for arms. In terms of this act the whole process is kept secret, and there are severe penalties for even disclosing that a given plant, mine, or installation has been designated a keypoint.

Some multinationals initially protested about having to bear the costs, but there is no evidence that any have refused to comply. In fact, there is reason to believe that the overwhelming majority of identified keypoints were cooperating fully with the Pretoria regime. It cannot be denied that international companies are cooperating with the South African military establishment not only in instances where they are required to do so by law. As the case of the topping up of salaries of employees who are doing national service shows, their cooperation is extensive and indefensible, particularly before their black labour force which is so grossly exploited.

We have taken some time to dwell on these aspects because we believe that statements rejecting apartheid must be accompanied by concrete action which visibly breaks the intimacy that characterizes the relationship between international business and the apartheid state and economy. The cooperation that exists in relation to the repressive machinery of the state tends to be ignored by those who justify their refusal to disinvest on the grounds that by their presence they are helping to bring about change in the interests of the black man.

With apartheid universally condemned and disinvestment and sanctions vigorously resisted, international business has turned to justify its presence by promising to provide so-called neutral support in the form of black education, housing, and welfare. It is strange indeed that support for the cause of the black man has to be neutral while support for the apartheid system is as positive as emerges in the connection to be found in relation to the repressive machinery of the state. In any event, the issue is not simply about black education, housing, or welfare, notwithstanding that these are grossly neglected by the apartheid state. The point is that such neutral support will always be compromised by the apartheid system. In fact, such neutral support will further enmesh international business in the apartheid system.

If the preponderance of evidence points to the fact that hitherto corporations have undermined their own future by assuming political impotence, today it has become far more urgent that they define their political alignment. This, necessarily, means that corporations have to distance themselves from and resist the short-term pressures that lock them into Pretoria's embrace. It is our firm view that the true interests of the business community lie not in continuing to identify with a system doomed to disappear but in relating to the forces for change which are destined to take charge of the socioeconomic life of a nonracial, democratic South Africa.

55 *Address to the People's National Party of Jamaica*

Excerpted from the Founder's Day
Banquet Address, July 4, 1987

Our presence in Jamaica also gives us an opportunity to make our acquaintance with and to salute such national heroes as Nanny, Tacky, Sam Sharpe, Paul Bogle, Marcus Garvey, Alexander Bustamante, and, of course, Norman Manley. We make this tribute not to satisfy any formal requirements of protocol but because we truly feel that these outstanding fighters belong to us as well. They are of that detachment of men and women whose example reaches beyond national boundaries and crosses the vast oceans to inspire all who are oppressed, to give hope and encouragement to those who are struggling.

And what is it that specifically ties them to us, Comrade President? It is the vision that instructed their lives, that the voiceless can and must have a voice; that the downtrodden and the despised should have an unfettered right to shape their lives; that none has a prerogative to set himself up as a god presiding over the destinies of others. These national heroes of Jamaica are tied to us because from these shores thousands of miles from our own, they stood up and even perished, to assert our own entitlement to a democratic future.

Comrades and Friends, a strange contradiction besets the world of international politics. Those who strut the globe posing as the champions of democracy entertain the greatest dread of a truly democratic universe. Those who it is claimed are developing and, still but mere toddlers because they do not have a century or more of experience of democratic practice, have become the standard-bearers of the same democratic practice of which they are supposed to know so little and to despise.

As you know, the situation in our country is not dissimilar from what obtained in Jamaica 120 years ago. At that time, this country's Parliament, the Constituent Assembly, was elected by about 1,790 voters out of a population of over 440,000! And, as in South Africa today, those who had the exclusive right to vote and could be elected to positions of power were the white minority.

In South Africa, this criminal charade still parades itself as democracy. It claims a place for itself within that cauldron of history, values, and experiences which is sometimes described as Western civilisation. The apartheid system in South Africa is perhaps correct so to describe itself, because it represents the perpetuation of the system of colonial domination under which you and all oppressed peoples in other parts of the world suffered for so long.

It is the direct successor and inheritor of elements of the age of slavery which brought so many of our ancestors to Jamaica. Apartheid is also a particularly pernicious expression of the brutalities of the practice of the exploitation of man by man, of social systems whose motor of development is

fired by the objective of the enrichment of the few at the expense of the majority.

All these, Comrade President, are very much part of what is proudly called Western civilisation—slavery, white minority rule, colonial domination, and the superexploitation of the oppressed. It is firmly within this historical experience that the apartheid system belongs. It is itself bathed in the blood of the oppressed no less than its Jamaican counterpart in Western civilisation was covered with the blood of those that fell during the early slave rebellions, the Maroon Wars, the 1831 Emancipation uprising led by Sam Sharpe, the Morant Bay Rebellion, and the Workers' Rebellion of 1938.

If the apartheid regime is right to assert that its ancestry derives from the system of imperialist and colonial domination and from slavery and feudalism, we on the other hand have a right and a duty to claim as our progenitors all those who have risen against oppression, domination, and reaction. These too are very much part of all civilisation, including that which describes itself as Western.

We refer here as much to the French and American revolutions as to the historic revolution which liberated Haiti at the beginning of the last century. We are talking of the struggles led by such outstanding figures as Sam Sharpe, Paul Bogle, José Marti, and Simon Bolivar. These, no less than the revolutions which liberated Cuba and Nicaragua from the Batista and the Somoza dictatorships, respectively, are part of the human process by which injustice is abolished and more equitable social systems brought into being.

The contradiction to which we referred earlier arises from the fact that those who claim to represent democracy in world politics are intent to define democracy in a manner that serves the interests of the high and mighty, in a way that promotes the cause of a new oligarchy. To achieve this objective, the representatives, theoreticians, and publicists of this new oligarchy will stop at nothing, including the denial of their own history.

Contrary to these, we uphold it as an undeniable historical truth that so-called Western democracy owes everything that is progressive within it to revolution. And more, it owes many of its claimed achievements these 200 years to the actions of the oppressed and the enslaved who fought and sacrificed in order to defend and maintain democratic principles and to expand the horizons of humankind.

It is true that the abolition of slavery was enacted by a British Parliament, but it was the refusal of many thousands to acquiesce in their own slavery that created the imperative for the legislation. It is a distortion of the truth to speak of Britain, France, Spain, or Portugal "granting" independence to this or that colony. Independence was achieved because the colonised struggled and made colonial rule untenable, and even where there were no formal wars of liberation, many died in the process.

The descendants of those who brought into being the Magna Carta, those who rallied to the cry of "Liberté, Egalité, Fraternité," and those who signed the Declaration of Independence today demand recognition of the fact that they were prepared to die in order to fight fascism, to defend peoples against

foreign occupation and destroy the scourge of Nazi racism. Yet we should not forget that they were not alone in that war. In addition to the millions in the socialist countries who died, many hundreds of thousands of young black people from the Caribbean, Africa, and Asia also sacrificed their lives for these objectives.

Nor when these events are cited in support of the West's democratic credentials, can we fail to note that freedoms have been defended and racism challenged on a very selective basis. These same descendants have not hesitated to deny freedom to others, to occupy their countries and to condone and give active support to racists when it suited their purpose. Wars have been fought by the Western powers to maintain colonial rule and in support of dictators and undemocratic governments.

In our own time, in this region, and in southern Africa, we see this contradiction being spelt out. The government of the United States, which holds in trust the freedoms and independence its citizens fought for in their War of Independence and the Anti-Fascist War, now uses its political and economic power to try and maintain this area in neocolonial subjugation, and miles across the Atlantic in southern Africa, it attempts to do the same.

It is not coincidental that the profits extorted from the sale of arms to Iran, are now revealed as having gone to those intent on overthrowing legitimate, popular, and sovereign governments in Managua as well as in Luanda—governments that hold in trust for their peoples the freedom and independence they were forced to fight for at great sacrifice.

The Reagan administration has supported the UNITA bandits both covertly and with public funding and the supply of sophisticated arms. It condones and encourages South African aggression and the continued occupation of parts of Angola and all of Namibia. The responsibility for having prevented the Namibian people from achieving their independence must be laid firmly at Washington's door. The U.S. government has intervened, not to secure South African compliance with UN Resolution 435, but to support Pretoria's intransigence by offering a totally unrelated linkage with the presence of Cuban troops who are assisting the Angolan government to defend the country against South African aggression.

Pretoria's illegal actions; its state terrorism in the region; the attacks on neighbouring states; the murder of Zambians, Zimbabweans, Swazis, Batswana, and Mozambicans; its open warfare against the black people; the trade unions and other democratic organisations of our country; and the military occupation of our townships receive no more than the formality of a mild rebuke. For here, as in the Caribbean, Western policy is less concerned with promoting democracy, removing alien occupation, or destroying racism than with a profitable return on the investments of multinationals and with a crusade against communists perceived or imagined.

For years, nay, for nigh on three decades, we have been told to be patient by Western governments who claim to have perceived signs of the regime's intention to end apartheid. We have been urged to abandon our armed struggle and to seek a negotiated settlement.

There is no logic in the expectation that the apartheid regime will destroy itself. The recent white elections and the events thereafter confirm our long-held view, and that of the Commonwealth Eminent Persons' Group, that Botha is interested neither in negotiations nor in ending apartheid. Rather, he seeks to engage black nominees, so-called moderate African leaders, in the process of working out the best structures and mechanisms to attain his objective of involving Blacks in the joint administration of white domination. That's what he means by reform.

For us, negotiations are not, and can never be, an end in themselves. They must be based on the recognition by both parties of a common objective, namely, the establishment of a nonracial, democratic, united South Africa—a society based on the very principles so often proclaimed but not practiced by the Western powers.

Should not all those concerned with democratic solutions address themselves to the regime that denies their validity in what it describes as a unique South African situation? If the stated preference for a negotiated solution is to be taken as more than a pious platitude, where are the measures which will create a situation in which the regime will be compelled to negotiate?

Now that the continued links with Pretoria, the influence that friendship with the regime was supposed to buy, and Western diplomatic persuasion have all proved to no avail, should not these governments learn from experience? Is it not overdue—long overdue—that they cease shielding the Botha regime from international action? Is it not time that they address Pretoria now in the only language that is likely to be effective? Is it too much to hope, even at this late stage, that when the U.S. Congress reexamines its sanctions legislation, when the Commonwealth summit once more considers apartheid in South Africa and the protection of Commonwealth and other countries in Southern Africa from Pretoria's aggression, and when the Security Council addresses itself to the questions of Namibia and South Africa—is it too much to hope that the voices from the White House, from Downing Street, the Elysée Palace, and the Bonn Chancellory will join the overwhelming majority of the international community and impose comprehensive mandatory sanctions against the apartheid regime?

Perhaps it is—but we are not deterred. Norman Washington Manley's perceptive observation that "men stand strongest when their own master" explains the resolution of the oppressed, the resilience of their struggle, and confirms the certainty that regardless of the odds we will triumph.

Now it is time to address a final word to the people of Jamaica in recognition of their role in keeping alive and advancing not only the visions of Marcus Garvey and Norman Manley but also the great tradition of struggle they represent. Every freedom fighter is a warrior in any and every struggle for liberation and justice. You are soldiers of all mankind and for the freedom of all people. Thus like those who have gone before you, like those who will follow in your footsteps, like the very destiny of Jamaica, you are inexorably linked to the struggle of the South African people against apartheid and for freedom, nonracialism, unity, and democracy. You are warriors in the struggle

for a new international order: a struggle in which the oppressed, the economically exploited and deprived, will cooperate and fight together for a free, prosperous, and peaceful future for us all. Like Comrade President Michael Manley and his distinguished predecessors, you have a special place in the heart of our struggle as well as in all other just struggles.

Never forget that we all have a rendezvous with history. Remember that even as slavery, colonialism, racism, apartheid, and imperialism imposed artificial divisions between the peoples of South Africa, Jamaica, and all other fighting peoples the world over, we must overcome these divisions. The struggle has entered a most difficult phase—but we must stand firm. We must struggle hand in hand so that when we triumph, we shall be reunited in freedom. That is the "promised land" for which we must fight. When that vision is realised, we shall have finally arrived—then our mission will have been accomplished.

The Morant Bay massacre and the Soweto massacre as well as every other massacre of the oppressed people any and everywhere will finally be laid to rest and all the people shall take their rightful place as citizens of this earth. Then we shall pay full tribute to Marcus Garvey, Norman Manley, and to John Gumede, Pixley Ka I Seme, Albert Lutuli, Gamal Abdel Nasser, Sojourner Truth, Ida Weekes, Kwame Nkrumah, Wilmont Blyden, W. B. DuBois, Paul Robeson, Amilcar Cabral, Agostinho Neto, Samora Machel, Antonio Maceo, Camillo Cienfuegos, Lilian Ngoyi, Antonio Mella, Augusto Sandino, Maurice Bishop, Henry Winston and all other stalwarts in the struggle for human freedom.

Once again, thank you to my brother, Comrade President Michael Manley, to the entire leadership of the PNP and to the people of Jamaica.

The struggle continues! Forward to people's power!

56 *Address to the Congress of the Socialist International, June 20, 1989*

Excerpted from *Sechaba*, August 1989

On what basis can we take seriously the statements by de Klerk, as he aspires to the presidency, that the National party has recognised that the time has come for apartheid to go? Have we not heard this before? P. W. Botha promised "power-sharing," and now he is going out having orchestrated authoritarianism; B. J. Vorster, before him, once asked for six months to remove apartheid, and he went to his grave having reinforced the system. Now de Klerk says apartheid will go and in the same breath assures his supporters that one person, one vote is not acceptable and that "group rights" are not negotiable.

Fundamental Issues Remain

Yet we have been surprised to find that the general election in September, in which of course no African will be allowed to vote, is being perceived in some quarters as a historical turning point for our country. In the face of Pretoria's propaganda offensive promoting the regime as the agent of imminent change, it is appropriate to remind ourselves of what the issues are in South Africa.

In his last major speech on Southern Africa, before the People's Parliament Against Apartheid, held in Stockholm, the late Olaf Palme remarked that the Pretoria regime, faced with an avalanche of opposition and resistance at home and abroad, resorts to a window-dressing exercise couched in terms such as "reforms."

"The truth," he said, "is that apartheid in South Africa cannot be reformed as the regime is trying to assert in its advertising campaigns. A system like apartheid cannot be reformed, it can only be abolished."

These words ring true to this day and stand as an injunction to all those who feel that they have a role to play in the transformation of the system in South Africa.

Our Aim Is Full Equality

The struggle of the people of South Africa is not directed towards amending the apartheid system but at destroying it. Liberation must entail a shift in power relations such that all South Africans can engage in the political process on the basis of full equality and collectively shape society, establish the institutions of government, and adjudicate on how the resources of our country and the product of our labour should be used for the common good.

The bantustanisation and fragmentation of our country and the division of our people can only be brought to an end in a united South Africa. Our commitment to a nonracial society cannot encompass any division by law of the South African people along lines of race or ethnicity, nor the exercise of political rights through separate institutions of government defined in similar terms. The rights of all South African citizens can and will be guaranteed in a bill of rights.

Our democratic system must provide for the equal participation of all South Africans in decision making. There can be no doubt that the franchise at all levels must be for common political institutions on the basis of one person, one vote, one constituency.

These demands of the South African people are no different from, or more than, what is universally understood as democracy. There can be no justification for any suggestion that as South Africans we are entitled to less.

The reforms that have been promoted by the Pretoria regime are not a translation into policy of these aspirations of the majority. The changes that have been made do not arise from any desire to dismantle apartheid but are an expression of the ideas of the ruling group acting in the interests of the white minority in order to deflect domestic and international pressure.

Central to all the reforms made and proposed is the concept of group rights. We reject both the concept and the premise upon which it is based, namely, that South African society is composed of mutually incompatible peoples, whose survival and freedom is dependent on political and geographic segregation.

Our People Reject "Reforms"

Experience has shown that democracy can only flourish when rights and obligations are vested equally in all citizens. These rights are negated when their exercise is linked to membership of racial or ethnic groups, for thereby the rights of all citizens are diminished. The concept of group rights, which provides a minority with a veto over the wishes of the majority, carries with it the seeds of continued division and conflict, and hence cannot provide lasting peace or security for either the minority or the majority, whereas a nonracial and democratic system provides a basis for building an enduring security for all South Africans.

There is thus a clear and fundamental divide between the demands and aspirations of the oppressed majority and the reforms put forward by Pretoria.

By their very nature, the changes we seek can only be brought about through the struggle of the oppressed. The steadfast refusal of the majority of South Africans to be coopted into the reform process; the continued resistance notwithstanding ever greater restrictions, detentions, and violent repression; the courage and willingness to sacrifice life itself; all testify to the determination to continue to struggle until our objectives have been achieved.

All the evidence indicates that as yet Pretoria's interest is limited to seeking the involvement of black agents in the implementation of apartheid and thereby prepetuating white domination. The regime has singularly failed to take even the preliminary steps that would begin to indicate that it is seriously contemplating negotiations directed at dismantling apartheid.

No Climate for Negotiations

There can be no climate for negotiations in a state of emergency or when the people's leaders remain in prison and their national organisations are banned or severely restricted. There is no genuine commitment to negotiate a solution where no freedom of expression, opinion, or organisation is permitted and where even to peacefully seek fundamental change outside of parameters set by Pretoria is held to be treason.

Negotiations are not an end in themselves; they can be a means to the realisation of our objectives, but they must involve the genuine representatives of the South African people and can succeed only when it is possible for all parties to enter into discussions on the basis of equality and with agreement on the objectives to be achieved.

The ANC has over decades expressed its preference for a resolution of our country's problems through these means, but our repeated calls have always been shunned.

There can be no viable political settlement that falls outside these parameters, for any agreement would not meet the demands of the people, and the "solutions" would be transitory and an even more bitter conflict ensue.

Pretoria persists in its refusal to dismantle apartheid and countenance the establishment of a nonracial democracy in a united South Africa. Experience has shown, however, that every policy shift or even "reform," and the divisions among the ruling whites, have come about as a consequence of domestic and international pressures. We therefore call upon the international community to apply effective pressures and to deny the regime the political, financial, and material resources to continue to implement apartheid and maintain itself in power. Quite simply, what the situation demands is an intensification of the struggle inside South Africa, as well as the imposition of comprehensive and mandatory sanctions.

57 *Welcome Back, Comrades!*

Excerpted from Statement to Soweto Rally,
October 29, 1989, in *Sechaba*, December 1989

This is a joyful day for all of us. It is a day of celebration for all the people of our country. Those who have chosen to turn their backs on our festivity are the small minority who continue to cling to the antihuman concept and practices of racial arrogance, white minority domination, and the superexploitation of the masses of our people. Yet they, too, are part of our heritage. They are part of that history and continuing reality of our country which has meant and means the imprisonment of the best representatives of our people for a quarter of a century and more; the murder of thousands by the apartheid army and police and their secret murder squad; the detention of tens of thousands under the state of emergency, including the very young who ought to be free as the wind to enjoy the pleasures of childhood; the millions who have suffered from the daily violence inherent in the apartheid system.

Our continuing obligation to uproot and obliterate the apartheid system contains within it the responsibility to release these slaves of the criminal ideology of white supremacy from the kraals of infamy in which they have incarcerated themselves. In the end, they too must learn to celebrate freedom not oppression, life not death, our common humanity not separation and definition of people according to racial and ethnic groups. But as of now we meet without these sorry souls to celebrate a victory that truly belongs to all the

people of our country as well as the countless millions throughout the world who are engaged in struggle to help us end the apartheid system and transform South Africa into a united, democratic and nonracial country.

Comrades Walter, Govan, Kathy, Raymond, Elias, Andrew, Wilton, and Oscar, welcome to you all. Welcome back to the foremost ranks of the mass army that is engaged in an heroic struggle to deliver our country and our people out of the long night of apartheid tyranny. Welcome back to active service within the collective leadership of the people's movement, the African National Congress.

Dear comrades and fellow leaders, your return is not only a tribute to the relentless and historic campaign to secure your immediate and unconditional release. It is also, in no small measure, due to your own steadfast refusal to be cowed by the rigours of the apartheid prison—the inspiration you never failed to give us by your unwavering commitment to the just cause for which you were unjustly arrested, tried, sentenced, and imprisoned.

As we held the fort within the National Executive Committee of your organisation and inside the command structures of Umkhonto we Sizwe, we valued immensely the comments, observations, and suggestions you were able to communicate to us even while you were in prison.

Even now we continue to pay the greatest attention to the comments, observations, and suggestions communicated to us by Nelson Mandela and other comrades still in prison—all of them disciplined members of our movement whose actions are inspired exclusively by the desire to serve the people, to contribute what they can from where they are to the realisation of the noble objectives contained in the Freedom Charter, to maintain an unwavering loyalty to the movement they have served and continue to serve with such distinction.

Indeed, comrade leaders of our people, we welcome you today also as a result of the committed and selfless efforts by Comrade Nelson Mandela, working quietly and energetically behind the scenes. This rally is also in part a tribute to that magnificent struggle by one of our longest-serving political prisoners, Nelson Mandela.

Comrade leaders of our people, compatriots who have gathered in your thousands today, our country has arrived at a crossroads. Whatever road it follows, the destination will be, as surely as the sun rises in the east, the final and total destruction of the apartheid system. Which road it takes is a matter entirely in the hands of F. W. de Klerk and the rest of the leadership of the Nationalist party. By their actions they will determine whether we go along the road of increasing confrontations and a bitter conflict between the forces of democracy on the one hand and those of racial tyranny on the other. By their deeds they will decide whether we proceed along the road of a negotiated settlement aimed at the total abolition of the apartheid system of white minority domination and exploitation.

As we meet today to welcome back our leaders, we will without doubt also pledge ourselves to continue and intensify the struggle in whatever form the situation demands until freedom has been achieved. Of this nobody harbours

any doubt, including the armed men and women who surround us as we celebrate.

If F. W. de Klerk finally accepts the positions the ANC and the masses of our people have upheld for decades by opting for peace with justice, he may yet earn a place among the peacemakers of our country, many of whom have had to bear arms or carry the honoured title of "Young Lion" as they prosecuted the struggle whose aim is precisely the attainment of peace and justice for all our people and for the entire region of southern Africa.

We must state it here that if the Pretoria regime seeks the path to a genuine political settlement of the conflict in our country, the way forward has been clearly spelt out in the Harare Declaration which you, the people of our country, and your organisation, the ANC, prepared and which now has the express support of over one hundred countries.

If, on the other hand, F. W. de Klerk continues to entertain the illusion that he can perpetuate apartheid by the use of force and deceitful manoeuvres, he will need to know that thereby he condemns himself to disappear forever into the dim mists of history together with the criminal system he will have sought to defend.

We are strengthened by the knowledge that within the country we have a powerful cadre of leaders, both young and old, men and women, black and white, who will, together with the tried and tested stalwarts who have now been released and those yet to be freed, as well as the patriots who are in enforced exile, work in unbreakable unity to lead our people to the deeply cherished goals of national and social emancipation.

Your glorious rally today expresses exactly that unity, dedication, and common resolve. We look forward to the day, which is not far from now, when we shall rejoin you within the country as servants of the people to take further orders from these heroic masses as to what new task they give us to perform.

AFRICAN NATIONAL CONGRESS

58 *Strategy and Tactics*

Excerpted from Document of the First Consultative
Conference of the African National Congress,
April 1969, and *Sechaba*, July 1969

The struggle of the oppressed people of South Africa is taking place within an international context of transition to the socialist system, of the breakdown of the colonial system as a result of national liberation and socialist revolutions, and the fight for social and economic progress by the people of the whole world.

We in South Africa are part of the zone in which national liberation is the chief content of the struggle. On our continent sweeping advances have been registered which have resulted in the emergence to independent statehood of forty-one states. Thus, the first formal step of independence has been largely won in Africa, and this fact exercises a big influence on the developments in our country.

The countries of southern Africa have not as yet broken the chains of colonialism and racism which hold them in oppression. In Mozambique, Angola, South-West Africa, Zimbabwe, and South Africa, white racialist and fascist regimes maintain systems which go against the current trend of the African revolution and world development.

This has been made possible by the tremendous economic and military power at the disposal of these regimes built with the help of imperialism.

The main pillar of the unholy alliance of Portugal, Rhodesia, and South Africa is the Republic of South Africa. The strategy and tactics of our revolution require for their formulation and understanding a full appreciation of the interlocking and interweaving of international, African, and southern African developments which play on our situation.

Our Approach to Revolutionary Armed Struggle!

In a way, the decision taken in 1961 was, historically speaking, in the tradition of the earlier armed resistance to the entrenchment of the foreigner. But it is now occurring in a new situation. Not only had this situation to be understood, but the art and science—both political and military—of armed liberation struggles in the modern epoch had to be grasped and applied. The head-on mobile warfare of the traditional African armies of the past could not meet the challenge. The riot, the street fight, the outbursts of unorganised violence, individual terrorism; these were symptoms of the militant spirit but not point-

281

ers to revolutionary technique. The winning of our freedom by armed struggle—the only method left open to us—demands more than passion. It demands an understanding and an implementation of revolutionary theory and techniques in the actual conditions facing us. It demands a sober assessment of the obstacles in our way and an appreciation that such a struggle is bitter and protracted. It demands, too, the dominance in our thinking of achievement over drama. We believe our movement acted in accordance with these guidelines when it embarked upon the detailed preparation for the launching of guerrilla struggle.

We understood that the main physical environment of such a struggle in the initial period is outside the enemy strongholds in the cities, in the vast stretches of our countryside. The opening steps in 1961—organised sabotage mainly in the urban areas—served a special purpose and was never advanced as a technique which would, on its own, either lead to the destruction of the state or even do it great material damage (although guerrilla activity in the urban areas of a special type is always important as an auxiliary). At the same time, there was a threefold need to be met in order to lay the foundations for more developed and meaningful armed activity of the guerrilla type.

The first was the need to create a military apparatus and, more particularly, to recruit large numbers of professional cadres who were to be trained and who would form the core of future guerrilla bands.

The second was the need to demonstrate effectively to all that we were making a sharp and open break with the processes of the previous period which had correctly given emphasis to militant struggle short of armed confrontation.

The third was the need to present an effective method for the overthrow of white supremacy through planned rather than spontaneous activity. The sabotage campaign was an earnest indication of our seriousness in the pursuit of this new strategy. All three needs were served by this convincing evidence that our liberation movement had correctly adjusted itself to the new situation and was creating an apparatus actually capable of clandestinely hitting the enemy and making preparation for a more advanced phase. The situation was such that without activity of this nature, our whole political leadership may have been at stake both inside and outside the country, and the steps which were simultaneously taken for the recruitment and preparation of military cadres would have met with less response.

The Relationship Between the Political and Military

When we talk of revolutionary armed struggle, we are talking of political struggle by means which include the use of military force, even though once force as a tactic is introduced it has the most far-reaching consequences on every aspect of our activities. It is important to emphasise this because our movement must reject all manifestations of militarism which separates armed people's struggle from its political context.

Reference has already been made to the danger of the thesis which regards the creation of military areas as the generator of mass resistance. But even more is involved in this concept. One of the vital problems connected with this bears on the important question of the relationship between the political and military. From the very beginning our movement has brooked no ambiguity concerning this. The primacy of the political leadership is unchallenged and supreme, and all revolutionary formations and levels (whether armed or not) are subordinate to this leadership. To say this is not just to invoke tradition. This approach is rooted in the very nature of this type of revolutionary struggle and is borne out by the experience of the overwhelming majority of revolutionary movements which have engaged in such struggles. Except in very rare instances, the people's armed challenge against a foe with formidable material strength does not achieve dramatic and swift success. The path is filled with obstacles, and we harbour no illusions on this score in the case of South Africa. In the long run it can only succeed if it attracts the active support of the mass of the people. Without this lifeblood it is doomed. Even in our country with the historical background and traditions of armed resistance still, within the memory of many people and the special developments of the immediate past, the involvement of the masses is unlikely to be the result of a sudden natural and automatic consequence of military clashes. It has to be won in all-round political mobilisation which must accompany the military activities. This includes educational and agitational work throughout the country to cope with the sophisticated torrent of misleading propoganda and "information" of the enemy which will become more intense as the struggle sharpens. When armed clashes begin they seldom involve more than a comparative handful of combatants whose very conditions of fighting existence make them incapable of exercising the functions of all-round political leadership. The masses of the peasants, workers, and youth, beleagured for a long time by the enemy's military occupation, have to be activated in a multitude of ways not only to ensure a growing stream of recruits for the fighting units but to harass the enemy politically so that his forces are dispersed and therefore weakened. This calls for the exercise of all-round political leadership.

All-Round Political Leadership

Guerrilla warfare, the special, and, in our case, the only form in which the armed liberation struggle can be launched, is neither static nor does it take place in a vacuum. The tempo, the overall strategy to be employed, the opening of new fronts, the progression from lower to higher forms and thence to mobile warfare; these and other vital questions cannot be solved by the military leadership alone; they require overall political judgments intimately involved with the people both inside and outside the actual areas of armed combat. If more awareness of oppression combined with heroic examples by armed bands were enough, the struggle would indeed be simple. There would be no collabor-

ators, and it would be hard to find neutrals. But to believe this is to believe that the course of struggle is determined solely by what we do in the fighting units and further involves the fallacious assumption that the masses are rocklike and incorruptible. The enemy is as aware as we are that the side that wins the allegiance of the people wins the struggle. It is naive to believe that oppressed and beleagured people cannot temporarily, even in large numbers, be won over by fear, terror, lies, indoctrination, and provocation to treat liberators as enemies. In fact, history proves that without the most intensive all-round political activity, this is the more likely result. It is therefore all the more vital that the revolutionary leadership is nationwide and has its roots both inside and outside the actual areas of combat. Above all, when victory comes, it must not be a hollow one. To ensure this we must also ensure that what is brought to power is not an army but the masses as a whole at the head of which stands its organised political leadership. This is the perspective which is rooted at all levels of our liberation movements, whether within or outside the army. Our confidence in final victory rests not on the wish or the dream but on our understanding of our own conditions and the historical processes. This understanding must be deepened and must spread to every level of our movement. We must have a clear grasp, not only of ourselves and of our own forces, but also of the enemy—of his power and vulnerability. Guerrilla struggle is certainly no exception to the rule that depth of understanding and knowledge of realities, both favourable and unfavourable, make for more lasting commitment and more illuminating leadership.

The laager-minded white group as a whole moves more and more in the direction of a common defence of what is considered a common fate.

These monolithic tendencies are reinforced by a Hitlerlike feeling of confidence that the fortress is impregnable and unassailable for all time. This process of all-white solidarity will only be arrested by the achievements of the liberation movement. For the moment the reality is that apart from a small group of revolutionary whites who have an honoured place as comrades in the struggle, we face what is by and large a united and confident enemy which acts in alliance with and is strengthened by world imperialism. All significant sections of the white political movement are in broad agreement on the question of defeating our liberation struggle.

This confrontation on the lines of colour—at least in the early stages of the conflict—is not of our choosing; it is of the enemy's making. It will not be easy to eliminate some of its more tragic consequences. But it does not follow that this will be so for all time. It is not altogether impossible that in a different situation the white working class, or a substantial section of it, may come to see that their true long-term interest coincides with that of the nonwhite workers. We must miss no opportunity either now or in the future to try and make them aware of this truth and to win over those who are ready to break with the policy of racial domination. Nor must we ever be slow to take advantage of differences and divisions which our successes will inevitably spark off to isolate the most vociferous, the most uncompromising and the most reactionary

elements amongst the whites. Our policy must continually stress in the future (as it has in the past) that there is room in South Africa for all who live in it, but only on the basis of absolute democracy.

The African Masses—The Main Force for Liberation

So much for the enemy. What of the liberation forces? Here, too, we are called upon to examine the most fundamental features of our situation which serve to mould our revolutionary strategy and tactics. The main content of the present stage of the South African revolution is the national liberation of the largest and most oppressed group—the African people. This strategic aim must govern every aspect of the conduct of our struggle, whether it be the formulation of policy or the creation of structures. Amongst other things, it demands in the first place the maximum mobilisation of the African people as a dispossessed and racially oppressed nation. This is the mainspring, and it must not be weakened. It involves a stimulation and a deepening of national confidence, national pride, and national assertiveness. Properly channelled and properly led, these qualities do not stand in conflict with the principles of internationalism. Indeed, they become the basis for more lasting and more meaningful cooperation, a cooperation which is self-imposed, equal, and one which is neither based on dependence nor gives the appearance of being so.

The national character of the struggle must therefore dominate our approach. But it is a national struggle which is taking place in a different era and in a different context from those which characterised the early struggles against colonialism. It is happening in a new kind of world—a world which is no longer monopolised by the imperialist world system, a world in which the existence of the powerful socialist system and a significant sector of newly liberated areas has altered the balance of forces, a world in which the horizons liberated from foreign oppression extend beyond mere formal political control and encompass the element which makes such control meaningful— economic emancipation. It is also happening in a new kind of South Africa, a South Africa in which there is a large and well-developed working class whose class consciousness and in which the independent expressions of the working people—their political organs and trade unions—are very much part of the liberation front. Thus, our nationalism must not be confused with chauvinism or narrow nationalism of a previous epoch. It must not be confused with the classical drive by an elitist group among the oppressed people to gain ascendancy so that they can replace the oppressor in the exploitation of the mass.

But none of this detracts from the basically national context of our liberation drive. In the last resort, it is only the success of the national democratic revolution which—by destroying the existing social and economic relationships—will bring with it a correction of the historical injustices perpetrated against the indigenous majority and thus lay the basis for a new—and deeper

internationalist—approach. Until then, the national sense of grievance is the most potent revolutionary force which must be harnessed. To blunt it in the interests of abstract concepts of internationalism is, in the long run, doing neither a service to revolution nor to internationalism.

Our Fighting Alliance

Whatever instruments are created to give expression to the unity of the liberation drive, they must accommodate two fundamental propositions:

Firstly, they must not be ambiguous on the question of the primary role of the most oppressed African mass and, secondly, those belonging to the other oppressed groups and those few white revolutionaries who show themselves ready to make common cause with our aspirations must be fully integrated on the basis of individual equality. Approached in the right spirit, these two propositions do not stand in conflict but reinforce one another. Equality of participation in our national front does not mean a mechanical parity between the various national groups. Not only would this in practice amount to inequality (again at the expense of the majority), but it would lend flavour to the slander which our enemies are ever ready to spread of a multiracial alliance dominated by minority groups. This has never been so and will never be so. But the sluggish way in which the movement inside the country responded to the new situation after 1960 in which cooperation, continued between some organizations which were legal (e.g., SAIC, CPO, COD) and those that were illegal (e.g., ANC) sometimes led to the superficial impression that the legal organisations—because they could speak and operate more publicly and thus more noticeably—may have had more than their deserved place in the leadership of the alliance.

Therefore, not only the substance but the form of our structural creations must, in a way which the people can see—give expression to the main emphasis of the present stage of our struggle. This approach is not a pandering to chauvinism, to racialism or other such backward attitudes. We are revolutionaries, not narrow nationalists. Committed revolutionaries are our brothers to whatever group they belong. There can be no second-class participants in our movement. It is for the enemy we reserve our assertiveness and our justified sense of grievance.

The important task of mobilising and gaining the support of other oppressed nonwhite groups has already been referred to. Like every other oppressed group (including the Africans), we must not naively assume that mere awareness of oppression will, by itself, push the Indian and Coloured people in the direction of opposing the enemy and aligning themselves with the liberation movement. The potential is, of course, there, because in a very real sense the future of the Indian and Coloured people and their liberation as oppressed groups is intimately bound up with the liberation of the Africans. But active support and participation has to be fought for and won. Otherwise, the enemy will succeed in its never-ending attempt to create a gap between these groups

and the Africans and even recruit substantial numbers of them to actively collaborate with it. The bottom of the barrel will be scraped in the attempt to create confusion about the objectives of the liberation movement. More particularly, the enemy will feed on the insecurity and dependency which is often part of the thinking of minority oppressed groups. They will try to raise a doubt in their minds about whether there is a place for them in a future liberated South Africa. They have already spread the slander that at best for the Coloureds and Indians, white domination will be replaced by black domination.

It is therefore all the more important, consistent with our first principle, that the Coloured and Indian people should see themselves as an integral part of the liberation movement and not as mere auxiliaries.

The Working Class

Is there a special role for the working class in our national struggle? We have already referred to the special character of the South African social and economic structure. In our country—more than in any other part of the oppressed world—it is inconceivable for liberation to have meaning without a return of the wealth of the land to the people as a whole. It is therefore a fundamental feature of our strategy that victory must embrace more than formal political democracy. To allow the existing economic forces to retain their interests intact is to feed the root of racial supremacy and does not represent even the shadow of liberation.

Our drive towards national emancipation is therefore in a very real way bound up with economic emancipation. We have suffered more than just national humiliation. Our people are deprived of their due in the country's wealth; their skills have been suppressed, and poverty and starvation have been their life experience. The correction of these centuries-old economic injustices lies at the very core of our national aspirations. We do not underestimate the complexities which will face a people's government during the transformation period nor the enormity of the problems of meeting economic needs of the mass of the oppressed people. But one thing is certain—in our land this cannot be effectively tackled unless the basic wealth and the basic resources are at the disposal of the people as a whole and are not manipulated by sections or individuals, be they white or black.

This perspective of a speedy progression from formal liberation to genuine and lasting emancipation is made more real by the existence in our country of a large and growing working class whose class consciousness complements national consciousness. Its political organisations and the trade unions have played a fundamental role in shaping and advancing our revolutionary cause. It is historically understandable that the doubly oppressed and doubly exploited working class constitutes a distinct and reinforcing layer of our liberation and socialism and do not stand in conflict with the national interest. Its militancy and political consciousness as a revolutionary class will play no small part in our victory and in the construction of a real people's South Africa.

59 *Political Report and Communiqué of the Second National Conference of the African National Congress*

July 1985 (Excerpts)

Our Strategic Tasks

It is clear to all of us present here that we have the possibility actually to make this our Decade of Liberation. That requires that we must in fact and in practice accomplish the strategic tasks that we have set ourselves and which our strategic objective of the seizure of power demands. We have spelt out these tasks before and publicly communicated them even to the masses of our people. As the general command of our revolution, we should carefully identify the decisive theatres of action on which we should concentrate in order to achieve purposeful movement forward.

The apartheid system is in a deep and permanent general crisis from which it cannot extricate itself. The apartheid regime cannot rule as before. It has therefore brought its military forces into the centre of its state structures and is ready to declare martial law when the need arises. The widespread and increasing use of the army in the effort to suppress the mass struggle in our country, even before martial law is invoked, reflects the depth of the crisis engulfing the racist regime.

Despite massacres and murders that are carried out daily by Botha's assassination squads, the masses of the people are engaged in a widespread struggle which the enemy cannot suppress and which is driving the enemy ever deeper into crisis. Of decisive importance is the fact that this mass offensive is directed at the destruction of the apartheid state machinery, at making apartheid inoperative, at making our country ungovernable.

International Solidarity

Internationally also, the movement of solidarity with our movement and our struggle is growing and increasing its effectiveness. Already, many countries consider the ANC virtually as a government and work with us as such. On the other hand, the process of the isolation of the racist regime is developing rapidly, especially and notably in the United States.

In this respect, we should also mention the extensive political and material support that we enjoy from the non-aligned countries, the Nordic and other Western countries and the international antiapartheid movement. Our relations with these important world forces have also contributed greatly in further weakening the Pretoria regime and strengthening our movement and struggle.

The key to our further advance is organisation. Our NEC addressed itself to this question in its last January 8th statement when it proclaimed this the Year

of the Cadre. The face of the matter is that despite the enormous impact we have made in developing the struggle to the level it is today, our organisation inside the country is relatively weak.

Need for a Strong Revolutionary Organisation

We need a strong organisation of revolutionaries because without it, it will be impossible to raise the struggle to greater heights in a planned and systematic fashion. Without such a strong revolutionary organisation, we cannot take advantage of the uprisings we have spoken about and which are a reality of the mass offensive of our people.

We have to discuss carefully the question why we are not as strong as we can and should be, review our experiences, and draw the necessary conclusions. One thing that is clear is that we have to realise that we have in fact developed many cadres inside the country who understand our policy very well, who are in daily contact with the situation and our people and are committed to our organisation and struggle. It is vital that these cadres should be properly grounded in our strategy in its entirety, so that they can in fact advance all our strategic tasks.

It is very important that our leadership, by which we mean all those whom we consider most mature among our ranks, must begin to involve itself directly in this work of internal organisation. We have to be in daily contact with our people.

We must also move with all due speed to tackle the tasks posed by our perspective of people's war. In this respect, we would like to mention in particular that we have to take the question of mass revolutionary bases very seriously. We shall also be discussing this issue when we consider the document on strategy and tactics.

As a result of the strength and tenacity of the people's offensive, many areas in our country are emerging, perhaps in a rudimentary way, as such mass revolutionary bases. The people are engaged in active struggle as a conscious revolutionary force and accept the ANC as their vanguard movement. They are organised in mass democratic organisations. They have destroyed the enemy's local organs of government and have mounted an armed offensive against the racist regime, using whatever weapons are available to them. What is missing is a strong underground ANC presence as well as a large contingent of units of Umkhonto we Sizwe.

We must correct this weakness in a determined and systematic manner because it is within these mass revolutionary bases that we will succeed to root our army. It is the risen masses in these areas who have to be organised into larger formations of Umkhonto we Sizwe, turned into organised groups of combatants, and who have to replenish and swell our military ranks. We have to bear in mind the fact that the comrades we are training outside constitute the core of our army. They are the organisers and the leaders of the mass army that we have to build inside the country. They are our officer corps. We cannot

deploy them forever as combat units. For obvious reasons, no army in the world fights with combat units composed of officers. Ours will be no exception.

Cadre Policy

The question of the kind of cadre we are producing assumes greater significance with each passing day. The level of struggle demands that we deploy inside our country as many of our cadres as possible. As we succeed to do this, these cadres will constitute an important component part of our internal structures and therefore of the ANC as a whole. They must therefore be what the ANC wants them to be. This cannot be left to chance.

It is a good thing that [this] conference will be discussing the question of cadre policy. Our decisions in this regard will have to be implemented seriously and consistently. All other decisions we take at this conference will only have real meaning if we have the cadres to implement them with the sense of purpose that everything we decide here will require.

We are raising questions which might be organisational. But they are central to the solution of the question of how we raise the struggle to higher levels. Anyway, they are issues which require our most serious reflection.

Release of Political Prisoners

We would also like to raise the question of the release of political prisoners. But in the first instance the NEC would like to report at this conference that over the years, we have tried our best to keep in contact with these outstanding leaders of our people and activists of our movement. In this we were assisted by the great ingenuity and daring that these comrades showed in themselves ensuring that we kept in contact. When the need arose, we have consulted them on important questions of our revolution. Their constant steadfastness and their calibre as leaders was demonstrated only recently when they turned down Botha's offer to release them on condition that they renounced violence.

By its actions the Botha regime has admitted that it is finding it difficult to withstand the internal and international pressure for the release of our comrades. We can take pride in the fact that through consistent campaigning, we have utterly defeated all attempts by this regime and others before it to blot out the memory of these heroes of our people by keeping them behind bars for such a long time.

Our National Executive Committee is of the considered view that we must do everything in our power to secure their release. Their release would have an enormous impact on the advance of the people of our country towards a united, nonracial, and democratic South Africa, apart from meeting the profound humanitarian concern that their return to the ranks of the people is long overdue.

As [the] conference knows, of late there has been a fair amount of speculation about the ANC and the Pretoria regime getting together to negotiate a settlement of the South African question. This issue has arisen at this time exactly because of our strength inside the country, the level of our struggle, and the crisis confronting the Botha regime. The NEC is, however, convinced that this regime is not interested in a just solution of the South African question.

Rather, it is interested to use the question of negotiations to divide our movement, demobilise the masses of our people by holding out the false promise that we can win our liberation other than through its overthrow. It also seeks to improve its image internationally. In any case, it is clear that no negotiations can take place or even be considered until all political prisoners are released.

However, the NEC is of the view that we cannot be seen to be rejecting a negotiated settlement in principle. In any case, no revolutionary movement can be against negotiations in principle. Indeed, in our case, it is correct that we encourage all forces, particularly among our white compatriots and in the Western world, to put pressure on the Botha regime to abandon the notion that it can keep itself in power forever by the use of brute force.

The growing crisis of the apartheid system is, in any case, causing some sections of the white population to consider ways in which they can defuse the situation. Among these are elements from the big capitalists of our country, representatives of the mass media, intellectuals, politicians, and even some individuals from the ruling fascist party. Increasingly these seek contact with the ANC and publicly put forward various proposals which they regard as steps that would, if implemented, signify that the racist regime is, as they say, moving away from apartheid.

This poses the possibility that our movement will therefore be in contact with levels of the ruling circles of our country that it has never dealt with before. It is absolutely vital that our organisation and the democratic movement as a whole should be of one mind about this development to ensure that any contact that may be established does not have any negative effects on the development of our struggle.

ANC Holds the Key

Yet another significant result of the growing strength of our movement is that many Western countries are also showing interest in establishing and maintaining relations with us. Our policy on this kind of question has of course always been clear. In principle we can have no objection to establishing such relations. However, there are important tactical questions to consider about the timing of these developments and the form that the relations we may establish should take. The NEC would be happy to see us come out of this conference with a consensus as to how our movement should handle these important questions of our revolution which, once more, confirm the centrality of the ANC in the solution of the problems of our country.

These events draw attention to the fact that we have to act in a manner that accords with the responsibilities that rest on our shoulders, with regard both to the short and the long term. If we seriously consider ourselves as the alternative government of our country, then we need to act and operate both as an insurrectionary force and a credible representative of a liberated South Africa.

With respect to the issues we have just raised, it is clear that we have to improve the quality of our diplomacy and therefore the training of our representatives and their staff. We need also to tap and utilise in a better way the intellectual cadres available to us, both inside and outside our country.

The scope, spread, and intensity of our struggle have also thrown up a large leadership corps of our democratic movement. It is important that we pay close and continuous attention to the issue of maintaining close relations with these leaders, educate the masses of our people to understand and accept our own positions, and at all times ensure that we are, as a movement, providing leadership on all major questions, in accordance with our position as the vanguard movement of our struggling people.

That, in any case, is the main lesson of our last 16 years of struggle since the Morogoro Conference. It is that we must act as a vanguard force, the repository of the collective experience of our revolutionary masses in their struggle for national liberation. We must be organised to act as such. We must focus on the offensive, instruct ourselves that we will win and enhance our position as the front commanders of our millions-strong army of revolution. Through 16 years of persistent struggle, we have placed ourselves in a position where we can discharge this responsibility and finally achieve the great dream of our people, the liberation of our motherland.

And so the conference "hammered out the guidelines for future progress." And what are those guidelines?

Our conference agreed unanimously that the Botha regime is still determined to defend the apartheid system of white minority rule by force of arms. Accordingly, it agreed that there was no reason for us to change our broad strategy, which pursues the aim of seizure of power by the people through a combination of mass political action and armed struggle.

It, however, agreed that the possibility of victory was greater now than at any other time in our history. This requires that we should step up our all-round political and military offensive sharply and without delay. The masses of our people have been and are engaged in a struggle of historic importance directed at making apartheid unworkable and the country ungovernable. They are creating the conditions for the escalation of our attack leading towards the situation where it will be possible for us to overthrow the apartheid regime.

The delegates agreed that it was vital that we take all necessary measures further to strengthen the ANC and Umkhonto we Sizwe inside our country exactly to meet the demands of our people and our situation for a heightened and coordinated political and military offensive.

The conference also resolved that we cannot even consider the issue of a negotiated settlement of the South African question while our leaders are in

prison. It agreed that we should continue with the campaign for the immediate and unconditional release of these leaders.

In the situation which obtains within the country in which the crisis of the apartheid system has become endemic, the conference agreed that the Freedom Charter provides the basis for the satisfaction of the aspirations of the overwhelming majority of our people. In this regard, the participants agreed that it was important that we should win as many whites as possible to our side. We should also adhere to our opposition to and our struggle against the Bantustans as well as the apartheid tricameral parliament and related institutions. We must continue to pose the alternative of a united, democratic, and nonracial South Africa.

The conference endorsed the view advanced by our imprisoned leaders about the importance of unity. In a call to our people inside the country, the delegates said: "Those of us who are true liberators should not fight among ourselves. Let us not allow the enemy's dirty tricks department to succeed in getting us to fight one another." The conference noted and paid tribute to the contribution that the United Democratic Front has made towards the strengthening of the unity of the democratic forces of our country and condemned the arrest and prosecution of its leaders and activists.

The participants also agreed that this unity must find expression in the mass activity of all our people against the apartheid regime. Consequently, it is important that all our people should be organised and mobilised, in the towns and the countryside, including those in the Bantustans. The black workers are of special importance in this regard and are, as we have said before, the backbone and leading force in our struggle for national liberation.

The conference also assessed the international situation. It agreed that we should further expand our system of international relations and reach out even to regions, countries, and governments with which we might not have had contact before. It urged the international community to "declare the apartheid white minority regime illegitimate."

60 *Statement by the National Executive Committee of the African National Congress, October 1987*

From *Sechaba*, December 1987

We are convinced that the Botha regime has neither the desire nor the intention to engage in any meaningful negotiations. On the contrary, everything this regime does is directed at the destruction of the national liberation movement, the suppression of the democratic movement, and the entrenchment and perpetuation of the apartheid system of white minority domination.

The racist regime has raised the issue of negotiations to achieve two major objectives. The first of these is to defuse the struggle inside our country by holding out false hopes of a just political settlement which the Pretoria regime has every intention to block. Secondly, this regime hopes to defeat the continuing campaign for comprehensive and mandatory sanctions by sending out bogus signals that it is ready to talk seriously to the genuine representatives of our people.

Fundamental to the understanding of the apartheid regime's concept of negotiations is the notion that it must impose its will on those it is talking to and force them to accept its dictates. In practice, the Botha regime is conducting a determined campaign of repression against the ANC and the mass democratic movement. This includes the assassination of leaders, mass detentions, military occupation of townships and a programme of pacification carried out by the so-called Joint Management Centres (JMCs).

The racists are out to terrorise our people into submission, crush their democratic organisations, and force us to surrender.

All these efforts will fail. Rather than create a climate conducive to genuine negotiations, they will only serve further to sharpen the confrontation within our country and bring to the fore the prospect of the bloodiest conflict that our continent has ever seen.

Our struggle will not end until South Africa is transformed into a united, democratic, and nonracial country. This is the only solution which would enable all our people, both black and white, to live as equals in conditions of peace and prosperity. The overwhelming majority of our people accept that the Freedom Charter provides a reasonable and viable framework for the construction of a new society.

We wish here to reiterate that the ANC has never been opposed to a negotiated settlement of the South African question. On various occasions in the past we have, in vain, called on the apartheid regime to talk to the genuine leaders of our people. Once more, we would like to reaffirm that the ANC and the masses of our people as a whole are ready and willing to enter into genuine negotiations, provided they are aimed at the transformation of our country into a united and nonracial democracy. This, and only this, should be the objective of any negotiating process. Accordingly, no meaningful negotiations can take place until all those concerned, and specifically the Pretoria regime, accept this perspective which we share with the whole of humanity.

We further wish to state again that the questions whether or not to negotiate, and on what conditions, should be put to our entire leadership, including those who are imprisoned and who should be released unconditionally. While considering these questions our leadership would have to be free to consult and discuss with the people without let or hindrance.

We reject unequivocally the cynical demand of the Pretoria regime that we should unilaterally abandon or suspend the armed struggle. The source of violence in our county is the apartheid system. It is that violence which must end. Any cessation of hostilities would have to be negotiated and entail agreed action by both sides as part of the process of the creation of a democratic South Africa.

Equally, we reject all efforts to dictate to us who our allies should or should not be and how our membership should be composed. Specifically, we will not bow down to pressures intended to drive a wedge between the ANC and the South African Communist party, a tried and tested ally in the struggle for a democratic South Africa. Neither shall we submit to attempts to divide and weaken our movement by carrying out a witch hunt against various members on the basis of their ideological beliefs.

The conflict in our country is between the forces of national liberation and democracy on the one hand and those of racism and reaction on the other. Any negotiations would have to be conducted by these two forces as represented by their various organisational formations.

We reject without qualification the proposed National Council (NC) which the Botha regime seeks to establish through legislation to be enacted by the apartheid parliament. This can never be a genuine and acceptable mechanism to negotiate a democratic constitution for our country.

In practice, the National Council can never be anything more than an advisory body which would put its views to the apartheid parliament and the regime itself, which retains the right to accept or reject those views. What the Botha regime proposes as a constitution-making forum—the National Council—is therefore nothing but a device intended to enmesh all who sit on it in a bogus process of meaningless talk which has nothing to do with any genuine attempt to design a democratic constitution for our country.

In addition, this National Council seeks to entrench and legitimise the very structures of apartheid that our struggle, in all its forms, seeks to abolish. The unrepresentative organs of the apartheid structure of repression, such as the racist tricameral parliament and the bantustans, cannot be used as instruments for the liquidation of the very same system they have been established to maintain.

An essential part of the apartheid system is the definition and division of our people according to racial and ethnic groups, dominated by the white minority. To end apartheid means, among other things, to define and treat all our people as equal citizens of our country, without regard to race, colour, or ethnicity. To guarantee this, the ANC accepts that a new constitution for South Africa could include an entrenched bill of rights to safeguard the rights of the individual. We are, however, opposed to any attempt to perpetuate the apartheid system by advancing the concept of so-called group and minority rights.

Our region is fully conversant with the treacherous and deceitful nature of the apartheid regime. There are more than enough examples of agreements which this regime has shamelessly dishonoured. Taking this experience into account, we insist that before any negotiations take place, the apartheid regime would have to demonstrate its seriousness by implementing various measures to create a climate conducive to such negotiations.

These would include the unconditional release of all political prisoners, detainees, all captured freedom fighters, and prisoners of war as well as the cessation of all political trials. The state of emergency would have to be lifted, the army and the police withdrawn from the townships and confined to their

barracks. Similarly, all repressive legislation and all laws empowering the regime to limit freedom of assembly, speech, the press, and so on, would have to be repealed. Among these would be the Riotous Assemblies, the Native Administration, the General Laws Amendment, the Unlawful Organisations, the Internal Security, and similar acts and regulations.

We take this opportunity once more to reaffirm that the African National Congress is opposed to any secret negotiations. We firmly believe that the people themselves must participate in shaping their destiny and would therefore have to be involved in any process of negotiations.

Being fully conscious of the way the Pretoria regime has, in the past, deliberately dragged out negotiations to buy time for itself, we maintain that any negotiations would have to take place within a definite timeframe to meet the urgent necessity to end the apartheid system and lift the yoke of tyranny from the masses of our people who have already suffered for too long.

There is, as yet, no prospect for genuine negotiations because the Botha regime continues to believe that it can maintain the apartheid system through force and terror. We therefore have no choice but to intensify the mass political and armed struggle for the overthrow of the illegal apartheid regime and the transfer of power to the people.

We also call on all our people to reject and spurn Botha's so-called National Council and make certain that this apartheid council never sees the light of day.

We reiterate our appeal to the international community to join us in this noble struggle by imposing comprehensive and mandatory sanctions against racist South Africa to end the apartheid system and reduce the amount of blood that will otherwise have to be shed to achieve this goal.

Finally, we would like to express our gratitude to the Organisation of African Unity which, at its last summit, adopted a Declaration on Southern Africa pledging Africa's support for the positions contained in the statement. We commend that declaration to the rest of the world community as an important document laying the basis for concerted international action to banish apartheid racism, colonialism, and war, once and for all.

61 *United Action for People's Power*

Excerpted from Message from the National
Executive Committee of the African National
Congress, January 8, 1988

As our Jubilee Year came to a close, it was clear that our country has polarised into two opposing camps, one representing liberation, democracy, and peace and the other, oppression, racism, and war. Throughout this past year our

enemy has tried to defeat and suppress the forces of national liberation and democratic change. At the same time the racists have sought to increase their own strength by working to consolidate their own ranks and luring to their side as many people as possible. All this has been without success.

The failure of the enemy to achieve these objectives constitutes for us a strategic advance and is central to our assessment of the continuing shift in the balance of forces in our favour and therefore our advance towards people's power.

To appreciate the decisive importance of this advance, it is necessary to understand, in its fullness, the degree and scope of the counteroffensive launched by the Pretoria regime in its efforts to recover ground that it had lost in the previous two years in particular. At the heart of the response of the enemy has been its attempt to liquidate the ANC and the mass democratic movement through a sustained campaign of extreme repression and open terror.

This has been coupled with an aggressive political offensive both inside and outside the country designed to give the white minority regime a cloak of legitimacy and to turn the masses of our people and the world community against our broad movement for national liberation. As we have said, the rest of the peoples of our region have themselves, more than ever before, been victims of the integrated counteroffensive of the forces of racism and fascism.

Rule by Force

In 75 years of struggle under the banner of the ANC, we have never known a campaign of repression as coldly calculated and systematic as we have experienced this past year. The emergence into the open of the so-called National Security Management System as the central instrument of government, its core composed of the racist army and police, is indication enough of the decisive importance of the use of force as the principal means of government. Accordingly, we have seen the network of the so-called Joint Management Centres, operating under the direction of the State Security Council, envelop our people under a blanket of institutionalised state terrorism which we have never had to endure before.

We are all aware of the practical meaning of these developments. The issue is not just the imposition of the dastardly state of emergency. The effort to maintain the so-called security of the apartheid system has meant a determined attempt to break the will of the people and to destroy our organisations through sustained terror carried out by soldiers, the police, kitskonstabels, and secret assassination squads.

Mass Arrests and Torture

Together with all these activities, which it is hard to believe are carried out by people who still expect to be called human beings, have been the mass arrests

and detentions. The torture, physical, and psychological persecution and abuse of our people, among them children, goes on unabated. So determined has the regime of the oppressors been to use force that it has employed teargas against detainees inside prisons themselves. To break the youth in particular, the enemy has, as we know, even set up special indoctrination camps designed to train the young to serve as pliant tools of the regime of murderers.

Some among us the fascist regime decides to imprison or to hang. Even now, countless show trials are taking place, with some reported and others not. As we speak, scores of our people are facing execution while others are doomed to serve long terms of imprisonment. By the end of the year more will be confronted with the same grim prospect of legalised murder, some of which will be carried out in secret, as is happening already.

The fascist tyrants are determined to ensure that none of this truth should be known or told. For them the darkness of the night and the terrible void of ignorance are elements which guarantee the success of their nefarious schemes. Nothing should be known except that which the killers decide should be known. Lies and disinformation are among the tools that must be used to guarantee the survival of the apartheid system. To ensure this, the racists have imposed press restrictions which are without precedent in our entire history.

Military Occupation

Many of our townships remain under the occupation of the murder squads of the army and the police which we have been talking about. To camouflage their true purpose and to bribe us to accept the tyrannical rule of the apartheid regime, these same killers come to us bearing gifts. Such is the fool's paradise which derives from the arrogance of racism, making the slave master believe he can quell the rebellion of the slaves by increasing their rations.

What we have spoken of is not a system of random acts. The incidents, the acts, and the measures are all part of a systematised and integrated process of rule by terror. The plan of the enemy is that those who dispose of this tyrannical force should occupy all vantage points in society and coopt as many people and social forces as possible into the organised system of repression. Hence we see that some municipal councils, elements among the white business community, some teachers, and others have already been drawn into the Joint Management Centres as partners in state terrorism. None of those who continue to accept to cooperate with the apartheid regime can expect that they will escape this fate of having to serve within the military structures of terrorist domination that this regime is putting in place.

At the same time, we are aware that the racists have themselves recognised the fact that their campaign of repression has not succeeded as they thought it would. Therefore they continue to devise new measures further to tighten the noose around the people. The new conditions which the Pretoria regime seeks to impose on the universities, to transform their administrations into instruments of repression, are part of this process. So also is the bill, which the racist

parliament is considering, designed to paralyse the trade union movement by effectively abolishing the right of the workers to strike. In an effort to break the widespread rent boycott and deprive us of this weapon in future, the apartheid regime also continues to work towards passing legislation which will compel employers to deduct rents from the pay packets of their employees. These are but some of the ways and means that the racist regime is and will be devising and implementing to ensure the survival of the criminal system of apartheid.

Our central task is to organise and mobilise our people in their millions to deliver mighty blows against our common enemy, the white minority regime, for the realisation of the objective of a united, democratic, and nonracial South Africa. This means that we must continue to build the broadest possible united front against apartheid for a democratic South Africa. All organisations to which the people belong, whether cultural, sporting, professional, religious, or of other types, should understand that they, too, have an obligation to engage in struggle in pursuit of the common cause. Let the fact of the united opposition of millions of our people to the apartheid system find expression both in united action and action within a united front.

Build Unity

That unity must also characterise our concerted action to defeat the attack on COSATU, the trade union movement in general and the workers as a whole represented by the amendment to the Labour Relations Act currently before the racist parliament. All formations of the democratic movement must join this fight as their own because it is indeed their own. We know that the enemy has identified as one of the principal tasks of its campaign of repression to break the strike movement. Through united national action, let us stop the enemy in its tracks and, by our victory, further consolidate the trade union movement and strengthen the bonds of common struggle among all formations that make up the democratic movement.

Strengthen the People's Organisations

Much work remains to be done to accomplish our tasks of organising the unorganised and the unemployed workers both in the towns and countryside and to engage them in struggle. The fact that the apartheid regime and the employers take advantage of the unorganised and unemployed to recruit for the organs of state repression, to break our strikes, and to guarantee themselves superprofits, emphasises the importance and urgency of these tasks for the entire democratic movement. The same urgency to carry out further organisational work among the youth and students obtains, despite the great strides that we have made in this regard. The women's movement has the potential, already proven in struggle, to become one of the strongest components of the mass political army of revolutionary change. For this to be realised, the tasks we have set ourselves in the past to organise a broad women's movement have to be accomplished. Similarly, the religious commu-

nity is of vital importance to the success of the common struggle to end racism and racial domination. Further to enhance the contribution that this community is making, we must adopt new measures to ensure that it plays its role to the full. The decisions originally adopted at the Conference of the World Council of Churches in Lusaka last year and since endorsed by the churches within our country provide an important vantage point from which to engage the religious community in struggle at an even higher level.

Cultural Workers

The workers in the field of culture have clearly recognised the vital importance of their own participation in the struggle. We have to work consistently in this field to ensure that these workers also see themselves as frontline fighters and not merely a reserve to be called upon by somebody else as need arises. This applies similarly to the sportspeople, both amateur and professional, who should themselves, together with the rest of the democratic movement, elaborate ways and means by which to harness the energies of all sports enthusiasts, players, and spectators, to help end the apartheid system so that in a normal society we can all have normal sport with all the benefits that will accrue to the people and the sportspersons themselves as a result of this change.

Education

The area of education remains one of our crucial fronts of struggle. The victory of the democratic and nonracial perspective in this theatre of action requires, among other things, that the educators themselves, the teachers at schools, universities, and other institutions of higher learning, should be organised into democratic formations that consciously and systematically pursue the objective of a people's education in the full meaning of those words.

Transform the Bantustans

The masses of our people within the bantustans must be [activated] to transform these into strong and reliable mass bases of the revolution. New possibilities exist for the people to act decisively to turn these enemy-created institutions against their creator, the Pretoria regime.

The accomplishment of this task requires that the fighting masses of our people should join hands with those elements within the bantustan administrative systems that are prepared to break with the apartheid regime and join the people in the struggle for a united, democratic, and nonracial South Africa. Contrary to the wishes and designs of the enemy, there are many of these— politicians, chiefs, soldiers, police, and civil servants—who have no stake in the corrupt and venal system created by Pretoria to perpetuate its rule and who are willing to act in the national interest against those who employ them. Let us act together with these healthy forces to transform what the enemy conceived as its rear base of counterrevolution into forward trenches of militant struggle for

the victory of the national democratic revolution. Of central importance to the success of this process is the need to ensure that the masses of the people are organised into their own mass formations as well as into underground units of our movement.

The Responsibility of White South Africans

As our struggle intensifies and the crisis of the apartheid system deepens, so does the responsibility on our white compatriots increase, to act together with the majority of the people of our country to end the apartheid system. To our white compatriots we say, as the Botha regime prepares to celebrate, in your name, the ignoble history of a system that has been categorised as a crime against humanity, what are you going to do?

You have the possibility to contribute decisively to redress an historical injustice which has persisted over three centuries. The decision is yours to make, and you need to make it now. The hour of the day demands of you that you break with racism and apartheid unreservedly and recognise the fact that the apartheid regime is an illegitimate creature of an immoral and criminal system which no decent human being can support or tolerate. Your children are being used to kill for this regime. Your intellects are used to create options for the survival of the same regime. The wealth we both create is expropriated by this regime to keep itself in power. Why do you allow all these indecencies to occur and continue? The time for you to act against the apartheid system is now.

Rebuild and Expand Our Organisational Strength

It is clear that in the coming period, many tasks of decisive importance will fall on the shoulders of the mass democratic movement. This necessitates that this movement should itself be strong, well organised, and clear about its tasks. Serious efforts have therefore to be made to ensure that we recover from the reverses that we have suffered as a result of extreme repression. We have to rebuild all affected structures from the local up to the national level and further expand our entire organisational strength.

The situation of extreme repression requires that we strive even harder to ensure the democratic participation of the people in our decision-making processes. Our leadership collectives should remain close to the people and be accountable to them. At the same time, we have to fight against all factionalism, against all tendencies to develop contempt for the masses of the people, and therefore to think that decisions must be taken on their behalf. We must build up unity within our own organisations on the basis of a common commitment to an agreed programme of action, democratic participation, and the accountability of the leadership.

If we attend to these issues, as we should, as well as others that we have mentioned already, then it will be possible for us to score new successes in the

campaigns we have to continue to conduct, including those for a living wage and national united action. As we know, there are other issues that we have to take up in addition to those we have already dealt with. These include the rent boycott, the observance of May Day on a day we ourselves decide, the education campaign, and the observance of March 21, June 16, June 26, August 9, and December 16. We also have to increase our solidarity with the peoples of Namibia and the Frontline States. We have a duty in action to demand the independence of Namibia, that Pretoria withdraws its troops from Angola and ends its aggression against independent Africa. Furthermore, this year the OAU will be marking its 25th anniversary on May 25. We, too, must observe this anniversary and in future join the rest of our continent in observing May 25 as Africa Day.

The situation of extreme repression has once more brought to the fore the importance of the underground structures of our vanguard movement, the African National Congress, as a central component of our struggle.

We have to redouble our efforts further to expand these structures to ensure that they are in contact with the people everywhere and at all times. Indeed, as we all realise the fact that no revolution is possible without a revolutionary vanguard, we all have a task to build this vanguard, the ANC, in the interests of our revolution. The progress we have achieved in this regard has given us the basis to proceed even faster in pursuit of this goal.

62 *Constitutional Guidelines for a Democratic South Africa*

From Document by the African National Congress,
July 1988

The State

(a) South Africa shall be an independent, unitary, democratic, and nonracial state.

(b) Sovereignty shall belong to the people as a whole and shall be exercised through one central legislature, executive, judiciary, and administration. Provision shall be made for the delegation of the powers of the central authority to subordinate administrative units for purposes of more efficient administration and democratic participation.

(c) The institution of hereditary rulers and chiefs shall be transformed to serve the interests of the people as a whole in conformity with the democratic principles embodied in the constitution.

(d) All organs of government, including justice, security, and armed forces, shall be representative of the people as a whole, democratic in their

structure and functioning and dedicated to defending the principles of the constitution.

Franchise

(e) In the exercise of their sovereignty, the people shall have the right to vote under a system of universal suffrage based on the principle of one person, one vote.

(f) Every voter shall have the right to stand for election and to be elected to all legislative bodies.

National Identity

(g) It shall be state policy to promote the growth of a single national identity and loyalty binding on all South Africans. At the same time, the state shall recognise the linguistic and cultural diversity of the people and provide facilities for free linguistic and cultural development.

Bill of Rights and Affirmative Action

(h) The constitution shall include a bill of rights based on the Freedom Charter. Such a bill of rights shall guarantee the fundamental human rights of all citizens, irrespective of race, colour, sex, or creed and shall provide appropriate mechanisms for their protection and enforcement.

(i) The state and all social institutions shall be under constitutional duty to eradicate race discrimination in all its forms.

(j) The state and all social institutions shall be under a constitutional duty to take active steps to eradicate, speedily, the economic and social inequalities produced by racial discrimination.

(k) The advocacy or practice of racism, fascism, nazism, or the incitement of ethnic or regional exclusiveness or hatred shall be outlawed.

(l) subject to clauses (i) and (k) above, the democratic state shall guarantee the basic rights and freedoms, such as freedom of association, thought, worship, and the press. Furthermore, the state shall have the duty to protect the right to work and guarantee the right to education and social security.

(m) All parties which conform to the provision of (i) to (k) above shall have the legal right to exist and to take part in the political life of the country.

Economy

(n) The state shall ensure that the entire economy serves the interests and well-being of the entire population.

(o) The state shall have the right to determine the general context in which economic life takes place and define and limit the rights and obligations attaching to the ownership and use of productive capacity.

(p) The private sector of the economy shall be obliged to cooperate with the state in realising the objectives of the Freedom Charter in promoting social well-being.

(q) The economy shall be a mixed one, with a public sector, a private sector, a cooperative sector, and a small-scale family sector.

(r) Cooperative forms of economic enterprise, village industries and small-scale family activities shall be supported by the state.

(s) The state shall promote the acquisition of management, technical, and scientific skills among all sections of the population, especially the blacks.

(t) Property for personal use and consumption shall be constitutionally protected.

Land

(u) The state shall devise and implement a land reform programme that will include and address the following issues:
 • Abolition of all racial restrictions on ownership and use of land
 • Implementation of land reform in conformity with the principle of affirmative action, taking into account the status of victims of forced removals.

Workers

(v) A charter protecting workers' trade union rights, especially the right to strike and collective bargaining, shall be incorporated into the constitution.

Women

(w) Women shall have equal rights in all spheres of public and private life, and the state shall take affirmative action to eliminate inequalities and discrimination between the sexes.

The Family

(x) The family, parenthood, and children's rights shall be protected.

International

(y) South Africa shall be a nonaligned state committed to the principles of the Charter of the OAU and the Charter of the UN and to the achievement of national liberation, world peace, and disarmament.

63 *Harare Declaration*

Excerpted from Statement Prepared by the
ANC and Adopted by the OAU *Ad Hoc*
Committee on Southern Africa, August 21, 1989,
in *Sechaba*, October 1989

[Sections I and V have been omitted.]

II. Statement of Principles

14.0 We believe that a conjuncture of circumstances exists which, if there is a demonstrable readiness on the part of the Pretoria regime to engage in negotiations genuinely and seriously, could create the possibility to end apartheid through negotiations. Such an eventuality would be an expression of the longstanding preference of the majority of the people of South Africa to arrive at a political settlement.

15.0 We would therefore encourage the people of South Africa, as part of their overall struggle, to get together to negotiate an end to the apartheid system and agree on all the measures that are necessary to transform their country into a nonracial democracy. We support the position held by the majority of the people of South Africa that these objectives, and not the amendment or reform of the apartheid system should be the aims of the negotiations.

16.0 We are at one with them that the outcome of such a process should be a new constitutional order based on the following principles, among others:

16.1 South Africa shall become a united, democratic, and nonracial state.

16.2 All its people shall enjoy common and equal citizenship and nationality, regardless of race, colour, sex, or creed.

16.3 All its people shall have the right to participate in the government and administration of the country on the basis of a universal suffrage, exercised through one person, one vote, under a common voters' roll.

16.4 All shall have the right to form and join any political party of their choice, provided that this is not in furtherance of racism.

16.5 All shall enjoy universally recognised human rights, freedoms, and civil liberties, protected under an entrenched bill of rights.

16.6 South Africa shall have a new legal system which shall guarantee equality of all before the law.

16.7 South Africa shall have an independent and nonracial judiciary.

16.8 There shall be created an economic order which shall promote and advance the well-being of all South Africans.

16.9 A democratic South Africa shall respect the rights, sovereignty, and territorial integrity of all countries and pursue a policy of peace, friendship, and mutually beneficial cooperation with all peoples.

17.0 We believe that agreement on the above principles shall constitute the foundation for an internationally acceptable solution which shall enable South Africa to take its rightful place as an equal partner among the African and world community of nations.

III. Climate for Negotiations

18.0 Together with the rest of the world, we believe that it is essential, before any negotiations can take place, that the necessary climate for negotiations be created. The apartheid regime has the urgent responsibility to respond positively to this universally acclaimed demand and thus create this climate.

19.0 Accordingly, the present regime should, at the very least,

19.1 Release all political prisoners and detainees unconditionally and refrain from imposing any restrictions on them.

19.2 Lift all bans and restrictions on all proscribed and restricted organisations and persons.

19.3 Remove all troops from the townships.

19.4 End the state of emergency and repeal all legislation such as, and including, the Internal Security Act, designed to circumscribe political activity.

19.5 Cease all political trials and political executions.

20.0 These measures are necessary to produce the conditions in which free political discussion can take place—an essential condition to ensure that the people themselves participate in the process of remaking their country. The measures listed above should therefore precede negotiations.

IV. Guidelines to the Process of Negotiation

21.0 We support the view of the South African liberation movement that upon the creation of this climate, the process of negotiations should commence along the following lines:

21.1 Discussions should take place between the liberation movement and the South African regime to achieve the suspension of hostilities on both sides by agreeing to a mutually binding ceasefire.

21.2 Negotiations should then proceed to establish the basis for the adoption

of a new constitution by agreeing on, among others, the principles enunciated above.

21.3 Having agreed on the principles, the parties should then negotiate the necessary mechanism for drawing up the new constitution.

21.4 The parties shall define and agree on the role to be played by the international community in ensuring a successful transition to a democratic order.

21.5 The parties shall agree on the formation of an interim government to supervise the process of the drawing up and adoption of a new constitution, govern and administer the country, as well as effect the transition to a democratic order including the holding of elections.

21.6 After the adoption of the new constitution all armed hostilities will be deemed to have formally terminated.

21.7 For its part, the international community would lift the sanctions that have been imposed against apartheid South Africa.

22.0 The new South Africa shall qualify for membership of the Organisation of African Unity.

Nelson Mandela and Oliver Tambo. Stockholm, Sweden, 1990.
(International Defence & Aid Fund for Southern Africa)

Conclusion: Mandela, Tambo, and the ANC in the 1990s

Through the 1980s Mandela and his Rivonia coprisoners, along with Oliver Tambo and his coleaders in exile, became progressively more visible symbols for all South Africans, black and white, pro-government and antigovernment, of the leadership of the ANC. All government efforts to split the ANC by enticing "moderates" away from the communists or to get Mandela to renounce violence in return for release from prison failed. Yet the government of P. W. Botha persisted in its refusal to accept the ANC or its leaders as legitimate representatives of the black majority.

In 1989 the stroke and subsequent resignation of P. W. Botha and the ascendency of F. W. de Klerk as head of the National party created possibilities for new initiatives. P. W. Botha's July meeting with Nelson Mandela marked a dramatic and tacit reversal of government policy. De Klerk's subsequent unconditional release of Sisulu and the six other Rivonia prisoners in October and the toleration that followed of their open political activity seemed a further sign that the new National party government headed by F. W. de Klerk was ready to accept the ANC in some form as a negotiating partner in any discussions about the future of South Africa. De Klerk's statement on December 2, 1989, that Mandela would be released, followed by his meeting with Mandela on December 13, only heightened anticipation of how and when the government would finally release Mandela and permit him to resume open political activity. De Klerk's final announcement in Parliament on February 2, 1990, of the government's intention to release Mandela unconditionally and the lifting of the bans on the ANC, PAC, SACP, and other antiapartheid organizations set the stage for Mandela's release on February 11, opening a new chapter in the seventy-eight-year struggle of the ANC to obtain full democratic rights for Africans in the land of their birth.

Botha's and de Klerk's belated and explicit recognition of Mandela capped a steady process by which the ANC had returned to the center of the political stage, occupying again the position that it held in the 1950s as the most prominent of the black opposition groups. In more than four decades of opposition to the National party government, the ANC remained remarkably

consistent in its vision for an apartheid-free, nonracial social democracy with equal opportunities for all citizens. After 1960 it reluctantly adopted violence and adapted to enforced exile and a clandestine existence. In the post-Soweto years its new stance, complemented by renewed attention to popular mobilization and the encouragement of dialogue with a broad range of opponents to apartheid, enabled it to achieve unprecedented mass support and national preeminence.

The ANC of the 1990s has many features in common with the ANC of the 1950s. Although many leading figures of the 1950s have died in exile or in South Africa (most notably Chief Albert Luthuli), the ANC's most prominent current leaders, Nelson Mandela and Walter Sisulu in the country and Oliver Tambo overseas were among those in the forefront when the ANC was banned in 1960. They are of the political generation that rose through the ANC Youth League in the 1940s to revitalize and expand the ANC in the 1950s. Under the leadership of their generation in the 1950s, many of the major goals for a new political and economic order in South Africa and the political tactics to be practiced to realise these goals were fashioned; many of the goals and tactics remain essentially unchanged today.

Articulating their vision for a postapartheid society through the 1950s and early in the 1960s, Mandela, Tambo, and the ANC delineated a nonracial and democratic South Africa in which African nationalism—conceived as the freedom and fulfillment of the African people in their own land—could be realized (see Documents 14, 23, and 24). Central to their vision were a universal franchise for all South Africans, legally guaranteed individual rights, and a government open to all South Africans. Impressed by the egalitarian features of socialist societies and determined to achieve redistribution of economic power in the interests of the majority, they advocated a mixed economy in which banks, mines, and selected large industries would be state owned and in which the state would actively intervene to advance the economic well-being of the black disadvantaged, notably in redressing inequities in access to land. Deeply influenced by antiracist and nonracial sentiment, they advocated the end of not only apartheid statutes but also all racially discriminatory legislation and practices. They urged a policy of racial inclusiveness and participation by South Africans of all races in common institutions. The Freedom Charter summarized their blueprint for a new and just South Africa (see Document 14).

To achieve their goals, Mandela and Tambo looked to the ANC as the prime vehicle for mobilizing expanded opposition to apartheid. In keeping with practice since the foundation of the organization in 1912, the ANC was to continue to be an African "parliament" inclusive of all political persuasions united in common opposition to discrimination and apartheid. Among the political persuasions that had been accepted by the ANC since the 1920s was communism. Although Mandela and Tambo had been among the Youth League members critical of communist participation, in the wake of the Suppression of Communism Act of 1950 and the enthusiastic participation of banned communists in the common struggles of the 1950s, they came to accept the historical ANC position of including all Africans who accepted ANC goals,

regardless of their ideology (see Document 23). Similarly, moving away from the original Africanist exclusivist stance of the Youth League, they came to accept that the ANC should work together with other antiapartheid opponents of all races. From 1955 onward these groups were organized together in the multiracial Congress Alliance. Through united political struggle under the leadership of the African-led ANC, it was believed that apartheid eventually could be challenged and ended.

More than three decades later Mandela, Tambo, and the ANC still are committed to the broadly defined conceptions of democracy, socialism, and nonracialism that they put forth in the 1950s. In his interviews with Lord Bethell and Samuel Dash in 1985, and then subsequently in discussion with the EPG, Mandela not only reaffirmed his commitment to the Freedom Charter but also conveyed his convictions about the relevance of Western democratic institutions for a postapartheid South Africa, reiterating the praise for the British Parliament and the American division of powers expressed in his Rivonia speech. At the same time he reiterated his belief that a mixed economy would be appropriate (see Documents 34, 35, and 37). Tambo has articulated similar views, both before foreign audiences (see Document 53) and in the lone post-1960 opportunity he has had to speak directly to South Africans, through the interview published in the *Cape Times* in 1985 (see Document 52). In mid-1988 the ANC in exile released its *Constitutional Guidelines for a Democratic South Africa*, also published in South African newspapers, in which the sentiments of Mandela and Tambo were echoed in a formal ANC document stating its parameters for debate on a postapartheid constitution (see Document 62). In contrast with the Freedom Charter the *Constitutional Guidelines* implicitly endorsed an independent judiciary and a multiparty system (provided that racism is not advocated) at the same time they muted the commitment to extensive nationalization.

On the question of the role of communists in the ANC and links with the Soviet Union, an issue regularly raised by Americans and Britons, Mandela has reiterated his view that the ANC is beholden to no other body, likening its communist members to radicals in Britain (see Document 35). Tambo likewise has asserted his confidence that the ANC would continue to determine its own policies independently while including communists in its ranks and accepting support from the Soviet Union and its allies (see Document 52). In a forceful statement reaffirming the antiracist convictions that had driven him and his generation of ANC members, Tambo justified the ANC's willingness to include all accepting its antiapartheid platform within its ranks, including communists, by reference to American willingness to create a broad anti-Nazi alliance in World War II, including the Soviet Union (see Document 53).

The banning of the ANC in 1960 and the immediate necessity of reconsidering the strategy and tactics for survival underground and in exile, conditions for which the ANC was ill prepared, precipitated rethinking in the ANC on the central question of whether its policy of nonviolence should be continued. Mandela was among the small group of ANC leaders who established Umkhonto we Sizwe to conduct sabotage and continue toward guerrilla activity,

articulating a measured argument for the use of carefully controlled violence against "hard" political, military, and economic targets with no loss of life, if possible, as a tool to bring a change in government policy (see Document 23).

To a large degree, the position formulated in the early 1960s, in which the indiscriminate killing of terrorism was rejected, has been sustained through the 1980s in the vastly changed situation of more extensive government violence and mass mobilization in South Africa. Since the reappearance of Umkhonto we Sizwe guerrillas in the late 1970s, many of their actions have been "armed propaganda" directed at both white and black, avoiding as much as possible the loss of life. From the early 1980s, in the wake of South African attacks on targets in neighboring states and successful assassinations of exiled ANC leaders, such as Joe Gqabi in Zimbabwe, and even more in the mid-1980s with rising injuries and loss of life at the hands of the police and the military called in to suppress mass demonstrations in the townships, the ANC argued that the distinction between "hard" military targets and "soft" nonmilitary targets would become blurred in the intensification of the struggle against the violence of apartheid (see Document 51). Amidst growing anger at the government repression under the state of emergency, Umkhonto we Sizwe members placed explosives not only in government buildings but also in shopping centers and public gathering places, resulting in civilian casualties. Responding to vigorous debate in the ANC and to outside criticism Tambo led the National Executive Committee in August 1988 to restate explicitly that it was contrary to ANC policy to select solely civilian targets, distancing itself from the actions of its headstrong guerrillas in the field and broadly reaffirming the ANC's stance on the controlled use of violence set in the early 1960s.

The question of violence was also posed in the stark new form of so-called black-on-black violence in the townships, including widely publicized incidents of "necklacing." In response to questions, Tambo explained the crowds' attacks against individuals regarded as collaborators as an understandable response of Africans to the violence inherent in apartheid, not as a part of ANC strategy (see Document 51). Both Mandela and Tambo convey the image of reluctant advocates of the use of violence. In their view, violence is a necessity forced on the ANC by the violence of the state and the apartheid system and the lack of alternatives left to it by the government; it is appropriate only if it is used in carefully controlled fashion to complement and advance political mobilization (see Documents 24, 34, and 52).

As the role of violence became a central issue for the ANC after its banning in 1960, so too did questions concerning the international activities of the ANC. Before 1960 the ANC had paid limited attention to overseas operations and the mobilization of overseas support. But as the ruthless government campaign of the early 1960s succeeded in its goals of imprisoning much of the ANC leadership, destroying the initial ANC and Umkhonto we Sizwe underground, and forcing many remaining activists into exile, the ANC inevitably was forced to give priority to external operations to muster crucial financial, logistical, military, and political support.

In its efforts to gain facilities and funds for exile operations the ANC has had mixed success on the African continent, mustering generally strong support from the Front Line States of Angola, Botswana, Mozambique, Tanzania, Zambia, and Zimbabwe, while encountering difficulties with Malawi, Swaziland, and more distant francophone states. Beyond the continent it has received Soviet and East European military and training support plus material and moral support from Western European and North American sources.

Since the early 1960s the ANC has advocated economic sanctions against South Africa as a means of forcing the government to reconsider its policies and to limit loss of life in the transition from apartheid (see Document 24). Frustrated by its lack of success in influencing the Western powers, particularly the United States and Britain, the ANC welcomed the passage of limited economic sanctions by the United States in 1986 (see Document 53).

By the 1980s the ANC's external efforts, both in lobbying to get governments and international organizations to change their policies toward South Africa and in diplomatic representation to gain practical support for its exile operations, had become the major visible component of its organizational activities. In contrast with the 1950s, external sources of support played a major role in the ANC's ongoing operations.

The ANC of the 1990s is committed to the racial inclusiveness that has characterized it since the 1950s, but the organizational expression of its commitment has shifted from multiracialism to nonracialism. In the 1950s questions about the role of non-Africans in the ANC continued to be raised, becoming more salient after the formal establishment of the multiracial Congress Alliance in 1955. Africanists, invoking the Africanism of Anton Lembede and the stance of the Youth League in the 1940s, split away in 1959 to form the PAC, asserting inter alia that only Africans should be members of a liberation movement. The ANC rejected the PAC contention, reaffirming its commitment to working with opponents of all races who shared its views, a practice continued underground and in exile.

In 1969, at the First National Consultative Conference in Morogoro, Tanzania, the ANC translated its commitment, expressed in the multiracialism of the Congress Alliance, into nonracialism when it opened membership to all South Africans. Simultaneously, in recognition of the centrality of African interests (and perhaps explicitly recognizing some of the appeal of Black Consciousness), it gave priority to recognizing African national pride and confidence and restricted membership of the National Executive Committee to Africans. In the mid-1980s, however, at the Second National Consultative Conference in Kabwe, Zambia, at a time when the nonracialism of the UDF in South Africa was expanding, the ANC removed the last barriers in the organization to non-Africans by elevating two Indians, two Coloreds, and one white to the thirty-member National Executive Committee. In contrast with the Congress Alliance of the 1950s, composed of linked racially based political bodies headed by the ANC, the ANC in the 1980s became a nonracial organization open at all levels to South Africans of all races.

Even more striking was the change from the 1950s to the 1980s in the nature and base of support for the ANC. In the 1950s, spurred by the Defiance Campaign of 1952–53, the ANC expanded to a membership of approximately 100,000, concentrated for the most part in urban townships. Additional tens of thousands responded intermittently to ANC campaigns but were not actively involved in the organization. With the banning of the ANC in 1960 a new situation was created in which the ANC in the country could be only an ambiguously stated affinity or implicit identification with an underground and exile organization.

With membership in the ANC illegal and the declaration of support for a banned organization a criminal offense, the costs of explicitly identifying with the ANC were high. Through the 1960s and 1970s the government systematically moved not only against suspected Umkhonto we Sizwe members and underground ANC cells but also against all who manifested support for the banned organization. Yet the success of the mass mobilization campaigns of the 1980s, led primarily by the ANC-oriented UDF and its affiliates since 1983, made it impossible for the government to suppress all support for the ANC. Although no longer a legal political organization as it had been in the 1950s, the ANC as a recognizable political orientation, symbolized in its charterist stance, clearly again captured the loyalties of a broad spectrum of South Africans. The response to the activities of the UDF and its affiliated bodies showed that hundreds of thousands of black South Africans, if not millions, identified with the charterist orientation and, through it, with the ANC.

In contrast with the supporters of the Congress Alliance in the 1950s, the bulk of charterist supporters at the end of the 1980s were grouped in hundreds of local community organizations or trade unions affiliated with the UDF or COSATU rather than as members of a single national political organization. The organizationally decentralized nature of charterist affinity remained a source of resiliency in the face of government repression of national political organizations, including the UDF. The fact that the expression of support for charterist goals easily fused with a general antiapartheid stance and did not require explicit adherence to a party platform also ensured a broad diversity of viewpoints among those who identified with an ANC orientation.

Other major features of the ANC in the 1980s marked not so much shifts from the pre-1960 period of open politics but shifts reflecting the changing currents of post-1960 black opposition politics. Continuing in the founding ANC tradition of opposition to "tribal" bodies as a base for national African politics, the ANC opposed separate development from its inception under Verwoerd in the 1950s. Yet in the late 1960s and 1970s the ANC explored the utility of working through and with independent-minded bantustan leaders, specifically identifying Gatsha Buthelezi with his solid base in KwaZulu. From 1980, however, relations with Buthelezi and Inkatha soured in the wake of his opposition to school boycotts and other ANC-supported campaigns in South Africa, as well his well-publicized antisanctions stance, his attacks on ANC "terrorism," and Inkatha-supported township violence in Natal in the mid-1980s. Nevertheless, the UDF attempted to negotiate with Inkatha to stop

township violence in Natal, and to this end in 1989 Mandela continued to correspond with Buthelezi.

In line with the overarching goal of establishing as broad a front as possible, the ANC remained willing to meet with bantustan leaders who seem receptive, entertaining a delegation of KaNgwane leaders in Lusaka in 1986 and urging that potentially sympathetic elements in the bantustan administrations be cultivated (see Document 61). The fruits of this policy were dramatically visible on November 26, 1989, when the recently freed Walter Sisulu addressed a pro-ANC rally in Umtata, the capital of the Transkei, and also met with General Bantu Homolisa, the head of the military government of South Africa's first "independent" bantustan who has continued to show signs of reversing the policies of the deposed Matanzima regime.

The ANC's relationships with adherents of Black Consciousness have also shifted with changes in the nature of both the Black Consciousness movement and the ANC's fortunes. From an initial critical stance in the late 1960s the ANC moved in the mid-1970s to seek links with Black Consciousness adherents. After Soweto, the 1977 bannings of Black Consciousness organizations and the imprisonment and flight of many Black Consciousness movement militants, the ANC was successful in attracting significant numbers of the young exiles to its ranks, anticipating a movement that accelerated internally in the 1980s, particularly as Black Consciousness militants were released from prison, where many had changed their views through close contact with ANC leaders and ordinary members (see Documents 29 and 30). Although important Black Consciousness adherents remained opposed to white participation and committed to exclusively black opposition through AZAPO and other Black Consciousness–oriented successor organizations, by the mid-1980s many former supporters were playing prominent roles in the nonracial UDF, and many Black Consciousness-initiated community organizations were participating in the UDF.

The ANC unquestionably enjoys strongly rooted and widespread support among the black majority and growing respectability among a minority of the white population. Indicative of the depth and breadth of its support was the crowd of seventy-thousand, including whites, that assembled for the first ANC rally permitted by the government in late October 1989, shortly after the release of Sisulu and his fellow prisoners. Among ANC supporters are South Africans of all ages, ranging from the pre-1960 generations, to those whose political initiation came through Black Consciousness, to even more recently mobilized youth whose participation started with the militant actions of the 1980s. As all ages are represented, so are diverse political viewpoints, ranging from communists to non-Marxist socialists to radical democrats to more conservative elements.

Buoyed by this diverse support, the ANC enters the 1990s dedicated to realizing a postapartheid South Africa, on the basis of a program articulated in the Freedom Charter of the 1950s and modified little in its essential features by the Constitutional Guidelines for a Democratic South Africa of 1988. Among the antiapartheid opposition it faces rivalry from other militants, both

those who still identify with the PAC as well as whose who identify with the modified Black Consciousness stance that also rejects nonracialism, and also gives higher priority to the achievement of socialism rather than merely to the institution of full democracy. It also faces the seemingly well entrenched Inkatha organization, headed by Gatsha Buthelezi and supported by the financial and institutional resources of KwaZulu.

Unlike its rivals in the antiapartheid movement, the ANC is strongly established both outside and inside the country. Although it has temporarily lost the unifying presence of Oliver Tambo, it is active on many fronts. It has strong links with many African states. It has relied on the Soviet Union for the majority of its military requirements and continues to receive assurance of Soviet support. It actively maintains its policy of sustaining and expanding contacts with both antiapartheid citizen movements and governments in Western Europe and North America to increase pressure on the National party government.

The center of gravity of ANC activities, however, has unquestionably shifted back to South Africa. Despite the increasing government surveillance and intimidation in the 1980s, the three internal ANC leadership clusters—Mandela and his fellow prisoners, the underground internal organizations of both Umkhonto we Sizwe and the ANC, and those operating above ground and semiclandestinely in the UDF and COSATU—managed defiantly and resourcefully to extend their capacity to communicate and coordinate with one another and the fourth leadership cluster, the exiled leadership (see Documents 42 and 57). In the changed setting of 1989 created by the new tolerance of the National party government headed by de Klerk, the four components of the ANC leadership seized new opportunities to coordinate their activities and to continue to build support among the South African population, including antiapartheid whites who did not identify fully with the principles and goals of the ANC.

With the unbanning of the ANC on February 2, 1990, and the release of Nelson Mandela on February 11, the antiapartheid struggle of more than four decades entered a new stage. Speaking before tens of thousands of supporters within hours of his release, Mandela reaffirmed the aims and goals of the ANC which had been articulated through the 1980s, emphasizing its unchanging commitment to majority rule, universal suffrage, and democratic rights in a unitary South African state in which major economic reforms, including nationalization, would be required to redress the inequities of apartheid and discrimination. He reiterated the ANC's willingness to enter negotiations with the government, listing the conditions that had been enumerated in the Harare Declaration. At the same time he repeated that armed struggle remained appropriate as an additional weapon to challenge the government to end apartheid (see Document 44).

In the hectic days and weeks that followed Mandela's release, he and his ANC associates continued to advance the platform articulated prior to his release. In countless meetings and appearances, including consultations with ANC supporters and leaders of the antiapartheid opposition, interviews with

domestic and foreign correspondents, and public speeches before nationwide audiences in South Africa, Mandela was thrust into the maelstrom of everyday operational politics. Designated deputy president of the ANC at his first meeting with the National Executive Committee in Lusaka in early March, Mandela carefully showed that he would conduct himself within the ANC ethos to which he had so often pledged allegiance—that of a loyal member of the organization. It was also clear that he had become the prime spokesperson for the organization at home and abroad.

In the changed setting of freedom and legality for the ANC, Mandela, Sisulu, and other ANC leaders worked simultaneously to broaden the anti-apartheid movement linked with the ANC and to push the government to release remaining political prisoners, amnesty exiled ANC members, and end the state of emergency. With the full support of the National Executive Committee, Mandela led an ANC delegation comprised of longtime exiles (including military leaders and communists), erstwhile prisoners, representatives of the UDF, trade unions, and churches, and representing all of South Africa's racial groups to a three-day meeting from May 2 to May 4 with President de Klerk and cabinet ministers at Groote Schuur, the president's residence in Cape Town. At the first meeting ever between an ANC delegation and the head of the white South African government, agreement was reached that the state of emergency and security legislation would be reviewed by the government and mechanisms would be established to consider the release of political prisoners and the return of exiles. In well-publicized visits elsewhere in Africa and in Europe and North America, Mandela counterpointed the negotiations with repeated appeals for the retention of sanctions until the full dismantling of apartheid.

The first stage of the negotiation process advocated by Mandela from prison (see Document 43) and by the ANC in the Harare Declaration (see Document 63) has begun. The length of the process and the specific details of the new postapartheid South Africa remain unknown. However, Mandela and the ANC have demonstrated that they will continue to demand, as they have since 1948, the end of apartheid, democratic rights and full opportunity for all South Africans, and recognition as the preeminent voice of the opposition.

Abbreviations

AAC	All African Convention
ANC	African National Congress
ANCYL	African National Congress Youth League
ARM	African Resistance Movement
AZAPO	Azanian People's Organization
AZASO	Azanian Students Organization
BPC	Black People's Convention
CONCP	Conferencia de Organizacoes Nacionalistas das Colonias Portuguesas
COP	Congress of the People
COSATU	Congress of South African Trade Unions
CUSA	Congress of Unions of South Africa
EPG	Eminent Persons Group
FOSATU	Federation of South African Trade Unions
FRELIMO	Frente de Libertacao de Mocambique
ICU	Industrial and Commercial Workers Union
IDASA	Institute for a Democratic Alternative in South Africa
MDM	Mass Democratic Movement
MK	Umkhonto we Sizwe
MNR	Movement of National Resistance (RENAMO)
MPLA	Movimento Popular de Libertacao de Angola
NACTU	National Council of Trade Unions
NP	National party
NUSAS	National Union of South African Students
OAU	Organization of African Unity

PAC	Pan Africanist Congress
RENAMO	Resistencia Nacional de Mocambique (MNR)
SABA	South African Black Alliance
SACC	South African Council of Churches
SACP	South African Communist party
SADF	South African Defense Force
SASM	South African Student Movement
SASO	South African Student Organization
SWAPO	South West African People's Organization
UDF	United Democratic Front
UNITA	Uniao Nacional para a Independencia Total de Angola
ZAPU	Zimbabwe African People's Union

Chronology of Important Events, 1910–1990

1910 Formation of the Union of South Africa; installation of General Louis Botha as first prime minister of South Africa

1911 Mines and Works Act (legalizing the "color bar" in employment)

1912 Founding of the African National Congress (under the original name of the South African Native National Congress)

1913 Natives Land Act (establishing the African reserves that later served as the base for the bantustans)

1914 Founding of National party, with General J. B. M. Hertzog as its leader

1916 Establishment of South African Native College at Fort Hare

1917 Birth of Oliver Tambo (October 27)

1918 Birth of Nelson Mandela (July 18)

1919 Initiation of South-West Africa as a South African mandate under the League of Nations; founding of the Industrial and Commercial Workers Union (ICU); death of General Botha, with General J. C. Smuts succeeding him as prime minister; approval of the constitution of the South African Native National Congress

1921 Founding of the Communist party of South Africa

1922 Suppression of Rand rebellion by the government using military force to crush the white miners' strike

1923 Renaming of South African Native National Congress as the African National Congress; Natives (Urban Areas) Act (establishing the principle that South Africa's cities belong to whites)

1924 Installation of General J. B. M. Hertzog as prime minister as result of the National party–South African Labor party joint electoral victory

1926 Submission to Parliament by Prime Minister Hertzog of his "native bills"

1928 Breaking away of Natal branch of ICU to become ICU yase Natal

1929 Further splits in the ICU, with the Independent ICU founded in opposition to the ICU; founding of the South African Institute of Race Relations

1930 Suffrage for white women

1933 Invitation by Prime Minister Hertzog to General Jan Smuts to form a coalition government

1934 Founding of the "Purified" National party under leadership of D. F. Malan; formation of United party (UP) by followers of Hertzog and Smuts

1935 Founding of the All African Convention (AAC)

1936 Enactment of "Hertzog bills"—the Representation of Natives Act (removing Cape African voters from the common roll, setting up separate representation in Parliament, and establishing the Natives' Representative Council) and the Native Trust and Land Act (providing for additional purchase of land to add to the African reserves)

1939 Hertzog's resignation as prime minister over issue of South Africa's entry into World War II; General Smuts's succession as prime minister

1940 Joining of Hertzog's followers with Malan's in the Reunited National party; election of Dr. A. B. Xuma as president-general of the ANC

1941 Atlantic Charter

1943 ANC's adoption of Africans' Claims; provisional founding of Non-European Unity Movement (NEUM)

1944 Founding of the African National Congress Youth League (ANCYL)

1945 Representation of ANC at fifth Pan-African Congress, Manchester, England

1946 African mine workers' strike; adjournment of Natives' Representative Council in protest over government actions

1947 Issuing by presidents of ANC (Dr. Xuma), Natal Indian Congress (Dr. Naicker), and Transvaal Indian Congress (Dr. Dadoo) of Joint Declaration of Cooperation, commonly known as the "Doctors' pact"

1948 Election victory by National party, with Malan becoming prime minister

1949 Prohibition of Mixed Marriages Act (first major piece of the new apartheid legislation); ANC's adoption of Programme of Action, with Dr. James S. Moroka as president-general and Walter M. Sisulu as secretary-general

1950 Major apartheid legislation: Group Areas Act, Immorality Amendment Act, Population Registration Act, and Suppression of Communism Act; dissolution of Communist party of South Africa under threat of Suppression of Communism Act; ANC's stay-at-home day of protest— National Day of Protest and Mourning (June 26)

1951 Bantu Authorities Act; submission of Separate Representation of Voters Bill to Parliament to remove Coloreds from common voting roll; joint meeting of the ANC and South African Indian Congress (SAIC) executive committees

1952 Establishment by Africanists in ANC of Bureau of African Nationalism; joint Defiance Campaign, by ANC and SAIC, with the government responding with arrests and banning of leaders; election of Albert Luthuli as president-general of ANC

1953 Additional significant apartheid legislation: Bantu Education Act, Criminal Law Amendment Act, and Public Safety Act; constitutional controversy over government efforts to remove Colored voters from the common roll; founding of the Liberal party; Western Areas Removal Campaign; founding of South African Coloured People's Organization (SACPO); founding of South African Congress of Democrats (COD); founding of underground South African Communist party (SACP) as successor to dissolved Communist party of South Africa

1954 Planning of Congress of the People; succession of J. G. Strijdom as prime minister

1955 Removal of Africans from Sophiatown (Johannesburg); founding of the South African Congress of Trade Unions (SACTU); ANC-led boycott of Bantu education; meeting of Congress of the People at Kliptown, where it adopts the Freedom Charter

1956 Government's requirement of African women to carry passes; government's successful effort to remove Colored voters from common roll; arrest of 156 persons on charges of treason, including Mandela, Tambo, and Luthuli, leading to the treason trial, with final charges dismissed in 1961

1957 Call by SACTU and ANC for £1-a-day campaign

1958 Beginning of government's piecemeal banning of ANC; meeting of First Conference of Independent African States in Ghana; succession of Dr. Hendrik Verwoerd as prime minister upon Strijdom's death; walkout by Africanists from ANC conference

1959 Promotion of Bantu Self-Government Act, establishing bantustans and ending separate representation of Africans by whites in Parliament; Extension of University Education Act, establishing apartheid in higher education; founding of the Pan-Africanist Congress (PAC); founding by former UP members of Progressive party; planning by ANC and PAC of rival anti–pass law campaigns

1960 Sharpeville massacre (March 21); departure of Oliver Tambo from South Africa to head the ANC's organization in exile; declaration of a state of emergency (March 30–August 31); Unlawful Organizations Act, empowering government to proscribe national political organiza-

tions; banning of ANC and PAC under Unlawful Organizations Act; consultative conference calling for "all-in" conference

1961 Announcement by Prime Minister Verwoerd of intention to withdraw South Africa from British Commonwealth; rebellion against Portuguese rule launched in Angola; call by All-in African Conference for a national convention; conclusion of treason trial, with all defendants found not guilty; stay-at-home protest over South Africa's becoming a republic; formation of Umkhonto we Sizwe; award of Nobel Peace Prize to Albert Luthuli; Umkhonto's launch of sabotage campaign

1962 Six-month-visit by Nelson Mandela outside South Africa, to independent African countries and Great Britain; passage of Sabotage Act; arrest of Nelson Mandela and sentence to five years in prison; call by UN General Assembly for sanctions against South Africa

1963 Mass arrests of PAC underground members; passage of General Laws Amendment Act (allowing state to hold suspects for ninety days without charging them with an offense; sentence of Walter Sisulu to six years in prison (but he skips bail and goes underground); capture by police of underground ANC leadership in Rivonia raid; establishment of Transkei as first self-governing bantustan

1964 Conclusion of Rivonia trial, with Nelson Mandela, Dennis Goldberg, Ahmed Kathrada, Govan Mbeki, Raymond Mhlaba, Andrew Mlangeni, Elias Motsoaledi, and Walter Sisulu sentenced to life imprisonment; beginning of Frelimo's war to liberate Mozambique from Portuguese rule

1965 Rhodesia's Unilateral Declaration of Independence (UDI) from Great Britain

1966 Independence for Basutoland as Lesotho; independence for Bechuanaland as Botswana; upholding by International Court of Justice of South Africa's claims to South-West Africa; assassination of Prime Minister Verwoerd and succession of B. J. Vorster as prime minister; SWAPO's declaration of war against the South African occupation of South-West Africa; UN General Assembly's revocation of South African mandate over South-West Africa

1967 Death of Albert J. Luthuli, ANC president-general; succession of Oliver Tambo as acting president-general; crossing of combined force of ANC–ZAPU guerrillas over Zambezi River and their attacks in Rhodesia; establishment by South Africa and Malawi of diplomatic relations; Terrorism Act (broadened definition of terrorism and authorized indefinite detention)

1968 UN General Assembly's decree that South-West Africa henceforth will be called Namibia; independence for Swaziland; Prohibition of Political Interference Act (prohibiting multiracial political parties); dissolution of Liberal party and dismissal by Progressive party of black members

1969 Endorsement by UN Security Council of General Assembly action revoking South African mandate over Namibia; ANC consultative conference at Morogoro, Tanzania; inaugural meeting of South African Students Organization (SASO); formation by NP dissidents of right-wing Herstigte National party (HNP)

1972 Founding of the Black People's Convention (BPC)

1973 Massive wave of strikes by African workers in Natal and on the Witwatersrand

1974 Military coup overthrowing the Caetano government in Portugal; revival of Inkhatha as Zulu-based political organization under the leadership of Chief Gatsha Buthelezi

1975 Independence for Mozambique and Angola; outbreak of civil war in Angola; invasion by South Africa

1976 Repulsion by Angolan government, with the assistance of Cuban troops, of South African invasion; Soweto uprising (beginning on June 16); establishment of Transkei as first "independent" bantustan

1977 Death of Steve Biko in police detention; banning by government of seventeen Black Consciousness and other antiapartheid organizations; dissolution of United party; formation of Progressive Federal party from Progressive party and moderate ex–United party members; banishment of Winnie Mandela to Brandfort, Orange Free State; imposition by UN Security Council of mandatory arms embargo on South Africa

1978 Forced resignation of Prime Minister Vorster because of government scandal (Muldergate); succession of P. W. Botha as prime minister; founding of the Azanian Peoples Organization (AZAPO); formation of the Federation of South African Trade Unions (FOSATU); installation of Bishop Desmond Tutu as first black secretary of South African Council of Churches (SACC)

1979 Lancaster House Agreement, ending Rhodesian UDI and paving the way for a majority-ruled Zimbabwe

1980 Beginning of *Sunday Post* editor Percy Qoboza's "Free Mandela" campaign; nine-month boycott of schools by black high school and university students; founding of Council of Unions of South Africa (CUSA); establishment of Zimbabwe's independence; successful and dramatic raid by Umkhonto we Sizwe on Sasol refining complex

1981 Assumption by Progressive Federal party of role as official parliamentary opposition; recognition by Labor Relations Amendment Act of African trade union organizing and collective bargaining; step-up of South Africa's policy of destabilizing neighboring African states

1982 Formation of Conservative party (CP) by National party dissidents opposing projected new constitution (providing for power sharing with

Coloreds and Asians); transfer of Nelson Mandela, Walter Sisulu, and three other Rivonia defendants from Robben Island to Pollsmoor Prison; attack on Koeberg nuclear power plant outside Cape Town by Umkhonto we Sizwe; display of ANC colors in mass demonstration at funeral of trade union organizer Neil Aggett

1983 Explosion of Umkhonto car bomb at air force headquarters in Pretoria; referendum among white voters for new constitution establishing tricameral parliament for whites, Coloreds, and Asians; founding of National Forum Committee; founding of United Democratic Front (UDF); beginning of large-scale school boycotts under leadership of the Congress of South African Students (COSAS)

1984 Nkomati Accord between Mozambique and South Africa; award of Nobel Peace Prize to Bishop Desmond Tutu; elections for the new Colored and Indian chambers of Parliament under provisions of new constitution boycotted by majority of voters; promulgation of new constitution; election of P. W. Botha as president; outbreak of black township revolt against apartheid, with military units sent into townships

1985 Offer by President Botha to release Mandela in return for his renouncing violence; commencement of visits by delegations of white and black groups from South Africa to Lusaka (Zambia) to talk with ANC leaders; large-scale protests over government intentions to forcibly remove Africans from the Crossroads settlement outside Cape Town; government declaration of state of emergency in twenty-six magisterial districts; Second ANC Consultative Conference at Kabwe, Zambia; suspension of credit by foreign banks, thereby creating financial crisis; founding of Congress of South African Trade Unions (COSATU)

1986 Resignation of Van zyl Slabbert from Parliament and leadership of Progressive Federal party; formation of Institute for a Democratic Alternative in South Africa (IDASA); lifting by government of 1985 state of emergency; three months later, an imposition of national state of emergency, with thousands detained; unsuccessful attempt by Commonwealth Eminent Persons Group (EPG) at mediation between the government and its opponents; simultaneous South African raids on Gaborone (Botswana), Harare (Zimbabwe), and Lusaka (Zambia); repeal of influx control regulations (pass laws); passage by U.S. Congress of Comprehensive Anti-Apartheid Act, over President Ronald Reagan's veto; imposition of near total censorship on media reports of political protest

1987 Visit by President Oliver Tambo of ANC to United States, received by Secretary of State George Shultz; IDASA-sponsored meeting in Dakar (Senegal) of ANC leaders and Afrikaner professionals; release from prison of Rivonia trialist Govan Mbeki; escalation of violence between Inkatha supporters and UDF adherents in Natal, hundreds killed

1988 Ban by government of seventeen antiapartheid organizations (including UDF) from political activity; beginning of negotiations among South Africa, Cuba, and Angola under United States' auspices over withdrawal of Cuban troops from Angola and Namibian independence; boycott by majority of blacks of government-sponsored, racially segregated local council elections; transfer of Nelson Mandela from Pollsmoor Prison to hospital and subsequently to clinic for treatment of tuberculosis and then to bungalow on grounds of Victor Verstor prison in Paarl; signing by South Africa, Cuba, and Angola of linked agreements providing for Namibian independence and withdrawal of Cuban troops from Angola

1989 President Botha's stroke and succession of F. W. de Klerk to leadership of National party; meeting of Nelson Mandela with President Botha at presidential office in Cape Town; beginning of Mass Democratic Movement's Defiance Campaign; Oliver Tambo's stroke and removal to London; resignation of President Botha and succession of F. W. de Klerk as president after white election; President de Klerk's announcement of end of beach segregation and other petty apartheid regulations and freeing of Walter Sisulu and other remaining Rivonia trialists from prison; mass rally called for still-banned ANC, drawing 70,000 supporters to Soweto stadium; Conference for a Democratic Future, bringing 4,462 antiapartheid delegates to University of Witwatersrand; meeting of Nelson Mandela with President de Klerk at presidential office in Cape Town (December 13)

1990 Commencement of treatment of Oliver Tambo in Swedish clinic; meeting of Walter Sisulu, Govan Mbeki, and other Rivonia trialists in Lusaka with ANC leadership in exile; end to three-month railway strike, with reinstatement of 23,000 workers; President de Klerk's announcement at the opening of Parliament of unbanning of ANC, PAC, SACP, and other organizations, relaxation of some emergency regulations, and impending unconditional release of Nelson Mandela (February 2); release of Nelson Mandela from Victor Verster prison (February 11)

Guide to Further Reading

The published literature on twentieth-century South African history and politics is extensive. The University of California Press, for example, offers a Perspectives on Southern Africa series, now numbering some forty-four volumes, and other publishers also list many titles pertaining to South Africa. Several journals also have published articles relevant to the contents of our book. The most important of these is the *Journal of Southern African Studies*. It is not our purpose, however, to provide a thorough review of the entire body of this literature. Rather, we want only to suggest further reading on the topic of black politics and especially the roles of Mandela, Tambo, and the ANC during the post–World War II era. Readers should keep in mind, however, the much larger body of literature and also be aware that the works we suggest are only an introduction.

For those who are unfamiliar with South African history in general, a good place to start is with J. D. Omer-Cooper, *History of Southern Africa* (Portsmouth, N.H.: Heinemann, 1987), which provides a good introductory overview of the region's history. For more detailed studies, see Leonard Thompson, *A History of South Africa* (New Haven, Conn.: Yale University Press, 1990); and T. R. H. Davenport, *South Africa: A Modern History*, 3rd ed. (Toronto: University of Toronto Press, 1987), which also contains exceptionally thorough bibliographic notes. Because Africans have been fighting the policy of apartheid for more than forty years, some readers might wish to learn more about apartheid. A useful study is that by Leonard Thompson, *The Political Mythology of Apartheid* (New Haven, Conn.: Yale University Press, 1985). Americans in particular also need to be aware of the differing race relations in the United States and in South Africa, a topic that is ably dealt with by George Fredrickson, *White Supremacy: A Comparative Study in American and South African History* (New York: Oxford University Press, 1981); and by John W. Cell, *The Highest Stage of White Supremacy: The Origins of Segregation in South Africa and the American South* (Cambridge, England: Cambridge University Press, 1982).

The antiapartheid struggle that began in 1948 constitutes only the most recent chapter in a long history of efforts by Africans to secure their full rights in a common South African society. For the formative period of African politics, see Andre Odendaal, *Black Protest Politics in South Africa to 1912* (Totowa, N.J.: Barnes & Noble, 1984). Peter Walshe, *The Rise of African Nationalism in South Africa: The African National Congress, 1912-1952* (Berkeley and Los Angeles: University of California Press, 1971), takes up where Odendaal leaves off with his study of the oldest and most important African political organization in South Africa, and indeed the oldest such organization in sub-Saharan Africa. There are two studies that cover the history of the ANC from its founding to the present day: Heidi Holland, *The Struggle: A History of the African National Congress* (New York: George Braziller, 1990); and Francis Meli, *South Africa Belongs to Us: A History of the ANC* (Bloomington: Indiana University Press, 1988). Meli's work combines the perspective of a trained historian with that of an insider, as the author holds a doctorate in history and is also the editor of *Sechaba*, the official organ of the ANC. Two important books deal with African politics from the 1940s through the 1970s. The first of these is by Gail M. Gerhart, *Black Power in South Africa: The Evolution of an Ideology* (Berkeley and Los Angeles: University of California Press, 1978), and deals primarily with the intellectual dimension of black political history. Complementing the Gerhart study is a study of black resistance movements that examines them in their local context: Tom Lodge, *Black Politics in South Africa Since 1945* (New York: Longman, 1983). Stephen M. Davis, *Apartheid's Rebels: Inside South Africa's Hidden War* (New Haven, Conn.: Yale University Press, 1987), provides an assessment of the ANC and its underground resistance movement in the years since the Soweto revolt of 1976.

Biographical studies of the principal figures engaged in African politics since 1948 are relatively scarce. Nelson Mandela is the subject of two studies: Mary Benson, *Nelson Mandela: The Man and the Movement* (New York: Norton, 1986); and Fatima Meer, *Higher Than Hope: "Rolihlahla We Love You"* (Johannesburg: Skotaville Publishers, 1988). Winnie Mandela's autobiographical *Part of My Soul Went with Him* (New York: Norton, 1984), deals at length with the life she shared, and had been unable to share, with her husband. Oliver Tambo has not been the subject of a biography to date, although a book of his writings has been published. Two books have also been published of Mandela's writings and speeches. Albert Luthuli, president-general of the ANC from 1952 until his death in 1967, is the author of an autobiography, *Let My People Go* (New York: McGraw-Hill, 1962). Another major African nationalist figure of the 1940s and 1950s is the subject of Monica Wilson, ed., *Freedom for My People: The Autobiography of Z. K. Matthews, Southern Africa 1901 to 1968* (London: Rex Collings, 1981). For a study of the most important individual in the Black Consciousness Movement of the 1970s, see Donald Woods, *Biko* (New York: Random House, 1978). Finally, Gail M. Gerhart and Thomas Karis, *Political Profiles, 1882-1964*, vol. 4 of Thomas Karis and Gwendolen M. Carter, eds., *From Protest to*

Challenge: A Documentary History of African Politics in South Africa, 1882–1964 (Stanford, Calif.: Hoover Institution Press, 1977), is a particularly valuable source of information about the chief personalities of the lengthy African effort to gain a rightful place in white-dominated South Africa.

Long-term imprisonment has been a central experience in the lives of Nelson Mandela and many others engaged in the struggle against apartheid, especially since 1962. The most important South African prison for the African leaders and one that has come to symbolize their prison experience is Robben Island, which lies offshore from Capetown. Michael Dingake served for fifteen years as a prisoner on Robben Island and wrote about it in *My Fight Against Apartheid* (London: Kliptown Books, 1987). Indres Naidoo provides similar information in *Robben Island: Ten Years a Political Prisoner in South Africa's Most Notorious Penitentiary* (New York: Vintage Books, 1983).

There are major sources of documentary evidence for the study of African politics and the antiapartheid movement in general. Two books contain selections from Nelson Mandela's speeches and writings. The first collection, edited by Ruth First with an introduction by Oliver Tambo, is *No Easy Walk to Freedom: Articles, Speeches, and Trial Addresses of Nelson Mandela* (London: Heinemann Educational Books, 1965); and the second is International Defense and Aid Fund, ed., *Nelson Mandela: The Struggle Is My Life* (New York: Pathfinder Press, 1986). As we noted, a volume of Oliver Tambo material is also available: Adelaide Tambo, comp., *Preparing for Power: Oliver Tambo Speaks* (New York: Braziller, 1988). The most extensive source of published African political documents, including many Mandela and Tambo documents, is the first three volumes of a four-volume work, Thomas Karis and Gwendolen M. Carter, eds., *From Protest to Challenge*. Volume 1 is by Sheridan Johns, III, *Protest and Hope, 1882–1934* (Stanford, Calif.: Hoover Institution Press, 1972); volume 2 is by Thomas Karis, *Hope and Challenge, 1935–1952* (Stanford, Calif.: Hoover Institution Press, 1973); and volume 3 is by Thomas Karis and Gail M. Gerhart, *Challenge and Violence, 1953–1964* (Stanford, Calif.: Hoover Institution Press, 1977). The documents published in these three volumes form only a small portion of the extensive Carter–Karis Collection of South African political documents housed in the Melville J. Herskovits Africana Collection of the Northwestern University Library and available on seventy-one reels of microfilm that can be obtained from the Cooperative Africana Microform Project of the Center for Research Libraries. For a guide to this collection, see Susan G. Wynne, comp., *South African Political Materials: A Catalogue of the Carter–Karis Collection* (Bloomington, Ind.: Southern African Research Archives Project, 1977).

Sources for Documents

The sources for the documents in this volume are indicated in the headings for each document. To assist those readers who would like to consult the documents in their unabridged form or in a lengthier excerpt, we have listed other published sources in which they appear. For full bibliographical information on other published sources, see the Guide to Further Reading.

I

Mandela

Document 1 Presidential Address to the African National Congress Youth League. Also available in the Carter–Karis Collection, Reel 2B 2:DA 16/3:85/1.

Document 2 The Shifting Sands of Illusion. Also available in the Carter–Karis Collection, Reel 28B 2:Z14/7; Mandela, *The Struggle Is My Life*, pp. 43–45; First, *No Easy Walk to Freedom*, pp. 32–35.

Document 3 No Easy Walk to Freedom. Also available in the Carter–Karis Collection, Reel 12A 2:XM33:85/2; Karis and Carter, *Protest to Challenge*, vol. 3, pp. 106–15; Mandela, *The Struggle Is My Life*, pp. 34–42; First, *No Easy Walk to Freedom*, pp. 17–31.

Document 4 People are Destroyed. Also available in the Carter–Karis Collection, Reel 28B 2:Z14/7; Mandela, *The Struggle Is My Life*, pp. 59–61; First, *No Easy Walk to Freedom*, pp. 39–42.

Document 5 Freedom in Our Lifetime. Also available in the Carter–Karis Collection, Reel 12A 2:XM33:82/1; Karis and Carter, *Protest to Challenge*, vol. 3, pp. 245–49; Mandela, *The Struggle Is My Life*, pp. 54–58; First, *No Easy Walk to Freedom*, pp. 55–60.

Document 6 Land Hunger. Also available in the Carter–Karis Collection, Reel 28B 2:Z14/7; Mandela, *The Struggle Is My Life*, pp. 61–64; First, *No Easy Walk to Freedom*, pp. 43–46.

Document 7 Bantu Education Goes to University. Also available in the Carter–Karis Collection, Reel 28B 2:Z14/7; Mandela, *The Struggle Is My Life*, pp. 64–68; First, *No Easy Walk to Freedom*, pp. 47–52.

Document 8 A New Menace in Africa. Also available in the Carter–Karis Collection, Reel 28B 2:Z14/7; Mandela, *The Struggle Is My Life*, pp. 72–77.

Document 9 Verwoerd's Tribalism. Also available in the Carter–Karis Collection, Reel 28B 2:Z14/7; Mandela, *The Struggle Is My Life*, pp. 77–86; First, *No Easy Walk to Freedom*, pp. 67–79.

Document 10 Courtroom Testimony in the Treason Trial. Also available in Karis and Carter, *Protest to Challenge*, vol. 3, pp. 592–96 (p. 626 has further information about Mandela's testimony in the *Treason Trial Record* itself); Mandela, *The Struggle Is My Life*, pp. 87–94; First, *No Easy Walk to Freedom*, pp. 81–85.

Tambo

Document 11 ANC Stands by the Alliance with Congress of Democrats. Also available in Tambo, *Preparing for Power*, pp. 33–38.

African National Congress

Document 12 Basic Policy of Congress Youth League. Also available in the Carter–Karis Collection, Reel 2B 2:DA16:12/2; Karis and Carter, *Protest to Challenge*, vol. 2, pp. 323–31.

Document 13 Programme of Action. Also available in the Carter–Karis Collection, Reel 2B 2:DA16:14/1; Karis and Carter, *Protest to Challenge*, vol. 2, pp. 337–39.

Document 14 Freedom Charter. Widely reprinted. Also available in Karis and Carter, *Protest to Challenge*, vol. 3, pp. 205–8.

II

Mandela

Document 15 The Struggle for a National Convention. Also available in Mandela, *The Struggle Is My Life*, pp. 98–100.

Document 16 Deliver the Knockout Punch.

Document 17 An Appeal to Students and Scholars. Also available in the Carter–Karis Collection, Reel 7B 2:EA2:84/2; Karis and Carter, *Protest to Challenge*, vol. 3, pp. 633–34; Mandela, *The Struggle Is My Life*, pp. 101–2.

III

African National Congress

Index

335